THIS IS MODERN ART

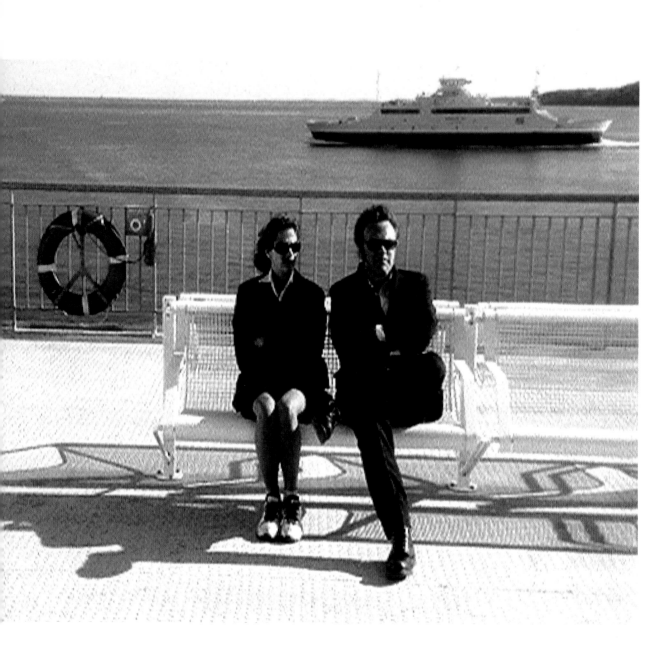

THIS IS MODERN ART

MATTHEW COLLINGS

Watson-Guptill Publications / New York

First published in the United States
in 2000 by Watson-Guptill
Publications, a division of
BPI Communications, Inc.,
1515 Broadway,
New York, NY 10036

Design and layout © Herman Lelie
Artists' biographies © Melissa Larner

Library of Congress Catalog Card
Number: 99–69934
ISBN 0–8230–5362–8

Typeset by Stefania Bonelli
Set in Gill, Joanna and Garamond
Printed in Italy by
Printer Trento S.r.l.

Manufactured in Italy

1 2 3 4 5 6 / 05 04 03 02 01 00

Frontispiece: Tracey Emin on a boat
in Norway with Matthew Collings,
1998

Contents

Introduction
7

Chapter One I am a Genius
21

Chapter Two Shock, Horror
63

Chapter Three Lovely Lovely
101

Chapter Four Nothing Matters
141

Chapter Five Hollow Laughter
183

Chapter Six The Shock of the Now
223

Picture Credits
264

Acknowledgements
268

Index
269

INTRODUCTION

KICKING ARSE

Gary Hume 1999

Start here

The sun was shining over Hoxton Square in London's East End. The sky was blue. The square was leafy. The buildings were picturesque. The air was buzzing with creativity and irony. Everybody was an artist. I walked past the Lux Cinema, the LEA gallery, and Rongwrong, the restaurant named after the title of a Dada pamphlet from 1928, published by Marcel Duchamp, on my way to the north-east corner where Gary Hume's studio is to look at some of his paintings. I was going to see if there was one that could go on the cover of this book – something that said Modern art but in a new way. But not so new that it didn't have any dignity or looked like it had just come out of nowhere and wasn't connected to anything, even though that's the main principle of Modern art, it's sometimes thought. It must be auto-genetic, born out of its own heavings and not come out of the frothy waves of the sea of joy that the art of the past swims around in, like schools of rainbow fish. This was the rambling course of my thoughts as I was smiling and saying Hello and Gary Hume was asking me how I wanted my coffee and telling me he'd given up smoking. 'What a problem it is', he was saying, 'to think up new ways to arrange the body and limbs when you're out with a lot of people and you suddenly realize there isn't a smoking ritual to unconsciously fall into.' 'White, please!' I was saying.

Magnolia

The abstract sublime – hospital doors; his paintings of the 80s joined them up into an expression of the age. They were big, stark, reflective surfaces of shop-bought

magnolia gloss, with a configuration of circles and lines showing faintly through the magnolia, the geometric shapes suggesting the rectangular finger-plates and circular windows of hospital swing-doors.

They suggested hospital cuts and Thatcherism and decadence and death and designer-handsome-ness. Minimalism is empty, death is emptiness, death occurs in hospitals. Minimalism is democratic. Death is too. Meaning bounced off the magnolia if you wanted it to, along with the high sheen. You didn't have to torture it out though.

I looked around the studio at his new paintings with their emphatic silhouette forms and bright colours. They had the attractiveness of wallpaper but the depth and mystery of art.

Burger King

In the early 90s he varied the hospital door style. He did this by introducing searing high colour combinations or having door-configuration paintings of unequal size and different colour schemes joined in a row, or by joining up door paintings that were all the same colour but the colour might be a strongly loaded one like flesh pink.

Then he wanted to drop doors and get on to something more flexible. But to get there he first had to try some things that were more awkward. It was to get his mind in a new shape. One of them was a film made in the studio yard. In it he wears a Burger King cardboard hat and talks aimlessly to the camera about art while sitting in a tin bath with all his clothes on. His young son hands him matches to light his fags. The film just comes on and he does all that for a while and then it ends.

Perhaps it was a Rimbaudian derangement of all the senses. Or a Jungian rite of passage. Or just an artist being an arse. You'd have to think you had a really worth-while self in the first place to believe that deranging it for art might be a worthwhile experiment. But that's why I like his art, because he's imaginative, even though he has an alarming personality. Alarming alternating with charming. So you're often not sure if you've been insulted or not when he's just insulted you.

King Cnut

Hume's film was called *King Cnut*. It was grungy and grainy, with bad sound quality. The action was minimal, the atmosphere abject. It was an allegory of art. What can you do with art? How can you make it make sense and be real? King Canute has to perform an impossible task. He is mad and thinks he can do it, or else his people are mad for believing he can do it. Conveniently Cnut might really be an Anglo-Saxon spelling of Canute as well as an anagram. Burgers, burger hats, cunts and ordinariness are all outside the realm of art but here they all were in *King Cnut*, jostling forward impossibly.

Around the same time, he painted abstract shapes of brown and blue to represent the earth and sky in a cosmic union. He fringed the sides of the painting with pages from *Shaven Ravens*, *Asian Babes* and *Big Uns*, extending the painted surface out

Gary Hume
b Kent (England), 1962
A member of the phenomenal group of British artists who graduated from Goldsmiths College in 1988, Hume came to the attention of the art world with his extensive series of door paintings. These achieve an interesting balance between figuration and abstraction. Painted in household gloss on large-format sheets of metal or MDF to imitate the double swing-doors found in hospitals and other institutions, they are the ultimate in representational painting, but at the same time, they are two-dimensional studies reduced to circles and rectangles. More recently, Hume has been taking his subject matter from the imagery of popular culture to create large, shimmering works in enamel paint that explore the seductive possibilities of surface, colour and form. Again, these are not easily categorized as either figurative or abstract – images and shapes are immediately recognizable but are subjugated both to the emotional aura they convey and to the intellectual investigation of painting they undertake.

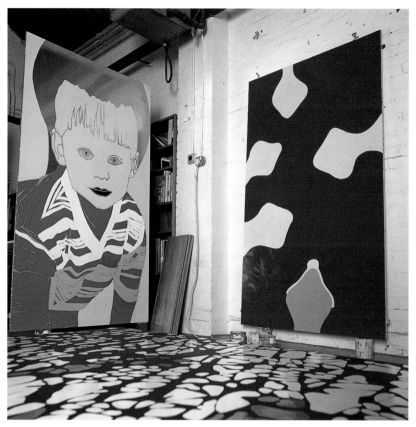

Gary Hume's studio. *Messiah* is on the left.

into real space and making the union a porny one as well as a cosmic one. Another painting was a blue Madonna with a stuck-on plastic dummy instead of a nipple.

Out of these awkward stumblings came a steady flow of large, decorative, logo-like paintings. And that's basically his style now. Gloss paint and pop mass imagery. A Modern look combined with a high street look.

The Messiah

I was looking at one now, an image of a boy on a heroic scale painted on metal which had just been completed. The colour was mostly shades of blue with accents of red. He said the title was *Messiah,* and the image came from a photo in a news story about a deaf boy. The whites of Jesus's eyes were beige. His halo was unpainted metal reflecting the colours in the rest of the studio. The aggressively frontal, painted and unpainted areas of the painting – thick gloss slicks and shiny reflective steel – all jostled against each other in a visually satisfying way, like Modern painting is supposed to do, from Picasso to now, whether it's Monet or Patrick Caulfield.

Divertimento pentimenti

The classic model of Modern painting I had in mind was Picasso's *Les Demoiselles d'Avignon* of 1907, because of its fractured space. Like the fracturing that these metal areas and painted areas in *Messiah* seemed to be a reminder of. And the paintings by Monet I had in mind were his waterlilies of the 1920s, with their looming banks of mysterious *pentimenti*, because they were all on show at the moment at the Royal Academy. Monet is nothing like Gary Hume, except they're both supposed to be full of pleasure, or bringing back pleasure. The papers were full of articles about a new Monet for our age. Was he really a ridiculous snob and a sugary-minded moron? But that's his image now and we have to live with it – the Queen Mother of Impressionism.

Britain's image abroad

After looking at the *Messiah*, Hume and I looked at some *assemblages* or *bas-reliefs* or take-away-coffee-cups-used-to-mix-paint-in-and-then-stuck-to-aluminium paintings, which were a new decorative abstract departure. But before that, he showed me a model of the British pavilion in the little park in Venice where the Venice Biennale is held. This year, he would be representing Britain there. Colour photos on double-sided Sellotape of about twenty of his paintings lined the walls, with plastic model people standing around to show the scale. A flower-pattern painting from a couple of years ago hung upside down on a ceiling. And a hospital door painting from ten years ago lay out on the steps of the pavilion. Through the cardboard rooms there were more paintings showing plant forms, cell forms, single naked women, multiple naked women with their outlines all overlaid, faces, a teddy bear, a pair of abstract circles on their own, a pair of circles laid over a face.

Monet Exhibition at the
Royal Academy, London 1999

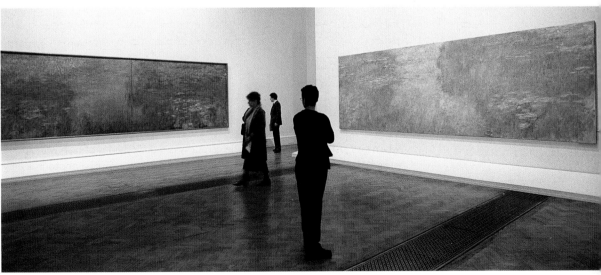

Tracey Emin
b London (England), 1963
Tracey Emin takes to an extreme
a strand in contemporary art
that utilizes intimate details from
the artist's own life as subject
matter. Haunted by an unhappy
adolescence, she treats her art
as a kind of therapy, creating
an overall, complex self-portrait.
Her best-known work is
Everyone I Have Ever Slept With –
1963–1995 (1995), a tent
appliquéd with all the names
of her lovers and bedfellows,
including her aborted foetuses.
In other works, she has displayed
her contraceptive coil, or child-
hood dental brace. In the video
piece *Why I Never Became a Dancer*
(1995), she reconstructed painful
memories of her teenage experi-
ences in Margate. She has also
toured America, giving readings
from her book *Exploration of the*
Soul (1994), and opened a shop
with Sarah Lucas selling their
works. And in 1995, as the
ultimate gesture of self-
commemoration – or perhaps
self-invention – she inaugurated
The Tracey Emin Museum in
south London.

TASTE. AND SEE

Tracey Emin, Artist, photographed by Malcolm Venville.

Uniquely distilled with 10 botanicals.

Tracey Emin advertising
Blue Sapphire Gin 1998

'It's good to get all this layering of possibilities all laid out and for it all to make sense,' I said. 'Yeah,' he said. 'But does it kick arse?' 'Ha ha!' I laughed. 'Well, you know, you don't have to kick arse all the time.'

Very Modern art

Today there is a lot of interest in very Modern art. When I was at art school in the 1970s Modern art seemed detached from everything else and nobody talked about it except artists and art students. You used to sometimes see it on TV with someone complaining about it. There would be a canvas with nothing on it except a line round the edges drawn with a biro. Or there would be a sculpture made of bricks on the floor. Nobody knew the names of the artists who made these works or what they looked like. Now that's all changed. Tracey Emin's colour-graded blue eyes look out from ads for Blue Sapphire Gin at all the airports. Gary Hume models Hugo Boss. Ads for Go Airlines imitate Damien Hirst's spot paintings – or imitate 60s graphics, which Hirst's spot paintings also imitate. And new Modern art is well known to a wide audience almost as soon as it's made.

Art fits with everything else now, all the other expressions of our time, and it's not out on a limb. Love tents, paintings of supermodels, Minimal sculptures, maps of the London tube system with all the names of the stations changed – they all fit with contemporary pop culture. (Well, one painting of a supermodel – Hume's

painting of Kate Moss – but a general feeling that Modern art and supermodels might be naturally aligned.) They all make sense. Myra Hindley paintings, cow sculptures, blood heads, a bullet hole in the head – Modern art's new sights are part of glamour, part of fashion and they fit with the spirit of now.

Earlier stirring

There used to be a similar relationship between the pop world and the art world in the 60s, people think. But in fact it was only a little spurting of the huge thing we now have. There was Pop art, dresses influenced by Op art, Pop art films, like Antonioni's *Blow-Up*, and there were album covers designed by artists, like Peter Blake's Pop art cover for *Sergeant Pepper* and Richard Hamilton's Minimal cover for The Beatles' *The Beatles*. *The Beatles* is the real name for what became known, because of Richard Hamilton, as *The White Album*. But how many other albums were designed by Modern artists? I can't think of any now. Except Andy Warhol's unzippable banana for *The Velvet Underground and Nico*. Does that count, though, since The Velvet Underground didn't really exist before him? His later unzippable jeans cover for The Rolling Stones' *Sticky Fingers* might be a better example. But still that's only four records, hardly a revolution, and it was all over pretty soon.

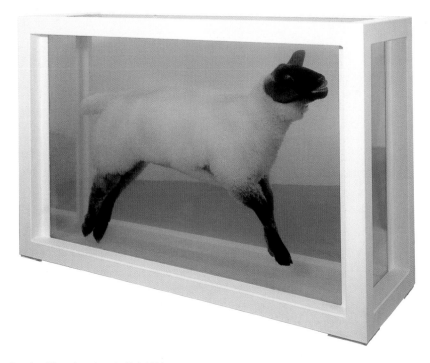

Damien Hirst *Away from the Flock* 1994

Minimal flats in the 80s

With Pop art in the 60s, popular culture just absorbed the part of Modern art that seemed to fit it and rejected the rest. Then the rest rejected Pop art and popular culture. The rest was Minimalism and Conceptualism, which was basically what art was in the 70s, as well as all the offshoots of Minimalism and Conceptualism — video art, performance art, body art, land art. This was the least popular art there has ever been. It was art drifting out to sea in a boat on its own and with nobody waving, either to it or from it.

Then unexpectedly in the 80s, Minimalism seemed to be influencing ordinary life. Minimalism was now a lifestyle choice instead of an obscure art movement because everyone wanted a Minimal flat with no furniture or they wanted to look at Minimal flats in magazines. It wasn't exactly Minimalism but a kind of sampling of an earlier notion of modern, pared-down living, which came to be known in the 80s as Minimalism. It was Modern art finding its way back into the wider culture.

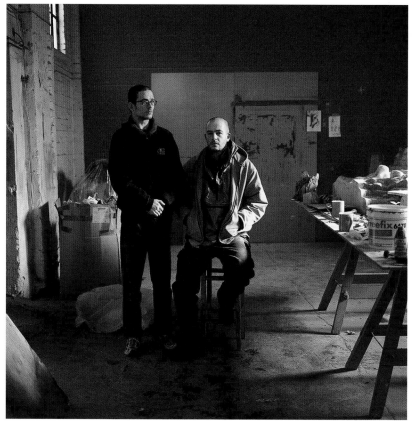

Jake and Dinos Chapman in their studio
1999

Picasso and now

Picasso and the art of the Chapman brothers, their shocking sights that we're not really sure we're actually shocked by – is there a complete gulf between the two? Is our present Modern art something new, with no links at all, virtually, with anything in art further back than Conceptual art? Or is it all part of a seamless whole that goes back to Impressionism? We're sometimes supposed to believe the second idea and think well-known artists of today are like the geniuses of the past and it's great that we've suddenly got a lot in London when we used not to have so many and they were all in New York or Paris. The first idea is more realistic and likely and less confusing. The type of Modern art that goes back to Impressionism is over and the thing we have now is something new.

It's not just that it expresses the present and the present is different to the past. It's also that it doesn't express reverence for the art of the past, which older art used to do. A weird inversion of something that used to be a truth of art now

Pablo Picasso
self portrait taken
in Picasso's studio

operates – new Modern art often imitates the exact surfaces of old Modern art, precisely because it doesn't care about it. It does the same to pre-Modern art, whereas old Modern art used to strive not to imitate the exact surfaces of older art precisely because it believed in it. It believed in it enough to want to develop it and advance it, and developing and advancing meant not copying the surface but advancing the idea or principle that lay beneath the surface.

On the other hand, new Modern art is still art. It's art because it isn't anything else. It wants to be popular and to go on being popular and never go out of fashion but that doesn't mean it's only cynical – or only enjoyable because of its witty way of expressing cynicism. It expresses new meanings, it doesn't express only itself and it doesn't express only popularity or fashion or glamour.

Rise of now

At some point – perhaps it was the late 80s, early 90s – between the craze for Minimal flats and whatever the equivalent domestic architectural craze is now, Modern art became popular. The version of Modern art we now know was established and settled in. And this time it was glamorous, mysterious, sexy, soulful, macabre, gloomy, quirky, kinky and funny and it was going to last the course, it wasn't going to go away. It wasn't going to be only ritzy and funny, like Pop, and it wasn't going to be only uptight and white like mid-60s Minimalism.

Looks are everything

Modern art today often imitates the past, whether it's older Modern art or pre-Modern art. But popular culture is fascinated by the surfaces of the past too. It's a drive towards the retro which has been going on since the 1970s. We don't find it hard to imagine that ads and movies have a weightless relationship with the past and that when the past is sampled in these contexts, well, that's all it is. But when art does the same or seems to, it is more disturbing and we ask ourselves if it's really allowed and we feel a bit relieved when there's someone thundering against it in the papers, taking a stand against cynicism, even though there's something a bit reheated and un-urgent about the thundering position as well, as often as not.

Some things from the past are more likely to be sampled or recycled by the present. Matisse and Magritte, for example, are always coming up now but Cubist paintings of newspapers and pipes and mandolins hardly ever do because we are out of sympathy with this kind of subject matter and also this kind of space. Magritte and Matisse, previously so different, now align in their way of making a very compressed image – an image with a single, clear impact.

Magritte plays a game of ambivalent meanings. You could say ambivalence was two meanings. But Magritte's impact is in the idea of ambivalence itself, or contradiction. With Matisse the impact is in the colourful flat sign for an object – a plant or a face or a figure. And both the world of ads and the world of new art are full of these types of singular impact. Cubism is everywhere in the look and

Duane Hanson *Tourists II* 1988

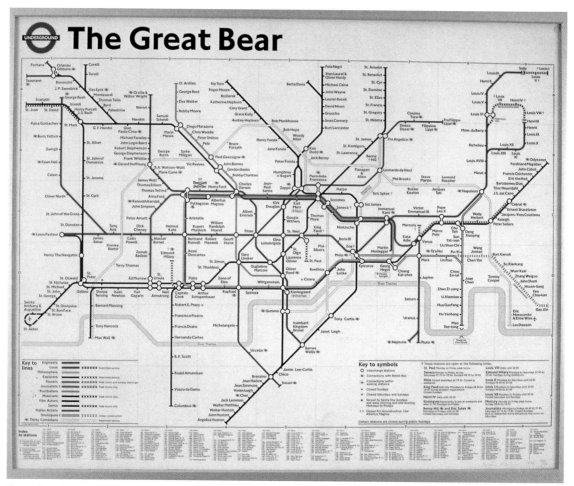

Simon Patterson *The Great Bear* 1992

surfaces of modern life in diluted amounts but real high Cubist paintings from 1908 or whatever are too much Cubism for us.

How looks work is a mystery. It's clear now that looks are everything but why do we want some looks at some times and not others?

Less usable Modern art

Some parts of old Modern art go on being more and more popular but are not recycled or sampled by new art. They can't be re-used to express the age in a new way however expressive of the age they might already be. Crowds of couples stand around like Duane Hanson sculptures of ordinary people, updated to the 90s by having whirring CD exhibition guides hanging on their chests in transparent CD

players. They're at a big blockbuster show of Monet. So what if he stayed at the Savoy when he was painting the Thames? His paintings are beautiful, moving, and ravishing, the height of aestheticism and powerful, expressive art as well. Charing Cross Bridge, overcast weather, the bridge blue, the Thames banana yellow, the steam coming from a train on the bridge, purple: it's *Charing Cross Bridge, overcast weather*, a painting by Monet from 1900, the year Freud's *Interpretation of Dreams* was first published.

Landscapes

A typical new Modern art landscape scene – say, early 90s – is an urban landscape with a warehouse and an Underground station. The sky is an unnatural blue, as if the blue is bumped up artificially by some computer digital technique or other. The warehouse is a converted one, formerly part of industry but now part of culture and full of artists, with a private view going on downstairs and studios upstairs. The Underground station has had its name changed from Walthamstow to Walter Benjamin. The artists have had their T-Shirts changed from striped like a Marseilles fisherman's T-Shirt to ones with Mod targets on them or *My Drug Hell*.

The scene is one of a series of 90s urban landscapes, all the same but with variations, going on throughout the decade until now, maybe going on forever. In this landscape there is a blurred figure – it's your guide, myself. A blur with a pass for Zones One and Two – the old and the new. Shortly we'll be touring them both, going back and forth, taking six basic ideas about Modern art which are common and popular as the main stopping off points.

The first idea is that the notion of genius is still an important one. After that it will be Modern art's shocks – why are there so many, what are they for? Then beauty – is Modern art against it? Then nothingness – why are there so many blank canvases or all-white ones? Then jokes – why is Modern art full of jokes, are they funny? Then lastly hype, money, repetition, realism, all at once, and the anxiety that goes with them.

So let's go then, down the tunnel to the platform where mannequin children smile, supermodels glide, sharks loom, heads bleed, Myra Hindley stares and the trains are rushing in and the passengers are getting out and the next stop is St Thomas Aquinas, for the Comedians and Footballers Lines.

CHAPTER ONE

I AM A GENIUS

Gilbert and George
The Singing Sculpture
1970

Gilbert and George
Gilbert Proesch: b Dolomites
(Italy), 1943;
George Pasmore: b Devon
(England), 1942
As students of St Martin's
School of Art in the late 1960s,
Gilbert and George designated
themselves 'Living Sculptures',
a decision that has not only
involved dedicating their entire
existence to art, but which also
broadens the definition of what
art can be. Their performances
and photographs may be
shocking, but their principal
aim is to make art that is as
accessible as possible. Early
works ranged from the 'Singing
Sculpture' performances, in
which they dueted 'Underneath
the Arches' for an eight-hour
period, to photographic collages
with titles like *George the Cunt
and Gilbert the Shit* (1970).
More recently, they have been
producing vast, brightly coloured
photographic works, in which
they present taboo imagery,
sometimes political or religious
in content but usually featuring
themselves, naked or surrounded
by giant turds (*Naked Shit Pictures*,
1994). As a result of their
provocative, dead-pan
double-act, Gilbert and George
are amongst Britain's most
famous contemporary artists,
pushing questions of taste and
conformity into the mainstream.

Three big myths

Three important myths of Modern art are the myths of Picasso, Jackson Pollock and Andy Warhol. All three myths are vivid and powerful and each myth, once it emerged, changed the codes of art history. These myths are all referred to unconsciously all the time by critics and art historians and by artists. And in the popular imagination they are also referred to because everyone knows them.

Old sausage

Sometimes mythologizing is part of what a Modern artist does – Gilbert and George and Joseph Beuys are well-known examples. These artists have their acts and acting is part of what their art is. They make objects as well, but their mythic rituals are just as much their art as their objects. Obviously an old sausage by Beuys is less of an object than a huge multi-part photo-work by Gilbert and George. So we could say Beuys relies more on myth. But both rely on myth in a way that Picasso, Pollock and Warhol don't.

Camp

Warhol of course had an act but he didn't present his act as art, or say he was a living artwork, which Gilbert and George do. But in doing this, Gilbert and George might be said to be only foregrounding or theatricalizing or making camp the whole idea of artists having acts within a mythical context where having an act is considered to be bad and art speaking for itself is good. Which was the same mythical context that Warhol elaborated his act within, even though he didn't call his act art and he didn't even call it an act. He just carried on like that. And even though it was a camp act.

Siberian camp

Beuys actually had a myth of his own self-realization as an artist, which he told to people and which has entered art history not as fact but as a myth. He said he crashed his plane in Siberia when he was a Luftwaffe pilot in the war. He was rescued by primitive Siberian tribesmen who took him back to their camp and bound his

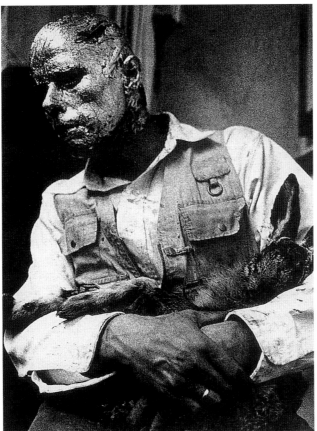

Joseph Beuys
*Explaining Paintings
to a Dead Hare*
1965

Joseph Beuys
b Krefeld (Germany), 1921;
d Düsseldorf (Germany), 1986
In 1943, as a Luftwaffe pilot, Beuys was shot down in the Crimea. His life was saved, he claimed, by a group of nomadic Tartars, who kept him warm with felt and fat. These materials and his trademark fedora hat, which he wore to hide the scars, became central therapeutic symbols in his personal mythology, expounded in highly influential performances and installations. Beuys was a leading figure of the European avant garde in the 1970s and 80s. Like other members of Fluxus, which he joined in 1962, he was intent on the demystification of art, and on demonstrating that life itself is a creative act. His sculptures were made of junk and rough wood. Eventually, however, he rejected the art object as 'a useless piece of merchandise'. His performances often involving living or dead animals included *Explaining Paintings to a Dead Hare* (1965), in which he attempted just that. When, in 1972, his policy of unrestricted admission got him sacked from his Professorship at Düsseldorf University, he turned his attention to public debate, exchanging ideas with Andy Warhol and the Dalai Lama. By the end of his life, his spiritual, democratic practice had accorded him the status of internationally celebrated art guru.

Joseph Beuys
Vitrine for: 'two Fräuleins with shining bread'
1963–82

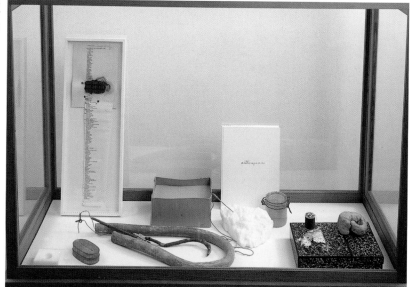

broken body in layers of felt and fat as part of his recovery treatment. This myth is the ur-myth of Beuysian Happenings and installations and objects, and it connects to all the fat and felt that he used as materials. There might be some truth in it or it might be entirely true but it isn't necessary for the Beuys myth to work that it should be true, whereas it is necessary for the Pollock myth for it to be true that he had drunken rages because it connects to the aspect of doom which is a major part of his myth.

Different self-mythologizing

Other examples of self-mythologizing artists are Sophie Calle and Cindy Sherman. Gilbert and George and Beuys's self-projections are always the same or variations on the same theme – twenty-four-hour living sculptures or wise guru of art and life. Whereas Calle's and Sherman's are deliberately always different. No one will ever know the real Cindy because she is always in disguise as someone else. Someone grotesque and glamorous at the same time. While the real Sophie is always present but only in whimsical fragments. Narrative fragments presented in an installation form. Cindy is a cypher and Sophie is a modern psychoanalytical, perpetually fragmented, self.

So these artists' mythologizing goes in the opposite direction to Gilbert and George's and Beuys's but mythologizing is still the basis of what they do.

Cindy Sherman
Untitled No 70 (Girl at Bar)
1980

Sophie Calle
Days Under the Sun B, C & W (detail)
1998

Usual myths

But usually, or classically, myths build up around the artist and it is a delicate question as to how much the artist is pushing the myth self-consciously and how much the myth is a product of fantasies imposed upon the figure of the artist from outside. This is certainly the case with Picasso and Pollock but even with Warhol too.

Sunny

Picasso's myth is of the protean genius who keeps coming up with new ideas and styles. Attached to this is the myth of painting like a child. And attached to this is the myth of revolution against false finesse. Picasso stripped away pomposity and falseness and painted in an incredibly direct way. He attacked convention. He risked ugliness instead of beauty.

Attached to these myths is the myth of the good life. He lived a life of sensual pleasure. He got up when he liked and it was always sunny, except at night when he painted while everyone else was asleep because they had to get up early. And attached to sunniness is the myth of darkness. Picasso was a man like any other and aggression and fierceness ran through his veins. Bad Picasso!

All these make up the glaring aspect of the myth of Picasso. One of the subtle aspects of the myth, that we might mention, is the sub-myth of Picasso's archaism. His avoidance of cars and aeroplanes and business suits or nylon cardigans or TV sets, as subject matter for his art. They were as much a part of his life as they were a part of everyone else's but he preferred to paint centaurs.

Nowhere

Jackson Pollock's myth is the myth of rugged inarticulacy and untamed genius. He came from nowhere and invented a style that came from nowhere. With it he defeated Europe and oldness and made American newness the new thing. But he didn't know what he had done or if he had really done it. So he could not feel satisfaction. Attached to this is the myth of his martyrdom. The false world was too much for Pollock and it made him die young in a tragic car crash.

Pollock's main sub-myth is the myth of tragic unevenness. After the moment of triumph he lost his way and remained in a failure-limbo for years. It was not a limbo-lounge but a limbo-inferno, full of suffering. Obviously limbo is not hell, but a stage just before it, I think. But for Pollock it was all the same because in America failure is considered to be even more hell than war.

Supporting this myth are numerous mythic incidents of depressed, violent, drunken behaviour in an art context. These actions, innovated by Pollock and described shakily by craggy oldsters who now make up a familiar cast on TV documentaries about Pollock, are now archetypal and part of Modern art martyrology and also the martyrology of film and rock and roll culture.

No cigarettes

Andy Warhol's myth is the myth of Pop celebrity and shallowness and packaging replacing tortured sincerity and inner depth – the myth of self-consciously making yourself into a myth to begin with instead of waiting for a myth to build up. Picasso is Gauloise, Pollock is Marlboro, but Warhol is the pure concept of the brand name without even the necessity for cigarettes.

With shallowness Warhol defeated the withering disease that had afflicted Modern art because of its turning away from the outer world. Artists were in conflict with the outer world because it was rubbish or plastic or phoney or too consumerist or capitalist. But Warhol let the outer world into his inner world so there wasn't any conflict. He remade himself in its image. His iconic, celebrity mass art was a pure expression of his new inner self.

Warhol sub-myths include being gay as well as coming from the wrong side of the tracks socially. And being a Catholic. And having an old mother who was Catholic and who he kept in the basement. And never having sex because he preferred voyeurism. And being an obsessive collector of bric-a-brac which he kept in boxes.

As with Pollock, Warhol's triumph was achieved by a great gesture of skill-dumping and finesse-ditching and etiquette-trashing. Shallow naïveté is part of the glaring aspect of the Warhol myth but equally present is his mythic, sharp business acumen. His skill lies in his charlatanism, it is thought – unrivalled while artists attempting to emulate it are numerous (the inevitable connecting thought).

Freud

Other Warholian sub-myths include the myth of killing the father. He was formed as an artist in a climate of Abstract Expressionism but he could only become an artist by killing Abstract Expressionism. This Freudian myth is a given in all Modern art myths. Pollock had to kill off Picasso. And Picasso had to kill off tradition.

Rank

The myth of stylishness that attaches to Warhol as it attaches to all the main mythic figures, includes a distinguishing myth of rankness – stylishness that is gone off because of archness and mannerism and camp.

Industry

Another Warhol sub-myth is the myth of industriousness – he worked very hard; he had nutty, shallow ideas about what new art could be, but unlike his circle of decadent friends, who all took even more drugs than he did, he had the energy and industry to make the ideas into objects. (And they turned out not to be all that shallow after all.) Yet another Warhol sub-myth also connects to industry. His output, because it is so vast, is uneven. He had no quality control. (In fact he did and it's only a myth that he didn't.)

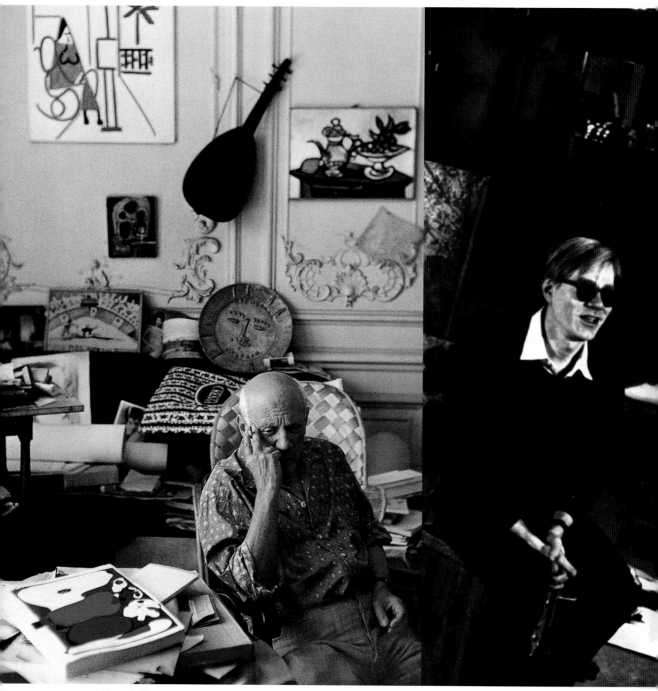

Picasso at Villa la Californie, Cannes, France 1960

Andy Warhol in the Factory, New York 1966

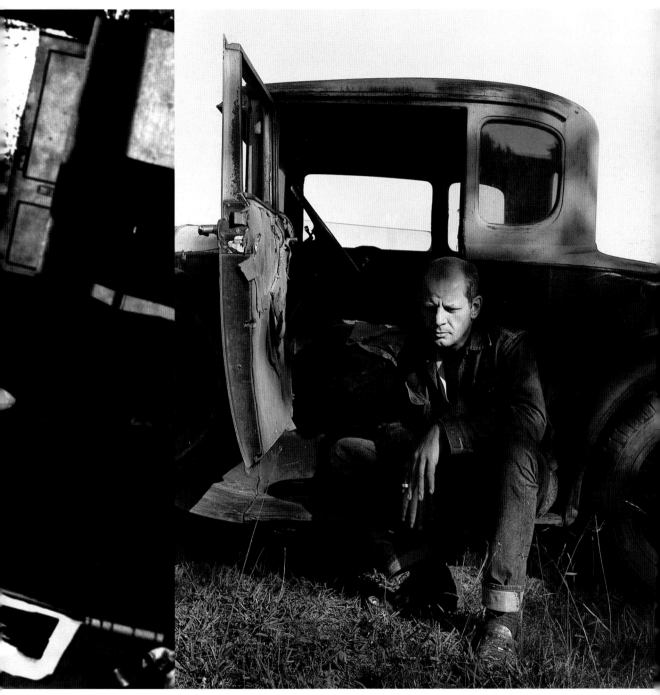

Jackson Pollock and Model A Ford 1948

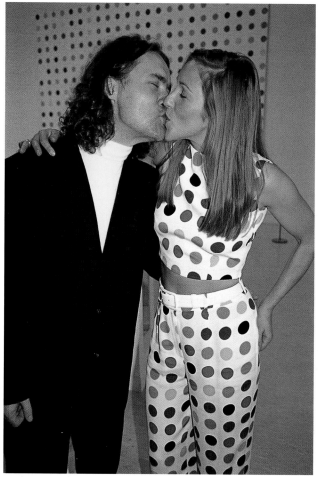

Damien Hirst and Maia Norman at the Turner Prize award announcement 1995

What did they do?

All these artists changed the definition of what Modern art is. With Picasso it was ugliness instead of beauty. With Pollock it was American instead of European. With Warhol it was irony instead of tortured emotion. Each of them in their time stood for making art that seemed to be aggressively about the present and not about the past. But now they're all in the past too. Warhol entered culture in about 1961. A lot's happened since then.

Up-to-date myths

Who are the mythic artists of now? Damien Hirst is one. He stands for constant innovation and popularity. Obscurity is part of his myth but it is never all that obscure. For instance, death is a mystery and death is part of the Hirst myth but

it is not difficult to get why dead animals might symbolize death. So the idea of Hirst as an artist of death has entered the popular imagination. Plus, he stands for a new connection between art and the jazzy world outside art. So he has made art more jazzy. Fashion people and ad people and people in rock and TV all embrace him and he embraces them but there is no doubt who the band leader is. He also stands for clear ideas, which he got from going to Goldsmiths College in London in the 80s. His restaurant Pharmacy, in Notting Hill Gate, stands for the buzzing generality of art now, the way Modern art is part of glamour and show biz and the way the old deep ideas of art can be made into bar décor, which is a twist on the popular idea of the old deep artists hanging out in bars like The Four Cats in Barcelona or the Cedar Tavern or Max's in New York.

New image of Modern art

Many vivid impressions make up the new image of Modern art. These impressions also make up the legacy of the earlier geniuses. Installation bric a brac and films and videos is one – things lying around, staging meanings. They break up pleasure because they are literally broken up and the pleasure or meaning isn't all concentrated in a single object. A TV monitor is a single object but the video playing on it in a typical installation of nowadays rarely has a narrative so the fragmentation principle is still operating.

Another impression is people arguing for and against installations in a stagey way on TV. The arguments are straightforwardly unreal, with everyone happily talking in short-cut versions of formerly difficult ideas only roughly connected to the short-cuts everyone else is using. And the installations only roughly seem to stand for the ideas. New pleasure is the main idea and everyone more or less gets it (even if they are on stage to attack it).

Old clothing and personal effects in installations is another impression. They can be from Oxfam or from the artist's childhood but they are always emotionally charged, because old clothing now stands for that idea. 'Hmm, where did she get that old cardigan?' would be an inappropriate response at a Louise Bourgeois exhibition, for example.

Important artists from Germany or other European countries having retrospectives at big public galleries in London and nobody knowing why and the art all looking a bit like 'Sensation' but with Swiss titles is another.

Vivid realistic ordinariness is another impression – ordinary council blocks, dads, mums, kebabs, mattresses, cans of Guinness, the *Sunday Sport*, the police, the map of the London Underground system: all these now have a place in Modern art iconography.

The new sights of art are all seen in white sites, the pleasurable, grungy, realistic ordinariness of the art surrounded by a corporate-style whiteness. It's a pleasure just to find yourself in there, separated from the real reality outside, like being in

Damien Hirst
b Bristol (England), 1965
Hirst broke onto the art scene as a recent graduate of Goldsmiths College when he curated two historic exhibitions – 'Freeze', 1988 and 'Modern Medicine', 1990 – which launched the work of the Young British Artists. He deals with the big themes of Birth, Life, Death, Love in a series of controversial, visceral works often involving dead animals, such as a shark or a bisected cow, suspended in formaldehyde. These shocking qualities are balanced, however, by his use of the vitrine, which gives his work the formal cool-ness of Minimalism, and by his references to art history: the Vanitas, the Madonna and Child, the works of Francis Bacon, for example. Installations often include his medicine cabinets – simple structures supporting packets and bottles of drugs – and his *Spot Paintings*, glossy canvases covered in rows of coloured circles. Never afraid of self-publicity, and seeing little difference between his art and the products of popular culture, Hirst has also made commercial music videos and films and opened his own restaurant.

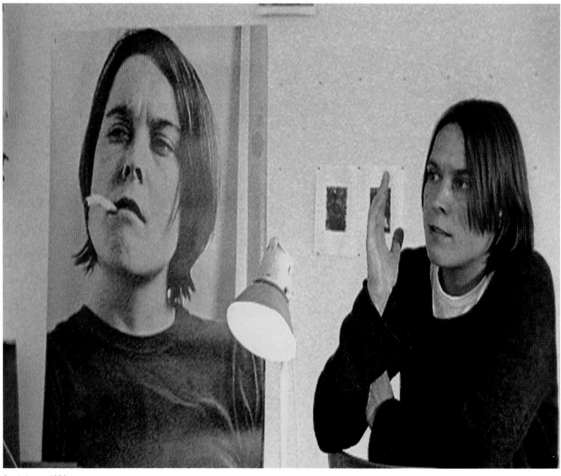

Sarah Lucas 1998

a cinema, only more brainy. The uniformly corporate style of art galleries makes it clear they really are galleries, not a new thing that hasn't got a name yet. The art must be unconventional but the galleries must be conventional so you can tell it's really art in them and not just something left over from a party or a murder.

The things artists say on TV or their statements in magazine articles make up another impression. With very few exceptions they tend to be full of reserve and dryness even though their art might be vivid. There will always be an interesting concern of some kind, about something the artist has personally noticed which no one ever thought was worth thinking about before, like the holes in cheese or the design of skirting boards or the patterns on socks.

There are many art bands, warehouse shows and private views, all adding their own textures to the other impressions. Art bands are full of irony. And artists stand

around at private views in neurotic ironic knots with their stomachs in knots, their faces twisted in ironic grimaces and with belly ache and their necks broken from twisting to see who's there or if their friends are being interviewed on TV.

Insider art jokes that would have become part of art scholarship and stayed there in a scholarship limbo, in the past, now make it straight into the Sunday supplements while the irony and sarcasm are still hot or icy.

Mass market magazines and little art magazines coming together is a part of art's new pleasure. 'Well done!' the members of the Bank artists' collective write in the margins of press releases which they send back to the galleries who sent them, stamped with the 'Bank Fax-Bak Service – Helping You Help Yourselves!' logo. They give marks out of ten for pompousness and general authoritarian feel. 'This last sentence is insufferably pompous,' one comment goes. 'Doesn't read as

Bank *Press Releases* 1999

deliberate, though. Try harder. 2/10.' Then it appears in the *Guardian* and everyone gets the joke.

The art magazines with their banal ideas and observations all twisted up and strangled in an impenetrable language contribute their own fun. Outsiders must never try to read them but artists must always be in them otherwise they cannot be serious, so they can't be nominated for the Turner Prize, which is about making Modern art more popular.

Place of art history

Art history has a place in the new system of art but it's hardly ever used. If the new art doesn't seem to be expressing urgent new meanings then art history can be called upon to explain why art exists at all. So in this sense art history is a kind of theology. It functions in relation to art as a kind of temporary back-up system. Because it's got nothing to do with new meanings, but only dates and influences, it cannot itself get the sparks of meaning going and it's art with vivid, immediate impact and meanings that society values now.

Anyone can relate to the new urgent meanings expressed by new art even if they don't want to. And to get meaning going, jokes will do. In fact they're good, even jokes about art history. Banal ideas, wrong ideas, popular ideas — anything will do as long as it's plugged directly into the present and there are sparks coming out the wire.

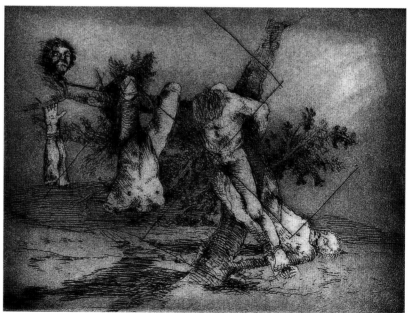

Jake and Dinos Chapman
Disasters of War 1999

Influence of Goya

For example, the Chapman brothers' art is influenced by appropriation, a style of the 80s. Their art appropriates Goya but Goya didn't influence the Chapmans in the way Cézanne influenced Cubism or Picasso influenced Jackson Pollock. Cubism makes a new kind of sense out of Cézanne and the sense Cubism makes is part of what Cézanne does, so there is a live connection between the two or a positive critical relationship. And it is the same with Pollock and Picasso but not with Goya and the Chapmans. Goya stands for goriness because his pictures are often gory and the Chapmans stand for goriness too because they copy his pictures. But that's it.

Meaning

Meaning itself is only a part of art. We object to there not being any but when there is some it's often not all that interesting.

Individualism

Individualism is not bad in itself but we don't want to be individual in a corny way like the Abstract Expressionists. They were not corny but to be like them now would be. Or, they were corny. Either thought works OK. In any case, we want to be individual but within a new climate, a climate where basically we have signed up to advertising. We simply don't challenge its assumptions. It expresses us. It has to sell things but this in itself isn't interesting or even particularly bad. In the old days it would say 'Go to the Regal, it is open at 7.30 in the evening' in a strained accent. But now it has all the accents we have ever heard and it does them all brilliantly and effortlessly. Advertising expresses a new world of oceanic oneness where no one is alone and that's good.

Do we believe in geniuses?

Mostly we do but we are wrong. Geniuses are out, along with crying clowns and Montparnasse and smoking pipes. Picasso is one of those artists where genius is a natural word because of the culture of Picasso but that's not our culture, like bullfights aren't part of our culture. Actually bullfights *are* part of our culture, because of Picasso. So we can't really say we reject him now because of his connection to bullfights. Actually we can't really say we reject him – it's the notion of Picasso as a magic being or a god that we feel it's important to reject because it makes him absurd somehow whereas in fact we know he is quite good.

Genius of Duchamp

Even with Duchamp, who we must agree has turned out to be the winner in the war with Picasso because now Conceptual art is known to be a powerful source for new ideas in art and Picasso's art isn't – but even with Duchamp the idea of genius isn't that interesting. Plain ideas about him, not ideas of magic, are more interesting.

For example, he was socially at ease and not wild. He might have modelled the realistic three-dimensional headless nude woman in his last work, *Etant Donnés*, on

the wife of the Brazilian ambassador in New York, whom he had an affair with. He made a living from advising collectors on what to buy. He acted as a dealer. He was an iconoclast but an aesthete. He never met Picasso. He met Matisse. He was kind to children. He was always profane but not angry. The charming American assemblage artist Joseph Cornell, who was interested in the poetic implications of Duchamp's Readymades, found his swearing appalling and it disturbed him. But Cornell was always dreaming about Duchamp and he had a fixation with him so he was probably more sensitive to bad language because he expected noble or poetic language. In fact Duchamp probably laid it on a bit heavy with Cornell just to keep his distance. When he was old there was a sudden widespread resurgence of interest in Readymades because of the vogue for Jasper Johns and Robert Rauschenberg in the 50s who both claimed Duchamp as an influence. So he started having them

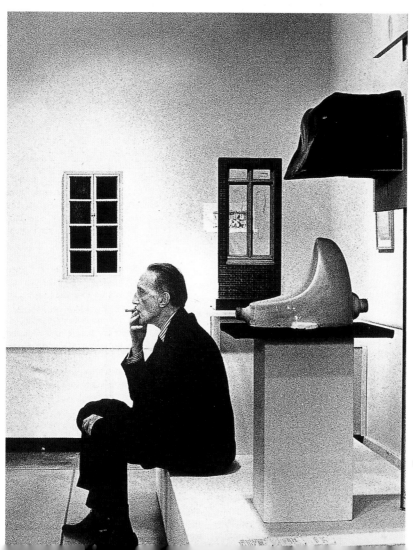

Marcel Duchamp in 1963

remade in Italy and signing the remakes and selling them in editions, because, although he was against commercialism, he thought it wasn't an impossible contradiction to get some cash in at this late stage while he still could.

All these things send up echoes for us of Modern art today and they all seem more interesting than worrying about whether Duchamp was a genius or a charlatan to say a urinal could be art.

Genius of Whiteread

Is Rachel Whiteread a genius? It's only part of the world of hype that is part of her world, as it is part of everyone else's, to use the word. Of course hype is false and an illusion. On the other hand, the world of Minimalism that connects to her world is not false but only unclear because it's still being explored. But Minimalism is about not relying on a mysterious force called genius but about paring art down to essentials. Therefore it's always uncomfortable to hear about the genius of an artist at all involved with Minimal forms which is what Whiteread is, even if she does make Minimalism more poetic or human.

Picasso likely genius

With Picasso it might be an acceptably loose use of the word to say he is a genius at transforming things so economically. With just a few strokes of the brush he transforms a triangle into a face and then into a flower and it's a wonderful sight to see that happening, especially when it's in a film from the 1950s. But this idea

Rachel Whiteread
b London (England), 1963
Whiteread became known for her plaster and resin casts of the interiors of domestic objects. The spaces beneath chairs were made visible as glowing chunks of amber-coloured resin, both familiar as Modernist forms, and revealing the unfamiliar nooks and crannies of everyday life. Baths cast in plaster were transformed into tomb-like manifestations of negative space; the subtly corroded innards of hot-water bottles turned inside-out. Whiteread has taken this metaphor for memory, the intimacy of private life, the spectres and traces of daily existence, to increasingly poetic realms. In *Ghost*, 1990, she cast a complete room, creating a haunting mausoleum, and in her most famous work, *House*, 1993, an entire derelict Victorian dwelling. Standing alone on a piece of wasteland in London's East End, this profound memorial to everyman documented door-knobs, fireplaces, windows in negative. Following great public controversy, it was quickly demolished. More recent projects continue to revolutionize the public monument – notably a concrete cast of a library in Vienna, presenting the concave spines of thousands of books, a poignant, permanent memorial to the 65,000 Austrian Jews who died in the Holocaust.

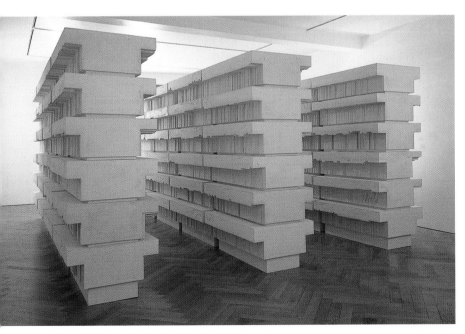

Rachel Whiteread *Untitled (Book Corridors)* 1998

Jeff Koons
Signature Plate 1989

of genius is always accompanied by a challenge to the notion of finesse so genius itself is challenged.

Koons possible genius

I might catch myself sometimes believing Jeff Koons is a genius because of the weird way he talks – confident but awkward, disjointed but streamlined, poetic but syntactically eccentric. It makes you want to shake him or tell him to snap out of it but it hypnotizes you at the same time. But this would be to use the word for its commonly acknowledged association of madness or being inspired to the point of madness, because he has that slightly mad feel about him when he's in full flow and this has been seen often on TV. Not the Romantic madness of the age of Shelley or Keats but some other new, unlabelled type, as if art school syntactic eccentricity had been given a poetic form and a load of mescaline.

Joie de vivre

Why do we have Warholian blankness now and not Picasso's joie de vivre? Compared to Koons and Hirst, Picasso seems sentimental. They have black joie de vivre, he has the full-blooded kind which has a lot of dancing and gamboling and pan-pipes and Mediterranean sunshine as one of its textures and this is a texture we don't approve of or want in art any more. We reject the *Zorba the Greek* notion of

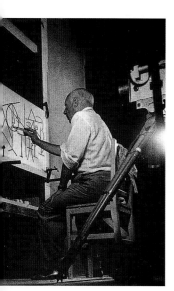

Picasso in a still from
Le Mystère Picasso 1955

Picasso, where darkness is never really all that dark because it is always ready to burst into song.

Two fried eggs and a kebab please

Sarah Lucas's symbols of female figures are morbid and obscene, made out of ordinary objects. A packet of kippers at one end of a table and two melons in a string bag at the other make up a sculpture called *Bitch*. A more famous one makes a female symbol out of two fried eggs and an open kebab. Another one is a couple – a fire bucket and two melons on a mattress, next to a cucumber and two oranges.

These sculptures are typically grim and deathly, like primitive totems but at the same time they seem deliberately beneath the level of art, too awful and silly to qualify as art or to make it onto the respectable

Pablo Picasso
Head of a Bull
1943

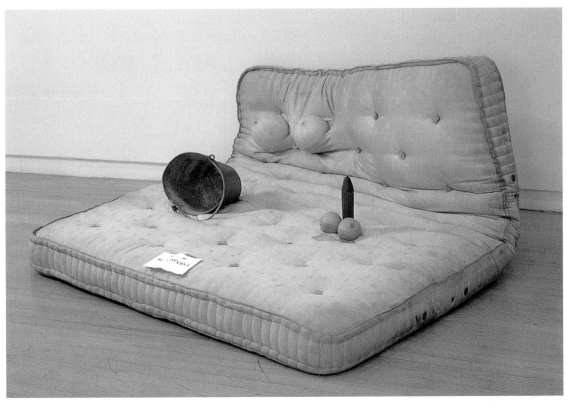

Sarah Lucas *Au naturel* 1994

Sarah Lucas
Two Fried Eggs and a Kebab 1992

Sarah Lucas
b London (England), 1962
Traditionally, female artists
interested in stereotyped gender
roles and the objectification
of women have focused on
an investigation of femininity,
eschewing the frameworks of
the male-dominated art world.
Lucas, however, adopts and
recontextualizes the tactics
of the laddish, innuendo-ridden
world of tabloid journalism and
sniggering schoolboy humour.
Two Fried Eggs and a Kebab (1992),
for example, is reminiscent of an
adolescent's smutty representation
of the female form. *One Armed
Bandits (Mae West)* (1995) – a
lavatory with a cigarette floating
in it, placed next to a chair
'dressed' in male underwear with
a candle sticking up from the
seat, is a gross depiction of
masculinity. This crude, 'bad girl'
approach is underlined by self
portraits in which she adopts
butch poses, suggestively eats
a banana, or aggressively smokes
a cigarette. *Bunny* (1997) extracted
the abject, unsettling qualities of
the earlier works in a poignant
evocation of contemporary
alienation. Most recently, Lucas
has been making smoking vaginas
and lavatories moulded from
urine-coloured resin or encased
in cigarettes.

intellectual plane where the idea of a primitive totem has some currency. But still there is an aura about them of objects that are intended for a tomb. They express life in an essential way – even if the essentials they express are the bleakest lowest denominators of existence – sex, life, death and relationships.

Lucas makes bits of discarded stuff stand for something, with a minimum of fuss, which is a sculptural technique that goes back to Picasso's welded metal sculptures of the 40s and 50s and back from there to his constructed objects of the 1910s. Her art might seem to laugh at the myth of Picasso but in this way at least it respects the myth too. That's why she's good. She keeps the ball rolling. It would be a parody of art history to say that *Bitch* therefore stands at the end of a timeline that begins with Picasso's earliest Cubist painting, *Les Demoiselles d'Avignon*, but it's true in a way.

I also like her ugly *Sunday Sport* blow-ups from the early 90s. They're really disgusting of course but quite impressive as a single visual blast. They too would be fine in a tomb, like hieroglyphs in a pyramid, to be pored over by future civilizations seeking the key to the meaning of the old mattresses and fossilized kebabs in the central chambers. *Sod you gits! Men go wild for my body!* That's what one of the headlines reads. A semi-naked dwarf woman grins out at the camera, all around

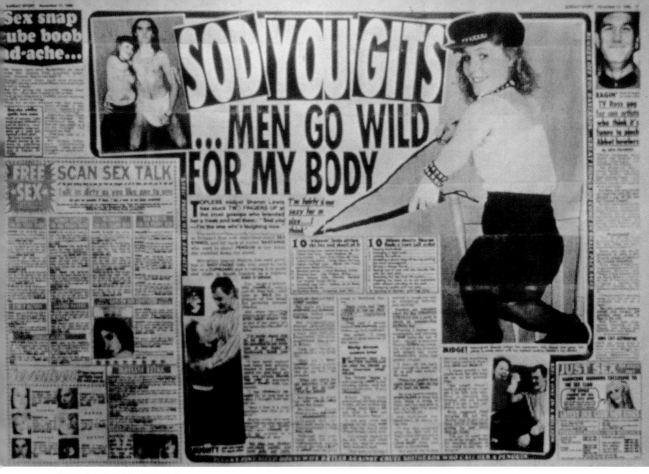

Sarah Lucas *Sod You Gits!* 1990

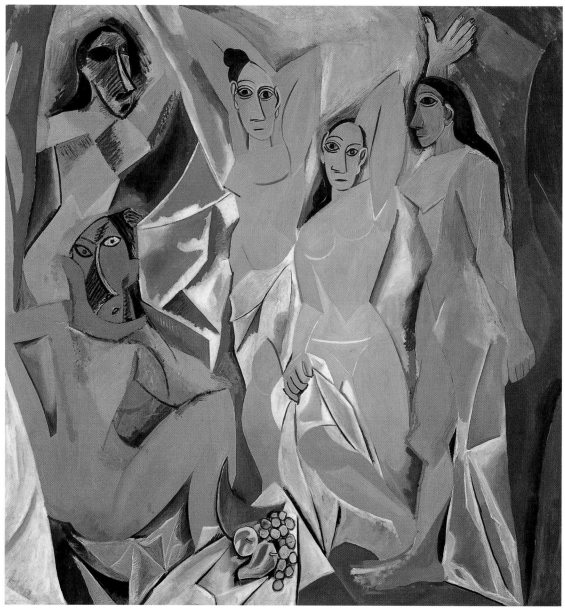

Pablo Picasso *Les Demoiselles d'Avignon* 1907

her are ads for phone sex-lines. Of course there's no point in looking at this work for long unless you want to read the ads. A lot of them are quite funny but it's not like looking at Picasso's welded metal assemblages from different angles or at the fractured space of *Les Demoiselles d'Avignon*. On the other hand, a lot of the same elements are present.

Myths again

Since the old myths seem to be rearing up on their own now, let's go back to them properly and see what's there. Picasso's blue and rose period paintings are well known, liked by people who don't normally like Modern art, disliked by people who like it. For Picasso, in the early 1900s, they were poetic symbolic paintings that expressed existence. At the same time he painted them he turned out hundreds of other pictures – engravings, watercolours, sketches – that expressed the texture of modern life as he experienced it. Night-life, bars, dancers, prostitutes, friends, lovers, other artists, all make an appearance, frequently in a context of mockery or outrageous obscenity, as well as a context of moody dreaminess or a poetic atmosphere. Another feature of this body of work, though not its most obvious one, is the different ways of making a figure read as a figure or simply of making representation work. Seen in this light, his blue and rose paintings might seem powerful and interesting and an odd quirk of Modern art and it is surprising that, since Modernism is over now, no one has thought of rehabilitating them or putting them in a big exhibition at the Royal Academy. From a Modernist perspective, though, these paintings are merely a lead up to *Les Demoiselles d'Avignon*; they haven't yet found a Modern form to express modernity so they're not that interesting.

Pablo Picasso
Self portrait
1903

Pablo Picasso
b Malaga (Spain) 1881;
d Mougins (France), 1973
Picasso is probably the most influential twentieth-century artist. His vast output of paintings, sculptures, graphics and ceramics passed through many styles and disciplines. The melancholy symbolism of his early 'Blue Period' (1901–4) gave way to the Harlequins and saltimbanques of the 'Rose Period' (1904–6), leading to the savagely revolutionary *Les Demoiselles d'Avignon* (1907), which combined the influences of African art, El Greco and Cézanne. With this work, and the subsequent sombre paintings developed with his close collaborator, Georges Braque, he invented Cubism. Picasso and Braque also pioneered collage with their radical *papier collés* and reliefs of 1912. After visiting Italy in 1917, Picasso began to make Neo-Classicist works with the recurring motif of the minotaur, but in the mid-1920s his paintings came under the influence of Surrealism. His strong political and nationalist views reached an intense pitch during the Spanish Civil War, when he produced the great anti-war protest, *Guernica* (1937). Post-Second World War works include variations on images by other artists and many graphics and ceramics.

Les Demoiselles d'Avignon

Painted in 1907, *Les Demoiselles d'Avignon* is the picture at the beginning of Modern art books. It introduces Cubist fragmentation and a scary notion of the anti-aesthetic, like the anti-Christ. It is a six-feet high squarish painting of five women in a room with drapery and a still life of fruit. The figures are blunt and flattened and the space of the room is also flattened so there's nothing behind the figures. Everything is pushed up to the surface. The figures have the feel of cut-outs. The middle one shares a contour with a section of drapery that runs down the length of the painting and the length of the woman. So there is a visual confusion running through the middle of the painting as if one side of the scene has been folded over the other. Sometimes it looks like the right side is folded over the left, sometimes the other way around. The same effect occurs with all the contours of all of the objects. This one makes a more continuous division while the others stop and start. The overall effect is of spaces and shapes interlocking and reversing. The expressions on the faces are mild or blank or masks of mild blankness. Three of the faces are actually stylized like African masks, one of them in a way that doesn't particularly jar with the stylization elsewhere, but two of them in a way that is very jarring and grotesque. This particular distortion is the main symbol of a new aesthetic of ugliness in Modern art that Picasso ushered in. And that's why this painting exerts a fascination.

It was originally conceived as a symbolic scene in a brothel with prostitutes, a sailor and a student carrying a skull. So the themes are prostitution, death, philosophizing about sex and death, connected to the themes of Picasso's pre-Cubist art. But here they're expressed in a primitive or pseudo-primitive form, so primitivism is the theme as well.

Picasso's comments on his use of African art are distorted by Chinese whispers, the subtlety of the original thought long ago lost. But apparently he really thought there was a voodoo magic to African masks and his fascination with them at this time wasn't on the aesthetic level. He thought they really were powerful and they could be used to make art more powerful.

I am Nature

Jackson Pollock made art more powerful by blasting it with primitivism. The Jackson Pollock story is a melodrama into which anything can be read. But directness and authenticity and agonies connected to the dilemma of authenticity, are constant themes of the story. Connected to these themes is the theme of a pared-down, pure type of art, an art free of phoniness.

The few statements Pollock made about his art which have been recorded fit in with the accepted ideas of his circle and are designed to explain why his art was abstract not figurative. He said, 'I don't paint Nature, I am Nature.' He said he was concerned with the rhythms of Nature: 'I work from the inside out, like Nature.'

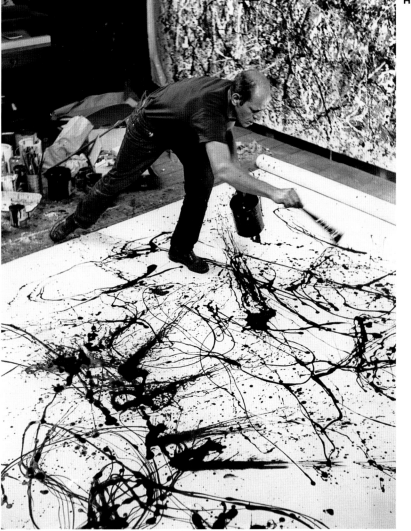

Another time he compared his method of working on the floor, working on all sides of the painting at once, to American Indian ritual sand paintings. Pollock's high point as an artist is considered to be the three-year period between 1947 and 1950 when he painted drip paintings. Before that he painted unremarkable, generalized abstract paintings. Influenced by Picasso, Surrealism, Mexican murals and psycho-analysis, they are not particularly bad but not particularly adventurous or distinctive either. His drip painting period is full of unevenness, but what makes these paintings

good when they are good is a kind of overwhelming light, airy, rhythmic, pulsating shimmeryness that appears to be present. And he achieves this simultaneously with an impression of overwhelming raw crudeness.

Close to, an airy high period classic Pollock of 1950, like *One* or *Autumn Rhythm,* can look ugly in the sense that the paint has a shiny curdled look, where the oil has contracted, like any dried oily drip. If your sense of beauty was mainly of smoothness then this could be offensive to the eye. But it would be odd nowa-days and maybe even neurotic to have such a restricted sense of the beautiful. And also the shiny wrinkled surface of the dripped paint is off-set by the woven matt surface of the cream-coloured canvas. There's a lot going on.

Backing off and looking at the whole thing, you get an impression of absolute visual rightness but a rightness that can't be pinned down. There seems to be a high element of chance. But chance itself isn't the content because that would be banal, just as drips aren't the subject. The content is the expression, the intensity of the sensation, the authenticity of the feeling.

What is meant when it is said that the paintings of the last years of his life represent a falling-off of quality is that they tend to be elegant and light and rather beautiful but without the impacted surface of the classic drip paintings. Or else too much in the other direction, sludgy and heavy like slabs of lino. They are still primitive but not eloquent, just inert tokens or reminders of a former eloquence.

Jackson Pollock
One (Number 31) 1950

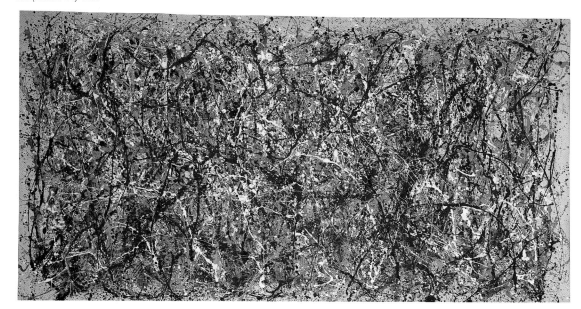

Are drips wrong?

Dripping in itself is not bad. Hans Namuth's 1951 film of Pollock in action has been seen by many people and is a cliché of Modern art. It shows him dripping, pouring and flicking paint in elegant loops onto a white canvas stretched out on a paint-spattered floor, as well as pouring it onto a surface of glass scattered about with bits and pieces of glass and pebbles and wire and stuff. Pollock is seen working intensely, with great concentration. The soundtrack includes a statement read by him in a stilted, distanced way. He starts a painting on glass and then after a minute wipes it off and starts again because it isn't right.

It's all quite artificial because it's a film. But one striking feature is Pollock's amazing control over the paint. Another striking feature is how un-macho the painting looks, how sensitive. The paint pots and rugged look of the studio environment are one thing, but the painting itself as it builds up is delicate and not particularly muscular and also not particularly tortured or anguished.

Pollock's ordinary life

Pollock was married to the artist Lee Krasner. They lived in a house in Fireplace Road in Springs, in the Hamptons, on Long Island, three hours' drive from Manhattan. Other artists lived in the area. His studio was a separate building at the back of the house. Krasner's was a small bedroom upstairs. She was dedicated to helping him even though in many ways it was damaging to her. They encouraged each other, she promoted his art and introduced him to artists, writers and dealers. One of the critics she introduced him to was Clement Greenberg, who became a close friend of the couple.

Greenberg was the writer most responsible for getting the Pollock style of painting over to other critics and to a gallery and museum audience and consequently to a wider public. Greenberg later said he had nothing against alcoholics but Pollock was the most radical alcoholic he ever met because his personality changed so dramatically when he was drunk. He also said Pollock got a lot from Lee Krasner in the way of understanding what art was about and he said he did too.

In 1955 Greenberg introduced Pollock to his own psychoanalyst, Ralph Klein. Before that, Pollock had seen a Jungian analyst. In a subsequent interview he said he thought everyone was influenced by psychoanalysis. Many of his symbolic paintings of the early 40s had Jungian titles.

In 1956, the last year of his life, he didn't paint but drank constantly and was depressed and often violent. He behaved outrageously and picked fights with anyone and smashed things up. He started an affair with a 25-year-old woman, Ruth Kligman, who worked in an art gallery in New York. He flaunted her in front of Krasner, who went on a trip to Europe in the hope it would blow over and when she came back things would be different. But as soon as she left, Pollock moved Kligman into the house. Then he became confused. It's like a soap opera.

Jackson Pollock
b Cody, WY (USA), 1912;
d Long Island, NY (USA), 1956
Jackson Pollock, or 'Jack the Dripper', as he was affectionately known, was the most famous of the gestural American Abstract Expressionist painters. He earned his nickname as a result of his method of dripping and flicking paint onto a canvas laid on the floor, sometimes adding texture with sand or broken glass. This process may sound messy or random, but these works emanate a harmonious, rhythmic control. Pollock emphasized the importance of process, the actual act of painting, often physically standing on his canvases when working. In 1949, the American critic Harold Rosenberg coined the phrase 'Action Painting' for this type of work. Pollock's early paintings, which alternated between elegantly linear compositions and all-over impasto surfaces, were also championed by the highly influential critic Clement Greenberg. Throughout the 1950s, Pollock was extremely prolific, swapping from black-and-white figurative works to the colourful drip paintings. By the time of his death in a car crash at the age of forty-four, however, he had lost confidence in his own ideas and was struggling to produce works.

Comic

Another thing that's like a soap opera is the story of Abstract Expressionism that many people have in their heads. They imagine it was all rough, tough, garrulous men, painting and drinking and fighting and calling each other out at the famous Cedar Tavern in New York for punch-ups. Pollock used to go there after his sessions with Klein. He would have a few drinks and destroy someone's hat or stare horribly at someone he didn't know or hit them and if they hit him back he would cry.

The Cedar doesn't exist any more but a facsimile of it does. It was built after the original burned down in the 60s. People still go there hoping to get a whiff of the old Abstract Expressionist spirit – perhaps see it rising off the tables like steam or ectoplasm. It all seems comic in a way but for Pollock it was tragic because he was in the grip of illness and also in the grip of a new surge of art, publicity, money and hype – the awakening rumble of the Modern art system of now.

Life

In one famous comment from his last tortured days he said he had been in *Life*, referring to the famous article about him in 1949, but all he knew was death. He was in *Life* twice in fact. First as one of a number of new artists cited in a round table discussion about Modern art – why was it so ugly, so strange, so alienating? Then in 1949 *Life* gave him an article to himself (called *Jackson Pollock – is he the greatest living painter?*) with pictures of him painting and posing in front of his old Ford (he already owned a different car). And then his paintings were in *Vogue*, used by Cecil Beaton as backdrops for fashion models. As a result of this kind of thing, he became world famous and letters from people he'd never met started arriving at his house. Critics argued over what his work meant – whether it was heavy-breathing Existential art, where the end-product didn't matter but the act of making it did, or whether he was a sensitive, creative, intelligent, aesthetic artist of great feeling, attempting to re-do traditional art by modern means.

Two views on meaning

The two main apologists for Abstract Expressionism in the 40s and 50s were Greenberg and Harold Rosenberg. They stand for opposite views on meaning. Greenberg in fact has come to stand for not standing for any talk about meaning at all because such talk is pretentious, while Rosenberg stands for the idea that not talking about meaning is some kind of moral betrayal of art. Rosenberg is a caricature Existentialist, Greenberg is a caricature aesthete. But bits of their mental wrestlings are joined up nowadays in CD-exhibition-guide rhetoric.

With the Rosenberg line, key subjects naturally flow into one another. The Void, Existentialism, psychoanalysis, the unconscious, the Bomb, subjectivism, primitivism, the depths, the id, Nature, authenticity, sincerity. It was a rhetoric that came out of the experience of the Second World War and its horrors and tumultuous changes. But also it was a response to the Cold War and to the emerging consumer society

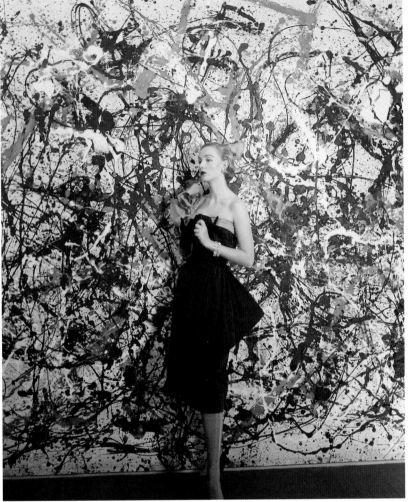

Cecil Beaton
Autumn Rhythm for *Vogue*
1951

and the fear of everything turning commercial and plastic and higher values going down the drain. This all runs through Abstract Expressionism's radical abstractness. It was abstract for a reason, not just to be aesthetic, because Rosenberg thought everything the artist did was a moral act.

But Greenberg thought Rosenberg was too windy. He noticed that artists behaved badly and were often actually quite immoral. He didn't want to be part of the artist-adoration cult growing up in America which he thought was a cult of regression, regression into childishness. He thought it was better if you were an art critic to try to think toughly about what you were actually looking at on the walls and this was a moral position in itself.

Willem de Kooning
Merritt Parkway 1959

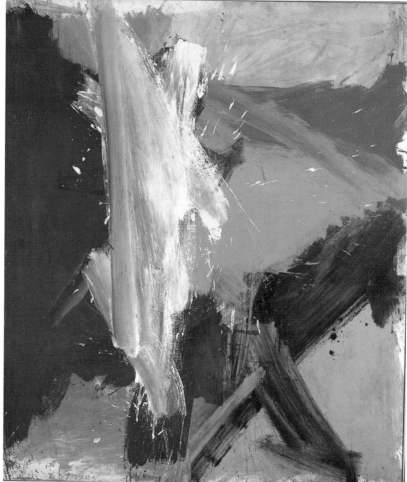

Willem de Kooning
b Rotterdam (Netherlands), 1904;
d New York (USA), 1997
In Rotterdam, de Kooning was a
commercial painter and decorator.
By the late 1940s, having travelled
as a stowaway to New York,
he had become a leading figure
of Abstract Expressionism. The
turning point came in 1927, when
he met Arshile Gorky, who
introduced him to the avant
garde. His works had previously
been influenced by Dutch Art
Nouveau, and the Barbizon
school; now they became
energetic, thickly painted
abstractions. Throughout the
1930s, however, he was still
making meticulous figurative
paintings alongside these, and
even when his style coalesced
in 1946 into black and white
abstracts executed in commercial
enamel paints, many of his
works still teetered on the brink
of figuration. The series *Women
Nos I-VI*, 1950 – sprawling,
frowsy grotesques painted in
frenzied brushstrokes – was
received with near-universal
disgust. However, *Woman I*
became one of America's most
reproduced paintings, and de
Kooning's influence on the young
painters of his day was immense.
He continued to work well into
his eighties, after being diagnosed
with Alzheimer's disease.

Action painting

Rosenberg published a famous essay about Abstract Expressionism in 1952 called
'The American Action Painters.' In it he proposed an Existential account of the
movement. He said the canvas wasn't a canvas any more. Instead it was an arena
in which to act. The painting wasn't a painting any more but an action and the act
was the thing not aesthetics.

Although nowadays the essay is thought to have a general significance, at the
time it was understood by the art audience to be a polemic in favour of one group
of Abstract Expressionists and against another. The leading figures of each group
were Pollock and Willem de Kooning. It was de Kooning's style of frenzied, gestural,
brushy painting that Rosenberg was for and it was Pollock's airy, atmospheric

abstraction that he was against, because it stood for a reduction of abstract painting to 'apocalyptic wallpaper.'

Death

On the last day of his life Pollock took Ruth Kligman and a friend of hers, Edith Metzger, out for a drive in a green Oldsmobile convertible he'd recently got in exchange for two small paintings. It was August and the top was down. He was drunk. They were supposed to be going to a concert. But when they got there he changed his mind and said he wanted to drive home. But first he thought he wanted a meal. Then when they got to the restaurant he said he wanted a nap in the car first. So he passed out and the women waited until he came round. Then he said he didn't want a meal after all and was going to drive everyone to his house right away. Metzger wanted to leave but Kligman persuaded her to stay on. Pollock started driving crazily at high speed.

Metzger was terrified and hanging onto the safety strap begging Pollock to stop as he drove the familiar winding roads back to the house at eighty miles an hour. But he just pulled ugly grinning faces at her and went on driving and then on a corner near the house, one he'd negotiated many times in the past, he lost control of the car and it sped off the road and ran up some thin saplings and flipped over. Pollock and Kligman were each thrown from the car but because Metzger was hanging on tightly she was caught and crushed to death in the back. If Pollock had lived he would have been charged with her manslaughter. Kligman was thrown into the brush and suffered major fractures including a broken pelvis. She was knocked unconscious. But Pollock was thrown fifty feet through the air. Ten feet above the ground he hit an oak tree head-first and was killed instantly. He was thrown so far from the car that when the police arrived it took them nearly an hour to find the body.

The crash was in all the papers. A story in one of the local ones featured a photo with the title: *A Still Life*. It showed a couple of Rheingold beer cans, a hubcap and Pollock's stylish right loafer, all in a group, with a caption claiming nothing in the picture had been arranged – it was all natural – and a warning against drunk driving.

Blankness

Andy Warhol's blank manner is sometimes interpreted as the manner of someone so emotionally traumatized they can only stand blankness because anything else would be unbearable. In fact for the last twenty years of his life Warhol really was in constant physical pain because of his shooting which occurred in 1968 when he was about forty (his real age wasn't known because he lied about it but it is usually assumed he was born in about 1928).

We don't have anything to go on with regard to his possible inner pain or tortured soul because agony and tortured feelings weren't part of his art and his statements about his art were parables or allegories or aphoristic insights that

Andy Warhol
Ambulance Disaster 1963

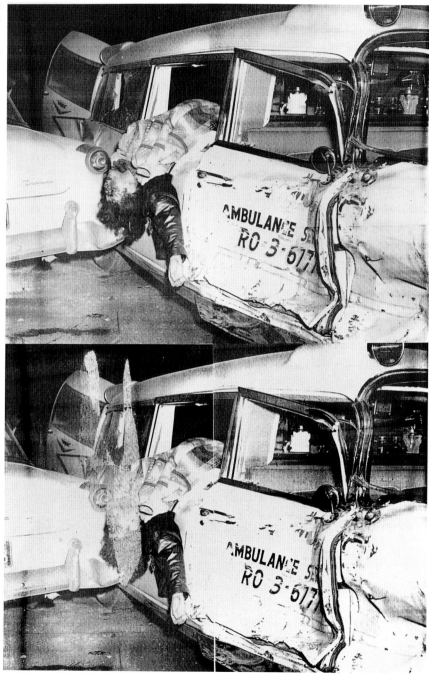

could be unravelled in lots of different ways. Blankness was his forte as an artist and that's all we can say.

But blankness with Warhol is a new twist on Modern art's theme of directness. His paintings are like primitive totemic icons in the sense that they are compelling and we want to look at them but we don't know why. Some are of celebrities and some are of death or disaster scenes. Some are of piss, some are of Rorschach blot tests, some are of shoes. None seem particularly more important than any others and all are abstracted from any kind of context. They come from life but the life is cut out. Typically they come in rows or in a grid formation. The context is repetition because they repeat themselves. This is a simplification of Warhol because he produced thousands of paintings, all working in slightly different ways or failing to work – on the occasions where they do fail – for slightly different reasons, but basically this is how his paintings operate. They turn ordinary things into weird totems that you want to stare at.

Being camp

Warhol's films of the 60s divide into very abstract and less abstract. The less abstract ones have dialogue and actors and the scenes sometimes change from one room to another room, or the shots change from a wide shot to a close-up, although once they've changed they usually stay locked off for a long time before changing again.

His early films didn't have any dialogue and sometimes not even actors, or if there were actors they didn't have to act, just sleep or get a haircut or have sex. They had pared-down titles like *Sleep, Haircut* or *Blowjob*. These more abstract films, which are nevertheless very concrete and real because the subjects are concrete and real, are good from a formal point of view. They introduce radical new ideas about structure. Films can be formal or abstract, as well as paintings and sculptures. If they are purely formal that can be off-putting but it's worth making the effort. And his early films are full of interest even though they might only be shots of someone sleeping, or a single shot of a building. You don't have to watch them all the way through. Obviously you wouldn't come away from *Empire*, his 1963 film of the outside of the Empire State Building that lasts eight hours, saying, 'That was full of interest!' and mean that every minute was full of interest. It would be the idea of the duration of the film that might be interesting coupled with the impression made by the image and its slow change from dark to light as day follows night.

But this pared-down aesthetic runs through Warhol's other films too, the ones that have a soundtrack and actors speaking and moving around. These films are also highly formal, although they show scenes of people interacting with other people. Usually the location is a single room, sometimes the scene changes from one room to another. But until the films of the late 60s and early 70s there's no ending or beginning or sense of dramatic build-up in the middle, no narrative to speak of,

Andy Warhol
b Pittsburgh, PA (USA);
d New York, NY (USA), 1987
Warhol invented himself as the enigmatic icon of Pop art and experimental film-making in the 1960s. His influence on contemporary culture is profound. Moving to New York in the 1950s, he worked as an advertizing illustrator. Early works included stencilled rows of dollar bills and Campbell's soup cans. Later, he took as subject matter newspaper images of fame – embodied by Marilyn Monroe, Elvis Presley, Elizabeth Taylor – or of death – the electric chair, road accidents. By the mid-60s, he was disrupting the notion of the unique artwork by mass-producing these as silkscreens, or creating large series of sculptures of household objects such as Brillo pads in his ultra-fashionable studio, 'The Factory'. Avant-garde films including *Sleep*, 1963 or *Empire*, 1964 take place in real time, the camera fixed on the static subject. *The Chelsea Girls* (1966) is a seven-hour film shown on a split screen. Warhol was also the manager of cult rock band the Velvet Underground. In 1968 he was shot and severely wounded by Valerie Solanas.

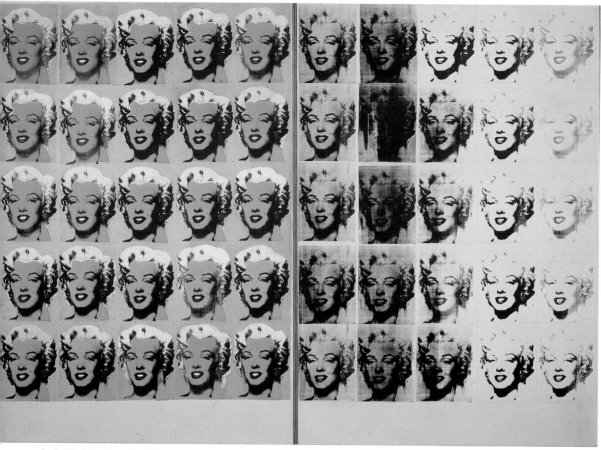

Andy Warhol *Marilyn Diptych* 1962

and basically it's the same all the way through. Anything might happen – there might be crying or shouting or slapping or laughter or all sorts of nuances of conversational tone, but the overall tone is one of distance. Like the earlier films, these ones are very real but very abstract too. And like them, there is nothing to indicate where Warhol stands as an artist, what his take or view on the action or non-action is, nothing apart from his literal position behind the camera.

In typical films of the mid-60s, say *My hustler*, *Beauty No.2*, or *Chelsea Girls*, someone is usually trying to get something from someone else, love, attention, money, a place to stay, and there is usually a resistance from the other person, resulting in frustration, misunderstanding, maybe even violence. Usually only a light flurry of violence though. Or sometimes there is just a soliloquy, someone talking

Andy Warhol *Blow Job* 1964

Andy Warhol *Chelsea Girls* 1966

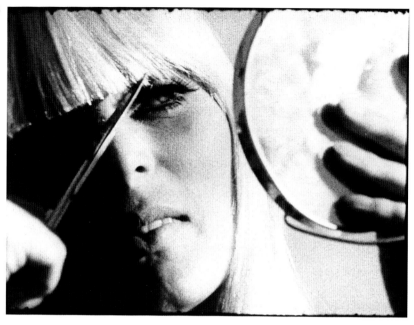

on the phone for twenty minutes in a monumentally self-absorbed way, or cutting their hair in monumentally narcissistic way and talking to the camera. So there is a sense of a possible Hollywood-type scenario but an absence of Hollywood effects – an absence of a Hollywood-type script but also all the techniques of framing and cutting that contribute to a sense of narrative pace or drama in Hollywood films. Instead of effects there are anti-effects, because everything is so minimal.

The actors might frequently deliver lines woodenly or artificially or in a way that is melodramatic or over the top or outrageously camp – obviously, because it's Warhol, camp is the most frequent mode. But then, these are not really actors but anti-actors, Warhol's superstars, exhibitionists on drugs. People whose natural mode of communication was exactly all those things – basically unnatural. And the overall effect is not at all wooden but the reverse, amazingly animated and weirdly like realism. In fact it's quite startling how much like documentaries these films seem to be, or how much like fly-on-the-wall observational film-making they seem to be.

This sense of a new type of realism comes from the pared-down perfect rightness of all the elements – the right non-moving shot, with the right non-acting actors expressing human emotion in the right cut-off, detached context. Right because it seems real. So the films are not about how glamorous the Warhol world is or how camp or funny or even about how phoney Hollywood is but they are representations of how the world works, images of existence.

Being less human

Warhol's famous quotes are all designed to deflate pomposity or a falsely elevated sense of self or of individualism, or the larger than life individual that artists are expected to be. Being a machine, being blank, not thinking, finding ideas tiring, not having feelings, revering celebrity, revering the ordinary, revering money and commercialism were all mock-wicked notions floated by Warhol in interviews between 'wows' and 'gees' and 'I don't knows' to be annoying.

In fact they were comments specifically against Abstract Expressionist values. Abstract Expressionists couldn't stand phoniness, or small talk. Warhol admired Abstract Expressionism and he was against phoniness too but he was for smalltalk because he was against the Abstract Expressionist ideal of over the top, loud individualism. It had become an ideal of sincerity that was a bit too much to take because it was a bit too aggressively human. He wanted something a bit less human. And that's why Warhol is closer to our present moment than Picasso and Pollock but not entirely divorced from them either, just as we are not entirely divorced from them.

Geniuses R Us

A good example of new subjectivity today is offered by the work of the twins Jane and Louise Wilson. They make dramatic, moody, menacing, atmospheric film installations, with the films set in various readymade locations. These include hotel and motel rooms, warehouses and the Stasi former headquarters in East Berlin. The twins are known to be a funny combination of daft and stylish in real life and this impression carries on into their art. So it's camp as well as menacing. It expresses a new paranoid world of fragmented selfhood and urban surveillance but in a light way, or in a way where lightness and heaviness can seem easily swappable.

When the twins themselves have appeared as the main focus of their films they are hypnotized or on drugs, so they are not themselves or only themselves in a trance. In other films they appear in fragments or glimpses and the location itself is the main focus. So they are probably not themselves then either, and there is always some kind of comment on subjectivity.

Women's camp

For example, *Gamma*, made in 1999, is a film installation by the twins based on the former nuclear weapons base at Greenham. The silo still exists and they filmed it without changing anything. Scenes of its grungy, dilapidated interiors go by as if shot by surveillance cameras – that is, in a disconnected way. But at the same time connected by suggestions and atmospheres. The main suggestion is of an exploration of alienated selfhood in the context of a science fiction horror film. So it's not really a surveillance film but it might express contemporary fears of surveillance and it's not fiction because the silo is real. So it's a fake masquerading as a fiction or vice versa. In any case, the comment doesn't seem to be that we should all breathe a sigh of relief that the cruise missiles have gone.

Jane and Louise Wilson
b Newcastle-upon-Tyne, 1967
The Wilsons' work frequently deals with popular culture, focusing on the role it accords to women, particularly in terms of sexual power. Adopting the tools of the media – video and large-format photographs, often presented in installations that include props from their scenarios – the Wilsons evoke its conventions in order to pinpoint its influence and allure. For the video *LSD* (1994), they submitted to hypnosis. Watching the twins in their trance, the viewer is also voyeuristically seduced by their passivity. Thus, the artists refer to the mass media's power of suggestion, but do not necessarily condemn it as more insidious than art's. *Normapaths* (1995) plays with the codes of horror and action films. Again, while they may be alluding to the contradiction between male fantasies of leather-clad, Avengers-type girls and the submissive way in which real women are expected to behave, the Wilsons – avid TV consumers in the 70s – demonstrate that performing aggressive stunts while dressed like Emma Peel can also be a female fantasy. *Stasi City* (1997), made in the disused Stasi headquarters in the former GDR, explores video as a means of control.

Jane and Louise Wilson
Gamma (Silo) 1999

Gamma offers a lot of textures all fragmented and broken up. Excitements are everywhere. It's so exciting it's hysterical. Or it could seem hysterical. Hysteria usually means over-excitement with an implication of displacement. The real fear is displaced and something that isn't really the fear becomes frightening and the result is hysteria. But there isn't any fear of that here because there isn't any real fear, just textures.

These textures include the look and atmosphere of old 60s and 70s conspiracy films with titles a bit like *Gamma* – like the *Parallax View* or *Capricorn One*. Plus Bomb scare films of the 80s like *The Day After*, or of the 60s like *The War Game*. Plus the pleasure of old décor, the excitement of almost anything from more than ten years ago, but not fear. Obviously not fear of the Bomb because that's over now, more or less. But also not fear exactly of psychological fragmentation or urban surveillance or sinister government agencies. That would be like being frightened of LSD or frightened that *1984* really happened, which no one is. Fragmentation, urban surveillance – they are new quirks of modern life, full of richness, but nothing to be frightened of. They're mock fears that contemporary art is interested in to make itself more spooky.

Old interior

In the film, mundane, old dilapidated interiors are made aesthetically exciting by vast enlargement, because the film screen is big, and by stylish editing. In fact there are four screens, in two opposite corners of a room. The room is relatively small, just a sectioned-off part of the gallery. Weird sounds from the film permeate the rest of the gallery. In some of the rooms there are large colour photos mounted on metal of silo scenes – corners of offices, plastic sheeting, graffiti on a wall, sinister, heavy steel hatchway doors left open. In another room, there is a mocked-up concrete bunker, or a mock-up of a stereotype idea of a concrete bunker – just a thick-walled box shape with two sets of metal security doors. Inside it's dark and claustrophobic, or it would be if the walls were concrete instead of plasterboard. The doors have NO ALONE ZONE and TWO MAN POLICY stencilled on them.

These stencilled signs read as ordinary signs and also as loaded signs, signifiers of challenged individualism or spookily modified subjectivity. For example, the twins' own psychological no alone zone and their two-man policy as collaborationist artists of the 90s. Also, the signs resonate with memories of women of the 80s. Women merging their subjectivity and becoming a collective of protesters and looking strange – living in 'benders' made of twigs, submerging individuality within a collective mass, resisting a monolith by becoming uniform, initiating a new model of protest and a new model of women. The literal meaning of the signs is loaded too – military personnel within the sinister silo barred from going unaccompanied into significant button-pressing zones in case their individuality has made them go mad and they might press the button and start a nuclear winter.

Clang

The film part of the installation is dark too. Gallery-goers walk into darkness, clangy sounds all around them. Or something like the roaring sound of amplified air-conditioning. Or ghostly sounds of sudden voices that can't quite be made out. Or clinking cutlery from a ghostly military canteen maybe. And then the viewer is suddenly surrounded by a filmic vastness of old corridors and stuff, with stylish panning and tracking shots all going by at a lively pace. The scenes are of abandoned atmospheric rooms, corridors, old clutter, sudden huge empty spaces, sudden close-ups of telephones, yards of flashing control systems. The same scenes are shown out of synch on different screens, or sometimes in synch, so they're doubled, or sometimes they're doubled and inverted, so they're mirror reflections. Sometimes they slide into each other, a scene disappearing into itself. It only takes a short time and then it starts up again, with no credits, just a burst of black.

Jane and Louise Wilson
Gamma (detail) 1999

Help!

The exterior of the silo on a hill at night or at dusk is the first shot, accompanied by the sound of panting as if someone's dragging themselves up there. Maybe the nuclear winter's already here and it's a post-apocalypse figure, because time is challenged. After that it's all interiors. Pipes, lights, buttons, tubes, control panels, conduits, security doors, signs saying EMERGENCY, lists of phone numbers with countries next to them – UKRAINE, RUSSIA – all go by. A shot of a real mirrored wall comes up, the mirrored surface divided into squares. A delirium of mirrors suddenly fills all the screens and then the images roll into each other in an ecstasy of kaleidoscopic mirroring. Sinister green arrows run along the floor of an old grim concrete corridor, with the camera tracking in the opposite direction. Plastic chairs, military brown, flashing red lights, diagonal yellow and black scare stripes, all contribute interesting texture-accents. A metal canister about a foot long drops with a clang – Help! It's plutonium! Or maybe it's just a thermos flask. A live twin appears, in a grey uniform, and does some walking in an emotionless way. Then there are some other shots of corridors and then a sudden close-up of a twin's ankles and calves and black military-style shoes, offering a *Carry On* texture of sauciness. Then it's the end. Then it's the beginning again.

CHAPTER TWO

SHOCK, HORROR

The grim stream

Modern art has a lot of shocks to offer. Increasingly, we find we want to be shocked by art. We know Damien Hirst's famous shocks aren't really that shocking – whether it's his shark at the Saatchi gallery, called *The Physical Impossibility of Death In The Mind of Someone Living*, or his bisected cow and calf at the Venice Biennale, called *Mother and Child Divided*, or his two eviscerated cows cut into lots of sections and all the sections intersected with each other, in 'Sensation', called *Some Comfort Gained from the Acceptance of the Inherent Lies in Everything*, or his flayed cows' heads in the upstairs bar at the Quo Vadis restaurant in Soho's Dean Street, one in a blue frame and one in a pink frame, called respectively *Kiss My Blue Arse* and *Suck My Big Pink Cock*. But nobody has yet written at all sympathetically about him without pretending to be a bit shocked by the sight of viscera in an art gallery.

It is felt that these sights must be shocking because they are real and not painted – reality is more shocking than paintings. But in fact they are presented as if they were painted. If they weren't they wouldn't be so good. Also, they are presented as if they were ads, even though they aren't advertising anything. They have the crispness and neatness of ads. Chaotic viscera in gleaming rectangles.

Damien Hirst

Some Comfort Gained from the Acceptance of the Inherent Lies in Everything 1996

Goya

Goya is at the black source of the grim stream. He's at one end and Jake and Dinos Chapman are at the other. At least, they might be connected but we don't know for sure. They were born in 1962 and 1966. Goya was born in 1746. To find Goya shocking you have to edit out a lot of what you're feeling. To find the sculptures of the Chapman brothers shocking you have to do that too. But the editing and the shocks are different in each case.

With Goya — not a Modern artist but a famous precursor of Modernism — an inevitable museumification interferes and makes even his most shocking sights less shocking. However gruesome and hair-raising Goya gets, he is an incredibly refined painterly aesthete, a master of the painterly shimmer — of a kind of form that seems to be making itself as you look. A form of dazzling complexity as well as gruesomeness.

That's what painterly painting is. Whether it's a painting of a water lily by Monet or demented women giving their babies to Satan by Goya. And the taste for it is a cultivated taste. Anyone can get something from it. But if they have a cultivated taste they will get a lot more from it, as with a taste for wine. Which is confusing because in some ways we might wish the values of art to be absolutely opposed

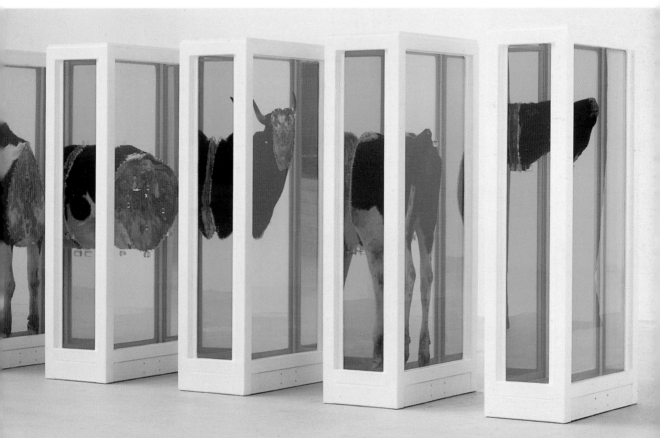

Francisco Goya
Saturn Devouring one of his Sons
c. 1820

to the values of the wine-tasters of this world, because we don't like their pre-ciousness. But of course that might only be ignorance of the world of richness that wine-tasting offers. Or it might be inverted snobbery.

The Chapmans

But with the Chapmans, the aesthetic is a comparatively low one. It's not that it goes from wine to Tizer. It's more that complexity is suddenly somewhere else. Off the form. The forms themselves are too ordinary to be all that interesting. They are hardly forms at all in the formal sense.

Damien Hirst has an eye for a painterly sight. The Chapmans might have that too – it's not all that uncommon. But that isn't what they do in their art.

Francis Bacon

With Francis Bacon, gruesome writhing things appear neatly framed. Not just framed by the gold frames that were always part of the finished painting with him. But by the painted doorways and black screens with pull-strings and weird glass cases and arbitrary shadows and so on that made up his well-known repertoire of rectangle devices. This contrast of sights comes from European Surrealism of the 20s and 30s, which was the dominant international style when Bacon was first getting interested in painting. Something nasty inside something geometric.

Hirst and Minimalism

With Damien Hirst, a Francis Bacon-Surrealist type of sight is presented as if it were an abstract Minimal object from the 1960s, possessing all the mysterious radiating power of Minimalism – the way Minimalism made the placing of a geometric, emotionally blank object in the middle of the white cube gallery seem powerfully theatrical.

The effect with this appropriation of a Minimalist aesthetic and a grafting of it onto a startling spectacle is of a kind of Minimalism of advertising. It's advertising marrying Minimalism and having a gruesome baby that is only partly shocking.

The parts in themselves aren't that interesting. The viscera is the most interesting but it's not mind-bogglingly interesting. It's interesting because we don't see that stuff every day. So it's interesting to see what it actually looks like. A lot of writing about Hirst actually takes this line as if it were the main thing about him. This is certainly wrong. The main thing is making spectacular images of alienation. Is he a great artist? Phew, that's a hard one. Obviously we can't dispute Goya's greatness though. That would be insane.

Francisco Goya
b Fuentendos (Spain), 1746;
d Bordeaux (France), 1828
Goya began working in Madrid, influenced in his early tapestries (depicting scenes from everyday life) by the decorative realism of Tiepolo. In 1789 he was made portrait painter to the King. Left permanently deaf by a serious illness in 1792, he became increasingly occupied with imaginative invention, and with satirical observations of humanity. A bolder, freer style evolved, his portraits becoming penetrating character studies. In his religious frescoes he employed an earthy realism unprecedented in religious art. During the Napoleonic War, he served as court painter to the French, expressing his horror of armed conflict in his series of etchings *Disasters of War* (1810–23) and in the painting *3 May 1808* (1814). When the Spanish monarchy was restored, Goya was called before the Inquisition to justify the shocking *Naked Maja* (1797–1800). From 1819–1924, he lived in seclusion, adopting an increasingly intense style. In the *Black Paintings*, executed on the walls of his house, he expressed his darkest vision.

Francis Bacon *Seated Figure* 1961

Murder

One strand of Hirst criticism is the vegetarian strand. Is the Great White shark a protected species? That's an arm of the strand. Animals shouldn't be eaten. Even though he didn't slay those animals himself he shouldn't exploit the fact that they've been slain. Because meat is murder. That's another arm. Well, the same arm really.

With this criticism a lot has to be edited out and a lot has to be edited in. It's not exactly like saying physical deformity is nothing to laugh at, so Picasso is cruel. But it's close.

Arms

A pile of severed arms. That's a painting by Géricault. And an image in the memory of Marlon Brando in *Apocalypse Now*. It's good when Géricault does it but a bit pretentious when Marlon does it. Don't do that Marlon!

Arms in theory

Many artists and writers on art now read books of theory by French authors or by authors influenced by these authors. A powerful and recurring theme of this literature has to do with the body and how it is not all that centred any more but all over the place, psychologically speaking. For example, this might apply in Feminist theory. But Feminist theory now applies in contemporary art theory, because Feminism has been very influential on art.

However, the image of the body as not all reassuringly centred with the self at the centre but fragmented or divided or always in a weird state of flux – and the self itself in such a state of flux – has become a cliché of contemporary art and discourse about art. Its employment can often seem like an empty mannerism, signifying that something important or original is being expressed – like when Alanis Morrisette or Robbie Williams appear to be very angry or intense in their songs. Fragmented bodies in this sense are more late Brando than Gericault.

More arms

The Charnel House. That's one of the paintings Picasso did in his run-up to *Guernica*, his protest against fascism. It has a lot of human arms and other limbs lying around in a shallow Cubist space.

Dismemberment

Dismemberment is always a shock. A painting by Goya shows cannibals in a misty wood about to cook some limbs and a head on a fire. Goya's title, which is journalistically matter of fact, makes it clear the subject of the painting is a historical event which actually happened – the Archbishop of Quebec and his secretary were murdered and eaten by Indians, and Goya painted the scene from imagination. However, the cannibals don't seem like typical savages but more like Europeans gone savage. They are naked and there is an atmosphere of unbridled sexuality within the general atmosphere of unbridledness.

Francis Bacon
b Dublin (Ireland), 1909;
d Madrid (Spain), 1992
Reviled in his early career, Bacon is now seen as perhaps the most important twentieth-century British painter. Existential horror, revulsion, loneliness, alienation are his overriding themes, treated with a hallucinatory, distorted realism that derives in part from the influence of film and photography, in part from an uncompromisingly bleak attitude to the modern human condition. Recurring images are carcasses, cages and empty rooms imprisoning deformed, grotesque figures. Originally an interior designer, Bacon received no formal art training, making his first drawings and watercolours in 1926. He has stated, however, that he 'began' as a painter at the age of 35 with *Three Studies for Figures at the Base of a Crucifixion* (1944), undertaken after he had given up painting for several years. This work subjects a conventional art-historical theme to a violent, contemporary treatment (the figures are reduced to lumps of meat). Similarly, his famous series of incarcerated, raging popes is based on reproductions of Velàzquez's *Pope Innocent X* (1650).

Francisco Goya
Cannibals Contemplating Human Remains
c. 1804

Bestiality, disgusting appetites, humans gone wrong – these are frequent themes in Goya's art. His suite of engravings, *Disasters of War*, which he began during the Peninsular War of 1808 – 14 and completed some years after the end of it – but which wasn't published until some years after his death – also includes terrifying scenes of dismemberment. Goya may have witnessed some of these scenes firsthand.

One of the *Disasters*, called *Great Deeds! Against the Dead!*, shows three naked male bodies hanging from a tree. The scene has been paraphrased by the Chapman brothers in their sculpture by the same name. Shop window mannequins with nylon wigs are used.

In the Chapmans' version, Goya's realism is contrasted with the nutty unrealism of high street shop window culture – the fashion dummy. Goya's engraving is about desecration but the Chapmans' version is a redesecration of one of the sights that sent Goya off the rails.

Francisco Goya
Great Deeds! Against the Dead!
from *Disasters of War* c. 1810

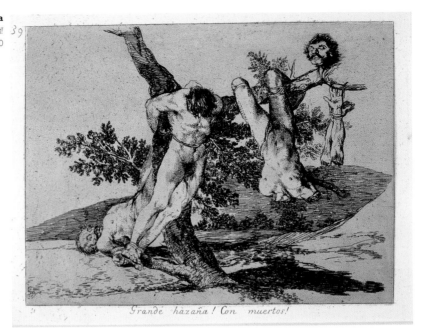

Jake and Dinos Chapman
Great Deeds against the Dead 1994

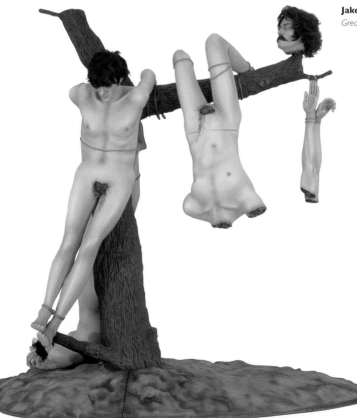

The details here – the airbrushed nipples and nylon wigs and exposed awkward seams of the mannequin limbs; the join of hand and arm, waist and torso; and the weirdly sexual look of the figures; their heroin-chic complexions – all suggest a perverse departure from Goya's theme of horror at atrocity: the subterranean desire-drives of the 1990s consumer world.

Mad flowing excitements

In Goya's original picture one of the corpses is castrated. One has been divided into three separate parts – four if you count the pair of arms tied together at the wrist as two. A third corpse is only half seen, hanging downwards from the tree, the head pushed into the chest – we have to imagine what horrible acts have been committed in this case. But it's pretty horrible just seeing the corpse upside-down and naked, hands tied behind the back.

The second corpse is headless. The armless torso with legs still intact hangs from one part of a branch. And the arms, tied at the wrists, hang further down. Next in line is the head, stuck upwards on a jutting fork of the main branch. So the head seems to be part of a body that is standing to attention. But the body is now a tree-body. The limbs of the tree and the three sets of separated human limbs are all a unity now, all making a single convincing satisfying dynamic rhythm.

Part of the shock of this image is the integration of body parts and tree – the sense of pleasure and satisfaction in making them fit together. Was it aesthetic for the dismemberers?

The solidity and rightness of Goya's drawing and his composition – the liveliness and energy and power of his arrangement of forms – shadow, grass, tree, leaves, body parts – is a powerful excitement in itself. We feel there ought to be a dividing line somewhere – between art and sadism. Someone should tell us what it is. Did Goya have a dividing line in his head? Were there any boundary lines in there at all?

Goya's titles are sardonic and ironic. In fact it's never completely clear to a non-Spanish speaker what they are because they're always different in different translations. They sometimes seem to be fragmentary – parts of a testimony or a report. They sometimes seem like gasps or ejaculations at the beginning of an idea, or at the end of one. Every title could suggest a lot of different things. And every image has an oddness and a rightness and cleverness about it – wit as well as horror.

Don't look

What more can one do? shows a group of soldiers castrating a naked prisoner with a sabre. Another one, called *This is worse*, shows an armless naked man impaled on a tree – the tree itself is only a black stump. *This I saw* is another title. And another one is *It is not possible to look*.

Disasters of War is a surprisingly complex document. Not just because some of the plates show fantasy images with mythical beasts and monsters and allegorical figures of Purity and Truth, while others are presented as realistic observation and

are believable as such. But because the direction of the thought is never clear and everything is open-ended. There is no particular sense of righteousness. Evil-doers might be French or Spanish, soldiers or monks, women or men. Corpses might be civilians or soldiers, monks might be evil or good, civilians might be tragic, courageous, heroic, or murderous, bestial or greedy.

Shocked by Airfix

The Chapman brothers' first big success in the art world was a remaking of all 82 of Goya's *Disaster* engravings in Airfix form, with all the scenes staged on a single smallish white table top, using plastic model soldiers as the raw material, and model-making techniques as the method. Little plastic one-inch high Eighth army soldiers, Romans, Koreans, German Storm Troopers – whatever – are mutated and melted with penknives and soldering irons and re-formed and painted by the two laughing dismemberers to make little eighteenth-century Peninsular War soldiers and civilians torturing each other.

With their *Disasters of War*, made using low model-making techniques – techniques which have a certain fascination but which we don't associate with the heroism or tragedy of art but on the contrary with banality or the rather circum-scribed creativity of male children – Goya's artistic vision suddenly becomes something else. The *Disasters of War* suddenly stop being art. Museumification evaporates. The figure of the artist evaporates. All his heroism and tragedy is taken away. New artists materialize in his place. But it might not be art they're making. Except it must be, because even though it's only model-making, which we know is mundane, the models are in a white cube art gallery. And we know these galleries are mysterious and important and places of transcendence.

Everything odd and inexplicable about Goya rushes to the foreground. And everything that was a timeless humane truth about the horror of atrocity seeps away.

Guernica

Picasso painted *Guernica* in 1937 as a protest against fascism. It is an allegory of war. A screaming horse at the centre is off-set by a burning building and dramatically posed figures, including a wailing mother and child. The composition is a stark, powerful pyramid. The colour is black, white and grey. The event referred to in the title was the bombing of a small town in Spain during the Spanish civil war – the conflict which had its origin in the civil war of Goya's time – by German aircraft collaborating with Franco's republican army. Picasso had already been invited to contribute a painting to the World Fair and he sent this one. It was intended to shock the world.

Unlike *Guernica*, *The Charnel House* was considered to be a successful painting by formalist critics and artists in New York after the Second World War. It was a marvel of greys and black and white. Whereas *Guernica*, although a dramatic image, with

Jake and Dinos Chapman
Dinos Chapman: b London (England), 1962
Jake Chapman: b Cheltenham (England), 1966
Ex-assistants to Gilbert and George, the Chapmans began to produce their own provocative works in 1993. Their first solo show, 'We are Artists', was an æsthetic manifesto presented on a wall smeared excrementally with brown paint. This was followed by a three-dimensional version of Goya's *Disasters of War* series (1810–23), in which detailed miniature models acted out the atrocities of conflict. In *Great Deeds Against the Dead*, 1994, they singled out a pair of Goya's mutilated soldiers, this time blowing them up into life-sized figures, amplifying the brutality of their ruptures. Recently, they have made their own versions of Goya's prints, loading them with contemporary allusions and anachronisms. For the 1996 exhibition 'Chapmanworld' (ICA), they unleashed their grotesque population of hermaphrodite pre-pubescents, with names like *Fuckface* (1994), or *Two-Faced Cunt* (1996), joined together Siamese twin-style, their features replaced by genitals and sphincters. These bewigged mutants in Nike trainers test our attitudes to beauty, humour, abnormality and taste.

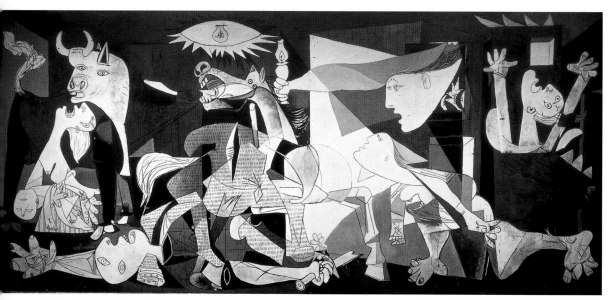

Pablo Picasso *Guernica* 1937

the same colours, was considered too rhetorical and stagey. It couldn't support its own hugeness. It was a windy painting.

This was the prevailing thought about *Guernica* for a long time. Nowadays the thought that *Guernica* is nothing but a masterpiece has replaced that thought. But not because the masterpiece idea has been rigorously thought through. Formalism died away in the 1970s and the masterpiece idea just flopped back centre stage as if by default, with no one particularly pushing it.

Feelings change

But although we may not be able to back up a natural feeling of awe we might experience nowadays in front of *Guernica* with a convincing formal analysis we have read somewhere, that's not necessarily a reason to doubt the significance of that feeling. We are part of a different culture now. Feelings change.

One of the reasons formalism died away was that there was a prevailing feeling against thinking about art as purely a matter of form. Or, to put it differently, there was a gradual rejection of the idea that forms alone had an incredible, mysterious power. We've seen all the forms, it was felt. They're not that mysterious. Let's have the other stuff back. What about those screams for one thing?

The Unconscious

Obviously child abuse is nothing to laugh about. Nazis too. The Chapmans have made a Nazi death camp out of Airfix soldiers and they make sculptures, using mannequins, of children with adult sex organs on their heads. But they are not cruel because of that. Their unconscious fantasies are probably quite cruel. But so are

Jake and Dinos Chapman
The Un-Namable 1997

all our unconscious fantasies probably. We can never know for sure because they're unconscious. That's what the unconscious is. You can never know what's back there.

Screaming

Modern art is full of screams. For example, Munch's *The Scream*; Gilbert and George screaming; Francis Bacon's screaming popes; the screaming horse in Picasso's *Guernica*.

Other people

When Gilbert and George scream at each other in the film *The World of Gilbert and George*, which was made in 1981, their faces are in profile – one on each side of the TV screen, with a black void behind them – and they each take turns to scream. When Gilbert screams his tongue is in and George's is out. When George screams his tongue is in and Gilbert's is out. Their tongues are like pink, quivering sex worms. The screaming noise is quite harrowing, more so than you would imagine if you just read about it somewhere. In this book for example. 'Hell is George,' you imagine Gilbert thinking when he's screaming. 'Hell is Gilbert,' you think when it's George's turn. They take the Existentialist cliché and make it into Morecambe and Wise and then turn it back into Existentialism.

Morecambe and Wise

In the images Gilbert and George present – frequently, images of themselves – a number of things mill around which are recognizable from various levels of culture but which, in their art, are recast in different ways. Comedy duo Morecambe and Wise's claustrophobic bedroom act plus Magritte's deadpan and his atmosphere of dread. Andy Warhol's wise/imbecile interview style plus Beckett's alienated loneliness: hip meets *Watt*. Francis Bacon's horrors and screams and smears plus an attitude of not caring about Bacon's painterly world – or perversely looking for and finding concrete, realistic, unmistakable objective correlations for the hints of effluvia-excitement that painterly goo in Bacon always suggests.

Annoyance

In the 60s it was reckoned any material could be art so Gilbert and George chose annoyance as their main material.

Their affected voices rise from their early works: 'That's a lot of bloody bollocks!' Or: 'He's just a silly old queen!' That's them sputtering drunkenly in their video of themselves as young men in the pub drinking their drinks and smoking their Senior Service.

They had real lives before then but from now on they would always be artificial because it was more real. Their whole lives would be art even when they were drunk which was every day on gin.

Everything they did they called a sculpture. Sculpture included singing or falling over. But also taking photographs and writing, and making up slogans like: *Art we only wish to serve you!* Serving art meant not believing anything anyone else said or thought. Especially if it was a polite or normal thought. They were the Unnormal.

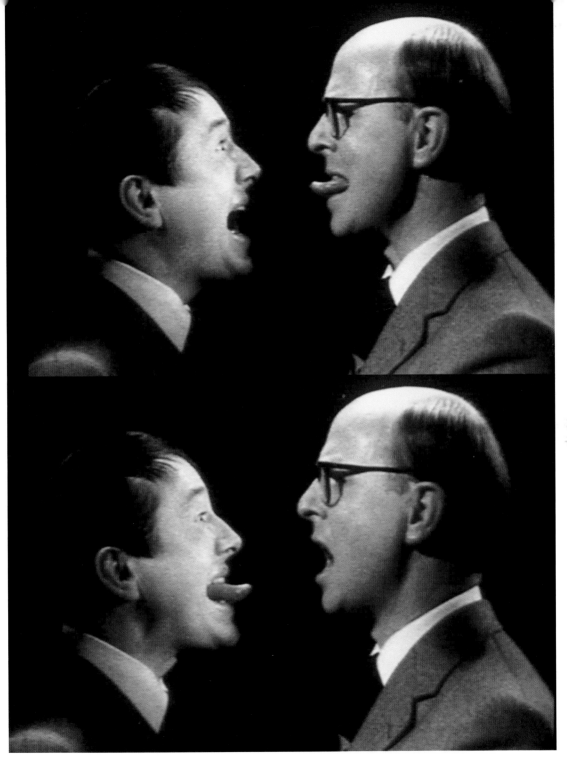

Gilbert and George stills from *The World of Gilbert and George* 1981

Ruin Art

In their house off Brick Lane in London's East End they pour champagne and George tells slightly offensive rumpy-pumpy jokes in an unreal Prince Charles accent. Earlier they were up on the roof talking about confrontation. They always want it, they say. And they want to shock their viewers because they want them to remember their pictures. Their new ones are full of spunk, shit and piss and extensive quotations from the Bible. As well as life-size images of themselves naked or in their underpants. The quotes are about the punishments that shall be meted out to men who lay with men, or with their sisters or their brother's wife, and so on.

'We want them to be disturbed for a minute,' Gilbert is saying. 'And we do believe they are shocked. They shouldn't be but they are.'

Gilbert and George and the Bible. They were bound to clash sooner or later. 'We want to be against it,' Gilbert goes on, in his Italian accent. 'We want to ridicule

Gilbert and George
Underneath the Arches 1971

Gilbert and George
Human Shits 1994

the Book! Ridicule the nonsense in front of us! Everybody for two thousand years, they tell us: You should do this! You should do that! And when you start reading it, it's nonsense. That's what we want to show the world. Confronting it with our nudity – our nakedness that should be totally acceptable. But the Bible says no. So we say yes!'

'Yes!' they say. To underpants whiter than white. But always either about to come off or already around the ankles. That's my inner voice as they're talking and pouring the drinks.

'The audience is shocked by the idea of the subject,' Gilbert goes on, 'the idea of spunk. Or – we don't want to look at piss! Or shit – Oh I hate that! But when they see – because we make them very powerful – they think: ooh! It's quite interesting! I didn't know that spunk would look like that! That's quite beautiful!'

'Normally,' George is saying now, 'we only drink this champagne called Ruinart.'

'Ruinart? I don't know it,' I say.

There is one called Ruinart.

'Cheers!'

Francisco Goya
The Sleep of Reason Produces Monsters
from *Caprices* 1799

'Cheers!'

I like being served champagne by the anti-Christs at their antique table in their oak-lined sitting room, feeling a bit like a living sculpture myself.

Goya's sitters

Goya's blurry portraits with their haunted eyes – his official portraits, even his portraits of royalty – are aesthetic marvels and marvels of timeless human feeling.

To feel deranged or unhinged or somehow in pieces, we feel, is a timeless human feeling. To be rampantly subjective would be to be mad. Goya actually painted mad people in insane asylums as well as mad people in nightmare fantasy scenes. These are just as marvellous, as paintings, as his formal portraits. But it's quite clear he didn't just think madness is the human condition and part of everything. Or that artists are mad so they must paint everyone looking a bit mad. Goya went temporarily mad himself so he would be in a good position to know the difference.

The Scream

Munch's *The Scream* is a painting of a homunculus-type figure on a bridge, under a red sky, screaming. The shock of Munch is the shock of the cold air as the protective outer layer is peeled away and the quivering inner being exposed. That's a cliché of what a typical personality is. Real inside, unreal outside. They must always be like that. The other way round is never considered.

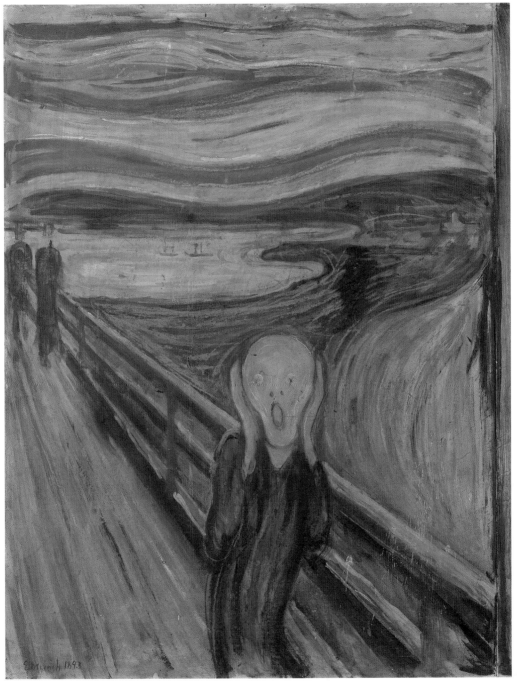

Edvard Munch *The Scream* 1893

Edvard Munch
b Lote (Norway), 1863;
d Oslo (Norway), 1944
Munch's harrowing, angst-ridden
subject-matter, exaggerated use
of colour, and distortion of
contours and line gave rise
to Expressionism in Europe.
When he was a teenager, he was
exposed to death and misery,
both his mother and his sister
dying of consumption. His first
paintings were of domestic inte-
riors, but when he returned
from a trip to Paris in 1885,
where he met Seurat, Van Gogh
and Gauguin, he resolved to
make works that would express
various mental and psychological
states. Themes of illness, death
and depression followed, in
parallel with the concerns
of contemporary Scandinavian
writers such as Ibsen. From
1892–1908, he lived in Berlin,
devoting himself to the ambi-
tious series 'The Frieze of Life',
of which his famous *The Scream*
(1893) was a part. It also included
works betraying his fear of
women, whom he depicted
in terms of three life stages
– awakening sexuality, voracious
sexuality, and death. After he
recovered from a nervous
breakdown in 1908–9, Munch's
works became less psychologically
charged, shot through with
a new optimism.

Munch suffered a series of unlucky losses which certainly would have contributed to a feeling of inner instability. First his mother – who died of TB when he was only five – and then his sister who died from the same thing. And then when he was still young his other sister and his father and later his brother. Many people live a great part of their lives without experiencing death. And then it's just their parents dying when they're old which isn't too bad. So they're not all that mortified about death. But Munch was tortured by it.

Tragedy is part of the frieze of life. Munch's paintings are particularly morbid though. Death, illness, bitterness, loss are constant themes with him. He suffered a breakdown – complicated by alcoholism – in 1908 when he was in his forties and was treated at a sanatorium. He recovered and went on to live a long life. He died in 1944 when he was 80. But after his illness he painted more realistically. Or at least, he turned away from the Symbolist/Expressionist style he had been famous for since he was 22 and reverted to a version of the Impressionism he learned at art school before he really became Munch. And now his subjects were taken from life rather than made up out of his head.

This change in subject matter and style might imply that he became less morbid because his inner suffering had abated – he didn't need to keep on expressing it. But that would imply his morbid subjects were only therapy. And also that his objective subjects were less emotionally urgent. Or less emotionally realistic. Or even that his realistic subjects were only therapy, to get over being morbid. In fact, we can't assume any of this. He was an ironic humorist as well as being psychologically tortured. He joked in letters to friends after his style-change that he had given up alcohol and women too.

Expressionism

Expressionism is a style as much as a mind-set. It is not a driving necessity or inevitability. Whether it's tortured German Expressionism – influenced by Van Gogh and Soutine or Munch himself – or American Abstract Expressionism.

Goya and Munch and shock itself

Both Goya and Munch introduce new things into painting which push ahead a kind of realism of emotions. They are sympathetic artists because of the humanist vision they each express and because of their psychological realism. Goya is more universal. Munch is more extreme and personal or obsessive, more tortured.

These are the prevailing feelings about both of them. There isn't a prevailing feeling that shock itself might be their main subject. But with the Chapman brothers this is the prevailing feeling, even though in interviews they don't ever say that. Never-theless it is widely assumed they are out to shock. That would be shallow of them of course.

Maybe they are bad to do that. But maybe they don't do it. Or maybe they do and it's not bad, because shocks are good. Maybe for us, shock itself is an interesting

subject and one worth thinking about, because we're so alienated. And they are masters of an art of alienated spectacularism.

How many artists?

'How many artists are here from that show "Sensation?" I'm here. I'm drunk. I've had a good night out with my friends and I'm leaving now. I want to be with my friends. I want to be with my mum. There's no way I want this fucking mike on me.'

That was Tracey Emin in 1997 on a live TV programme about whether or not painting was dead. It was a shock to the TV system when she got up and left. But it was only random reality and it didn't have any meaning. It was a weird awkwardness.

Her life slops over into her art. But when it's there it's expertly edited. It's spread out on hand-appliqued blankets with decorative sperm motifs and diary thoughts wrongly spelled – *And I said fuck off back to your week world where you come from* – and cleverly summed up in artful drawings that not anyone could do, and in short stories and films.

She wrote her autobiography from 0 to 13, from conception to loss of virginity. It was called *Exploration of the Soul*. She toured the book

Tracey Emin in live TV discussion on Channel Four 1997

across America, from New York to San Francisco. She took a chair with her and embroidered it on the way. She gave public readings in bed.

What makes her good or interesting or shocking? Is it the the way she edits her art and her awareness of Conceptual art strategies? Or the raw material of it – her abortions and teenage promiscuity and rape and broken-up tortured love affairs?

The things Emin confesses about herself are things we don't want to hear about. Or not in this way, at least. However artful the way is. It's too intimate, too personal. It's a shock to hear it.

Maybe it isn't the events or their presentation but the spectacle of her own confidence that makes an impact. We can't believe what we're seeing. Her life is the same as anybody's, more or less. And you could look those strategies up in Conceptual art books. But somehow you've got to hand it to her – some kind of award for confidence.

Also, her most famous work, her tent with the names embroidered on it of everyone she had ever slept with, was ingenious in the way it forced men, who wanted to go inside and see what names were in there, to crawl.

Shocking feelings

Munch's statements about art suggest that for him it is both the expression of a curse and a redemption at the same time. He would give it up in exchange for a relief from suffering. This is the idea we have about Expressionist painting generally: Why am I not as others are? Why was there a curse on my cradle? Why did I come into the world without a choice?

In her statements and interviews Tracey Emin says the same kind of thing: 'I would give up the art tomorrow – I would instantly give it up – if I could get rid of these feelings.' But she isn't a painter. She was one but she gave it up. The spectre of her former life as a painter keeps coming back though. Expressionist paintings and drawings appear in her art as elements within installations.

We don't question Munch's authenticity because we don't think of him as a stager of shocks. We think of him as a painter of images filled with feeling. We think of Tracey Emin's installations as stagings. Her suffering is real enough but on its own suffering is neither here nor there. And so her authenticity is questioned all the time because of her spectacularism and her exhibitionism and her willingness to

Tracey Emin
Monument Valley (Grand Scale) 1995

Edvard Munch
Painting on the Beach in Warnemünde
1907 (photo taken by Munch)

employ the forms of Conceptual art. And because of what we imagine to be an incredibly enjoyable life of constant champagne drinking. Authenticity can't go with those things, we think. We can't tell if we are right though. It would be absurd to re-do Munch as if nothing had happened in art since his time. But to re-do him in some other way might well be a good idea.

Male and female

I went on a boat up a fjord in Norway recently with Emin to see *The Scream* in the flesh at the Munch museum in Oslo. Was it male or female did she think? A foetus, she thought. And it wasn't the mouth screaming but the whole painting: the fjords, everything. It was a painting of a sound – maybe it was the first Conceptual art painting. After that she went out on the jetty near Munch's house and did some screaming herself. It was for art so it wasn't a raw scream. It was already half cooked. It was half embarrassing, half harrowing.

Shocks in 'Sensation'

When the exhibition 'Sensation' was at the Royal Academy there was a big media shock fest, like the one the media had in the 70s over the bricks sculpture at the Tate Gallery. Only now multiplied and amplified because the structure of the mock-shock news drama was well ingrained in the media nervous system and the drama only had to have more luridity added on. And also because there were a lot more shocks now. When it's bricks there's only the shock of there apparently not being much to look at. But with Myra Hindley and cows and sharks and mannequins with sex organs it's art-with-no-skill coming round again but this time being disgusting and immoral as well.

The artists were probably all a bit shocked that what had seemed old hat at art school and in the art world was considered to be absolutely outrageous in the world of the media. Alternatively they weren't shocked at all and neither were the media because both were lying or playing.

O-levels

Recently the Chapmans applied to do their O-levels and then showed the results of their examination as an exhibition. It seemed to be an exhibition about the ordinary world and what art and creativity are considered to be in that world. Their drawings looked adolescent, cramped, amateurish, obsessive, violent, funny. They all followed the brief of the examination paper and you could believe they were sincere and not contrived because there wasn't much at stake – they weren't being asked to be at the cutting edge of avant gardism but to be ordinary. So it was only natural that the drawings should include effortful but uninspired copies of shocking sights from 'Sensation.'

Their other exhibitions which are grander and more expensive to produce, with higher production values, appear to be about ordinary notions of what art might be too. Even when they've got Goya in them – who is an artist much less well-known to the ordinary world than, say, Salvador Dalí or Andy Warhol or David Hockney or Leonardo da Vinci or Ralph Steadman. It's sometimes shocking what the prevailing idea about what art is actually is.

They got B-passes.

You can't be shocked

Shocking art shocks people who don't think much and who read the tabloids but not people who are always wrinkling their brows and thinking and buying paperbacks of Felix Guattari's *A Thousand Plateaux* and wondering what it means.

An in-between stage is symbolized by the Sunday supplements' arts sections. This is the zone of middle-brow thought. Including thought about what art is. Every weekend you get a geiger-counter reading of where thought on art is at now. It's always pretty banal compared to the *Thousand Plateaux* zone.

Vivienne Westwood's dresses and T-shirts with swastikas and 'Destroy' printed

Vivienne Westwood
Gay Cowboys T-shirt c. 1975

on them, or homo-erotic images of cowboys with huge erections printed on them, caused a jolt in the 70s. 'How much can you take?' they asked. But the question could only be put in this way because the culture was secretly ready for this imagery. It was already there in the collective nervous system, just waiting to be put on a T-shirt.

Galleries are like that now. 'You can't be shocked by us,' the Chapmans' mannequins say to an outraged public, as it peers at perfect chins joined together by vulvas, and at hyper-realistic erect penises replacing tiny innocent noses – 'you produced us!'

But the middle-brow-thought people probably are a bit startled by them. Just as their 70s counterparts were startled by straitjacket dresses and bondage trousers and shirts made of bin-liners and blackmail writing. I know I was when I first saw them.

Hell

A lot of Nazis in miniature scale are eating other Nazis in a miniature concentration camp and torturing them with electronic equipment. Little piles of Nazi skulls lie around, as well as gnawed torsos and piles of feet. Some of the Nazis have doctors' white coats on and some have ordinary Nazi uniforms.

It's a sculpture by Jake and Dinos Chapman. It's not finished yet. They will be sending it to Germany when it's done, for an exhibition there of new international contemporary art.

The camp is incredibly detailed, with little shelves on the walls and realistic light switches and windows and doors and bunks and drainage pipes. It is quite extended, with many huts and offices. There are horrible scenes everywhere, with plenty of gnawing and writhing going on.

At the centre of the camp is a wide, dark circular hole with a high puckered ridge all round the edge. And from this hole, with its unmistakable anatomical associations, genetic-experiment mutant humans issue forth. These super-human or sub-human creatures seem to be the leaders of the camp and the Nazis their victims. But it's not completely clear because beyond the hole where the experiment-creatures are coming out, it seems to be all Nazis, all experimenting on each other or sucking the eye sockets or gnawing the spines of each other.

A drawing shows how the whole thing will look eventually. A giant swastika, twelve feet wide, with the hole at the point where the four swastika legs intersect. When it's done it will be a model of Hell.

'What are you doing?' I asked them. They said they want to drag refined aesthetic natures towards something more base.

Orgasm

In Katherine Hamnett's shop in Knightsbridge, a brain sits on a table. It is connected up by some wires or tendons to a penis. Both organs are part of a mechanical contraption. A real hammer is part of the contraption too. The hammer hits the brain at regular intervals. Every time it strikes, the penis ejaculates. It's another sculpture by the Chapmans, from 1993, called *Little Death Machine*.

Paul McCarthy
b Salt Lake City, UT (USA), 1945
Since the late 1960s, 'Bad boy' Paul McCarthy has worked in many different media, including painting, video and performance. Most of these works are voyeuristic stagings of taboo processes – birth, death, sodomy, masturbation. In 1972, he used his body as a brush, laden with ketchup and other food stuffs. The influence of Kaprow and Klein led to clumsy, autistic, often smelly events in which the masked McCarthy takes on a series of roles. In *Bavarian Kick* (1987), he introduced the motorized figures for which he is best known, placed in *mise-en-scènes* evoking trash-utopias such as Disneyland or B-Movie fantasies. Both disturbing and funny, these life-like characters commit obscene acts such as copulating with a tree (*The Garden*, 1992). The cynical suggestion of these 'tasteless' works is that the mass media and controlling social structures mould the individual into a hopeless, alienated victim.

Paul McCarthy stills from *Santa Chocolate Shop* 1997

Santa Chocolate Shop

Somewhere else, some elves are walking around a wooden structure. The structure is more or less like a room, only there are openings where there wouldn't normally be openings. So it's a bit like a dream. A dream of a lopsided house. Through one of the openings the bare arse of one of Santa's reindeer hangs. Out of a metal funnel Santa holds between the reindeer's legs, a stream of chocolate sauce pours. An elf with a phallic rubber nose holds her mouth open to receive it. So much of it pours in – so fast – the poor thing can't possibly swallow it all. It spills up out of her open mouth, pouring down the sides of her helplessly upturned elfin face. She's an obsessive, gorging, compulsive glutton elf in a film by the artist Paul McCarthy.

Seedbed

Some people go into a room in New York, which appears to be empty. It's 1972. At the end of the room is a ramp. They walk up it and they walk around it. They hear muttering and groaning. A man underneath the ramp is masturbating. 'I'm touching your leg,' he says. 'My hands are on your hair.' They hear groaning. It's Vito Acconci under there. The New York performance/video artist.

Vito Acconci *Trappings* 1971

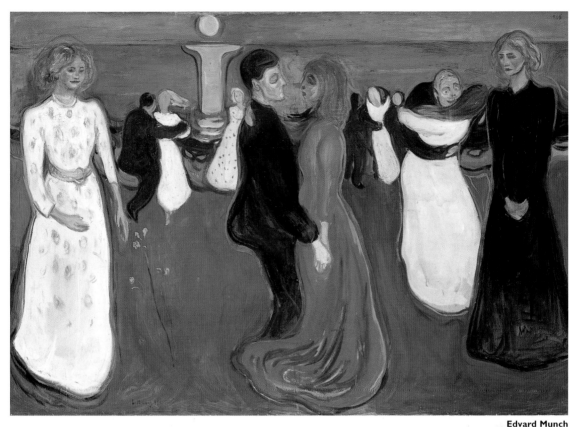

Edvard Munch
The Dance of Life c.1899

The Dance of Life

Now it's Norway, where the torture never stops. Some people are dancing by the sea under a red sun. It's the nineteenth century. A painting by Munch. The men wear black evening clothes. The women wear long dresses with symbolic colours. One woman is innocent. Some flowers grow in the grass near her white dress. One is haunted. Black dress. No flowers. One is being devoured by a man. Blood-red dress. It's the dance of life.

Somewhere else a sexy naked vamp with white skin and black hair and black eyes and a red mouth poses satanically in a lithograph, the image set off by a decorative frame with wriggling sperm motifs.

Munch said the camera could never compete with the brush and the palette so long as photos couldn't be taken in Heaven or Hell.

In fact Munch took photos himself in the 1920s, sometimes of himself. He photographed himself as a transparent shadow like a Victorian ghost. And he photographed himself painting naked in the garden outside his summer house, full of joy.

Santa's orders

Now it's modern times again. Santa and the elves mill around the chipboard and Formica space with their family-size, plastic food containers of chocolate and their metal funnels. The legs of the elves are bare except for Christmas socks with red and white stripes. There is runny brown liquid everywhere. The elves slide in it and stumble around the chipboard home, going about their work. They must do what Santa says. They are his helpers. One of them is calling out to another one: 'Bring that chocolate over here right now you God damned elf!'

Shadow Play

Now it's back in time again, only not very far – the 70s. The era of encounter groups and therapy cults. A man is boxing his own shadow. Vito Acconci again. It's his own self. His private self. But it's out in the open. It's a grainy video. A recording of a performance.

Vito Acconci 1998

Now it's another one, called *Two Takes*: he stuffs grass in his mouth until he chokes and then he stuffs a woman's hair in there.

He faces a nude woman in *Manipulations* and directs the movements of her hands over her body through his own hand movements. His reflection in a mirror faces out to the camera, alongside the woman. Side by side they appear to synchronize awkwardly.

In *Theme Song* he puts some tapes on by Van Morrison and The Doors and Bob Dylan and from the lyrics of the songs he improvises sleazy come-on lines to a woman in a horrible, insinuating, pleading, leery voice.

'I'll be honest with you OK? I mean you'll have to believe me if I'm really honest!' he whines.

Darkness

'It's not just that darkness will come,' says Acconci, in the studio in Brooklyn where he now works, making furniture sculpture and architectural projects, which is what he does now instead of videos and performances. 'But that it's here all the time.'

'There's always been the dark side. The underside. There is death, yes. But there's also the uncontrolled and uncontrollable deep desires of the mind. Ha ha!' He laughs his now middle-aged stones-and-gravel laugh.

'People walk around in the city. Everybody has clothes on but there's a mass of seething desire there. It always seems like the wonder of the city is, with all these people so close together – why aren't they just fucking each other all the time? Ha ha! Or why aren't they eating each other up? So you make a convention of politeness. But the other side is always there.'

Acconci never thought his films and performances were about producing shocks. It wasn't a time when people could be shocked by art, he thought. It was the end of the 60s. And since there was such an atmosphere in the air of shocks that had already happened in life, he didn't think anything he was doing within art was really particularly shocking.

Artists warping

But also Modern art wasn't popular in the 70s like it is now. So it would very rarely be seen by anyone who wasn't already part of the culture that produced it. And who already knew the terms and language and issues. Nowadays there's still a gap between art culture and popular culture but there is an illusion – at least in Britain – that the gap has been closed because of the availability of the products of art culture within popular culture.

In reality, though, it's quite a leap. Artists look at the culture outside art culture and warp bits of it. They warp the movies or ads or daytime chat shows or sitcoms. They even warp art. Then they get invited to make movies themselves, or ads, or be on chat shows. And, er, be artists.

Vito Acconci
b New York, NY (USA), 1940
Acconci was one of the leading exponents of Body art in the late 1960s and early 1970s. His provocative performances reacted against the austerity of Minimalism and, since they were not saleable, against the art market. His early works were 'language pieces' similar to concrete poetry. In 1969, he began a series of photographs of himself bending, throwing, jumping in a landscape. By the 1970s, he was filming his live performances and making provocative installations. For *Rubbing Piece* (1970), Acconci sat in a restaurant and rubbed his arm until it came up in a welt; for *Trappings* (1971), he dressed his penis in doll's clothes and talked to it like a friend. His most famous work is *Seedbed* (1972), in which he used himself as the subject of the work, masturbating for hours under a gallery ramp, while visitors above listened to the amplified sounds of his activity. More recently he has been making large-scale public artworks such as *Floor Clock* (1989), a permanent time piece in a Chicago plaza.

Being compulsive

Paul McCarthy's Santa and his elves are on colour TV screens at the Whitney Museum in New York. It's early 1997. The TV monitors are arranged here and there throughout the wooden structure that the film was made in. Art lovers walk around the structure, seeing the film on different screens, picking up the action in fragments, from different points.

The impulse is to laugh. The horrible low brutality of *The Texas Chainsaw Massacre* comes to mind. And the baroque black humour of that film – punky, culty, extremely unpleasant.

But with *Santa Chocolate Shop* you're not trapped in a cinema with the smell of everyone's sweat of horrible expectation in the air. You're not trapped in a horrible narrative. Or trapped in a room with Leatherface or at the dinner table with Grandpa sucking your blood from your fingertips.

You're just picking things up in fragments. And because of the nature of art you can walk out at any minute – without it being the kind of walking out you might do when you're watching a film and you've just got to get out of there.

No one is being murdered or eaten alive. And everything is clearly what it is – a set, people dressed-up, chocolate sauce, a stumbling, improvised narrative that is barely a narrative at all. Although everything is also powerfully associative – of gorging, shitting, being compulsive, being insane, being trapped, being in a nightmare version of ordinary everyday life – you can easily shrug off the associations.

McCarthy devised the performance and directed the film of the performance, and played Santa. Making the film was part of the performance. Everything is transparent. The house has spaces, the narrative has spaces.

The acting is hardly acting at all. Just impulsive commands issued by Santa, with the film crew and actor-elves all following the commands and playing along with a crude dialogue that sputters up and dies away. The structure of the film/installation is very simple and minimal. The feeling is the same all the way through. Nothing develops. If you went out and came back you wouldn't miss something essential.

It's a work that comes from the context of art. It doesn't make sense to take it out of that context – take a clip and put it on a TV programme, say. And say: 'Bloody hell, that's shocking!' But you naturally want to anyway. It feels claustrophobic to always have to obey the commands of the art context.

What's happening?

'What's happening at this point?' I asked McCarthy in his house in Pasadena, in LA, a year after I first saw *Santa Chocolate Shop*, as we watched a tape of the film rolling by on a monitor. 'What are they doing now?'

'Well, there were two elves,' he said. 'A green elf and a blue elf. And the reindeer is sat down in the hole with his ass hanging down over them. The chocolate flows through a funnel. The Santa Claus stoops over and pours as if he's taking a dump.

Paul McCarthy
in his LA studio 1998

But it's really also just pouring chocolate into a funnel. And the chocolate being both chocolate as in Christmas and the chocolate association of shit and then this eating of it. You know – eating the chocolate? The gluttony of eating chocolate but also eating shit. It's obsessional. It's traumatic. I don't know if it's personal to me or something I've witnessed, through the media.'

Six million pages

I looked *Santa Chocolate Shop* up on the Internet the other day, just out of interest, and the screen said there were over six million pages of entries that applied to that combination of words and I should refine my request. It's amazing the allure those three concepts have for ordinary people.

Proverbs, caprices

Artists are always complaining when only the shocks are talked about. 'What about the ideas!' they complain, because on the whole (when it isn't Tracey Emin rehabilitating Munch's raw pain as a viable type of contemporary expression) the shocks contemporary art delivers aren't about child abuse, murder, cannibalism, war, or other terrible things artists have witnessed and need to express in a burning way. They tend instead to be ironic stagings of abstract ideas about the alienated self or the capacity of the mass media to mould or fashion reality.

Goya is considered to be different because he really was expressing what he saw. Also, he had an Enlightenment agenda – to paint evil and darkness from a sophisticated point of view, maybe to propagandize against regression and in favour of progress.

But in reality Goya's pictures are so perverse that such a propaganda reading never seems particularly the point (in fact the point might well be the opposite). He will always appear quite inexplicably weird and his open-ness means that he is open to being appropriated by anybody at any time, for any purposes, whether it's by Fuseli or Picasso or the Chapmans.

Goya stages scenes that seem psychologically realistic. People and things look believable. But his realism is non-naturalistic – dramatic poses, dramatic editing, dramatic spaces, dramatic expressions. But all this drama is set around ordinary people very believably observed. Their muscles, their looks, their clothes, their demure smiles or their demented ones.

His portraits of royalty are psychologically convincing not because royalty must always be grotesque, as his royal subjects famously are and as the British royal family is often thought to be, but because you believe, with him, that these people appeared in this way, even though they're staged phantoms. And the space they're standing or posing within is a shallow, dramatic stage set. Or phantom space.

As well as *Disasters of War*, Goya produced other groups of engravings, including the *Caprices*. The *Caprices* include a sub-set of engravings called the *Proverbs*. The *Proverbs* all illustrate follies – for example, *Feminine folly*, *Flying folly*, *Ridiculous folly*, *Poor folly*, *General folly*, *Folly of Confusion* and so on. But the imagery is more grotesque and excessive than the popular sayings it's supposed to be illustrating – however richly dark and fascinating and revealing of bestial appetites and desires and human darkness old Spanish folklore might have been in the nineteenth century. As if the hidden twistedness of those popular sayings provided an open door for an anarchy of art.

Flying, gigantism, monstrous deformity, hallucinations, all play a part in the *Proverbs*. The atmosphere is surreal without Surrealism – heavy, black, lunar, dreamlike. *Un Chien Andalou*-like.

In the *Caprices* as a whole the dramas shown are peculiar. The images have a clear didactic intention. Goya lived through war, invasion, famine, the end of the

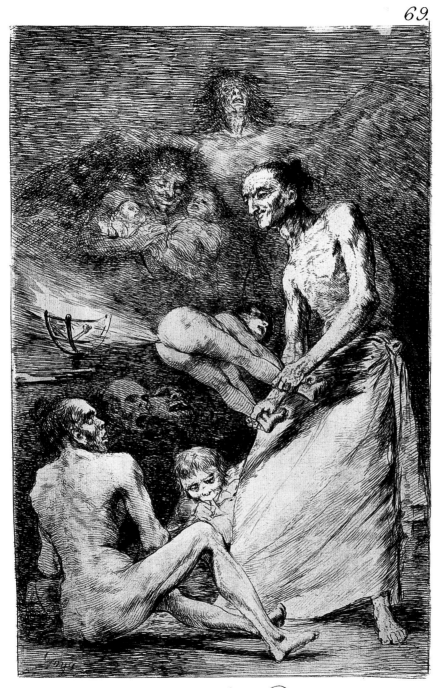

69.

Sopla.

Francisco Goya
What Next?
from *Caprices* c. 1799

Inquisition, sudden reversals of political regimes. He was in and out of favour with these regimes. He was director of the Academy of Painting and the court artist and the favourite of aristocrats and ministers. He was charged at one time with conspiring with the French – he found the invaders cultivated and sophisticated like him – but then got off. He was a schemer and a strategist. At times he was on the run or in hiding. He suffered an extreme illness from which he nearly died and which left him profoundly deaf after the age of forty. He painted all the pictures he is remembered for after then. He had a dramatic adventurous life. He witnessed a lot of atrocity and horror. When he portrays darkness we can almost believe it's because he wants to cast a light there and get rid of it.

But the human darkness he brings forth in the art he produced after the end of the eighteenth century – the point at which he started to set his own themes – is so peculiarly weird and savage, the tone so assaultive, so insinuating, so nasty, you have to wonder what he thought was worth saving. Or if he hadn't at some point just grown out of wanting to save anything. *Don't scream, stupid!* is one title.

The tone of the *Caprices*' most famous image – *The Sleep of Reason Produces Monsters*, which is now a favourite symbol of dreamy or disturbing nineteenth-century Romanticism – is not the general tone of the suite. The general tone is more ghastly. In *What next?* (which coincidentally is *Caprice* No.69) a demon fellates a baby. In the same scene a weirdo giant man/woman fans the flames of a fire with air pumped from the backside of a naked child, the stiff legs manipulated like the handles of a machine. Nude men with bestial, lolling-jawed, corpse-faces look on.

In another engraving in the series, a naked matron suspended in the air is caressed by flying creatures, part human, part animal, all making a totem-pole structure. The title is *Where is Mummy going?* An owl looks out from the crotch of one of the creatures – human legs splayed – while a pussy cat masturbates Mummy with the handle of a parasol.

Allegories of everyday Spanish life are clearly present throughout the *Caprices* but always far more twisted and obsessive than the point of the thought demands – so there is a continual doubt about what the point really is. The mind is continually shuffling, processing, filtering, feeling exhausted by the effort.

Beauties with blank faces, prostitutes maybe, wear upside down chairs on their heads but only gossamer nighties on their bodies. Dissolution is always dissolution gone so ripe and strange that the ordinary rottenness portrayed by contemporary English caricaturists like Rowlandson – who we know is very savage and whose prints Goya would have seen – seems only mild or obvious by comparison.

Stupidity and vanity is always terminal, very far gone. Prostitutes' clients are plucked like chickens and then swept away with brooms. They actually are little plucked chickens with human heads. Some of them fly around a tree. Goya himself is one of them with his sideburns and top hat and peasant face. Monkeys paint asses, donkey doctors feel the pulses of sick men, donkeys teach donkeys to read the

Francisco Goya
Dog Drowning in Quicksand
1820

alphabet. There are many drooling cretins, beaten bottoms, sex-frenzied crones and moonlit human sacrifices.

Black paintings

Between 1819 and 1823 Goya painted a number of images directly onto the plaster walls of the house where he lived, which were later removed and lined and now hang in the Prado under the collective title, *Pintura Negra* or Black Paintings. They're not really all black but the mood is very black. Approaching 80, he ate his meals every day surrounded by them. He painted them in bursts, apparently between

stints of gardening. They never had any titles and nobody knows what they mean. The titles they have now were given after Goya's death.

They were acquired by a French aristocrat who exhibited them in Paris but then returned them to Spain because nobody liked them. It was only relatively recently that they were considered to be any good. And in fact Goya generally was not widely considered to be much good until well into the twentieth century. An English art critic, who fought with Whistler, reviewed the exhibition of Black Paintings at the Paris Fair in 1878 for a London magazine. He said they were incomprehensible vile abortions painted by a sinner.

In these paintings the light is grim, space is unreal, objects often appear transparent, intangible. There are arbitrary scale changes – figures appear like giants because scenes featuring smaller figures are in the same painting. But there is no rationalizing narrative. A city appears to be flying in the sky. Maybe the sky was just painted around it one day. Soldiers in the corner of the painting aim at the city with their rifles. They might have been shooting something else though.

A cannibal giant in one painting is possibly a reworking of a classical theme. Goya would have studied a painting by Rubens in the royal collection, of the same theme – *Saturn Devouring one of his Sons*. The Rubens is polished and glowing. In the Goya version, a naked, mad-eyed giant holds the headless corpse of a young man and sucks one of the arm stumps. The strokes of the painting are broad and urgent. The old thin white-haired giant looks out from the blackness with a horrible expression – hungry, furtive.

A dog drowns in quicksand. Or else looks out over a hill. Most of this picture is just a dim void. Gruesome old people leer and eat their gruel. Women sit in a row in a smoky dark place worshipping Satan. Men stand in swamps beating each other with cudgels. A procession of mad people comes round a hill. The eyes are either blank or staring. The light's gone out in there. It's like the news on TV. All our own weirdness and randomness and blackness. As one of the captions of the *Disasters* reads: 'This is bad.'

With all these pictures – the cannibals and witches' Sabbaths and Satan and Saturn and processions of mad people and vampire oldsters sucking babies and demented royalty and the braying of animals parodying human society – the life of the imagery is only ever flickering. It can suddenly appear very vivid but it can easily die down. Aesthetic distance intervenes. Time intervenes. Amnesia intervenes. When it flares up it's a shock.

CHAPTER THREE

LOVELY LOVELY

Henri Matisse
Capucines à la Danse II 1912

Don't smile

Beauty and loveliness – we don't expect them to be high on the Modern art agenda or even on it at all because nobody talks about them. Did they used to in the old days?

We know Matisse was a great artist of beautiful colour and patterns. But we are not sure what to do with him since (apart from his late cut-outs which look like logos or fabric patterns and which seem to be everywhere in high-street culture and in advertising and packaging) he fits so awkwardly with the art of now. Shouldn't he have been more angry? Why was he only calm, luxurious and voluptuous instead?

Picasso seems more suitably restless and agitated. That's more like it, we think, what with all the wars and torture, and so on, that our century has seen.

On the whole, though, we don't think about either of them very much, unless there's a big blockbuster show on somewhere of them. Which there often is because of the culture industry and its need to keep rolling on and expanding. But neither of them are really part of our *fin de siècle zeitgeist* – to join French with German in an unsonorous way. Which Picasso or Matisse would never have done because it would have felt wrong to them. Perhaps it feels wrong to us too. Obviously not everything has changed since their time as much as we might sometimes believe it has.

Matisse and Picasso don't have a place in our Modern art heads now because they are too aesthetic. Matisse is the worst because he is the most aesthetic. He didn't want to be annoying but only to be soaring and swelling and beautiful like lovely music. What was he on, that Matisse?

Luxe, Calme et Volupté

Luxe, Calme et Volupté. That's the title of a famous painting by Matisse which was completed in 1905, two years before Picasso painted *Les Demoiselles d'Avignon.* It is from Matisse's Fauve period. But although Fauve means wild beast and Matisse was the leader of the Fauves – the Post-Impressionist movement based on the colour theories of Seurat, which started up in about 1900 and lasted for many years – we don't see the wildness in Fauvism any more.

In this painting, we see an arrangement across a white canvas of small squarish patches of colour, each roughly the same size, like a mosaic, with small areas of white left uncovered, roughly an equal amount across the whole space, so every colour is matched by white. Therefore, the light in the painting is hot and brilliant. The scene is of women lounging voluptuously, like patchy cartoon Ingres nudes, beside a Fauve multicoloured sea.

The nudes don't stare out contemptuously like the jostling prostitutes in *Les Demoiselles d'Avignon.* They are a bit distorted but their distortions aren't disturbing or hilarious. It is a painting of a beautiful or purely pleasurable sensation, not a sensation of violent strangeness.

Henri Matisse
b Le Cateau-Cambrésis (France), 1869; d Nice (France), 1954 Matisse stands beside Picasso as a colossus of modern art. The joyous, curvaceous forms, decorative agility and emotional, vibrant colours in a work such as *The Dance*, 1910, may be a delight to the contemporary eye, reflecting Matisse's definition of art as 'mental soother', but in 1905 his work, along with that of Derain and Vlaminck, was called *fauve* (wild animal) by a scandalized critic. Matisse's use of colour was revolutionary, and his interest in Eastern and African art brought about a new, exotic style. In 1890 he abandoned law to study art in Paris. Early works were restrained interiors and still lifes, followed by a period of intensive experiment with Post-Impressionist techniques. Neo-Impressionism and the colours of Nice were major influences on his heightened palette, but Cézanne was his dominant inspiration. The great mature works – the *Odalisques* (1920–5), the Barnes mural (1930–2), the Chapel at Vence (1949–51) and cut-paper gouaches (*L'Escargot*, 1953) – reflect his ambition to create an enriching, decorative art.

Henri Matisse
Luxe, Calme et Volupté 1904

Picasso might not be the artist of the present moment either but we don't turn away from him with a quite such a shudder. Being lovely, being angry — we know which is right. We know no artists will ever be nominated for the Turner Prize for their contribution to loveliness.

What is it?

Beauty, loveliness. What on earth are they?

There is a strain of Modern art beauty which is quite respectable. The intellectualized hysterical beauty of Surrealism for example — the poetic beauty of some odd thing or other next to something else odd on an operating table. This is a terrible beauty or a strange or ecstatic or mad or new beauty.

But the loveliness we find in a lot of art — even in much Surrealist painting — is another story. We don't talk about it, or at best only talk contemptuously of it, but hardly any forms of painting don't have it. It seems to be a property or quality that can never be wholly got rid of. However much we may stop mentioning it and try and shame it into leaving, it just keeps on hanging around.

Welcome

Matisse's most famous saying is that he wanted his art to be like a comfortable armchair for a tired businessman to relax in at the end of a busy day. This seems

Henri Matisse
Large Red Interior 1948

Pablo Picasso
Nude in a Red Armchair 1929

Henri Matisse
*Odalisque with
Tambourine* 1926

absolutely outrageous to us. Almost every element of the idea is offensive. Businessmen can bugger off, we say. And you can keep your armchairs.

But we probably don't really say this because the human nervous system is tuned to seek out loveliness and beauty and to crave them. Maybe what we really feel nowadays is a restlessness with the present rhetoric of anti-loveliness in art and a sense of alienation from it. As if it were a foreign invader who we must obey because otherwise we would be shot. But inside we know it's just an act. Or maybe it's a foreign invader we quite like even though they're foreign. Inside we know obedience is only an act but it's not like we're being driven mad by the split between inner feelings and outer behaviour. This is probably more like it. It's that Turner Prize coming round again, we say. Welcome to our land, disturbing sights that express a profound unease! Come drink with us! Share our women!

Beauty and abstraction

Is beauty in art simply a matter of art not being so abstract all the time? This is a common assumption. Pre-Modern art, like the Pre-Raphaelites, or Raphael, was not abstract and it did not value ugliness. Also, all the various isms of Modern art seem to be departures from a norm of beauty. Therefore it is natural to imagine each one might be a variation on an idea of ugliness. But in fact this is not true. For example, many forms of abstraction in Modern art are variations on a theme of beauty. A norm of representation might be departed from but not a norm of beauty.

Can there be a norm of beauty without representation though? How would we know if any beauty is there if it is not radiating off of something recognizable? And that's a good point. From the bluntest thoughts quite complicated issues arise.

Not going too far

Matisse was born in 1869, Picasso in 1881. They are the two great painters of our century. Nothing in painting that happened since 1900 can't be traced back in some way to them. We feel distanced from them now but for a long time they were the personifications of Modern art and avant gardism.

Picasso was thoroughly avant garde at least until the 1950s when his avant gardism was challenged by American art. Matisse was in and out of the avant garde but still mostly in it. In the 1920s he painted too many languid nudes in armchairs in a relatively undistorted style. So he was out for a few years and Picasso was the leader until the early 30s when they were neck and neck again. But in the 20s Picasso was charging ahead painting wild distortions and even occasionally parodying or caricaturing Matisse with a cruel sneer.

Picasso's *Nude in a Red Armchair* of 1929 is probably a conscious parody of one of Matisse's 1920s nudes. Matisse's nudes of that period look tame by comparison. For example, *Odalisque with Tambourine*, from 1926, has the same colours as the Picasso. This painting looks conventional at first instead of contemptuously idiotic

and horrible like Picasso's painting. Picasso's horror might be a horror at women or a horror at Matisse or a horror at painting.

But even to get the horror at all of Picasso's painting you'd have to be thinking quite hard about it because at first, both paintings look like generic Modern art. Nudes, interiors, oil paint, patterns.

Although, looking now at the Matisse, we do see it more for what it is – the rightness of the colour, the build-up of the textured surface, the beauty and love-liness of the painting. The posed model seems less of a type and there is less of an impulse merely to categorize her. The red and green in the Picasso and the red and green in the Matisse are also suddenly very different. And this difference is more engaging and striking suddenly than the difference between the surrealized, de-boned, nutty, cartoon woman-creature of Picasso – with its furniture-leg limbs and pin head – and the ordinary, passive, dauby, corny model in the Matisse.

But that's just the difference between the two artists. Matisse is about achieving a meditative, rare, sublime beauty with everything he does. Picasso is about being savage and masculine and psychological and peering mercilessly inside his own head and looking at what it is to be sexual or to be old or to be dying or to be still feeling OK and full of beans. How could you portray that? What hoops would you have to jump through as a painter? But he still has to hang on to quite a lot of beauty, though, because of the nature of painting.

Beauty and avant gardism

Beauty is part of painting. There always has to be some. For both Picasso and Matisse, avant gardism was not just moving forward, or being in the lead, as the military term suggests. They saw themselves as profoundly connected to the past as well. As if they had given themselves the job – or accepted the job when it was divinely thrust upon them – of carrying on the great tradition of Western painting but looking forward to the future at the same time.

Each had the same idea as the other of their role as a guardian of something important – the tradition of painting. They had to move it on and change it but in order to preserve it, not destroy it.

There would be no point for them in systematically getting rid of loveliness. The point was to re-make it, or make it new, mixing ugliness with it to freshen it up. If beauty and loveliness were things that had to be held on to, it was because there was a line that couldn't be crossed without painting ceasing to be painting at all and becoming just art. And then art could easily just seep out into everything else and there'd be no difference between it and the rest of the world. And that would be awful because it would be like Duchamp's idea of art and they never thought about him.

For Picasso and Matisse the stopping point before seeping started was not so far out as it was for some other artists – for example, Mondrian, who painted

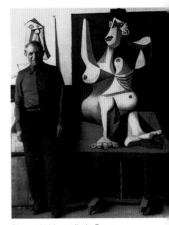

Picasso in his studio in Royan with *Woman Dressing Her Hair* 1940

Piet Mondrian
Composition with Large Blue Plane
1921

Piet Mondrian
b Amersfoort (Netherlands), 1872;
d New York, NY (USA), 1944
A key figure in the evolution
of abstract art, Mondrian is
celebrated for his geometric grid
paintings, in which strong black
lines accommodate asymmetric,
floating rectangles of primary
colours (*Composition with Blue
and Yellow*, 1929, for example).
Priestly and ascetic (he originally
considered becoming a minister
and converted to Theosophy in
1909), he believed these pure,
restrained works reflected the
laws of the universe. His early
paintings were naturalistic, taking
on a Symbolist character between
1907 and 1910. In 1912–14 he
lived in Paris, where he became
strongly influenced by Cubism.
During this period, he made a
series of a tree paintings, which
became progressively more
abstract until curves were
completely eliminated. Back
in the Netherlands in 1915, he
founded De Stijl with Theo van
Doesburg, promoting this new,
radically geometric abstraction,
which he described in *Neo-
Plasticism*, his book of 1920.
Moving to New York in 1940,
Mondrian developed a more
colourful, rhythmic style,
influenced by jazz and typified
by *Broadway Boogie-Woogie*
(1942–3).

abstract squares. For Picasso and Matisse the stopping point was well before pure
abstraction. On the other side of that was just a blank, for them. For other artists,
blankness was still a long way off and loveliness could be stretched a lot further.

Racy or normal

Picasso and Matisse had quite definite ideas about the types of beauty they wanted
to be known for. Picasso wanted to be known as an artist for whom anarchy and
raciness and swearing and sneering were as natural as palettes and cadmium red
and a beret and a T-Shirt. Whereas Matisse wanted to be known as a bourgeois
not a bohemian, with bourgeois tastes. When he was having a retrospective of his
paintings in America in 1948, he was desperate for the publicity for the show to
present him to the American audience as a family man who loved beautiful music.
Not as a wild beast.

Nature

Matisse thought instinct had a role in the creation of art. But it had to be thwarted,
he said – just as the branches of a tree are pruned so the tree will grow better.

For Matisse, not being wholly abstract – even at his most simplified, which he
was in the 1950s with his paper cut-outs – meant not losing touch with nature.
Nature was primal. Early on he had the idea that the patterns and colours of

primitive and oriental art were powerful and expressive and offered a path out of academicism on the one hand, or a languid – as opposed to expressive and urgent – decoration on the other. He thought painting was an art of sensation and he saw all the possibilities of his sensations offered up to him in, for example, Persian miniatures. But it was in nature that he thought these sensations had to be re-found.

Slow Matisse

Matisse is considered to be slower than Picasso and more methodical. And so it is easy to assume he was less adventurous or inspired. And he taught younger artists whereas Picasso never did. He was notoriously secretive and ungenerous.

Both of them surrounded themselves with the kinds of objects that appeared in their paintings. Lovely doves and musical instruments and pots and vases and patterned fabrics and old furniture and couches and examples of their own art and the art of other artists they admired, which included each other's art.

But Matisse drew and painted these things with a concentrated gaze. Just as we see him in old documentary films of the 40s – filling in the colour of the hair and dashing off the eyes, nose and mouth with a flourish, and with the costumed model in her make-up posed right there before him. Whereas Picasso just soaked up the forms of nature by osmosis and they came out transformed on the canvas, while his back was turned to them.

Everything

Matisse is often criticized for being outrageously chauvinist and sexist. The thought goes that he makes women into objects by reducing them to the level of patterns or wallpaper. We cannot criticize an artist for wrong views when they weren't wrong in his time though. Well, maybe we can. But in any case, another view might be that Matisse seems more and more cosmic as time goes on. As if he wanted to make an art where everything seemed to be in an explosion of utter feeling. And from that perspective, we can see the women in his paintings not so much reduced but elevated along with everything else to the same point of transcendental unity. The real human beings in his studio, receiving their modelling fees, taking their tea breaks, or absinthe breaks, whatever. And the trailing plants and patterned cushions and the view through the window and the sea and sailing boats and Riviera palm trees beyond. All now just a cosmic hallucination in oil paint.

We might say, well that's an objectionable subjugation of those models' real selves. It is an objectionable objectifying of their bodies. But that's to project Matisse into the values of a later age.

For example, in a lot of art of the 80s there was a big exploration of what pleasure was, what painting was and what the self was. It was part of identity politics and race and gender politics. It's good that there was that because a lot of the artists we now like – for example, the Turner Prize winner, Chris Ofili – who were art students when all that stuff was going on, and thus were formed as artists in

that climate, wouldn't now feel so relaxed with those notions and able to push them around and advance them by playing games with them. And we wouldn't be now applauding their brilliance or their Right On attitudes.

Another criticism sometimes levelled at Matisse is that he wasn't very active in the Resistance during the Second World War even though his wife and daughter apparently were and were even arrested and questioned by the Gestapo.

During this period Matisse was painting nudes in oriental costumes posing on cushions in lovely patterned interiors. Again, there probably isn't much that can be said in his defence. He knew what he was and what his mission was and there was no going off the course. He lived in a house near Vence called La Rêve, or The Dream. He named it himself. He was detached from the modern world. He lived in his own symbolic world of beauty. He thought that was enough for the war effort.

Expression theory

Matisse said it wasn't the expression on the face of a figure in a painting that was the key to the beauty of the painting but the expression of the whole painting. The face might be a set of curves that wasn't much different to the curves in the wallpaper pattern behind the face. Therefore, the wallpaper was just as expressive. We fear the wallpaper idea now because we fear Matisse is only wallpaper. We have already seen, though, that this might be wrong.

Colour, beauty, painting

With Matisse, colour is the key to beauty. He said colour wasn't descriptive but it was a value in itself and it possessed its own beauty. He said a square centimetre of blue is never the same as a square metre of the same blue.

The mystery of the exact quantity of a certain colour and its expressive quality – this kind of thought had a forehead-creasing urgency for art students at least up to the 1970s. After that it was less urgent because there was a general feeling that even if Matisse was right it didn't matter because colour in itself wasn't all that interesting. What had seemed like a radical idea now didn't seem so any more.

This is the thought we still have now about colour. Other things are more interesting. We think a talent for manipulating quantities of colour, or a feel for colour, is nothing special. It was special in the past but there's only so much we really want from the past, at present.

Quality

Colour was very important in Post-Painterly Abstraction. This was the name given by Clement Greenberg to the stream of abstract painting in America that attempted to follow the example of Jackson Pollock. It was an important movement of the 1960s with its roots in the abstract art of the 1950s. It was Post-Painterly because it was painterly but not gestural. Gestures were out. Colour was in. You had to get the colour on the canvas without using gestures. That was the task.

Henri Matisse
Blue Nude I 1952

Morris Louis
Aleph 1960

There were many followers but the leading figures were Morris Louis, Kenneth Noland, Helen Frankenthaler and Jules Olitski. They were all impressed by Pollock and encouraged by Greenberg. They thought Pollock's art was expressive and full of feeling. It was not absolutely amazing as far as colour was concerned though. But the other formal and technical things about it, they thought were good. And these could be used to advance the cause of colour.

It might seem a bit twisted put this way. But this was pretty much the idea. They didn't want the angst of Pollock but they did want the sensitivity and feeling and formal drama of his art. They thought that was a reasonable separation.

Pollock painted directly onto unprimed canvas – or canvas that was only sized, rather than coated with white paint. Unprimed or only-sized canvas was very absorbent. When the paint was very liquid it bled into the surface. The colour was therefore within the surface of the canvas rather than on top of it. These new painters really got hold of this notion and started to paint in a way that was more staining than painting. The results were often strikingly beautiful. It was a new type of beauty.

Their colour was high and strong and bright and spread out. Their canvases were big, sometimes vast. It seemed to work better that way. It was like Matisse's idea of the expressive quality of a colour being perhaps connected to quantity – fine judgements of quantity.

And indeed Matisse was a great figure for Greenberg and for these artists, even though they were abstract and not figurative. They liked him being Apollonian and not Dionysian. Apollonian means plenty of reason and dignity. Dionysian means all-out hairy savagery. It was a symbolic opposition that had a resonance at the time. We don't care about it now but for Post-Painterly Abstractionists it was a helpful idea.

Maybe it seemed appealing because there was an anxiety at this time about the way a vulgar idea of Modern art was creeping into the high idea because this was also the time of the arrival of Pop art. Not that Pop was savage. In fact, with hindsight, it seems a lot like Post-Painterly Abstraction – cool, large, flat, unemotional. But at the time it seemed like barbarism. Whereas Post-Painterly Abstraction seemed the height of refinement.

Pop art was only novelty art, Greenberg thought. It didn't have enough quality because it didn't have aesthetic power and consequently it didn't have any feeling – it did not express feeling. Feeling was the thing. If art had no feeling it wasn't worth bothering with.

This seems reasonable enough. But as soon as anyone looked a bit harder, or in a different way than the Greenberg way, at all these qualities – quality itself, feeling, aesthetic power – there were problems, it was thought. They could mean too many different things. One person's quality might not be another person's. In fact, quality could be a bad fascistic thing. Feelings might not even be an interesting thing to have in art.

Jules Olitski *High A Yellow*
1967

For Greenberg and the artists he supported there wasn't any problem so long as you stood your ground and saluted the notion of quality because, they thought, quality – or its absence – really was there in art for all to see. The good, the bad: you could see it. And it was just a philosophical game, or an intellectual perversity, or it was barbarism, to try and say that quality was incredibly fugitive and couldn't possibly be pinned down.

It was a bit fugitive, Greenberg thought. But not all that fugitive.

Greenberg himself became a hate figure quite soon into the 60s – at least for those outside his circle. He had seemed very authoritative when he was the critic who discovered Jackson Pollock before anyone else. But gradually he was thought to be only authoritarian. And then it was considered quite unbelievable that such a narrow view of art had been taken so seriously at such a high level for so long. The artists he supported went on painting in the Post-Painterly Abstraction way, experimenting with new formats, or going on and on with the old ones. But now they were just a little world unto themselves and their new works stopped appearing in Modern art museums and art magazines. Louis died tragically early from cancer. The others all continue today in the old vein.

One exception is Jules Olitski who changed his style recently and now paints landscapes and sunsets and sailing boats and nude women. In real life he is a

Jules Olitski
Envisioned Sail 1998

Jules Olitski
b Gomel (Russia), 1922
Olitski was born in Russia but
went to art school in New York
and Paris. He is associated with
Post-Painterly Abstraction and
Colour Field painting, which
rejects textural brushstrokes,
linear boundaries and composi-
tional devices in favour of the
primacy and visual sensation
of colour. His early works were
densely textured, smeared
surfaces in sombre hues. But
in the 1960s, he began to stain
the canvas using sprayed acrylics,
to create smooth, biomorphic
forms in the manner of Morris
Louis and Helen Frankenthaler.
By 1963 he aimed to dissolve
the contours of these shapes
altogether, through the sheer
force of rich saturated colour,
and by spraying tiny particles
of paint onto the unprimed
canvas. In his recent landscapes,
he has returned to the impasto
texture of the earlier paintings,
manipulating the pigment with
sponges, blasting the surface
with a leaf-blower, or allowing
paint to drip down the vertical
canvas. Olitski still lives in New
York, where he has taught for
many years.

sympathetic figure: in his 70s; still painting; still frowning and smiling and philoso-
phizing. But because he is associated with a movement that is hated and feared –
a wrong myth of beauty – there is not much interest in whether he paints sunsets
or not. At the moment they are not being allowed into culture so it will be up to
posterity to decide if they have any quality or not.

Alex Katz and beauty

What about beauty now in painting? The American painter Alex Katz, now in his
70s, has painted beautiful people in sunny landscapes since the 1950s, in a way that
has seemed quite stylish or else impossibly bland to various sets of audiences since
then – or illustrational or even inept. He has been in and out of critical fashion and
when he's out it's usually because of a suspicion of blandness.

But it might be that beauty itself is considered too bland a purpose for painting at
the times when he is out. Beauty definitely seems to be the point with him – the beauty
of Japanese wood-prints or of any art that is about dynamic arrangements of flat
areas of colour. And objective things in the world rendered in a stylized way. And an
execution that is not extremely functional or inexpressive, nor extremely the other
way – extremely dramatic or wild. But hovering oddly just above functional – just at the
level where functional might be about to take off into something more self-conscious.

With Katz, the self is hardly conscious at all. His style is a self-effacing style not a self-dramatizing style.

Now he's in fashion again. Not because there is a sudden new heightened dramatic relationship of a psychological kind between the suntanned figures he paints, standing around in their swimming trunks or with their well-pressed, pastel-coloured casual-wear and in their well-combed hair-dos. But because painting scenes in an ordinary way has come back into fashion.

It's more interesting than painting them in an exaggeratedly emotional way. Both ways require a lot of devices and tricks, so neither of them are all that ordinary. With all the technical devices and skills and concentrated discipline that painting requires, that's enough artificiality. A normality of subject matter seems a better balance of ordinary and extraordinary than an extreme subject matter.

Matisse, too, was self-effacing. He wanted to hide anguish and hide the heroic effort that went into making beauty look effortless. But he wasn't without anguish. In fact he suffered anguish when he thought the effort behind his art wasn't acknowledged. He wanted it both ways.

In Matisse's case he needed a lot of peace and quiet and a long run-in before starting painting. He could never paint when travelling for example. And he lived in Nice not just because he liked the light but because there were fewer distractions there than in Paris.

Once Matisse started a painting he was always erasing and restarting it. His paintings look effortless but they invariably show signs of change and movement.

In fact, when you follow all the joins and parts of his paintings, as if remaking them by looking at them this way, they almost always show signs of ugliness and awkwardness. And the final effect of effortless harmony, looked at again, is usually seen to be an odd harmony – one made of individually awkward or unharmonious or discordant things. Things leaning over, or oddly matched or unsymmetrical. It's odd that a slight discordant quality often seems to accompany beauty.

In Katz's case, his paintings are very large and it is part of their effect of both extreme stillness and dynamism that they seem to have been done all in one go. In fact they were. The colours are mixed and the brushes loaded and the image is painted in a few hours. There's no turning back or erasing allowed in the process. The lead-up to this process is a matter of making sequences of little oil paintings which each represent a different visual idea – variations on the original oil paintings or watercolours which were done from life.

His recent paintings are of piers and reflections in the water around his home in Maine. There are reflections, depths, motion, light. 'Water is like flowers,' he says. 'Very few people can paint them well.'

He says he's trying to paint a twenty-second sensation. The reflections are painted at sunset. Where he lives the sunset lasts from about 7.30 to 7.45 or so. He's got twenty minutes to soak up enough visual data to make an equivalent in

Alex Katz
b New York, NY (USA), 1928
On leaving art school, Katz supported himself by painting murals, and a billboard scale still dominates his work. The movie close-up also contributes to his larger-than-life, simplified images of beautiful sophisticates (often modelled on his wife Ada). His group scenes sometimes crystallize an enigmatic moment of social drama. In other works, a single subject gazes blankly from the canvas, both intense and detached. Due to their stylized light effects and the speed and facility with which they are painted, Katz's glowing, empty landscapes often recall Oriental art. But overall, the works have a quintessentially American feel that stems in part from his subjects – drawn from the New York art world and leisurely affluent life in Maine – in part from the influence of Pop art and jazz music, which gives the works their restrained cool. Katz became known in the late 1950s for his immediate, all-over, Abstract Expressionist canvases. Only now, however, has he achieved true art-world acclaim.

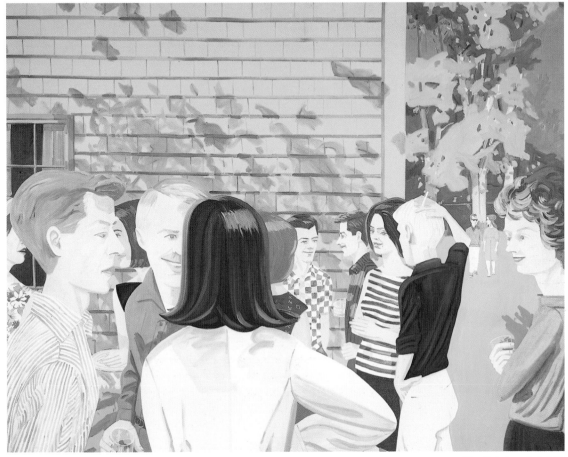

Alex Katz *Lawn Party* 1965

paint for a twenty-second sensation. Then the eventual big painting will have the same high-speed sensation.

'Beauty in modern art is usually associated with something soft, something wrong,' he says, 'like enjoying academic salon painting in the nineteenth century instead of Monet.' When Katz started out, though, he thought beauty could be something 'first class, like the image of Nefertiti.' And he thought he could paint beautiful people and the effects of light in a way that would stand up to the most ambitious achievements of muscular Abstract Expressionism.

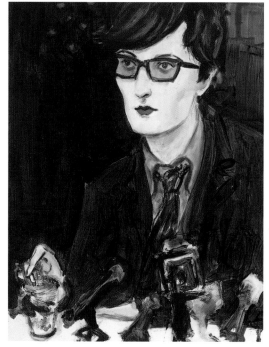

Elizabeth Peyton
Jarvis at Press Conference
1996

Stars

With art there's lots of problems with beauty. But with people it's not such a problem. Everyone knows when they find a person beautiful. Some people have the job of being beautiful. They're stars. They're polished and perfect and unreal. These are the subjects of Liz Peyton, the American painter, now in her early thirties and a recent star of the New York art world.

Her paintings seem even less like Modern art than Alex Katz's. They're beautiful in the way we might say a fashion drawing is beautiful. The subjects are sometimes her friends but mostly they're the famous, or the mega-famous. Jarvis Cocker. Leonardo DiCaprio. David Hockney. The Brazilian footballer, Ronaldo. Done in a frankly illustrational style. But she turns prettiness and illustration into a virtue. She answers a recent appetite for roots art. Not brainy or ironic. But straightforward.

She does straightforward, attractive, glamorous beauty that no one could dislike: transparent oil colour portraits from photographs, with the paint brushed freely onto grounds of brilliant white gesso, and the skin and hair and features and shirts of the figures appearing to have been formed by the colour simply melting into contours and highlights and shadows and forms.

Oasis keep appearing in her pictures. One picture shows the famous Gallagher brothers as infants. But even when they're not children any more, the stars of her paintings have had all the realism taken out and exaggerated elegance put in instead.

'There's loads of glamorous stars out there,' she says. 'But that's not the beauty I'm interested in.' She is outside her studio on Long Island, wearing reflecting sunglasses. A river runs by the back of the house. A yellow boat in the yard with a smiley face painted on it is reflected in her lenses.

'I like people who are glamorous because they're wilful and talented and they can make beautiful things. I think that's what gives them a very special beauty.'

She thinks the reason something from the Matisse world might be considered by many to be more important than something from the pop culture world is that pop is so new it isn't wholly known yet.

She paints stars as they're shown by the media – they're at the centre of historical events, personal events, glamour events. Events which are moving for everybody. 'And that's how Gros painted Napoleon in the early nineteenth century,' she says. 'He saw him as history personified. He was obsessed by him. It's the same with Ronaldo arriving at the airport after his panic attack, or Liam arriving at the airport when it was rumoured Oasis were splitting up. We find those moments riveting. We find those icons irresistible. Gros was in love with Napoleon. He romanticized him. When Napoleon lost his power he committed suicide.'

She makes Ronaldo much more faun-like than he actually is in the press photo she's painting his portrait from. His head is more perfect and sculptured and narrow and prettier than it looks in the photo, a transforming process that seems to happen just by the action of her brush. 'Well, the colour of the skin isn't right yet,' she says. 'It's looking a little plastic. But I love his Brazil jacket – their outfits are so great!'

Symbolic Basquiat

Jean-Michel Basquiat was a star of the New York art world of the 80s. Although he died in the late 80s his star still shines high in contemporary pop culture, where he is considered an absolute model of stylish hipness – in fact he really did model clothes on a fashion catwalk with real models and was always appearing in magazines looking amazing. He was famous for his suits. Famous for modelling them on the catwalk and for painting in them and for them being smeared with paint even though they were expensive.

Many older art critics take it for granted that Basquiat is just a symbol of 80s excess. They probably hate the 80s because it was the decade when critics were laughably weak and galleries and collectors were shockingly strong. So Basquiat appears in at least one mythology as a symbolic victim of the inevitable hangover after unearned gallons of free champagne because that's how the New York art world of the 80s is often seen. But in fact there were a lot of exciting things happening in art then. Not beauty or loveliness so much, maybe.

Elizabeth Peyton
b Danbury, CT (USA)
Peyton refers to her works as 'History Paintings'. When one compares the large, heroic canvases conjured by this term with Peyton's tiny, thinly painted portraits of pop-stars and footballers, this may seem inappropriate, but she is encapsulating the preoccupations of her celebrity-obsessed age in exactly the same way. Her earlier works were indeed of historical figures such as Ludwig II, Napoleon and Marie Antoinette, but since then she has turned her attention to the heroes of 90s popular culture, using magazines and videos as source material. Each of her idols, whether Jarvis Cocker, Ronaldo, David Hockney, or Sid Vicious, is etherealized into a pretty, pouting pin-up with a romantic, faraway expression. The way in which she feminizes her subjects into a single type, not dissimilar to her own elfin looks, may even hint at an element of self-portraiture, or may betray the identification of the fan with the star. The translucent, artificial colours and glazes and the small scale of these works transforms them into the religious icons of latter-day saints.

Within pop culture and youth culture Basquiat is considered to be incredibly soulful and the champagne isn't a problem. Even if it's the most expensive champagne money can buy. Which it was with him, along with the most expensive caviar, because he made so many hundreds of thousands of dollars from his enormous output of paintings. He used to carry huge fortunes in cash around with him, apparently, dropping hundred dollar bills in the laps of tramps.

But neither of these mythical Basquiats – shallow surfer of a brief wave of soulless fake art, or soulful model of artistic hipness – is talked about as a painter of supremely beautiful paintings, in the Matisse vein. But his paintings really are quite beautiful.

Colour with Basquiat is often just a matter of bits of rubbish stuck to a surface. Or welts or runs or splashes of paint – paint that might be iridescent or metallic or gold or silver acrylic. Or scrawled coloured lines – or black or white – done with a wax crayon or an oil-stick. Or simple crude gestural patches of colour laid on with a big brush roughly, like the painterly gestures of the 1950s Abstract Expressionist, Franz Kline.

But Basquiat is fizzy and elegant in every part of the painting and there is a dynamic relationship of every little part of the surface to every other little part. Everywhere there is an interest in painterly effects and in the bruised, tenderized colour-textures that are typical of Matisse.

Sampling

But aren't these just disaffected shallow quotings of already known effects? Post Modern samplings – samplings from Cy Twombly, Franz Kline, Robert Rauschenberg – not to mention Picasso and Matisse and all the other European painters that these American painters derived their styles from?

It's true Basquiat does sample. This is his mode because he is a product of the painting world of his time – a world that starts more with Jasper Johns or Andy Warhol than it does with Picasso or even with Jackson Pollock.

Jean-Michel Basquiat
Untitled (Yellow Tar and Feather)
1982

Jackson Pollock is somewhere toward the end of Modernism, Jasper Johns is somewhere at the beginning of Post-Modernism. Picasso and Matisse are the heart of Modernism. Post-Modernism doesn't have a heart, we think.

Jasper Johns enigma

Jasper Johns painted some beautiful, intense, melancholic surfaces in the 1950s, surfaces where everything was detached from everything else and there was no centre and no self and no meaning and only alienation. Only an enigma.

A flag. The alphabet. The numbers 0 through 9. A coat hanger. A target. A map. They were powerfully iconic compared to the vague, fuzzy abstract look of the Abstract Expressionist style that still dominated the art world when Johns first emerged. But they were iconic of nothingness, not going anywhere or saying anything. And that was what was exciting about them. Whether the colour was only grey or only red, yellow and blue. Or red, yellow and blue but with the names of wrong colours ironically stencilled over them: like GREEN stencilled over red. Or even sometimes the right one stencilled over: RED on red.

For about five years everything Johns painted seemed to have this cerebral, enigmatic, emotionless, cul-de-sac quality – an enigmatic, melancholic, deadpan, dead-end quality that was humorous in a supremely twisted way.

Johns was influential on the development of both Pop art and Conceptual art in the 1960s and even, partly, on Minimal art – the three big movements of the 60s from which all subsequent movements stem and which stand at the junction of Modernism and Post-Modernism. He was sensitive to the beauty and loveliness of Modern art but emotionally detached from it. Instead of faking a feeling of identification with it, he created a form that expressed his detachment. And it was a form that seemed to sum up and crystallize a whole state of mind. An exquisitely aesthetic surface like a system of communicating points – like electrical points – only with all the points short-circuited.

Jasper Johns
Flag on Orange Field 1957

Jasper Johns
b Allende, SC (USA), 1930
In 1955, not long after he had
moved to New York and begun
his collaboration with Robert
Rauschenberg, Johns dreamt that
he had made a painting of the
American flag. The resulting,
heavily textured canvas became
the first of many such works
focusing on mundane, emblematic
subjects such as targets, letters
and numbers, which avoided
representational concerns in order
to concentrate on the possibilities
of painting. In his interest in
forcing the viewer to look at
familiar objects in a different
way, which led to metal casts
of everyday items such as beer
cans and light-bulbs, Johns
created a bridge between Abstract
Expressionism and Pop art. One
of his major works, *False Start*
(1959), set up fake connections
between colours and the stencilled
labels incorrectly identifying
them. In 1961, he began a series
– similar to Rauschenberg's
'combine paintings' – in which
he attached collaged fragments
and found objects to the painted
surface. He now makes numerous
prints and is one of the most
collected living artists.

Live wires of Picasso and Matisse

Of course Picasso could never do that because he couldn't be Post-Modern. He couldn't be Post-himself. He could only express himself. That's why Picasso and Matisse are considered part of the past and not part of the present. They express themselves and their sensations. They express the world through their sensation of it. But we can't take that kind of thing for granted any more.

Even with them, we can't totally take it for granted that that's what they were doing because it's us thinking about them and we think in a different way to them. But we can certainly believe it a lot more with them than we can with us. In fact we have to believe it because it's one of the beliefs that defines us – that they were self-expressive and we are not. Or not in the same way. We are ironic. They were not.

Except when they were. Picasso was often ironic in a black-humorous or even sadistic way. And in his old age he was ironic in an amazing, mad, flowing, spattering, last gasp way, with the surfaces and forms of his last great paintings all looming and swimming almost in a Matisse-like way. But not in a torturous Conceptual art way, with wrong colour labels.

Because whatever age they were at, or whatever period they were in, or however much irony might occasionally play a role in their art, Picasso and Matisse could

only express themselves. They couldn't express a fear that there wasn't any self. Or that expressing anything at all might be an impossibility.

Virtually unalienated

On the other hand, Basquiat, who stands for a peculiarly Post-Modern type of beauty, wasn't alienated like Johns. In fact he doesn't seem to have been alienated at all. At least, not in that way. He might have felt alienated from some parts of society but who doesn't? And we don't know if he really felt this all that much more intensely than anyone else. We just assume it because he was black and he died young in tragic circumstances.

Samo

Basquiat was born in 1960, six years after Matisse's death and thirteen years before Picasso's. His father came from Haiti and his mother was born in Brooklyn of Puerto Rican parents. He was brought up in Brooklyn, speaking Spanish but watching American TV and reading English-language comics and being taken to art museums occasionally by his mother. His parents split up when he was seven. He spent two years in Puerto Rico in his early teens and then returned to Brooklyn and went to high school there. Then when he was sixteen he went to a progressive school in Manhattan. He didn't go to art school afterwards, but entered the New York

Jean-Michel Basquiat
New Nile 1985

Jean-Michel Basquiat
b New York (USA), 1960;
d New York (USA), 1988
Catapulting from New York
graffiti artist to fabulously
successful art-world star almost
overnight, only to die tragically
from a drug overdose at the age
of 28, Jean-Michel Basquiat has
taken on mythical status. Never
losing the raw, playful immediacy
of graffiti, his work explored
notions of the 'primitive',
challenging stereotypical views
of the black artist. Black peoples
wearing crowns, athletes,
musicians and revolutionaries
populate his works, along with
animals, consumer goods,
cryptograms and texts. Using
a wide variety of media including
crayons, ink, paintstick and oils,
he dripped, daubed, scribbled,
doodled and sketched over
furniture walls and canvases.
But despite their naive, informal
appearance, these quintessentially
Post-Modernist works are
complex, finely balanced
compositions, full of witty
references and puns – a kind of
visual hip-hop. Whether one sees
him as glamorous artist-hero,
or tragic victim of the white art
world who presented him as an
'urban noble savage', Basquiat's
unique explorations of identity
and spirituality continue to
inspire new generations of artists.

art world via the clubs and music scene, which in the late 70s was integrated with the art world.

While still a student, living on his own with no money, he was a graffiti artist and he was in a band. The band was called Gray, after *Gray's Anatomy* which he studied as a child while recovering from a road accident. The musicians were all untrained. The music was improvised over pre-recorded tapes and influenced by the club music of the time – No Wave, White Noise, hip-hop, funk and post-punk rock. Which already sounds quite nice just as a list.

Basquiat's graffiti art was done mostly on the walls of the art districts in New York and not so much in the subways – as is often erroneously assumed because that's where graffiti artists are expected to operate. He was consciously trying to get into the art system from the position of an outsider, but with the outsider-persona exaggerated or theatricalized. He famously signed his graffiti Samo, meaning 'Same Old Shit.' But then he killed himself off as a graffiti artist and sprayed 'Samo Is Dead' on the walls instead.

Black star

He was taken up by various galleries one after the other. He became successful very quickly. He was the first black art star. His post-graffiti paintings were usually dense with marks and words and sign-like images. They had a deliberately rough look and were done on various surfaces, including canvas. But often with the cloth roughly stretched, or stretched on eccentric supports that he had specially made for him. But they might also be on doors or other old bits of wood. His method was improvisatory, letting imagery build up in a stream of consciousness flow.

The results emphasized touch, surface, texture as much as signs or imagery. In fact an image with him might be only a sign. A single word, like MILK, drawn in black. Or a copyright symbol and the sign for a crown. Or it might be a crowded image full of different things. A diagram of the chemical composition of light fuel perhaps. Or black bone structure. Or schematized figures from a Leonardo da Vinci book. Or lists of names – for example, jazz musicians or black sports stars. Or the faces of black men done in a primitive stylized way, grinning or grimacing, with rows of square teeth.

The pictures were frequently dense with wide-ranging references and learning. The references were as much to white culture as to black, to high culture as much as street culture. Because he wasn't working class he probably didn't particularly identify with the black sports stars whose pictures he painted or whose names he listed. They were just part of anyone's culture. He painted pictures of famous black stars like Jimi Hendrix or Charlie Parker but in interviews he said he it was more because he was interested in being famous than in being part of black culture.

But the wonky, irregular, off-square rectangles he tended to paint on and the flowing, rhythmic, visual structures he came up with meant that nothing on its own

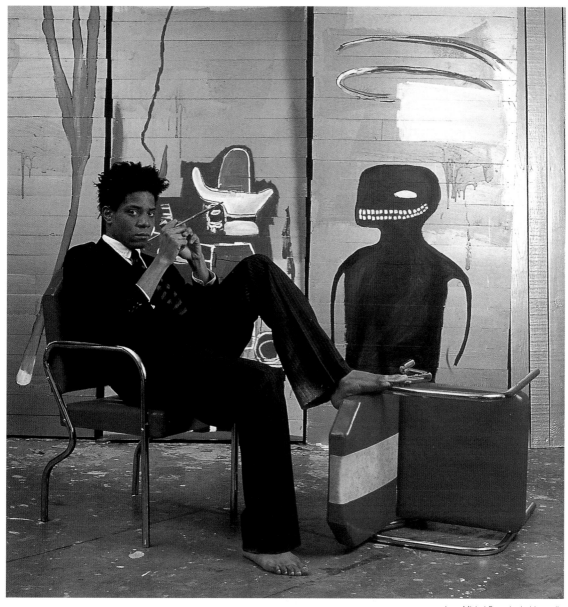

Jean-Michel Basquiat in his studio
in New York 1985

seemed to be the picture. The focus was everywhere. The surface of the canvas or
paper or piece of wood or fridge door was as sensitized as anything done on top
of it, and as much a part of the impression. It was a stylish look, full of hip references

Poster for joint
Warhol and Basquiat show
1985

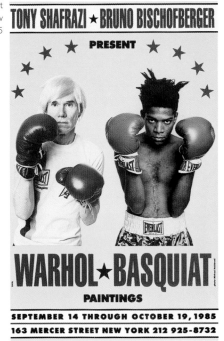

and wittily jangled-up sign systems. But it was also unmistakably a *belle peinture* look, with painterly *cuisine* written all over it.

Basquiat started making a lot of money straight away with his first one-man show in 1981 and he lived an expensive, restaurant-infested, notoriously sybaritic lifestyle, before dying tragically from an overdose of heroin in 1988 at the age of 28.

Untortured

Basquiat was at the centre of New York art culture in the 80s. But he clearly wasn't alienated from his own creativity and self-expression. He just had an expanded sense of what a self might be and he naturally expressed it.

So, although an American like Johns, he seems to belong just as much to the heroic painting world of Picasso and Matisse as he does to our own Post-Johns, or Post-Warhol, ironic or alienated world. But because his touch is so nuanced he is more like Matisse than Picasso (who was the one he admired).

On the other hand, in formal terms, his art is almost purely an art of touch. The touch is so eloquent that it is easy to forget that painterly touch could be put to a grander formal purpose, which it was with Matisse. So it would be an exaggeration to say he really is like Matisse. But it would be an odd idea anyway to insist that he should be because Matisse's type of grandness was only possible at a time when painting was important.

The good life

But in the end Basquiat belongs in a museum of sensuous, beautiful, painterly High Modernist art and not merely to a myth of doomed youth. In fact he probably doesn't even really belong to a myth of the tortured artist. Since although it was short his life seems to have been a pleasure-filled one.

Outside in

Some of Basquiat's paintings have symbols of globes. Some have references to African art. It would be nice and circular to think of the story of Modern painting starting with a movement around the globe westwards from Africa to Europe; from primitive outsider art to sophisticated insider art. With African masks first shown to Picasso by Matisse in 1906, in Matisse's studio in Paris. And then African art used by both of them in different ways to revivify traditional Western forms which had grown tired. And then Modern painting gearing up in a tremendous wave of new totem-like green-striped faces and symphonically blasting red studios and transcendental patterned nudes and open windows with trailing pot plants, all made possible initially by the injection of primitivism. And then Modern painting running its course and winding down and coming to an end. But then being revivified again in the 80s by Basquiat, coming in the opposite direction, from the outside in.

But that wouldn't work because however beautiful Basquiat's painting is, it's still only painting and painting isn't the centre of art any more. Also, Basquiat wasn't a primitive outsider but part of the modern, multicultural melting-pot.

Jean-Michel Basquiat
Untitled 1984

Chris Ofili
in his studio 1998

Captain Shit

In a studio in London King's Cross at the end of the century Chris Ofili glues small circular cut-out photocopies of Op art patterns from the 60s onto a big canvas, using a can of Spray-Mount. Music plays. The room is crowded with pictures in various states. Lots of little watercolours are stuck on the wall. There are shelves and boxes of junk. Take-away food containers sit around with their tin-foil covers stacked up beside them. One covered container is labelled *Dick Pink* in felt pen. Another one has cut-out body parts from porn magazines in it. Lumps of elephant dung from the Zoo stand on the floor nearby. Soon they will stand under the painting he is doing right now and support it because that's how he shows his paintings, standing on dung instead of hanging on the wall. A blow-up black sex doll

Chris Ofili *Afrodizzia (2nd version)* 1996

Chris Ofili

b Manchester (England), 1968
Ofili's elaborate, decorative
canvases layer up materials,
imagery and meanings to build
a complex picture of race
and related issues. Born in
Manchester of Nigerian parents,
Ofili injects the subject of black
identity with freshness and
humour. Black stereotypes, such
as the pimp-like superhero in his
series featuring 'Captain Shit',
or an African goddess (*The Holy
Virgin Mary*, 1996) are ironically
presented under a palimpsest of
transparent resins, sequins, tiny
faces cut from magazines, and
blobs of bright lacquer. Many of
these works incorporate roundels
of elephant dung, varnished and
decorated with map pins, either
supporting his large canvases like
feet, or decorating its surface.
In 1993, he adorned a lump
of it with dreadlocks in a wry
self portrait (*Shithead*). The use
of elephant dung not only
creates an earthy foil for the
cloisonné beauty of his paintings,
but also deftly questions the
exoticizing of African culture
in Western art.

with blond hair lies squashed on a shelf. Perhaps it was the model for one of his paintings – *Foxy Roxy*, where the figure is black but partly pink, with yellow hair. That would make him like Oskar Kokoschka, then, the Austrian Expressionist, who used a specially-made life-size doll as the model for one of his frenzied paintings, called *Murder Hope of Women*.

'Beauty will be convulsive,' André Breton, the Surrealist leader, wrote in the 1920s, 'or it will not be at all.' With Ofili, apparently, the idea is that beauty will not be at all if it's going to be all high and mighty and up its own arse. But it will be, if it's going to be amazingly intricate and decorative and partly out of the arse of an elephant.

Dung. Why does he use it?

'I made a decision to make these paintings that were really ornate and full-on about attractiveness,' he says. 'I wanted to include something in the paintings that would criticize that – to challenge that.'

He works fast on lots of different things at once, so that although his paintings are built up slowly, with many different layers, they never clog up. He glues stuff on one painting and then paints in dots on another one and then does some water-colours and then some drawings and then some two-inch high oil paintings of tiny black faces. They might have six eyes or the normal amount.

In all his paintings he combines a lot of different looks. Low high-street looks combined with high-art looks from all different periods. The look of *Shaft* combined with the look of Aubrey Beardsley. The look of Japanese gods on ancient chinaware or in woodcuts, with their bulgy eyes and flowing robes and fatness. The general look of free, painterly abstract gestures and blobs and lovely patterns. The look of doilies and wallpaper and spangly stuff and glitter and the look of Smarties. And the look of ancient cave paintings in Africa and body-scarring.

Is it identity politics that drives him? It would be exhausting now to remember what they are and write it all down. You must not accept the stereotype selves that are offered to you but, er, expose them as stereotypes. Plus the same with gender. But we are all driven by this stuff now and we don't have to look at a lot of art to get it any more. Now there's a new agenda – all the multiple possible selves that are now available, all gearing up to make as yet unimaginable new hybrids. Selves which are imagined or allegorized or prophesized in Ofili's painting, *The Adoration of Captain Shit and the Legend of the Black Stars*, perhaps.

He was born in 1968 in Manchester. His parents came from Nigeria. He went to church and was an altar-boy. He went to the Royal College of Art at the end of the 80s and studied painting there. His teachers were abstract painters who'd been successful in the 70s with a type of painting that imitated New York abstract art of the 50s and 60s. In 1992 he went to Zimbabwe on a scholarship and saw ancient Matopos dot paintings on cave walls and the body scarring of the Nuba tribe. When he came back he brought some elephant dung in his suitcase. He laid it out on a

cloth in street markets, first in Berlin and then in London. It wasn't to see if it would sell but to see what it would be like. It was the beginning of his career. Next he placed an ad in an art magazine that just read *Elephant Shit.* Then he was away.

The look of Ofili's paintings is always beautiful. Beauty with him is a matter of shimmering watery transparency, layered imagery, and an illusion of luminous depths. But also the beauty of some of the phrases and words of his titles, which have the ring of Victorian bible-reading about them. Even if it's a ring of blasphemy. Not just *Captain Shit* but *The Adoration of Captain Shit* or *Seven Bitches Tossing their Pussies before the Divine Dung* or *The Chosen One.*

Every interview he gives is different, and a bit like the way he moves around from painting to painting. He goes off on sound-association trips. *Captain Shit* might be explained as 'a king or King Kong or King Dong.'

When I ask him if he thinks the tension of ugliness and beauty in his art is like the same tension in Picasso and Matisse, he says he never thought about ugliness in Matisse. He always found Matisse to be about luxury. And lounging. Paintings in lounges and people lounging.

Chris Ofili
The Holy Virgin Mary 1996

Heron and Matisse

Until his death in 1999, the abstract painter Patrick Heron was a last surviving link with the world of Matisse. He once tried to wish Matisse a happy birthday in 1947, at La Rêve, but was turned away at the door by Matisse's assistant, Lydia Delectorskya, because Matisse was too tired to see anyone.

In the 80s and 90s Heron spent his days painting and thinking about Matisse. He looked at pictures by him all the time in art books and always found the master's organizational powers unpredictably marvellous. He thought, 'God I've never seen that before! The unfailing novelty! Totally twentieth century!'

'Matisse just goes on spurting inventiveness,' Heron was saying to me a few months before he died as we sat in his front room. 'He launches into crudities and achieves incredible harmony.' He said he would go half way round the world to see a Matisse that hadn't been exhibited before, even though he couldn't travel much because of bad lungs.

Spiritual beauty

At the time Patrick Heron tried to visit him, Matisse had duodenal cancer which was first diagnosed during the War. It was now ravaging his body and his intestines were so far gone he had to be drained each day by a nurse. Until he died in 1954 he was confined to a wheelchair. His last cut-outs – large paintings of dancing bodies, plants, flowers and waves, made from torn and cut pieces of paper painted over with gouache – were all made from this chair.

One of his nurses during the War became a nun later and in 1948 she came back to him to convince him to decorate a new chapel that had just been built near Vence. This is now known as the Matisse chapel.

Matisse said he wanted to make the chapel, which is quite small, seem to have the dimensions of infinity, purely through relationships of colour. If you don't believe in infinity, though, or in Jesus, or even in Matisse, that's a lot of work for colour to do. But it would be sad if you didn't believe in any of those things.

The light floods in through stained glass windows with desert flower motifs – symbolizing hope – onto linear paintings done in black oil paint on white tiles.

The black and white is striking against the luminous greens and blues of the windows. And as the sun moves during the course of each day, the pattern of light changes over the white tiles.

The paintings are of a Dominican monk, a nativity and the Thirteen Stations of the Cross. In themselves the paintings are not particularly visually pleasing, although the handling is very exciting. It is direct, primal, coarse – as if you could imagine holding one of these tiles in your hand and painting it yourself with a scrawling fast daub.

Picasso said it was absurd and hypocritical of Matisse, who was not religious, to decorate a chapel. The usual view, though, is that Matisse's art is quite spiritual and so it makes sense to have some of it in a chapel.

Patrick Heron
b Leeds (England), 1920;
d St Ives (England), 1999
Heron's principal concern was a passion for colour. Heavily influenced by Matisse, Bonnard and Rothko, he experimented extensively in his paintings with juxtapositions of colour and the resulting spatial effects. During the Second World War, as a conscientious objector, he went to St Ives in Cornwall, where he became assistant to the potter Bernard Leach. Later, he was an associate of Barbara Hepworth and Ben Nicholson, and in keeping with the aesthetic of St Ives, his forms were initially inspired by nature. Later, however, he totally rejected any notion of representation or anthropomorphism, seeking a pure abstraction in which large, simple shapes or stripes of strong colour hover on plain, contrasting backgrounds. The resulting relationship between image and ground creates a shifting, ambiguous sense of space. Heron also worked as an art critic, writing many texts based on his colour theories, designed textiles and taught at the Central School of Art in London.

The Chapel of the Rosary at Vence
1949–50

Henri Matisse at work on a preliminary
drawing for the Nativity in the chapel 1949

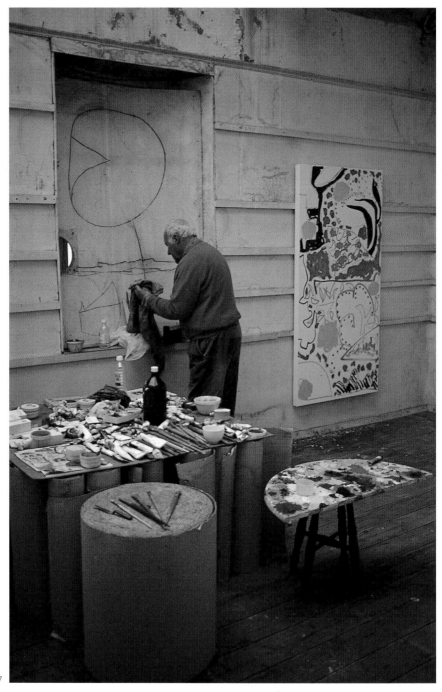

Patrick Heron in studio 1997

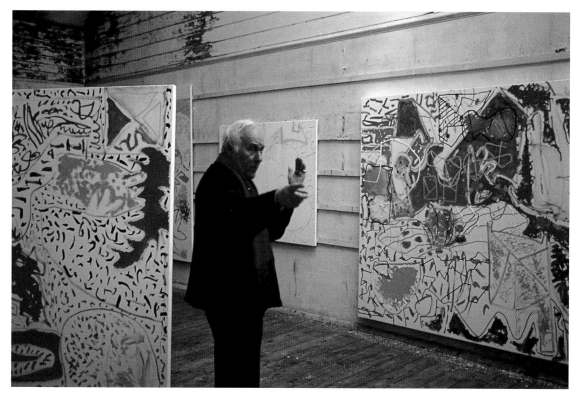

Patrick Heron in his studio

The centre of the universe

Chris Ofili's urban style. Patrick Heron's rural style. Heron was 79 in 1998, the year Chris Ofili turned 30 and won the Turner Prize. At that time both were sensitive consumers of the visual world. They were both painting beautiful paintings that could easily be thought of as being about pure visual pleasure. But pure visual pleasure isn't like lovely cakes. Nothing is purely beautiful or purely visual or purely pleasurable, probably.

Heron played the violin at school. Ofili plays all sorts of chopped-up rhythmic hip-hop sounds in his studio. His paintings are filled with the same thing in a visual version. Heron's are filled with the shapes and rhythms of the place where he lived, which was Cornwall, in a house on a cliff near Penzance, with a view onto the sea, 600 feet below. The fields between the house and the sea are laid out in patterns that go back 40,000 years to the bronze age. The grey granite boulders around his house were pushed up by volcanoes a million years ago. The shapes of the rocks are echoed in the shapes of the trees in his garden, which he had been personally clipping for 25 years. Everything echoes everything else and it all goes back a long time.

Patrick Heron *Red Garden*
Painting: June 3–June 5 1985

'What is it that grabs one and gets one's juices flowing?' Heron asked me.

He answered his own question: 'It must be beauty. So beauty,' he went on, 'although a meaningless word, is nevertheless perhaps a word that evokes all kinds of intensely felt and experienced relationships.'

Heron's paintings of the last twenty years have all been open and free with a lot of white showing through nervous calligraphic scribbles of colour. The landscape he lived in is the subject but the form is abstract. The landscape is a submerged influence, a matter of rhythmic flows. Wherever he looked every day, there were typical, irregular, essentially organic shapes. The shapes of the fields, the hills, of small stones. He found them very powerful.

'I find it enjoyable and pleasurable to talk about colour/shape interactions and the idea that the pleasure and enjoyment of art might be entirely a matter of those interactions.'

But I know a lot of people don't like that kind of talk and I can't really blame them. 'This whole discussion of form and shape,' I said to him as we went into his studio, 'people don't like it.'

The studio used to belong to Ben Nicholson. All around us on the day I was visiting were Heron's paintings. Some were finished in half an hour. Some he kept

going back to and they took nine years. They were all nervousness and no tailoring or flair. They seemed to want to be crude rather than handsome. So it would be odd to talk about them as elegant or composed-seeming. And yet they were as solidly rhythmic and composed as a Byzantine mosaic.

'People don't like it,' I was saying. 'They think you're bossing them around and telling them to pull their socks up and think about form and colour and they don't want it.' 'Really?' he responded, as if someone had said they liked mixing sugar with caviar.

'The subject matter of a painting is the least important thing,' he said. 'You apprehend it immediately but it's the last thing you want to dwell on. And you can't look at anything without moving your eye. Try it! The eye goes from this point to that point to that point. And the stuff of that is rhythm. A robin springs from branch to branch but each move has a perfect starting point and a perfect ending point. It's exactly the same with painting.'

I congratulated him on a good and appropriate metaphor for the visual mechanics of his paintings and he agreed that it was indeed a good one. 'How about some champagne?' he said. 'I think it's worth it – don't you?'

But it wasn't Ruinart, because the last thing he wanted to do was ruin that stuff. He found it the centre of consciousness, the centre of the universe. Especially the art of Matisse, who he considered to be his master and guide. But not Alex Katz who he found baffling: 'God Almighty! I mean, anyone who wanted to earn a living doing illustrations for *Vogue* or something could do better than that!'

But that's loveliness for you. It's pretty subjective.

CHAPTER FOUR

NOTHING MATTERS

Martin Creed
Work Number 200,
Half the Air in a Given Space 1998

Lights out

Standing on the pavement in Old Street, London, the other evening, I looked up at the first floor of a building across the road and watched the lights in there going on and off. It was a new artwork by the artist Martin Creed, who is in his early 30s. The artwork was in a new space that had just opened. This was its first event. It was only on for one evening. And you only had to look at it for a few seconds.

All Creed's works have plain descriptive titles preceded by a number. A work in the eighties from 1994 is a piece of paper screwed up into a ball, called *A Sheet of A4 paper crumpled into a ball.* A more recent work is the sound of a doorbell amplified through a guitar amp in a gallery. The sound can be heard inside every

time someone rings the bell outside. The event lasts as long as the sound lasts. When it's not heard there's no event.

Maybe the screwed-up ball of paper is always a sculpture, or always art. Or it goes back to being only paper again when no one is looking at it or if they're looking at it but not realizing it's art. If all this wasn't happening within an art context it would be happening in a vacuum, which might mean it wasn't happening at all. It would still be the lights turning on and off but not *The lights turning on and off*.

That was the title of the work I was looking at. They didn't turn on and off slowly because if they did it might be missed that they were going on and off. But it wasn't fast either because then it might just be a flickery strobe effect and that would be *The lights strobing* not *The lights turning on and off*.

After a few seconds I went to the private view of the event, which was in a nearby pub. It was full of people from the London art world, drinking and standing around, occasionally mentioning the event. And that was all that was needed to make art happen – virtually nothing. In fact Creed never uses the words art or artist, so even that wasn't needed. It was a crescendo of nothing.

Pale

It seems outrageous to many people that there are so many blanks in Modern art. So many blank canvases, so many white squares, so many black ones, so many paintings of nothing. One artist in the history of art making a white square is not so annoying for many people. They draw the line, though, at more than one doing it. Repetition in art is bad enough, they think. Artists should be original and always think up new things. But repeating nothingness is considered beyond the pale.

Martin Creed
b Wakefield, Yorkshire (England), 1968
Using the language of Minimalism, Fluxus and Conceptualism, Creed creates subtle interventions into social or art situations. These range from a screwed-up ball of paper, mailed to members of the art world, to a musical composition in which a single note is played once. Pieces like *Work No. 102 (a protrusion from a wall)*, 1994, or *Work No. 127 (the lights turning on an off)*, 1995, speak for themselves. 'Nothing' – the CD released by Creed's art band, Owada – hammers home the reductive message.
Apparently more affirmative was *Work No. 203*, 1999, in which the statement *Everything is Going to be Alright* was emblazoned in neon across the colonnaded façade of a classical Greek-style building in East London; a CD with equally cheerful-sounding titles such as 'I Like Things' and 'Nothing is Something' completed the work. But there was something sinister about these pale letters, hovering on the surface of the unoccupied, incongruously elegant building, like a message from the alien administration of a sedated, gullible society.

Martin Creed
Work No. 88, A sheet of A4 paper crumpled up into a ball 1994

Martin Creed *Work no 127,*
The lights going on and off 1995

Nothingness as a principle first emerged in Modern art at the time when pure abstraction emerged, which was in the years immediately after 1910, in particular in the work of the Russian artist, Kasimir Malevich. Since then, absence has been a constant presence in Modern art and we have seen a steady stream of radical blanks, nothings and voids. They won't go away and they used to be one of the main reasons for Modern art being unpopular.

Of course, there is no reason why Modern art should be popular. Enough other things are. Why not give popularity a rest now and then?

Fear of nothing

But certainly in ordinary life popularity and nothingness are old enemies. We even have a term for our horror of nothingness: *horror vacui* – horror of the void. Many Modern artists demonstrate their *horror vacui*. These tend to be the more popular ones – Picasso, for example. He is always obsessively filling up the canvas with stuff.

But recently it has become evident that Modern art generally is not that unpopular any more because it is more connected to ordinary life now. And even its most radically blank manifestations are probably not all that unpopular either.

Minimalism in the 60s

One art movement known to be extremely tolerant of empty spaces and blankness is Minimalism. Within the Minimalist mind-set these emptinesses were probably not all that empty or blank. But when Minimalism came out in New York in the 60s it was extremely unpopular because of its apparent blankness. It was popular with artists but not with everyone else.

In fact Minimalism is not an art of nothingness. It was an art of very little made into a radical something. But at the time, people saw Carl Andre's metal plates on the floor, or Donald Judd's boxes, or Robert Ryman's all-white paintings, or Dan Flavin's single neon tubes, and they felt there wasn't really anything there.

To see something there instead of nothing much required a massive effort. And nobody wants that because they've got better things to do.

60s Minimalism now

Nowadays we don't feel all that horrified by Minimalism. It's not that a hidden friendliness within Minimalism suddenly emerged, like aliens shedding their frightening metallic or green skins and coming out as handsome Prince Charmings. When Minimalism became more popular in the 80s it wasn't Minimalist principles so much as the general Minimalist look that was popular. The popularity of Minimalist art today is largely a product of that 80s type of popularity. It isn't because the education departments of the big museums all heroically got the difficult meanings of 1960s Minimalism over to a wider public and made them understandable. Minimalism's difficulties were just suddenly ignored by this public and a new stylishness that Minimalism was thought to possess was enjoyed instead. And Minimalism was now about an essential pared-down simplicity with a *World of Interiors* spin.

And the museums weren't complaining. The old terms of the Minimalist discourse are still used in museum culture – the 'thing in itself'; the 'object'; the 'space' around 'the object'; the use of non-traditional materials; the relationship between the viewer and the object; the presence of the object; the theatricality of the object. But no one cares what the terms mean or once meant and they are just an empty litany. They can be employed any way round and no one will notice.

Christmas crackers

Art is still quite difficult. Artists are still artists and the culture outside art is still outside it; it hasn't moved in with abstractions and difficulty. It has just given art a different job – not to be so serious all the time. 'You're fired!' the ordinary world says to abstractions and difficulties in art. 'But you're on double overtime with big Christmas bonuses!' it says to all blandness in art.

Still odd

So Martin Creed's minimalistic processes and events and balls of paper, and so on, capitalize on the way Minimalism as a philosophy or a style or an art movement has become part of ordinary consciousness but is still quite an odd thing – taken for granted but not easily explainable. He is an example of the culture changing.

People at art school

In the 70s the newspapers said Minimalism was only rubbish and they deplored it. And it was natural they should do that because art had no business being beyond normal understanding. But people at art school in the 70s often thought Minimalism was fantastic. Carl Andre was absolutely fantastic, they thought. 'It's so simple!'

But it was a bit pretentious, too, of course, the students thought. And you had to do a bit of pseudo-spiritual wiffling to get it. You had to get from an absolutely glaring sense of outrageous nothingness to a sense of something. And it was a fine

Carl Andre
b Quincy, MA (USA), 1935
Andre's background as a worker on the Pennsylvania railway may have informed his preference for strong, industrial materials laid out in rows and grids. The influence of Russian Constructivism is also evident. In his Minimalist arrangements of identical elements such as bricks, planks, metal tiles, he never uses adhesives or joints, relying instead on the gravity of his materials to give the works their coherence and balance. Most often, they are displayed on the floor and can sometimes be walked on. His most controversial piece is *Equivalent VIII* (1966), a composition of builder's bricks, whose reductiveness and simplicity provoked accusations of squandered public money when it was bought by the Tate Gallery in 1976. In 1985 he was accused and acquitted of the murder of his wife, the artist Ana Mendieta, when she fell from a window.

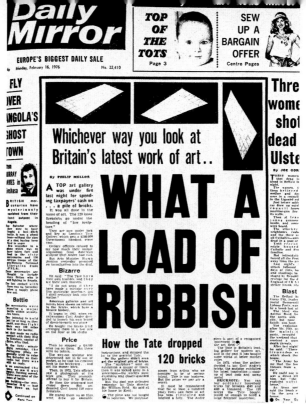

Daily Mirror headline 1976

line between the Minimalist artists that made it and the ones that didn't.

But it may not have been only the main historical figures of Minimalism they were thinking of; they might have been mixing up Carl Andre or Donald Judd or someone, with just a kind of generalized Minimalism, because by now there were thousands of Minimalists and Minimalism was everywhere in art. And conversely it was probably this generality of Minimalism that was being deplored when Minimalism was being deplored.

But now all that has changed and today there is a broad acceptance of Minimalism by everyone so long as it isn't too hard. This is our broad idea of Minimalism now. We don't care that much if it's Donald Judd or someone else.

Alarm

Today there is a new thought about Minimalism shared by art students and by people who are broadly cultivated but not necessarily all that up on art.

'Maybe Minimalism wasn't all that difficult in the first place; the meanings of Minimalism were probably not all that complicated. We were intimidated when we needn't have been. Silly us!' It is a common error to believe this. In fact the meanings of Minimalism were really complicated and contradictory and there were lots of them, all swirling around, all alarming.

For one thing, the typical Minimalist look – an apparently absurdly simple, elementary form on the floor or on the wall in a big white square art gallery – had

Carl Andre *Equivalent VIII* 1966

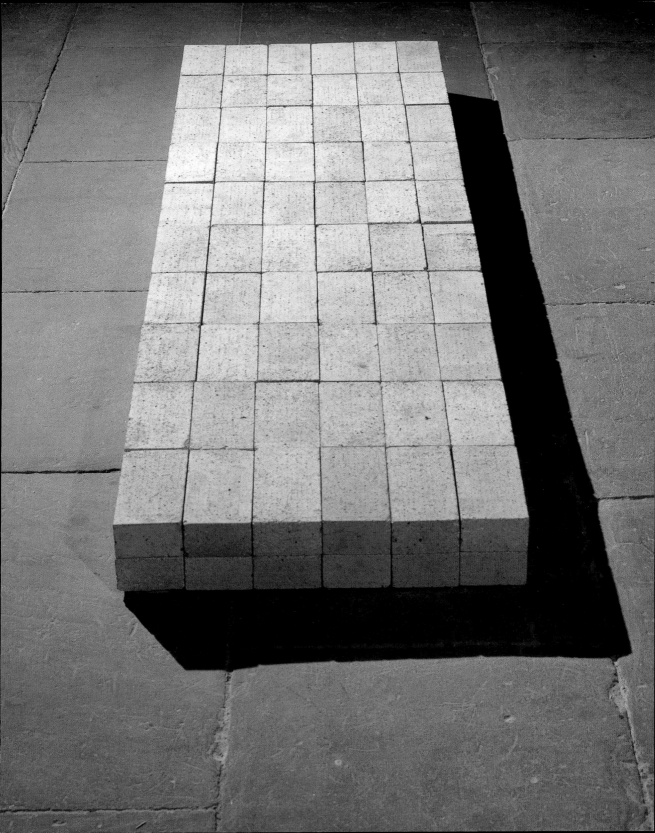

Flavin, Dan
b New York (USA), 1933;
d New York (USA), 1996
Flavin had little formal training
as an artist, but became one
of the key exponents of
Minimalism in the 1960s with
his works using light-fittings.
In 1961, he received his first
one-man show of watercolours
and constructions, held in
New York. He described the
series of 'icons' that he began to
make in the same year as 'blank,
almost featureless square-fronted
constructions with obvious
electric lights'. *Diagonal of Personal
Ecstasy* (1963) consisted of a
single fluorescent light-tube,
which entirely dispensed with any
form of support or structure.
These simultaneously take light
as the ready-made medium and
the subject of the work. Simple
and elegant, they make subtle
interventions into the gallery,
dissolving and redefining walls,
corners and ceilings, and shifting
the entire focus of the space.
Flavin has also received many
public commissions, including
the lighting of several tracks at
New York's Grand Central
Terminal.

quite different implications depending on who had made it. A stainless steel open-topped box by Donald Judd, in 1966, meant something quite different to a plywood box painted grey, in 1963, by Robert Morris. And both of them were different to a row of bricks on the floor by Carl Andre, put there in 1967; or a neon light on the wall by Dan Flavin, with the switch turned on in 1963.

One shared idea was that the Minimalist object was about a mysterious interaction between the object and the space around it. This applied generally: the thing – the nothingness around it. This is already a bit different to just thinking everything was in the object itself. But there were variations even on this idea. And each variation had a lot of different ideas attached to it, or springing out of it. Here are some of the ideas, coming up now.

Possibly chi-chi

A neon tube by Dan Flavin was nothing in itself – or nothing more than a neon tube that anyone could buy in a shop. And it might easily be sent back to the shop at the end of the exhibition because at first he didn't sell much. No one took his tubes seriously enough to buy them. Later they were bought by museums and collectors and they cost a lot.

But when the tube was in the shop again it would sink back into the world of ordinary objects. When it was in a gallery and someone was looking at it, there would be a magical rising of its status as an object.

Flavin himself was quite humorous about this and he saw the funny side of Minimalism. He liked its effrontery in the way it dared to be close to interior decorating, when obviously interior decorating was a bit chi-chi and nothing – certainly nothing like Abstract Expressionism. Abstract Expressionism had to be moved on from, it was widely agreed. It was the Freudian father who had to be killed. But all

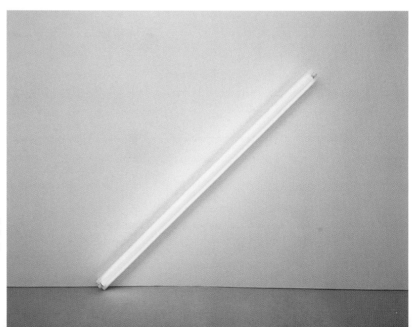

Dan Flavin
*The Diagonal of May 25, 1963
(to Constantin Brancusi)* 1963

its sons and daughters had something of the father within them. Actually there weren't any daughters.

But at the same time, like all the other Minimalists, Flavin was serious as well and his art was complex. It was complex because of everything that was involved – art's past, its present, everything that wasn't art, everything that might be art. Plus it had to look absolutely excellent.

So here there was an important issue about what art essentially was, whereas, with some other Minimalist art, the issue of whether the object was really art or not wasn't there. It might be assumed to be there as the conceptual gag or identity tag of the artist, but it wasn't really. Or at least, that issue wasn't the issue the artist was most thinking of.

No doubt

With this other type of Minimalist art, where there isn't a doubt about what art essentially is – for example, when it's Donald Judd making the art – the Minimalist object is a right and true art object, really well made; like a Brancusi sculpture might be thought to be well made. Or even one by Michelangelo or Bernini or an African tribesman.

Judd rejected the term Minimalism and the term 'sculpture' as well. But nevertheless, a fantastically concentrated effort went into thinking up what the exact proportions of his boxes should be and how the surfaces should be finished and what the scale should be. With him, the box was not an unaesthetic but a super-aesthetic object. And even when the gallery lights were out it was still art.

Or if it wasn't, that would be because of some philosophical or perceptual problem he wasn't all that concerned with – 'It's art if an artist says it is,' he would shrug – not wryly or shrewdly or provocatively, like Marcel Duchamp, with Old-Worldly world-weariness, but straightforwardly, with New-Worldly matter-of-factness. Even though, paradoxically, Judd's type of Minimalist object was made by a factory and not by the artist.

He sent the plans to the factory and the factory made the object. But he personally checked the steel was polished correctly and it was three-eighths of an inch thick and not three-quarters, and soldered and not riveted, and so on. And if the object was painted, or industrially sprayed, by the factory, it wasn't just any old colour but one carefully chosen by Judd.

So industrial mass-production techniques were part of the process of art-making for him but his box wasn't a mass-produced object. It was a unique art object. Unless there were three of them, or ten, or whatever. But even then, that was just a number greater than one. Not an infinite number.

Judd very rarely exhibited single boxes but usually two or several together. To see one was to see it in relation to another one that was the same but different. Each one had something slightly different about it – a top plane or a side one

Donald Judd
b Excelsior Springs, MO (USA), 1928; d Excelsior Springs, MO (USA), 1994
A leading theorist and exponent of Minimalism, Judd began as an art critic and painter. In the 1960s, abandoning what he later called his 'half-baked abstractions', he began to make monochrome reliefs and large, wooden, box-like constructions, which he called 'specific objects'. Placed on the gallery floor or hanging from the walls like paintings, they made no emotive appeal, never aiming to be representational. Their only subject was the object itself. Although they were exquisitely crafted, Judd wished to eliminate all evidence of the artist's hand, forcing the viewer into an intense acknowledgement of the relationships between onlooker, object and space. In 1963, he had the sculptures industrially fabricated from stainless steel and Plexiglas. A decade later, when he was producing site-specific pieces and outdoor works, he escaped the New York art scene by moving to Texas, converting an old army base into studios and eventually taking over the town. In the 1980s, he designed furniture in a similar style to the sculptures.

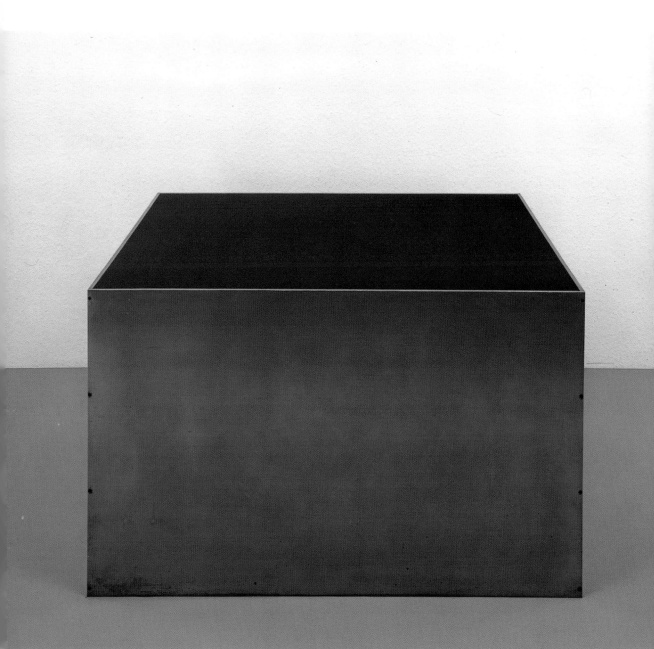

Donald Judd *Untitled* 1972

might be sloping inward, for example; or it might be running flat a few inches below the top edge of the side planes, so there was an effect of a shallow tray.

All this certainly looked different to the old idea of sculpture but it only looked different because Judd wanted to advance sculpture, or advance art, and make it better. Not because he wanted to kill art and have something else instead.

There was no sense with Judd of a magic wand of Conceptualism, or a Duchampian poetic gesture, making an ordinary object of the everyday world turn suddenly into something unique or extraordinary, or into art or anti-art.

Judd's boxes were never anything but art. With him there was still a mysterious interaction between the object and the empty nothingness around it but the mystery wasn't so mysterious or outlandish and there wasn't such a leap as there was with Flavin's neon tube. With Flavin there was the extra mystery of what happened when the lights went out.

Maximum negative

Judd's mystery was just the mystery of any sculpture – the negative and positive space of the sculptural experience. Except with him negative space was massively foregrounded. It was almost positive negative space. All sculptures by Michelangelo and Bernini articulate the space around them because that is the nature of any three-dimensional object. But with them we don't care about all that. It would be boring or perverse or tediously academic or pedantic to discuss them in that way.

But with Minimalist boxes negative space was unavoidable. It was bouncing off the Minimalist box's metal planes like crazy – totally there at maximum energy and not just shyly hovering like a wallflower at a perceptual psychology party, knowing no one cared about it. Which is what negative space used to do in the past before Minimalism was thought of. Nothingness was never so maximalized as it was with Minimalism.

Flavin shining

Dan Flavin's tubes had the mystery of the maximally activated negative space too but a bit more mystery as well. They were tubes that stood somewhere between Judd's boxes and Marcel Duchamp's urinal because they had the extra mystery of industrial, mass-produced objects having been made into art merely by an act of placement.

But they were also unlike Duchamp in that a poetic gesture wasn't part of the process. What kind of gesture was it then? I don't know. It wasn't really a gesture at all. It was more sculptural art than poetic gestural art. It wasn't Conceptual art. It didn't lie on a shelf challenging you to think of it as art, with the artist standing around smiling wryly at you. It stood on the wall shining its neon light and percep-tually changing the space around it and charging it with meaning. But it still wasn't quite sculpture. It doesn't sound like much, I know.

top: **Donald Judd** *Untitled* 1972

middle: **Giovanni Lorenzo Bernini** *The Abduction of Proserpina* 1622

bottom: Stool in form of a kneeling woman from Zaire. Late 19th century

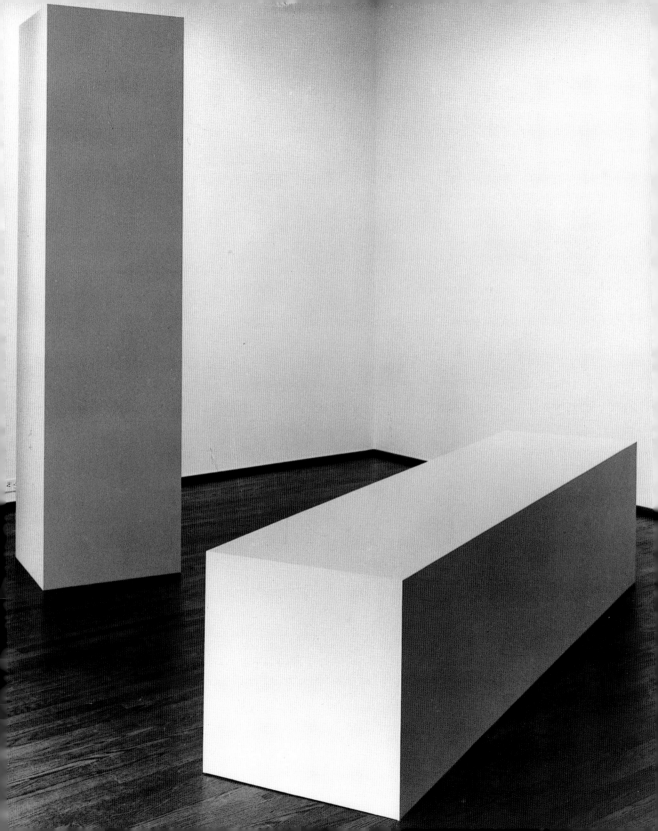

No Wow

But the normal sculptural mystery of Judd wasn't entirely normal either: the sculpture was only a box, or several boxes, made of polished steel or brass or aluminium or wood; or sometimes a kind of metal with a really crazy sparkly finish to it, like the finish on a 50s car. But however interesting these surfaces might be, there was a radical reduction of form to simply a rectangle. A rectangle in three dimensions. You wouldn't be likely to say: 'Wow, I'm really getting a good sculptural experience, here.' It was some other kind of experience. A bit like architecture, maybe. But still definitely art.

No to OK

But the Judd interaction between object and space was not as mysterious as the interaction that was supposed to be going on with a different type of Minimal box art – one where the box was made of plywood painted grey. This was the Minimalism of Robert Morris, another of the main, first-wave New York Minimalists. With Morris's box art, the idea was that the box really was nothing in itself. Even though, in this case, it had been laboriously hand-made by Morris in a real studio, using saws and hammers and nails and sandpaper, and not by a factory.

The mysterious interaction in this case was between the box, the space and the mind of the viewer. With the mind maximally foregrounded. Obviously, the mind of the viewer is engaged in any art experience. Except when the art is sent back to the neon supplier and has sunk back into the world of ordinary objects – because then it's not art any more.

But with Morris the intellect was more engaged because the aesthetic of his type of Minimalism was an anti-aesthetic. The aesthetic heart of art had been surgically removed. Or there was an attempt to do that. Some other weird stuff was put there in its place. It was new anti-art, within the old Duchampian anti-art stream. An art of negativity and dissent. Anti-art but still art. In fact, more truly art than art-art, Morris thought, because art must always be a radical No and not a wimpy OK.

Art good

With the other type of Minimalism – the right and true, well-made Judd art – no one is saying the aesthetic experience is bad or wrong or old hat. They are just saying it can be in metal boxes as much as lovely paintings. Judd maintained in the 60s that the great tradition of European painting and sculpture had run its course and now it was time for something new; something that was neither painting nor sculpture but still art – in fact, great art. The best that can be done. On the same plane as art by Dürer, or Impressionism, or the pyramids.

Robert Morris
b Kansas City, MO (USA), 1931
Sculptor, painter, performance artist and writer, Morris was a leading exponent of Minimalism. He began his career in San Francisco as an Abstract Expressionist painter, also creating improvisatory performances such as a work of 1961 in which he rocked back and forth inside a plywood column until it fell over. In 1962, when he moved to New York, he took up sculpture, experimenting with site-specific pieces and earthworks that disrupted the idea of the autonomous Modernist object, removing art from the gallery. The sculptures of this period were hard-edged, geometric, non-illusionistic forms in the tradition of Constructivist sculpture. Later, he made a series of 'anti-form' works involving softly folded, hanging fabrics. These were more concerned with the process of manipulation of materials than with their constitution into an object, linking back to Action Painting's emphasis on process and leading to further experimental performances concerned with temporal duration. In 1983 he reverted to paintings – this time figurative and often political. More recently, he has produced fossil-like reliefs containing body and machine parts.

Robert Morris *Two Columns* 1961

Very specific

But both these opposite types of Minimalist box forms – Judd and Morris types – align or come together or share common ground over certain issues. And the same ground is shared with shop-bought – or temporarily borrowed – neon tube-type art. The main shared ground is that they all agree the reason to have boxes or tubes at all is that these are very specific forms with all the matter-of-fact object-ness of non-art things. And somehow specific forms are better than complex forms because they are more modern.

Not that complexity is bad. Complexity is good. In fact it is an inevitable fact of life. But in New York in 1965 simple forms were felt to have more potential for radical artistic complexity than complex ones.

No to the extraneous

The objects of Carl Andre are just bricks or metal plates laid on the floor. The basic idea about space in Andre's case is that the space musn't be complicated but it is physical matter and the properties of matter that his sculptures are primarily about, not so much the mystery of the negative space being electrified. In fact he is one of the few Minimalists who doesn't object to the label of Minimalism because he likes its association of a radical purge. Everything extraneous purged, everything pertinent still there. 'Art is a very high form of pleasure,' he says. And he believes that for an audience to have to make an effort to get it is only right, as it is not entertainment.

Carl Andre *Equivalent I-VII* 1966

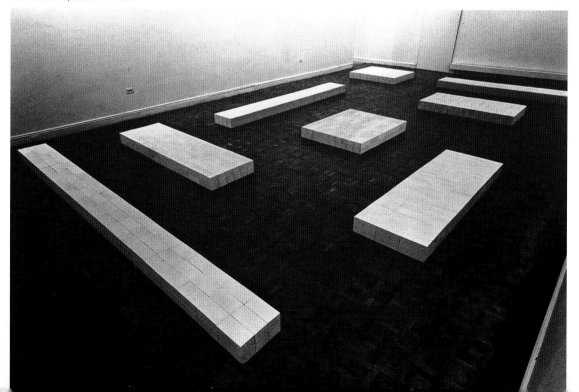

Ad Reinhardt
Abstract Painting 1960

Ad Reinhardt

Ad Reinhardt painted all-black squares which were always five feet across. They had a faint cross formation within the black; so that, when viewed very close to, the painting could be seen to be composed of nine faint black squares. The cross was not religious but was merely a formation. Reinhardt was part of the Abstract Expressionist generation rather than the Minimalist generation which succeeded Abstract Expressionism but he was against all the tenets of Abstract Expressionism. He wrote long lists of everything that art was not. For example, he said it wasn't about surface or gesture or shape or colour and it wasn't about self-expression. He published a long list of elaborations on Nos, many of them satirical. Among them he included 'No illusions, no representations, no associations, no distortions, no paint-caricaturing, no dream pictures or drippings.' Nobody can understand his paintings and they are not popular yet.

An exhibition of Ad Reinhardt's black paintings in New York 1966

Ad Reinhardt
b Buffalo, NY (USA), 1913;
d New York, NY (USA), 1967
Reinhardt strove for an art
'without illusion, allusion,
delusion', believing that 'Art is
art. Everything else is everything
else' – that it is impossible to
represent an object on canvas.
Neither satisfied by geometric
abstraction, nor by notions of
beauty, he eventually made his
final statement in the 'Black
Paintings', a series of mono-
chromes executed in minutely
nuanced shades of black. In
the 1930s he had produced solid,
geometric abstracts influenced
by Cubism and the work of
Mondrian, moving in the 1940s
from all-over paintings to Abstract
Expressionist works similar to
those of Robert Motherwell,
with whom he edited the book
Modern Artists in America (1950).
The monochromes emerged in
the 1950s, initially executed in
blue or red. In the black works
of the late 1950s, ghostly
rectangles and squares were
just visible through the pigment.
His uncompromising views on
the trends of modern art were
expressed in his polemical writings
and lectures, and in his series
of satirical cartoons for the
avant-garde newspaper *PM*. His
work created an important link
from the Abstract Expressionist
works of Rothko and Newman
to American Minimalism.

Everyone else's meanings and identities

After Minimalism had been around for a short while, it started to become clear that there was a problem with it which the Minimal artists hadn't thought of. Which was that it was a movement of male power. Male power was bad and so was High Modernism because they were fantastically exclusive. Exclusiveness was wrong and bad. Minimalism was the high point of High Modernism.

The thing that was excluded from both, it was felt, towards the end of the 60s and into the 70s, was everyone who wasn't a male Minimalist. Suddenly Minimalism became a thing for everyone else to identify themselves in opposition to.

For this reason Minimalism was incredibly important once again, but for a negative reason. So that's another important negativity that Minimalism stands for. It triggered a massive rise of forms expressing alterity. This was Post-Minimalism. Floppy forms or forms that were on film rather than on the floor or the wall; or performed forms; or forms that were not forms at all but only ideas, or written-down words; or just gases or condensation or steam. These new forms were only possible because of the reductionism that Minimalism ushered in, but they were forms that were against reductionism.

They were connected to a new consciousness of the possibility of art after Modernism – an art that was inclusive rather than exclusive. An art that could be an expression of everybody, not just white males, although white males could be expressed too.

At first it was right to talk of black art or women's art or gay art. Then there was a gradual socialization of art and the idea emerged that, however reduced or abstract or strange art was, it had a social aspect and a social meaning, or meanings; not just an art meaning. So with this new idea or attitude, art became more an expression of the swirling mass of different identities that the world is actually made up of. So it didn't make sense to hold onto these reductive labels indicating social groups or types.

Update on Judd, Andre, Flavin, Morris

Judd died in 1994, after establishing a fabulous empire of Minimalism out in the desert in Texas. He bought up a small town near the Mexican border and filled all the largest buildings with his own Minimalist art and the art of the other Minimalists he admired. Many pilgrims go there to see Minimalism at its most amazing.

Dan Flavin died two years after Judd. Carl Andre is still alive. And so is Robert Morris. Andre's work is like it always was. Morris's is too, but that's because it was always changing. So it is quite different now to how it was in 1966. It was only Minimalist for a short while. At first it seemed the same as Judd's – partly because it was mostly seen in reproduction in magazines, and one square in a small grainy black and white photo looks much the same as another. But also, it was only after a while that Morris and Judd found they were radically different artists. Judd liked Andre and Flavin but not Morris. He thought he just changed his style all the time to fit what was happening in the art world. Judd was a stern artist who did not tolerate much bending of what he felt were the rules.

White square

Robert Ryman really does paint all-white paintings that are always square. This is a mythical hate object for middle-brow cultured people. But with Ryman, who first started painting all-white squares in the late 50s and is still going today, the white square is not about mere repetition of whiteness or mere sameness. In fact it is about difference. The paintings are all about light and surface and making a million different types of white by refracting light off of different types of white. The white is different because it is put on in different ways. Squareness stays the same in order to draw attention to where the important differences are – which is the whiteness. Ruffled whiteness, flat whiteness, thin whiteness, transparent whiteness, encrusted whiteness – warm, cool, flowing, stumbling, agitated, and so on.

This might seem like there is no meaning but it is really just a different idea of meaning to one where there is a something happening somewhere else and the painting is referring to it. In Ryman's case it is all happening on the painting. Everything that a normal painting might have – a date, a signature, a shape, a surface, some paint, some white – these things are the only things Ryman's paintings have. So they all have a lot to do. Rather than just doing nothing. Which is the wrong idea that people often have about him. If they are thinking about him at all rather than an imaginary annoying artist who paints white canvases.

Back to Ad

Ad Reinhardt's black squares have a certain mysticism about them because Eastern philosophies were in the air when Reinhardt was alive and it was part of 50s and 60s art culture to feel at home with Zen. Reinhardt in fact taught Eastern art at art schools and he knew a lot about it. But this mysticism is only a vague idea that people have about his black paintings. It wasn't Reinhardt's idea – his idea was that

Robert Ryman
b Nashville, TN (USA), 1930
It is not what to paint that interests Ryman, but how to go about it. He began his career as a jazz musician in New York, but took up painting while working as a security guard at MOMA. Soon, he was making the predominantly white paintings, often with brightly coloured underpainting, or elements of black, that would define his style. He used a variety of different paints, supports and scales, but stuck to the square format to avoid the idea of a window or door, and for symmetry and balance, though sometimes surfaces are curved, or the work displayed like a shelf. By 1966, with the emergence of Minimalism, Ryman had found a context in which to show his work, although his concern with the intuitive working of paint set him apart from these artists. Believing that 'representation is illusion' and that his works were 'real' things in themselves, he felt that they needed no frame, but should interact with the gallery space as objects. Works on paper are glued, stapled or bolted directly to walls, the bolt heads activating the surface.

Robert Ryman *Term 2* 1996

art was art and there wasn't any reason to read anything else into it. This particular reading – an optional one, we might say – is not like the amazing certainties of Minimalism, which started up just at the point when Reinhardt died.

In charge

Who is in charge of meaning? It is a consensus. The artists, the writers, the audience – they all play a part. In the 60s there was a consensus that Minimalist art had certain meanings. Therefore it really did have those meanings. To think about the art in a different way would be to get it wrong. However, it is not against the rules of art for someone to do this. If they are not artists it will just mean they have missed the point. But if they are artists they might get the art wrong in a creative way, which might mean they would make some new art based on a misunder-standing, but the misunderstanding would give rise to a new idea that worked.

This isn't what happened with Post-Minimalism though. The Post-Minimalists got Minimalism right and they positively wanted to develop it in a different way.

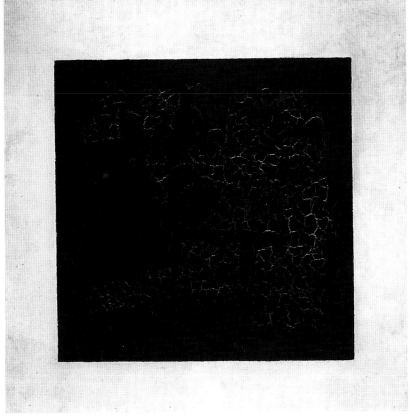

Kasimir Malevich
Black Square 1913

Black square

The other Modern artist known for painting a black square is Kasimir Malevich. Malevich, who died in 1935, is not particularly popular now but in Russia both before and after the Revolution he was well known and widely revered. He stood for the principle of Non-Objectivity.

Non-Objectivity means not painting pictures of the objects of the world but painting abstractions that symbolize dynamic energy and cosmic order. His painting *Black Square* was first exhibited in Moscow in 1915. It is not known when it was actually painted. Probably some time in 1913. It was during this year that Malevich began painting purely abstract shapes using only primary colours and black and white.

It is just an oddity for many people now, even for lovers of Minimalism. A plain black square within a white border, not particularly large. There are several versions. The first one still exists and is kept in a museum in Moscow. The black is a riot of

Kasimir Malevich
b Kiev (Ukraine), 1878;
d St Petersburg (Russia), 1935
'The painting of pure form' and
the 'supremacy of pure feeling'
was how Malevich described
Suprematism, the movement he
founded in 1915. This tendency
was characterized by its total
non-objectivity and the reduction
of subject matter to pure,
simplified, geometric elements.
The idea achieved its ultimate
expression in *Black Square* (1913),
and *Suprematist Composition: White
on White* (1918), in which the
monochrome image was painted
on a background of the same
colour, becoming the emblem of
Suprematism. Malevich reached
this position through early Post-
Impressionistic works followed
by paintings on 'peasant' themes
executed in Léger's tubular style.
These led to Cubo-Futurist
paintings and mechanical figures.
In 1927, he visited Europe,
meeting Arp, Schwitters and
Richter, and his treatise, *The
Non-Objective World*, was published
as a book by the Berlin-based
Bauhaus. His connections with
Germany, however, led to his
arrest in 1930, when he was
banned from publishing his
writings. During this period,
he returned to representational
works.

white cracks. Versions from the 1920s are blacker, but still they seem very under-stated, plain paintings, without much painterly energy. The energy is all in the idea, we feel. The idea to project nothing but black squareness.

This wasn't exactly the idea with Malevich but we are not in a good position any more to understand exactly what his idea was, even though all his main writings on art are available in translation. We are too distanced from the age he lived in and his cultural horizons are not our horizons. It's pretty hard now even to imagine that one of the most basic structures of cultural life then was for writers, poets and artists to all think the same thing, let alone that the main same thing might have been to have a revolution and storm the Winter Palace.

But also, the look of Malevich's art is relatively plain. We feel we can understand the ideas of Abstract Expressionism because it is easy to believe the ideas might all be more or less there in the churned surface of Abstract Expressionist paintings. With Malevich's *Black Square*, though, there isn't much going on with the surface. That's why Malevich is relatively unpopular now compared with Jackson Pollock.

Non-Objectivity and objects

Is Malevich Minimalism? No. Just don't even try to work out all the objects in Non-Objectivity and the Minimalist 'object.' There aren't any objects in Non-Objectivity but only geometric shapes. Minimalism is all geometric shapes but it is not Non-Objectivity. Minimalism is against the subjective realm and for the objective realm. Non-Objectivity is for a radical subjectivity and against Futurism.

The impersonality and understated painterliness of Malevich's Non-Objectivity look might make it seem a very sympathetic or influential look as far as Minimalist artists of the 60s were concerned. But although Judd admired Malevich's paintings and wrote eloquently about them and Flavin titled one of his neon tubes after Tatlin, the famous colleague of Malevich, neither Malevich nor Tatlin particularly figure in the story of Minimalism. They stand for a stage in the history of Modern art that probably didn't have much more resonance in the 60s than it does for us today. Maybe it had less, because since the 60s there has been a designer revolution and post-80s typography and magazine layout owes a lot to Malevich's graphic art.

A Malevich black square is quite small but Minimalist art is usually very big. With Minimalism in the 60s less was famously more. But it came in big sizes nevertheless. Less being more was a credo connected to a critique of 1950s Abstract Expressionism. Abstract Expressionism was allusive, atmospheric, gestural, illusionistic, sometimes violent and hysterical. Minimalism was against that but Malevich couldn't be against it because it hadn't happened yet. Malevich died ten years before Abstract Expressionism started and thirty years before Minimalism.

Remember – everything in art comes out of something and what it is against is part of what it is.

Kasimir Malevich
Suprematism (with eight red rectangles) 1915

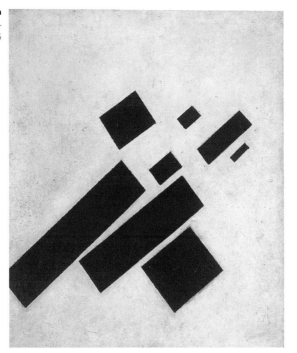

The world

Non-Objective art after Malevich is a strand of art that was considered a bit boring by the time of Abstract Expressionism. Within the general category of Non-Objective, was included Neo-Plastic and Constructivist. They all featured geometric abstract forms. By the 40s they didn't seem radically modern any more. In fact they seemed a bit dry. Surrealism was much better, it was thought. It was more exciting than just squares. Abstract Expressionism swallowed them both up: squares and Surrealism – objectivity and subjectivity.

Surrealism came back later in various mutant forms but although Non-Objectivity might be said to have lingered on in some areas of avant gardism after Abstract Expressionism, these were not the glamour hotspots of Modern art.

Did Abstract Expressionism share any ground with Non-Objectivity, since they were both abstract? Pollock said painting for him was 'nothing less than the expression of the age.' Malevich thought painting was linked to the totality of a particular culture and it expressed the world-view of that culture.

But with Pollock we think there is a lot of self-expression going on as well as age-expression and probably age-expression with him was just an unwitting by-product. Malevich's paintings are impersonal by contrast and we don't feel he is a great self-expresser. He must be expressing the age more, we think.

'Last Futurist Exhibition 0, 10' 1915

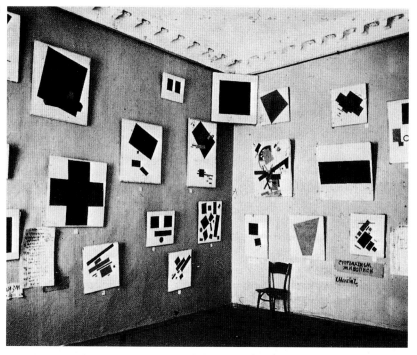

The cosmos

When *Black Square* was first exhibited in 1915 it was very exciting. It was the first icon of Suprematism, the movement Malevich invented, which was based on the principle of Non-Objectivity. Malevich thought of it not as a matter of mere geometric design but as a form of cosmic realism. There were other Russian artists involved, but Malevich was the leader and the main polemicist, pamphleteer and theorist.

His theories haven't particularly lasted. They are fascinating but they have a comic aspect for us. The comedy is partly witting, partly unwitting. Avant gardism had a brief to be menacing at this time, and Malevich is one of the great avant garde declaimers: The President of Universal Space was one of the names he called himself; Kasimir the Great was another. But he only did this because the Czar was a figure of everyone's dreams then and because Malevich's culture was different to ours and he thought the painterly world was connected to a great spiritual vastness and to cosmic depths or heights.

The *Black Square* was exhibited in a show called 'Last Futurist Exhibition 0.10 (Zero-Ten).' As well as Malevich, there were nine other artists participating, all advocating the new principle of Non-Objectivity. Photos of Malevich's section of the exhibition show a room crowded with smallish abstract paintings. They are

spread all over the walls in an irregular formation, three or four deep. Nearly all of them are of configurations of squares with other elementary geometric shapes – diagonal bars, circles, semicircles, triangles, all floating in a white space. The exceptions include a painting featuring a single wide rectangle and one of a cross.

But the most radically reduced formation is *Black Square*, which is just the square within a white border. It hangs higher than the rest, its top edge touching the ornate molding of the ceiling. It is the only painting to be hung across a corner of the room rather than flatly on a wall, in the normal way. From this position it looks down on the rest of the space as if it holds the key to meaning, which it does. Or did. It was a new Russian icon, replacing the old ones with Jesus on them.

The numerical flourish at the end of the exhibition title – '0.10' – was related to the radical nothingness of the *Black Square* – the idea of Malevich advancing from nothing to infinity. 'I have transformed myself in the zero of forms and gone beyond zero,' he wrote in his manifesto of Suprematism, which he handed out to visitors at the exhibition.

Victory

The event immediately preceding the 'Last Futurist Exhibition' was an avant-garde opera, with the libretto written by Mayakovsky, for which Malevich designed the costumes and sets. It was called *Victory Over The Sun*. The victory was the victory over illusion.

Before the moment of Suprematist consciousness, Malevich painted in various Modern art styles, including Impressionism, Pointillism, Symbolism, Cubism and Futurism. He gave them new style-names like Cubo-Futurism or Transrational Cubism or Alogism, as in a-logic. A lot of this art looks pretty hideous now. Malevich was a supreme aesthete but not a delicate flower. He thought of all this work as research. The already given styles were pushed in order to discover new theoretical contents and the styles just had to take the strain. His versions of these styles seem so clumsy and wooden compared to the real thing, it almost looks as though he was torturing them.

He painted some Cubo-Primitive pictures of peasants toiling. But even these paint-ings – which are moving because the idea of Modern art and peasants somehow coming together just is moving for us – are visually hideous in their bucklings and strainings and weird luridness. But Suprematism when it came was amazingly simple and elegant. And it remains a marvel, however removed we might feel from its historical moment.

For some, the new movement was a vile desecration and the *Black Square* meant the destruction of everything. But for others it actually was everything. It summed up everything. It had all meanings covered. It was the height of art. The best it could do. It was an art revolution. 'My new paintings no longer pertain to the earth,' wrote the President of Universal Space.

Kasimir Malevich
Red Square: Painterly Realism of a
Peasant in Two Dimensions 1917

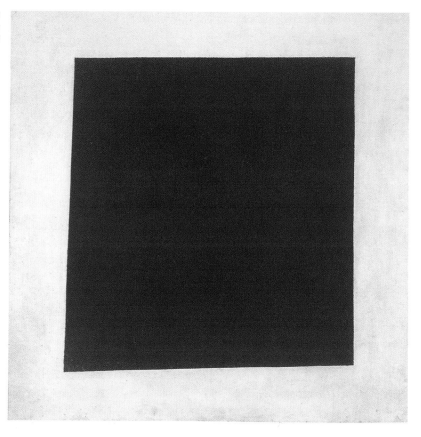

Red Square

Malevich's art of pure feeling was considered to be right for the Revolution at first but then it was considered to be wrong. For a few years he was a hero. He painted red squares and he produced suprematist teapot designs, book covers, textiles and film posters; and he helped found and run new museums and art schools dedicated to radical Modern art. Then splits began occuring within the radical groups he was associated with, and he began to appear too mystical and not hard-headed enough. And to those outside these groups he began to appear to be mad. As the political climate hardened he fell into wide disrepute. He was attacked by *Pravda* for being a crackpot. In 1927 he was briefly imprisoned for taking a trip to Berlin to promote his work. He was incarcerated for two months and interrogated on the nature of abstraction – What was its ideology? But then he was released. By now, with the rise of a new official realist propaganda style in the Soviet Union and the official dissolution of all independent artistic groups or movements, Malevich was officially tolerated but made to feel severely pressurized. He was no longer allowed to hold

any of the important academic or curatorial posts that had been created for him in the early post-Revolutionary years.

When Malevich died in 1935 his body lay in state for five days. A photo shows the long-haired, bearded, white-robed corpse, Rasputin-like, lying in a coffin that looks like a Suprematist sculpture, against a wall lined with Suprematist paintings. The body was transported from Leningrad to Moscow by train – paid for by the City of Leningrad – and the funeral procession through the streets of Moscow included mourners carrying banners bearing the icon of the black square. After Malevich's cremation his ashes were interred in a grave marked by a white marble square and a photo of the *Black Square*. The State Russian museum bought several of his works and awarded a pension to his family.

Strange bug within

Malevich's paintings from the mid-20s to his death in 1935 show him apparently torturing Suprematism in the way he had tortured Impressionism and Cubism in his pre-Suprematism period. He went back to all the old styles with weird results. He painted a lot of ugly Impressionist pictures and backdated them, apparently to make money, because the official Soviet museums were willing to buy them. And then he went back to Cubo-Futurist peasant paintings of the old days but now making them seem as if they were Suprematist-style compositions. Some of these have a rough brightness and strength about them, like bright signs or notices to 'Hire Your Beach-Hut Here.' But a lot of his later paintings are indistinguishable from a vapid brown academic realism.

Malevich really was oppressed creatively in his last years but also there is a feeling from his last works, and the weird twists he put his own ideas through, of something genuinely different about his version of pure feeling to the version that, say, Chagall or Kandinsky – his Russian contemporaries – demonstrate. They are sweet, he is harsh. They keep an even keel, he is full of uncomfortable contrasts. But to him it was all part of the same thing. Dreadful, insipid self-portraits and portraits of family and friends from his last years are still signed with the emblem of the black square. He seems to wind down from a cosmic vision of art to more or less outright rubbish. And as a result less of pressure from without as from a strange bug within.

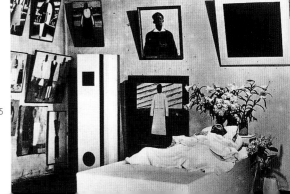

Kasimir Malevich in Suprematist coffin 1935

Mark Rothko
b Dvinsk (Russia), 1903;
d New York, NY (USA) 1970
Rothko is bracketed as a
leading exponent of Abstract
Expressionism. His calm, medita-
tive works, however, show less
concern with the gestural qualities
of Abstract Expressionism than
with the retinal effects of
colour-field painting; less interest
in exploring abstract notions
of colour and form than in
generating emotion in the viewer.
Largely self-taught, he co-founded
the Expressionist group The Ten
in 1935. In the 1940s, his
paintings showed strong affinities
with Surrealism and the biomor-
phic compositions of Arshile
Gorky. By 1947, he was moving
towards Abstract Expressionism
with the works for which he
is now well known — seductive
rectangular forms, their edges
softly blurred, which appear
to float hazily above pulsating
coloured backgrounds. He
regarded these as 'things', or
portraits, expressing basic human
sentiments such as tragedy,
ecstasy or doom, and described
the experience of painting
them as 'religious'. Plagued by
depression for much of his life,
Rothko committed suicide in
1970.

Optimism and pessimism

Historically Non-Objective art is an optimistic, forward-looking art. The forms are geometric because they are more democratic. Anecdote is out because it is trivial and symbolic subject matter is out because it is connected to the old order. Art was now freed to convey new cosmic meanings directly, without having to go round the houses. Also, houses could be geometric too, and everyone would live in the same kind of one and it would be more democratic in a good way. This was Constructivism, the movement that was developed by Rodchenko and El Lissitzky, partly inspired by Malevich but partly in opposition to his religious mysticism. But geometric art in general has these associations, at least up until the Second World War. It is connected with an idea of utopia, of society progressing and getting better, leaving the gloomy past behind.

Abstract Expressionism, when it came, was not just a stylistic twist on Non-Objectivity — abstract forms turning more organic, brushwork turning more frenzied, the scale getting bigger. It was a change in attitude. Rather than optimism about the future, it expressed a deep tragic feeling about man. Gloom, awe, the sublime — this was one strand of Abstract Expressionism. Turmoil, frenzy, the flesh — this was another strand. But pessimism was there in both strands, you could say, because there was no longer a feeling that abstract forms were necessarily democratic or even that art necessarily had to be democratic.

Feeling depressed

Mark Rothko was always incredibly depressed. He was an Abstract Expressionist but his paintings were not gestural and frenzied but atmospheric and virtually formless. What forms they had were feathery and soft and looming. Rather than form his paintings emphasized colour.

These colours could often be amazing to the eye — really odd and striking and in great expanses: plum, magenta, purple, brown, silvery-white, heavy yellow, strong blue. White that billowed or misted or frosted or flashed, or lay dense like snow. All sorts of blue tones, inky to milky. Nameless tones. Greys. Blacks of all different kinds — harsh, charcoaly, stormy, crisp, hard, terrible, subtle. Really odd combinations of colours shining through each other — like magenta shining through brown. And sudden steady expanses of strong mid colours all banked up solidly almost like Pop art — red, orange, blue, white.

But rather than colour, Rothko said, his paintings emphasized the Void. The Void with all its dread. It would be a mistake to see only colour relationships there, he said.

The spirit

Rothko was a deeply spiritual man. Malevich seems marvellous now, when we notice him, because he was spiritual too. But the Spiritual eighty or ninety years ago is different to the Spiritual now. It was a time when seances were still a craze and there was a belief in ectoplasm. And spiritualists used early phonograph

Rothko in his studio 1964

recordings to fake the voices and moans and groans and mutterings of departed spirits. It was the age of the locomotive and the aeroplane and the early telephone probably, too. So the spiritual had all that to be the opposite of. What was it the opposite of thirty or forty years ago?

For Rothko, spiritually wretched in the 1960s, drinking heavily and taking medication for his depression, the Spiritual was different as well. It was the age of Andy Warhol. Rothko was appalled by a lot of modern art. The way it was going. When he passed Warhol on the street one day in the early part of the decade, he had to turn away. The sight was too horrible for him. He couldn't bear the Pop glare. He wanted the murky Void with all its doom.

The blank orange of Warhol's big disaster diptych in the Museum of Modern Art in New York: one canvas has the repeated car crash silk-screened in black over orange but one canvas is just the orange. Warhol's mass media Void. It's probably not all that different to Rothko's solemn Greek tragedy or Old Testament Void.

The blank redness of the Rothko nearby. There's not much to say about it. It's not the red of Matisse's *Red Studio* downstairs. But it's not that different either. Except there's no studio in it. Just red. And the idea of Rothko's studio. Gloomy. Filled with Rothko's depression, his sense of timeless tragedy. And his own tragedy, which he experienced in real time, of no one seeming to feel all that tragic any more.

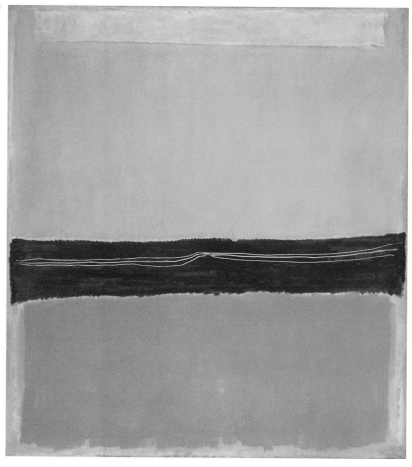

Mark Rothko *Number 22 1949*

And we've given him the job of being our tragic artist of nothingness. We will never say, well this Rothko's maybe not much good. That one before was better. Weighing them up like that would be churlish or pedantic or presumptuous. It would be a sacrilege anyway, because that's the way we believe in Rothko. It's our generosity toward him. Which we don't quite have for Warhol because we feel Warhol can take his knocks even in death.

The end

Rothko's strong colour period lasted about fifteen years, from the end of the 40s to the mid 60s. His paintings from the last part of the 60s are generally dark with less contrasts of colour. His most famous dark paintings are fourteen virtually all-black paintings completed in 1967 as a commission for a chapel in Houston. He did some other really murky maroon ones for a restaurant in 1959 but then changed his

mind and they went to the Tate Gallery in London instead. But his chapel paintings included his first true monochromes. Some have faint frame shapes three inches or so wide showing through the black – or seen the other way around, the shape of a huge rectangle of black floating in a void of a slightly different black. But the others are only black with no differentiations of form, however slight. In 1970 he committed suicide. His absolute last paintings were just flat sections of grey and black, artless and plain.

No to nothing

The Rothko Chapel is still there. Over the years it has become a centre of vague New Age religion, or religion *Lite*. It is a real chapel where people go to meditate or get married or just flop around outside on the benches – the flotsam and jetsam of modern society seeking a place to flop. Inside, there are Bibles and Korans instead of art catalogues. The paintings are hung as Rothko arranged them using a scale model in his studio, surrounded by his mixtures of tempera and size and his six-inch brushes and his packets of powdered pigment. He never saw the finished paintings installed because they didn't go up until a year after his death.

'There is no such thing as a painting about nothing,' Rothko said. And these ones are arranged around the octagonal central space of the chapel in giant looming threes and singles, suggesting holy trinities and Supreme Beings, maybe even symbolic crucifixions.

Rothko was outrageously over-fruity and grandiose in his statements about art and religion and the solemn importance of his own art. But actually the feeling here is not all that oppressive or laughable but sympathetic – black paintings, high ceiling, stone walls, prayer mats, unpretentious people with rucksacks standing around quietly in the dark calm.

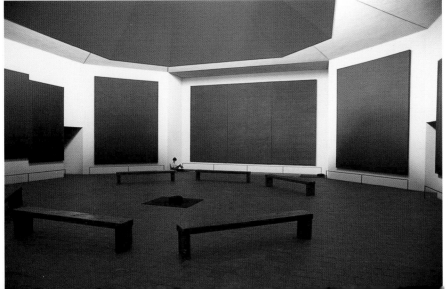

Rothko Chapel, Houston, Texas

Yves Klein
Leap into the Void 1960

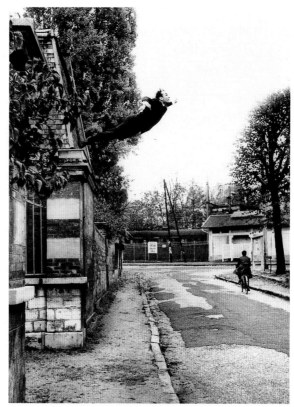

Judo mats

The French artist Yves Klein is famous for paintings that were all blue. He painted blue monochromes in the mid-1950s and early 60s. He used a blue which he patented himself under the name IKB, or International Klein Blue. The blue was symbolic of the Void. Klein advocated a theme of immateriality. His void was far from Rothko but it wasn't far from Malevich. It too was arrived at by passing through a zero zone: 'Having rejected nothingness,' Klein wrote, 'I discovered the Void.'

When we find ourselves in an art gallery today, frowning into one of Klein's strange, erotic, round-cornered, textured, densely blue monochromes, we see our own contemporary selves. Partly because we see our own reflection clearly frowning back at us in the Plexiglas glazing that typically encases them. But also because Klein was an extremely theatrical and literary artist and an inspired performer, as well as a visual sensualist. And he seems a lot like Andy Warhol or Gilbert and George who we also feel quite comfortable with. We feel in tune with them and their fake selves more than we do with Rothko, with his flayed self and his bleeding moaning all the time.

Yves Klein *IKB 79 1960*

Klein's blue is almost always textured, but the texture isn't tortured Modern art texture but rollered-on texture, obvious and light. It is at its craziest when the texture is exaggerated by the addition onto the already textured surface of real sponges soaked in IKB. Klein lived his whole life as an artist as a play. He called himself Yves Le Monochrome. And he tried to teach himself to levitate. He had an approach to art which can seem childish. But he was an intellectual with an elegant and forceful prose style. So he wasn't just an irritating Peter Pan figure who you could feel like punching – or shouting at them to join the army.

As a child he could believe in Modern art but it didn't have to be on Modern art's terms. It could be on his own monomaniac terms. All systems of knowledge went into his system of belief – the system of Modern art but also the system of alchemy and the system of Judo. He really was a Judo expert, earning his Black Belt at the Kudokan Institute in Tokyo in 1953 and teaching Judo in Paris for five years. And he was a member of the secret society of Rosicrucians and an initiate into the Holy Order of the Knights of Saint Sebastian. He believed he had made the sky into a blue painting and that he would fly behind it and sign it.

In one of his manifestos he announced that 'birds must be eliminated' for the crime of flying into his greatest painting – the blue void of the sky – and 'boring holes into it.'

He had himself photographed apparently leaping from a tall building into the street, as if into the Void. It was called *Leap Into The Void*. He lectured at the Sorbonne on 'The evolution of art toward the immaterial.' He sold Zones of Immaterial Pictorial Sensibility but he would only accept pure gold as payment. Offered ingots, or gold leaf, by collectors, he threw the gold into the Seine in a special ceremony, and burned the receipts from a receipt book he had specially printed – they read: *Received XX grams of pure gold against one zone of immaterial pictorial sensibility.*

He put on a show called 'The Void,' which was an empty gallery with white curtains and an empty vitrine. He composed a monotonal symphony called *Monotone – Silence – Symphony*. A lot of instruments playing a single chord followed by a silence. And he made paintings with a flame-thrower, with a fireman standing by. Plus he made a wall of blue flames using gas burners, with the collaboration of the gas company.

Climate of flesh

As well as densely textured IKB monochromes painted with rollers, or covered with sponges, he produced a series of *Anthropometries*, which were paintings of flying blue bodies – sometimes gold – in a white space, made by imprinting the IKB-smeared bodies of nude models onto canvas. Klein said it wasn't at all the shape of the body that he was interested in, because that would be mere illusionism. But only 'the essential, pure, affective climate of the flesh.'

Yves Klein
b Nice (France), 1928;
d Paris (France), 1962
Klein was closely associated with Nouveau Réalisme, but his anti-traditionalism was filtered through a spiritual vision. After extensive travelling in his twenties, including a year spent mastering judo in Japan, he returned permanently to Paris in the mid-1950s. The textured, monochrome canvases made at this time virtually denied their own existence by blending with the wall. In 1958, he developed this idea by exhibiting an empty gallery – the 'Void' that was to preoccupy him throughout his short life. His Rosicrucian theories on the cosmic energy of colour eventually led to the exclusive use of his trademark 'International Klein Blue' in monochromes and works using natural sponges. In the *Anthropometries* (1958–60), he made imprints on canvas from the bodies of naked women covered in blue paint. This live work exemplifies not only Klein's provocative showmanship, but also his interest in ritual, activity and process. Similarly, the *Cosmogonies* of 1960 reached completion only by exposure to air and water; the *Fire Paintings* were made with a blow-torch.

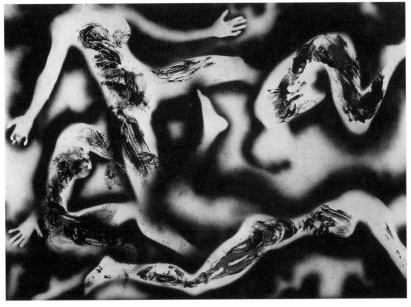

Yves Klein
Untitled Anthropometry 1961

When he began them in 1957 they were made in his flat in Paris. It was a small one, in rue de Campagne-Prèmiere, a street now famous for its cultural associations: Modigliani had lived at one end and Trotsky had briefly stayed at the other. Marcel Duchamp lived in the Hotel Istria, there, for three years. And Jean-Luc Godard filmed Jean-Paul Belmondo's death scene in *Breathless* there. In fact during the filming, Belmondo and Godard visited Klein and had a look at his work.

Klein would roll up the carpet and get out the painting materials and the female models would work with him in a process that was, at least in part, a genuinely collaborative one. They had to do a kind of method-imprinting, rather than just a deadpan imprinting – they really had to believe in their imprinting.

When the *Anthropometries* first started to be shown, they were the subject of rumours and scandal. Klein's response was to ritualize the process. He tried out a semi-public performance first and then a fully theatricalized event in a gallery.

This time the event was filmed, with some of the footage later turning up at the Cannes film festival in the movie *Mondo Cane*. Which unfortunately was a rubbish film about saucy goings-on in a plastic version of Bohemia. And not at all the dignified poetic drama Klein had imagined when he agreed to collaborate with the film-maker.

Don't do it women!

When this old footage is shown as it sometimes is on TV in art programmes, most viewers now are appalled at the sight. The audience of Parisian toffs is all lined up in rows on chairs, wearing formal outfits; a posh orchestra plays the monotonal symphony; and Klein in his tuxedo looks like Alain Delon at an outrageously offensive

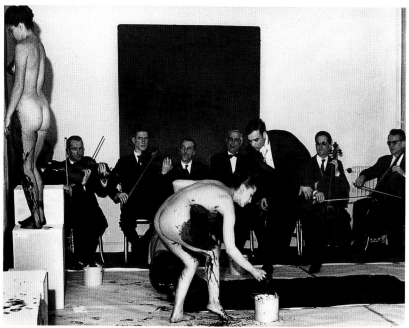

Yves Klein painting models in
Anthropometry performance in Paris
1960

1960s art event. The nudity of the models is shocking compared to the stiff overdone evening-wear of everyone else.

'Don't do it models!' we cry out – 'Liberation is just around the corner!'

But they go on smearing their strikingly voluptuous forms with the blue mud – which in the black and white film, of course, is black mud. And Klein, up a ladder, directs them with imperious arm gestures where to roll and squirm on the virgin canvas. Lengths of which are spread out on the wall and on the floor.

'Oh OK then. If you must!' we sigh – 'But we're turning away!'

Ascent into the Void

But really this sequence is a comic-tragic example of the way you can never really control the discourse of art. Klein was an artist of the Void and all his activities were directed toward expressing the poetic meanings of the Void. Anthropometric art was art about a poetic principal of Voidish celestialism meeting a poetic principal of flesh. When he saw this footage – which he felt would be a vindication of his seriousness – used as farce in *Mondo Cane*, he suffered the first of the three heart attacks that led to his early death at age 34, in June 1962.

Klein's *Anthropometries* were meant to be ritualistic, technical, aesthetic paintings. Bodies dissolving in a celestial blue. The year he started making them was the year Yuri Gagarin first circled the earth. 'It's blue,' the Russian cosmonaut reported back to earth, on his crackly radio. 'An intense blue.'

Extremely foreign

When some of Klein's works were shown in New York after his death, Donald Judd, who was earning a living as a reviewer, was the only one there to give him a good one. In New York, Klein was thought to be merely an artist of shenanigans. But Judd, himself a fierce opponent of shenanigans, nevertheless was impressed by Klein's textured monochromes. He said they were simple and broadly scaled and thus related to the best new American art, as he saw it.

But what he found 'extremely foreign' was the 'unmitigated, pure but very sensuous beauty' of the blue monochrome. He suggested a parallel in Ingres' painting, *Turkish Bath*. 'There is nothing which objectifies or mitigates the pungent beauty,' he wrote, 'but its difficult strength.'

This was a striking type of language because the new American art that was rising up at this time was nothing to do with beauty and nobody much used that word; if they did it was to disparage not to praise.

But Klein's theatricality and old-style avant gardist manner was difficult to take in New York in the 60s. It was intellectual in a completely alien way – seriousness just wasn't signified in this way. You just didn't behave like that.

When he exhibited there in 1961 he had a manifesto distributed to explain his paintings, which he'd written in the Chelsea Hotel. In it he listed all his exploits of the last fifteen years in quite literary language and then distanced himself from all associations of American Action Painting. He said he kept as far away as possible from all messiness. He preferred to wear his tuxedo and white gloves instead. Then, warming to a theme of outrage, he said morbidity, graves and tombs now interested him and the next phase of his art would be cannibalism.

Avocado El Dorado

Jonathan Richman and the Modern Lovers was a proto-Punk album that came out in 1976. I bought it when I was at art school because of the name – The Modern Lovers. It was already making a good statement. Track Four was called *Pablo Picasso*. It just droned on in E minor without any complicated chord changes or any changes at all. The words were intoned rather than sung. The verses were about Picasso's effect on women. *He was only five foot three*, the words went. *But girls could not resist his stare. They turned the colour of an avocado when he drove down the street in his El Dorado.* The chorus went something like, *No one ever called Picasso an asshole – not in New York!* With a variation that went, *No one ever called Picasso an asshole – not like you!*

I didn't know it at the time but this was the sound of Post-Modernism. Picasso doesn't really rhyme with asshole. And of course he never went to America, he was much too arrogantly European. And he couldn't drive. And was he really only five feet three? In fact the song is all lies and the words are deliberately empty, deliberately meaningless. Meaning was somewhere other than in the meaning.

Peter Halley
Glowing and Burnt-Out Cells
with Conduit 1982

The problem-maker in your head

Post-Modern art of the 70s and 80s was an art where all the old meanings were drained out. It was art of radical draining leaving a lot of baffling blanks. It was nothing like Picasso but very much like *Pablo Picasso*. Lots of new art forms came out which just seemed to recycle older art forms. Even Non-Objective abstract art made a reappearance. But the meaning was always somewhere other than what seemed to be right there in front of your eyes. Just as it was with recycled Rothkos.

Abstract red squares in the paintings of Peter Halley, for example, were not the Void any more, or a peasant in two dimensions, but only cynical blanks or psychological prison cells. Recycled Op Art swirls in Philip Taaffe's paintings were not seductive visual explosions like a Modern version of Impressionism, as they had been in 1962, but signifiers of the death of meaning and the end of history. (In the 90s they would be recycled again by Chris Ofili and then they would be recycled Philip Taaffes as well as Bridget Rileys.) And Seduction itself was a menacing abstract force that now ruled the world, controlling and manipulating highbrows and barbarians alike, in a unified environment of rising psychic poison. Apparent meanings were wrong and real meanings were baffling, because the real meanings

were anti-canonical and most people weren't even sure what the canon meant yet, let alone the anti-canon. Meaning meant nothing and nothing mattered. But now Nothing mattered in a traumatized Post-Punk way, not in a spiritual or celestial or tragic or even Minimalist negative space way.

And not even in a revolutionary way, since there was nothing to revolt against – not even yourself, in a 60s or 70s self-awareness way – because the problem was not you but the problem-maker in your head.

'Phew!' everyone thought at last – 'What about having our meanings back?' But they couldn't have them back, because they didn't mean the same any more. The old meanings were dead meanings. To bring them back would be to bring back zombies.

Depressing joy division

In a bright white studio in East London, Glenn Brown, an artist in his 30s, who sucked in 80s blankness like mother's milk when he was at art school in that decade, paints a stunningly detailed copy of the nineteenth-century German Romantic painter Arnold Boecklin's *Island of the Dead*. There seem to be even more details than in

Glenn Brown
*Searched Hard For You And
Your Special Ways* 1995

Peter Halley
b New York, NY(USA) 1953
Peter Halley has been called the 'chief theorist' of Neo Geo, a cool, impersonal tendency that emerged in New York in the mid-1980s as a reaction against the emotionalism of Neo-Expressionism. He cites his inspiration as a combination of growing up in Manhattan as it developed into a grid of office towers, to the influence of Albers at the Phillips Academy in Andover, to the New York School of the 1950s, and the works of Guston and Baldessari. Characterised by Day-Glo colours and synthetic Roll-a-Tex surfaces, his large geometrical compositions are parodic, Post-Modern critiques of transcendental artists like Ryman, Newman and Rothko, whose evocative forms he translates into mechanistic conduits ('I've taken Newman's zip and made it into plumbing,' he has said). But these schematic diagrams aim to put the content back into formalism. Not simply abstract images, they are repre-sentations of spatial experience, showing that abstraction can also function on figurative, political and symbolic levels. And while the recurrent presence of cells in his work equates ideal geometry with prison, the Day-Glo conduits and arteries suggest communication and energy, piped into these systems of isolation and control.

Glenn Brown in his studio 1998

the original. Now all the wriggling sheens, arbitrary lights and darks, and new colours of the reproduction from which the new image is being painted, are details too.

He has painted copies of Frank Auerbach and Salvador Dalí as well, and de Kooning and the works of a 70s cult science fiction illustrator. He gives the re-done versions new titles which are often grimly comic, or camp, like the titles of 70s cult horror films. For example, *The Living Dead* is the new title for a re-done painting by Auerbach, which had originally been titled just with the initials of Auerbach's sitter. But now Auerbach's gouged expressionist surface has a new meaning, of creeping mutant flesh. Another painting is Brown's upside down copy of a beautiful face painted by Fragonard. Its new title is a line from a depressing Joy Division song – *Searched Hard For You And Your Special Ways*. Perhaps it is appropriate that this song was recorded in 1980 – the dawn of the dead.

'I'm just using the contemporary landscape,' Brown says, about his use of art that was made originally by someone else.

His studio is a conventional one, with lots of tiny brushes and tubes of paint and little jars of turps and medium. And his work as an artist is not mechanical or without feeling. Or it may be a bit mechanical but there's a definite feeling. It is the feeling of being alone in a studio, taking a very long time to paint something, living an unhealthy inward-turned, isolated life with long stretches of boredom. The feeling is expressed right there in the exaggerated hyper-detail of the brought-back-to-life paintings.

'The exaggeration comes from the colour. It's hyped-up colour, so it appears drug-induced, acidic. In my best paintings the colour is almost as if the painting's gone off. It's decaying. It was fresh once.'

It's an odd new nothingness. His paintings are so full you'd think this would be the last place to find it. But they're full of something that already exists perfectly OK somewhere else. It's the opposite of Robert Ryman, for example, who makes much out of little – the opposite turned inside out as well and with all the oxygen taken out. On he works, a figure at the end of a white space, painting a painting that doesn't need to exist again.

Very new monochromes

In another studio, Jason Martin paints a monochrome. The canvas is huge. There are many hundreds of pounds worth of oil paint on it. The paint was scooped out of big tins of different colours and then mixed up in a big plastic bucket to make a mass of strong deep blue. Then the mass was knifed onto the white canvas in gloops and the gloops were smeared out. They had to be plastered over the white so it would be covered more or less evenly with no bald patches. Then a long length of metal, like a metal comb, was dragged across the surface of the paint, scoring deep grooves in it. It was dragged back and forth again and again. For hours. It was exhausting to see it. After that, the painting was finished. And now there it stands. The formerly gloopy matter is now a single balletic movement of matter, extremely satisfyingly grooved, in a wave movement, across a wide deep surface.

'What you see is what you see' was a maxim of Minimalism in the 60s. There wasn't anything other than what you saw, was the idea. So what you saw had to be very particular and you had to be particularly careful to see it in the right way and not be looking for something else, because Minimalism wasn't anarchic and free but rigid and with lots of rules. At least, that's what was thought after a while, when a reaction against it set in. But now some of the rules are fine again. And they can be mixed up with other rules too.

The surface of this new monochrome is a record as well as an expanse of inert matter – the movement of the metal comb records and documents the movement

Glenn Brown
b Hexham (England), 1966
Glenn Brown studied for his MA at Goldsmiths, London in 1990–2, and his witty theoretical work reflects the intellectual aesthetic emerging from this influential institution at the time. Appropriating and ironically renaming iconic paintings from the canon of Modern art – Auerbach, de Kooning, Karel Appel – he presents exact copies using a tiny brush, which reduces their textures to a completely flat surface, like a colour photograph. This playful enquiry into authenticity, authorship, and celebrity hit the nail directly on the head when in 1994, in the exhibition 'Here and Now' at the Serpentine Gallery, his works were excluded from the show when the Dalí Foundation threatened to take legal action over the unauthorized use of their images. Brown began by making *trompe l'oeil* representations of the moon's surface, but found the results 'too rich in romantic meaning'. In recent works such as *Jesus; The Living Dead (after Adolf Schaller)*, 1997–8, he avoids this problem by reproducing on a billboard scale a scientific rendering of a planetary surface by the American commercial artist Adolf Schaller.

Jason Martin
Untitled (jet loop paint #6) 1997

James Turrell
b Los Angeles, CA (USA) 1943
Turrell sculpts with light, making
it seem almost tangible. An
experienced pilot, his vision is
influenced by the big Californian
sky and by Eastern traditions
such as meditation. After studying
for his degree in perceptual
psychology at Pomona College
in 1965, he began to make light
sculptures using flames. The
current works can be separated
into four categories: the *Projection
Pieces* in which precise rectangles
of light are created through
high-intensity projection; the
Space-Division pieces, where pulsing
architectural chambers hold hazy,
atmospheric light; the *Dark Pieces*,
so dim that artificial light can
barely be distinguished from
the natural light generated in the
retina; and the *Skyspaces* – knife-
edged apertures into open sky
that make light seem like a film
of intense and ever-changing
colour, seemingly stretched across
the opening. Turrell's ambitious
work-in-progress, the *Roden Crater*
project in the Arizona desert,
incorporates all four types.

of the artist's body through space. 'So what?' we might say if we weren't artists. But to artists, it's an important idea from the 60s. Something to do with some rule or other from then.

The thoughts stopping

Jason Martin, a London artist still not yet thirty, does matter without spirituality. It might be thought of as having spirituality. But at the same time it wouldn't matter if it didn't. James Turrell, a minor American Minimalist from the 60s, who has become the undisputed leader of radical insubstantiality in the 90s, does spirituality without matter. His art is just planes of coloured light. Every installation is a different experience of light. If it's in a gallery it might be a wall of red light, with the light shone by projectors. Or a blue light. Or it might be a tiny spot of light in a black space that you have to wait in for a long time before anything happens. Feeling a bit claustrophobic. Or if it's not in a gallery and it's natural light, then it might be the vast natural light of the night sky in the open desert in Arizona seen from a crater and you have to make a heroic pilgrimage to get out there.

Meeting is a new work by Turrell at a big public art space in New York. It is a square minimal section of bright white space. A square of natural light from the sky. You go into a room and the atmospheric Minimalist square is above you. Maybe

Meeting is a meeting of atmosphere and mind, or the rational and the irrational, or some other spooky dichotomy. Maybe to section off a misty atmosphere in a geometric square is Caspar David Friedrich *Lite*.

The room itself is square-shaped and smallish. A wooden bench goes right round all four walls, stopping only at the door. You come in, look up, sit down. Time passes. You find yourself now lying back and looking up. It's the natural elements. You feel like a child. The sky gets darker and the white becomes blue and then bluer and the ceiling around the square gets correspondingly yellower.

What happens when it does that? Some spacing out. The sound of your own breathing. It's like transcendental meditation. We're probably going to fly in a minute. The minutes are very long. What else? Well, we're just lying here. We don't reject the spectacularization of all experience. We love it. We can see it happening – a square going from blue to black. The mind blowing. The chapter coming to an end. The thoughts stopping.

CHAPTER FIVE

HOLLOW LAUGHTER

Piero Manzoni
Artist's shit No 068 1961

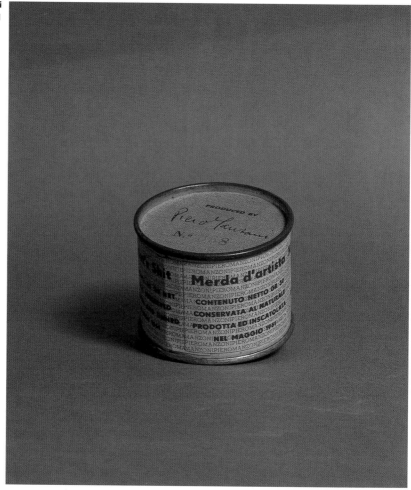

Modern art jokes

There are many jokes in Modern art. They are never all that funny. They often put people off. They often express self-hatred or sarcasm. If Modern art was a big communications company and there was a big shake up of it, to make it perform better, the jokes would all be called in to do a consciousness-adjusting course. On it, they'd be asked to think of Modern art as a person: 'There's no room for nasty people in Modern art,' they'd be told. Or they might be told to think of Modern art as a washing machine: 'It has many settings. You're only used to using two or three. Try some of the others.'

Top of the Pops

If a Top Ten of Modern art joke types were compiled, number one would certainly be jokes that are either outrageously obvious or outrageously obscure. Or both. The illustration for this type would be Marcel Duchamp's urinal. Marcel Marceau, as opposed to Duchamp, could stand on a French stage and easily mime the other nine types. They would include: No.2 (ha ha!): jokes about shit. No.3: jokes about sex. No.4: jokes about bottoms. No.5: jokes about ivory towers. No.6: jokes about any old rubbish. No.7: posh jokes in French, often based on asinine puns or word plays. No.8: jokes about the mystery of language (related to the last type but more mysterious). And No.9: Zen jokes. The tenth category might be the repetition of No.9 in a droning, annoying way, like the repetition of the words 'number nine' on *Revolution Number Nine* by The Beatles, which was influenced by Yoko Ono, who was a member of the Fluxus movement.

Two jokes

I went to see a psychiatrist. He said tell me everything. I did and now he's doing my act. This was a line written on a piece of paper by the artist Richard Prince, in 1985. It was just a joke copied from a joke magazine. He wrote it out, dated and signed the paper and then sold it as art for a small sum. Ten dollars. It was called *Untitled*. Then he wrote down another one and sold that one too, but this time for twice as much. Then he did it again and again.

Yoko Ono
Fluxfilm 1966

Richard Prince *Untitled* 1985

> I WENT TO SEE A PSYCHIATRIST. HE SAID "TELL ME EVERY THING" I DID AND NOW HE'S DOING MY ACT.

An index finger points upwards from a sculptural plinth, painted white. The finger is a cast of a real finger, done in wax. It is an artwork in a gallery. The title is *Receptacle of Lurid Things*. The artist is Sarah Lucas. It's the early 90s – that's when it was shown at the Saatchi gallery in London. Maybe it's a finger giving the finger to the world. What would the lurid things be?

Not even funny
Is the world the receptacle? Maybe it's the gallery. Wherever the finger goes on show, maybe that's the new receptacle. If Saatchi sells it in one of his sales, maybe whoever buys it and puts it in their living room will be sitting in a receptacle now. Maybe that's the joke. It's definitely different to the psychiatrist joke. Maybe it isn't even funny. Or not even a joke.

Not funny either
The psychiatrist joke might not strike everyone as funny either. In itself it might not be all that funny and many people might find it even less funny in a gallery. 'An art gallery is no place for jokes!' they might exclaim. Maybe they are psychiatrists themselves. Or they were having some psychiatry that morning, before going to the gallery. And this joke might have touched a raw nerve. Even more so, if they were stand-up comedians. But then, of course, they'd just make a joke about their pain.

Bad bourgeois
We assume all Modern art jokes target bourgeois people. But we are never all that sure of our ground. Who are the bourgeois? They change all the time. We praise them for having a French revolution but we despise them for being uptight and a drag.

Sarah Lucas *Receptacle of Lurid Things* 1991

Obviously Modern art jokes target the second type more than the first one, we assume. If we use the word at all to describe something, we will always be meaning something bad. But at the same time we will know we are bourgeois ourselves because today there is little resistance to a basic bourgeois outlook on everything.

A basic bourgeois value is that everybody has something mysterious and ineffable deep inside themselves that they could express if they were artists and if they weren't artists they could feel it being expressed by art. This is Romanticism. All Modern art comes from Romanticism but particularly Surrealism. Surrealism is vehemently against bourgeois consciousness because it is merely a tissue of lies. That's the idea today too. If you don't get it, the thought goes – in connection with some joke or other in Modern art – you are bourgeois. Even though you are bourgeois anyway.

Oppression

It is not true that the bourgeois class is now the only class. We all aspire to bourgeois values but we are still divided up into classes. Slaves and masters. Workers and bosses. The bourgeois are still basically the bosses. It is right to give them the finger. Therefore, Sarah Lucas's *Receptacle of Lurid Things* could contribute to a sudden awareness of class consciousness on the part of arty people within the bourgeoisie. Someone could argue that. They might find it harder to argue the same for the sculptor Anish Kapoor, though, because he seems so posh on the telly.

The media

Media people who comment and bray about art are, of course, dreadful foes of the proletariat because they are so weak and slippy-slidey. But they are not the ultimate foe. The ultimate foe is the oppressors. The media people work for them. But they could just as easily work for the workers and help overthrow the oppressors. They have bad faith though. And they don't have class consciousness. They laugh about all that stuff and they don't think anything bad will ever happen to them.

The Surrealists and the Situationists

Today, Surrealism seems the safest of all the dangerous art movements, the one least likely to cause offense. It is more or less laughable to think of the Surrealists ever bringing down world capitalism. We may as well admit that it is laughable too to imagine the Situationists ever doing it either. 'What? Have you forgotten the *evenements* of 1968!' Er, yeah, on the whole, we have. We have to remember them all the time, of course, because they are on TV all the time in documentaries about art or about ancient influences upon Punk music and graphics and fashion.

But we don't think of the paving stones coming up and the police batons coming down and the Renault workers and the black polo-necked students standing side by side and making capitalism tremble briefly, as much more than a photo-opportunity any more. So in a sense we have forgotten them because they are not inspiring.

Psychogeographic map c. 1960

For this is the terrible prophecy of Situationism coming true in our time – illusionism and cynicism and slavery and photo-opportunism going on and on and never ending. We don't care though. In fact we enjoy it. And that's the thing it didn't prophesy.

Situationist slogans really were on the walls during the Paris uprisings. *Beneath the paving stones – the beach! Live in free time!* Then in no time the workers were back in the factories and the slogans were on the walls of the Museum of Modern Art in New York.

Alienation

Situationism came out of Surrealism. But it didn't want any more Surrealist art. It advocated a revolution of everyday life. It wanted to get back to something more like Marxism in its early development. Marxism could not literally be got back to because of Leninism and then Stalinism and totalitarianism. And also because Marxism was a nineteenth-century idea of working-class emancipation and it was no use trying to make a nineteenth-century idea fit 1950s conditions.

What Situationism wanted to get back to, or to redo, was Marx's view of alienation, and Marx's famous line: 'All the time and space of his world becomes foreign to him with the accumulation of his alienated products.'

Bad fake world

The Situationists believed in an evil called The Society of the Spectacle. They believed it had to be got rid of. The Spectacle was what the new consumer society offered. From a Situationist point of view, consumerism offers lots of consumer

Détourned comic strip c. 1960

products as a substitute for real experience. Thus it offers lies instead of life and it is a bad fake world constructed upon the real world. It offers nothing but desires that can never be satisfied.

The reason for the existence of the Spectacle is to give the slave class an illusion of freedom. 'Take this illusion,' the boss class says, 'and don't worry about all that freedom stuff.' But really it is only freedom to buy more rubbish and to feel dead instead of alive. The Spectacle's lies infiltrate consciousness, making all consciousness into lie-consciousness.

To combat the Spectacle, the Situationists advocated setting up temporary situations as a new form of art, or as a substitute for art, or as something not quite art but definitely replacing art. The *dérive* and the *détournement*, Psycho-geography and Unitary Urbanism – these were the special names the Situationists gave to the things they did; which included walking pointlessly, reversing or upsetting meanings, making maps that were nonsense and having a revolutionary attitude toward architecture and public spaces.

The Situationists combated *arrondissements* by dividing the city up into emotional *quartiers* instead. Instead of conforming to the laws of the Post Office or the traffic police, the new made-up city sections would now have their own emotional laws, their laws of *ambience*, which existed only in the heads of Situationists.

The Situationists went on long walks throughout the city and they produced psychological maps that documented their moody travels. And they scrambled and turned around the meanings of the Spectacle by doctoring its language and imagery. They did this mostly with Situationist films and Situationist comic strips. They put reality-invoking Situationist slogans in them instead of the lies of the Spectacle – lies that only mollified or nullified. For the raw material they used bits of existing films and existing comic strips. This was the origin of Punk slogans in the 70s, composed in blackmail writing.

Spontaneity

With Situationism, jokes and jokiness were important because they were connected to spontaneity. Spontaneity was important because feeling and emotions were important. They had to be systematically monitored though. And there was something grim and mad about this aspect of Situationism. It is good to scandalize or slightly terrorize the bourgeoisie with *dériving* but it is bad for your documents recording your own self-monitorings to have to be handed in on time to a rigidly controlling leader.

Reasons to be expelled

Objects were out. So it was impossible to have a Situationist painting, say, or sculpture. It wasn't completely impossible because there are such things and they still survive today but their creators were expelled by the leader of Situationism. Expelled Situationists might form their own splinter groups but then they were just considered to be advocating second-class theory by the main group – they were unrevolutionary and merely artistic and they were unintelligent.

Life lived graffiti, Paris 1968

George Maciunas
b Kaunus (Lithuania), 1931;
d Boston, MA (USA), 1978
Maciunas founded the radical
movement, Fluxus, in 1963,
coining the term from the Latin
word for 'flowing'. Its ethos was
that anything can be art and
anyone can make it, and its
activities embraced photography,
street art, poetry and Happenings.
Maciunas is often described
as a clown, or jester, though
his revolutionary ambitions were
deadly serious. Plagued
throughout his life by illness,
he nevertheless energetically
provoked controversy, losing
an eye in 1975 when a group
of 'Mafia thugs' attacked him
for alleged non-payment of debts
on his Fluxhouse Co-operative
Building project, which instituted
artists' lofts in Soho. He also
embarked on a lengthy
'Fluxcombat' with the State
of New York, incurring many
arrests and subpoenas, to which
he responded with insulting
letters and photographs of
himself in a gorilla mask. He
had emigrated to New York
in 1948, studying design and
musicology, both of which
would remain central to his
Fluxus Festivals – literary and
musical events with John Cage,
Yoko Ono, and Joseph Beuys,
amongst others. From 1965
he shifted emphasis onto
publications, 'Fluxfilms',
multiples and installations.

The leader of Surrealism, on the other hand, would only expel you if you betrayed Surrealist principles by, for example, making some art which expressed a lack of amazement at the marvellous, or which expressed a belief that the conscious mind is better than the subconscious mind. But you couldn't be expelled just for making art at all.

Nevertheless, Situationism was like Surrealism in that with both movements there was a paranoid climate and a terror of weakness or badness breaking out within the movement and thus delaying the revolutionary process that the movement was a catalyst for. So there had to be purges.

Three leaders

André Breton was the leader of the Surrealists. Guy Debord was the leader of the Situationists. An off-shoot of both Surrealism and Situationism was the Fluxus movement, led by George Maciunas – another charismatic leader who also was notorious for having mad purging fits.

Fluxus was anti-art. All its manifestos were against it. Like Situationism, it was for some other kind of thing that was still creativity, but which would go on in the streets and in people's houses instead of in galleries and museums. It was full of light-heartedness. Maciunas was full of good humour and jokes and he frequently displayed a Zen attitude toward existence. In his last interview, conducted on his deathbed, when he was asked if Fluxus really was art after all, he said, 'No, I think it's good inventive gags.'

'I make jokes!' he said. But he was known to be an outrageous tyrant and control freak, as well as a Zen-fan, who had to control every detail of Fluxus events and personally design all the Fluxus posters and cards and statements. Or at least see that all such stuff was designed along lines he initiated. And if anyone went off the strict lines they were excommunicated.

Is it odd or inevitable or banal that these Modern art movements, which valued jokiness, should have such angry leaders? Or are all leaders angry?

Typical

A typical Fluxus object is a games box or a puzzle box produced inexpensively as a multiple. It has no appearance of being art at all. But it might contain dust or eggshells or dried up tea bags. Or it might contain a lot of cards with printed pictures of a hand pointing a finger on each one. Or there might be some yo-yos in there, or plastic balls. So its useful function is extremely limited too. There will be a title and a process, some instructions, something to do, something to think about, even if it's just a silly thing. Which it always would be.

The Fluxus movement had members from all over the world, including Joseph Beuys and Yoko Ono. Yoko Ono made films of an eye blinking and bottoms wobbling. She showed a piece of wood with a nail in it and a hammer hanging from the wood, called *Painting to hammer a nail*. And she produced works that were merely

George Maciunas, Dick Higgins, Wolf Vostell, Benjamin Patterson, Emmet
Williams performing Philip Corner's *Piano Activities* 1962

André Breton 1924

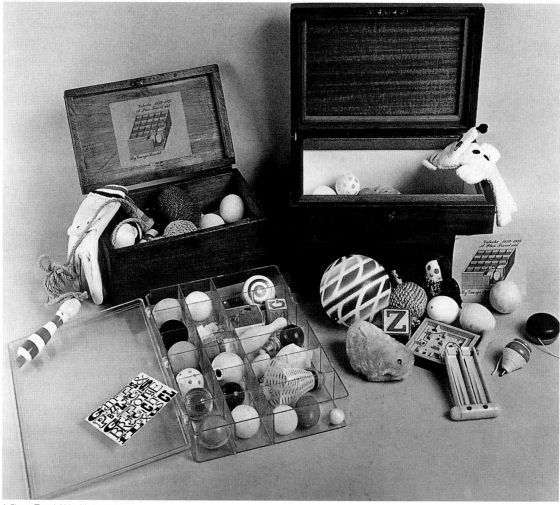

A Fluxus Travel Aid with a prototype made by George Maciunas using a *Games and Puzzles* label c. 1970

requests to imagine something, printed on postcards. Did she really break up The Beatles? Maybe we'll never know. But that's the kind of empty random thought-stream that Fluxus films seem to inspire – the mind zoning out on images of a toilet flushing or an idiotic sign reading *Genius at work* or a TV screen going fuzzy.

Fluxus was about life not art, Maciunas insisted. The artists took bits of life and made them into events. A Fluxus event or happening might be a pouring water event, or making music on a piano with a saw or a hammer event, or a lot of people roped together in the street and walking event, until they fell over as an event.

The lightness of the movement makes it seem odd that there was such an element of rigour running through it and that expulsions and excommunications for the sin

of rule-breaking were so commonplace. But in fact it's not so odd. Fluxus art or anti-art, or whatever it was, was very precise. It was rubbish structured precisely.

Zen v Mafia

Although the Fluxus look and the Fluxus attitude are trendy today, and they run through a lot of the art of well-known art stars of today — and the word 'Fluxus' has some of the same impressive mystery power within a dinner table context as the word 'Situationism' — Maciunas is little known. He died from cancer but his departure was hastened by some Mafia guys who beat him up badly and put his eye out, following an altercation over some building work which he considered to

have been badly done and refused to pay for, which occurred shortly before cancer was diagnosed. A Fluxus principle was that artists should live in communal situations and one of Maciunas's great contributions to the present-day lifestyle of artists was his conversion in the 60s and 70s of many loft spaces in New York's SoHo area into artist's living spaces. So this assault was a rare case of both Zen and avant gardism being defeated by the Mafia.

Guy Debord

Guy Debord is a cult figure and since his suicide in 1994 he has become almost a media star. From 1957 he began to operate Situationism as if it was a sect or secret society and to conduct purges. And in 1972 he dissolved the movement and went underground and was hardly seen or heard of again until twenty years later. In 1992 he wrote a new preface for the third edition of his famous book, *The Society of the Spectacle*, which was first published in 1966. In it he stated that everything the book had claimed and prophesied was true. The only difference was that with the fall of the Berlin Wall in 1989 the Spectacle was now an 'integrated' Spectacle and it seemed even more unlikely that it would ever be defeated.

André Breton

André Breton is a well-known art historical figure but for many people there is something boring about the mention of his name and they find themselves glazing over when they hear it, or see it written on the page. There is hardly anything he was famous for doing which seems all that interesting now.

He was a writer and a poet. He was a doctor in the First World War and he was interested in madness. He met Freud. He wrote a book called *Nadja*. He wrote the first Surrealist manifesto in 1924.

Only two interesting things

Interestingly, like Marcel Duchamp, Breton made a living from dealing in art for a while and in fact it was him who brokered the sale of Picasso's *Les Demoiselles d'Avignon* to the Museum of Modern Art, New York. Why this is interesting is because it seems the opposite of revolutionary idealism. But it might just seem like only common sense to choose to make money out of something you know about.

But it is also interesting from another perspective, which is that art dealers today are hardly ever intellectuals in reality, as opposed to in their fantasies, or even particularly sophisticated or interesting usually, or much more than quite amazingly thick considering all the Conceptual art they sell. So it's pretty interesting to think of the inventor of Surrealism being one.

Also, Breton conducted some Surrealist discussions about the nature of sexuality, which have come down to us in the form of pseudo-scientific verbatim reports, with earnest inquiries into things like whether Hans Arp had ever ejaculated into a woman's ear.

Guy Debord
b Paris (France), 1931; d 1994
Debord was the intransigent, self-appointed leader of the subversive movement, Situationist International. SI was born in 1957 when the anti-art, neo-Dada group Lettrist International, of whom Debord was a rising star, merged with the Movement for an Imaginist Bauhaus. It reached its high point with a series of occupations (the National Pedagogic Institute, the School of Decorative arts), pamphlets, songs and graffiti during the May events of 1968, disbanding in 1972. Debord's first essay in subversion, *Memoires* (1958), was bound in sandpaper so that it could not be comfortably accommodated on the bourgeois bookshelf. Central to Debord's theories was the concept of the spectacle, outlined in his book, *La Société du Spectacle* (1966), which indicted Capitalism for turning people into passive consumers of the depoliticized media spectacle that had replaced active participation in public life. To Debord, active public participation meant disrupting Charlie Chaplin's press conference at the Paris Ritz and 'hijacking' a priest of Notre Dame so that a member of the group could take his place during Easter Mass to declare that 'God is dead'.

But so far there has not been a way of really getting Breton's story off the ground as far as many people are concerned. They would much rather hear the story of Marcel Duchamp or Picasso, or Jackson Pollock or Tracey Emin, for example.

Of the movement of Young British Art, there is no charismatic leader in charge of purity. A list of principles of this movement could easily be drawn up and offenders against the principles could be isolated and expelled. But it's just not that kind of movement.

Flow of movements

Surrealism, Situationism and Fluxus all flow into Young British Art. Sarah Lucas's *Receptacle of Lurid Things* is a product of this flow. Although if it was taken back in a time machine to the peak moments of the three movements – say, the late 1920s for Surrealism; the late 1960s for Situationism; and the late 60s and early 70s for Fluxus – it would seem out of place. Surrealism would be the least awkward fit, maybe.

It wouldn't fit with Situationism because it is a well-made art object on a museum-like plinth. There would be something a bit too well-turned about it for Fluxus too. The gesture would be right but not the form, because it is realized so roundly and sculpturally.

The title of Lucas's work would fit with all the movements, although it would be quite flowery for Fluxus. It could certainly be part of a Situationist slogan. But the plinth would be the most wrong thing about it as far as Surrealism is concerned. The plinth is from a different flow – the flow of hyper-objects, mock-museum objects, mock-Minimalist objects, that began with the Neo Geo movement of the 1980s. If it was Surrealism, the finger would more likely be on a piece of black velvet, or only viewable through a keyhole.

Wry, dry, etc

Marcel Duchamp was revered by the Surrrealists but he never wanted to join them. He was a one-man art movement. He had various personae, and that was enough of a group for him. One of his personae was Rrose Sélavy, a pun on *eros c'est la vie*. He signed some of his works with that name and he had himself photographed as Rrose, in drag, by Man Ray. Another persona was R. Mutt, the name he signed on his most famous work, which was a urinal. It was a play on Mott, the company that made the urinal, and Mutt, of *Mutt and Jeff*, the strip cartoon characters. R stood for the French slang term *richard*, which means 'moneybags.'

Marcel Duchamp – ironic, laconic, sardonic, wry, dry, a bit austere and a bit erotic. A cool French guy. Never disturbed, always amused, always ready with a sardonic joke. Famous turn-er on-er of the stream of black, off-humour which runs through Modern art and which drives people nuts. It streams from his frightening urinal. The receptacle of lurid urine.

André Breton
b Tinchebray Orne, (France), 1896; d Paris (France), 1896 Breton has been called the 'Pope of Surrealism'. With the publication of his 'Surrealist Manifesto' in 1924, he invented the movement, becoming its chief theorist and promoter, hirer and firer. A poet and essayist, Breton originally concentrated on literature in his writings on Surrealism. However, he had a variety of passions, ranging from Gothic novels to butterflies, and was interested in naive and 'primitive' art, free association, automatism, psychotic painting – perhaps deriving from his work with the insane as a medical student – and the work of the Dadaists, whom he supported through his magazine, *Littérature* in Paris. In 1925, he organized the first Surrealist exhibition, famously attended by Dalí in a diver's suit. His most important statement on art was 'Surrealism and Painting', 1928, which saw painting as a way of releasing one's true nature. In 1927 he joined the French Communist party, and in 1938 wrote the manifesto 'Towards a Free Revolutionary Art' with Trotsky. During World War II he emigrated to the USA, where he belonged to a group of expatriot Surrealists who influenced Abstract Expressionism.

Fountain

Modern art jokes. They're not all that funny. But they are big. And *Fountain* is the first one, the biggest one of all, the unofficial icon of the Turner Prize. Bought from a shop, signed R. Mutt, sent to a big exhibition in New York in 1917, rejected, thrown away, then the next day raised from the dead and preserved forever in the minds of conservatives as the arch icon of the great Satan of Modern art.

'I was really trying to kill the artist as a god by himself,' the Great Satan told Joan Bakewell in a TV interview in the 1960s. It would be outrageous to remind ourselves now of the offensive nickname Joan Bakewell used to have — the thinking man's crumpet — but she certainly was an appropriate choice of interviewer. *Una cosa mentale*, was what Leonardo da Vinci thought art should be — 'a thing of the mind.' And Duchamp thought so too.

Today, *Fountain* lies in storage, in Paris, in the hidden vaults of the Pompidou Centre, the strong walls protecting an unsuspecting public from its full ironic blast. It wasn't actually Duchamp's first Readymade, because he had been producing them since 1913. But the others are not nearly so powerful as icons and they don't have the unique mixture of opposite tones — the cool and brassy — that *Fountain* has.

Do art in

Duchamp shrouded everything in irony, so you couldn't get the meaning straight away, or ever. You could only get intimations of meaning, or meanings. His main meaning was eroticism, it is often thought, based on things he said sometimes. He was always going on about erotic things. He made endless sex puns and saw the erotic symbolism that permeated the world but which no one else noticed, except Freud, who Duchamp didn't want to be psychoanalysed by, because there wasn't anything wrong with him. He didn't believe in psychoanalysis or in God either. And he said he was anti-art too. It was time to do it in, he said, because it had become a cult. So it was the time of the Readymade. Onto the stage it came.

At first it was a joke, then a whole line of works, then a world-shattering paradigm shift. The snow shovel, the bottle rack, the bicycle wheel, the typewriter, the metal comb, the urinal. They weren't from the art world but from the opposite world, the industrial one, the world of mass production — the desert wasteland which art had feared before but which from now on it would feel OK about.

Blankness, indifference, contempt. That's the message of Duchamp's look as he poses for a screen test for Andy Warhol in 1966. Warhol — the artist who said he wanted to be a machine, to have no feelings, to have a factory instead of a studio, to be a kind of robot of art — filming Duchamp — the artist who said anything could be art so long as an artist said it was.

Duchamp said to Joan Bakewell that the idea of Readymades generally was that only a thing he had no feelings towards — or only a feeling of indifference — could be chosen to be one.

Marcel Duchamp
b Blainville (France), 1887; d Neuilly (France), 1968
Duchamp's influence on contemporary art — particularly Conceptual art — is profound. A member of the anarchic Dadaist movement, he disrupted conventional attitudes with such gestures as appending a moustache and an obscene caption to a copy of Leonardo's *Mona Lisa*. More ground-breakingly, however, he entirely redefined the status of the original, unique artwork when in 1913 he began his series of 'readymades' — everyday items such as a urinal or a bicycle wheel, which he displayed almost unaltered in the gallery, claiming that any object is art as long as the artist defines it as such. In 1912 he produced *Nude Descending a Staircase*, one of his most famous canvases, which became the precursor to Futurist works depicting movement in two dimensions. Between 1915 and 1923 he created his monumental glass-and-wire construction *The Bride Stripped Bare by her Bachelors, Even*, (also known as *Large Glass*). Eventually, he gave up art in order to devote himself to chess.

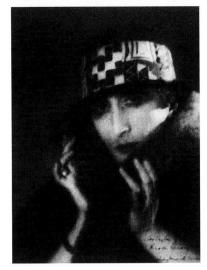

Marcel Duchamp as Rrose Sélavy 1921

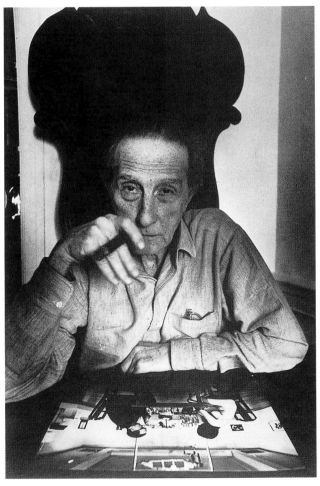

Marcel Duchamp 1965

So it wasn't him who first said his urinal was a beautiful white Modern sculptural object, sleek, shiny, smooth, gleaming, curvy, elegant. But this is how *Fountain* is often talked about now and how it has come to be viewed within art culture. And, yes, you could have all this without any skill, just by plagiarizing – using somebody else's skill.

Art kryptonite

Irony, eroticism, the mind. No need for manual skill of a special kind. Basic manual skill will do and, if need be, no skill too. These are the main themes running through Duchamp's works, a lot of which are housed in the Philadelphia Museum of Art. This is a huge building standing on a steep hill, rather like a tomb from the outside, at least from certain aspects – dark, gothic, Victorian, Edgar Allen Poe-like. Inside, it's like Pharoah's treasures. Except it's not all dark and musty but filled with light and dazzling advanced abstract and figurative Modern art hits. In the furthest chamber, like a nugget of art kryptonite radiating negativity vibes, is the Duchamp oeuvre.

An old American news film from the 40s shows Duchamp in the museum, in his shirt sleeves, smiling, kindly going along with the ideas of the film director. A voice announces: 'In the Philadelphia Museum of Art is a collection of paintings by a man whose unique view of life has greatly influenced Modern art.' Then the shot moves closer onto the figure of Duchamp and the voice says, 'Ah here you are Marcel, looking at your big glass.'

'Yes,' says Duchamp, as if he's in an ad for something. 'The more I look at it, the more I like it!'

Duchamp was already planning this work – the *Large Glass*, or *The Bride Stripped Bare By Her Bachelors, Even* – when he created *Fountain*. The *Glass* is thought to be an allegory of love. A lot of notes were produced by Duchamp to accompany it and to be a kind of guide to the various things going on. The notes are full of word plays, puns and word-associations. The Milky Way, a chocolate grinder, semen, wasps, malic moulds, dust, a polygon of sexual organs, a butter churn – they're all in there. The first three letters of *mariée*, which means 'bride,' is MAR; the first three letters of *célibataire*, which means 'bachelor,' is CEL; and that spells Marcel. That kind of thing is in there too.

Fountain is a Readymade but the *Glass* was very laboriously hand-made by Duchamp over a period of many years. He had already been making or producing or choosing Readymades for four years when he produced *Fountain*, and the *Glass* was a new departure. It was the most ambitious art work he made. Or it came to be seen in this way because it seemed to contain all his themes in an incredibly dense and layered form.

Other works could have the themes read into them. But this one has such a complicated and elegant appearance, it seems to map out the whole Duchamp

Marcel Duchamp
The *Large Glass* or
*The Bride Stripped
Bare by Her Bachelors, Even*
1915–23

vision in detail, rather than just symbolize it – or an aspect of it. But in fact there is no ultimate truth or treasure that the *Glass* is leading to. Because Duchamp was always being so erotic, the ultimate truth of Duchampianism is said by Duchamp scholars to be exactly that – eroticism, but of some special intellectual kind. But Duchamp himself said, 'There is no solution because there is no problem.'

Duchamp said the main thing he wanted from art was that it should amuse him. To do that, he didn't think it necessarily had to have a lot of manual skill. No skill being needed – or not much – to make art, is an unnerving idea for many people. Either it wasn't unnerving for him or else he wanted to be unnerving.

He claimed to have given up art for many years. He said he was working on chess problems instead. But it turned out he was secretly making the *Large Glass*. Then during the last twenty years of his life he was secretly making *Etant Donné*.

Marcel Duchamp *Etant Donné* 1946–66

Which consists of a view through a peephole onto a life-size, hyper-realistic, headless naked woman. So he was always making something. But he wasn't making new things for the joy of seeing them in a gallery. He said that kind of thing just made him ill.

Duchamp's Readymades look good now. They look sculpturally elegant. He said he chose them out of indifference but we know there's no such thing. It would be like saying you didn't think there was any meaning behind jokes. When he was asked in the 1960s at a museum conference, why – when he had said he wanted to destroy art – his Readymades now appeared so aesthetic, so much like art, he replied with the quip: 'Well, no one's perfect.'

Western civilization

'Hey Western civilization, artists deserve the fame of rock stars, let's begin with me.' That's a quote from one of the word paintings of the New York artist Sean Landers, who is now in his mid-30s. I am remembering it now, as I stand in Landers' studio in New York, looking round at some of his new works. It is in fact almost possible to be like a rock star if you are a successful artist in New York. Egotistical, arrogant, expecting to be worshipped. Landers, who became well known and successful in the early 90s, tempers the ego's urgings by playing the artist a different way – as abject and gormless and unformidable and as generally teenage as he possibly can be, without actually falling over.

He paints stream-of-consciousness thoughts in tiny words painted with tiny brushes. The thoughts rise in great banks. Each one is a perfect gag, perfect for the painting, which only requires the gags to have a mild comedic value but to have a definite beginning and ending so you can tell visually where one stops and another begins. The canvases end up as vast fields of tiny marks with rhythmic patterns running through them. Thus, early 90s Slacker atoms mingle with mid-60s Conceptualism atoms and make a new genetically modified Slacker-Minimal hybrid.

'Not only does he mock modernism but he also writes his mindless drivel all over each of his abominations,' another quote reads. The art reflects on its own making, like a classic work of 60s Conceptualism.

Many of his gags are about paranoia. The twist to these ones is that Landers actually is quite paranoid. I ask him if thinks he's more paranoid than everyone else or if it's only paranoia that makes him think that. 'That I can't answer,' he says, reasonably enough.

Let's look in his head anyway. Part of him is a grown man, part is arrested at a floppy, gormless stage. This part is well summed up in the 30-minute minimalistic video he exhibited at the Venice Biennale in 1993. In it he poses languidly in front of a wall of his own writings on sheets of yellow legal paper. They are neatly pinned in rows, in a parody of the favoured grid form that runs through 60s Minimalism and Conceptualism. The poses must be exaggeratedly moody, because the title is *Italian High Renaissance and Baroque Sculpture*.

Sean Landers
b Palmer, MA (USA), 1962
'My original idea was to make Conceptual art entertaining, sloppy, emotional, human and funny,' New York-based Sean Landers has said, adding that this ironic stance eventually turned into sincerity. The result is a kind of slacker art, in which naively painted images and banal subjects are set against a backdrop of scrawled texts – a ramble along his stream of consciousness. Painting, however, is only one of the many media he employs, eschewing 'masterly genius' in a single art form. The dichotomy of genius versus dumbness is one with which he often plays, presenting in a number of works a nerdy, self-deprecating image of himself: as a bronze monkey in *Singerie: Le Sculpteur* (1995); as an 'idiot', in his autobiographical book *[sic]* (1993); as a vain model in the video *Italian High Renaissance and Baroque Sculpture* (1993), or as a seventeenth-century Irish drunk in the series *A Midnight Modern Conversion (An Altercation)*, 1996.

Sean Landers in his studio 1998

Even though it's wrongly spelled he's got it to look as much like a sculpture as he can. Which is probably why his jeans are gradually coming down, inch by inch, revealing, first, jockey shorts, then as these inch down as well, alarming full hairy nudity. His long hair flops down, too – conditioned with Pantene, apparently, as we learn from his rambling autobiographical book entitled (*Sic*), as a joke on wrong spelling and a play on sickness.

In another video, mental floppiness is expressed by a Sean surrogate, a live chimp, who paints a random painting with paint brushes that Sean hands him. 'At least I didn't saw him in half and put him in formaldehyde!' he joshes to me, with the direction of the josh once again back toward art itself – reflection piling upon reflection.

Sean Landers *Bubble Boy* 1998

Sean Landers *Self-Something* 1994

But anyway, back to this dialectic of the floppy and fully formed. One part looks at the other, draws from it, makes a form from it. The floppy part flops out spontaneity. The grown part hones and perfects the material. It's a dialectic but you can't tell which is which.

'See I wanted to paint pictures,' another quote goes, 'but I wasn't that great at it so I decided to write on them to make them better. And check it out, it worked.'

Why Magritte is popular

There are visual gags and word gags. Artists who make art gags use both. The idea, the image – they must never fit. They must just grate together making art sparks. This was the system of René Magritte, the most popular Surrealist ever, next to Salvador Dalí. Magritte's joke is the joke of the wrong label. The wrong word for the image. The wrong thought for the word. The wrong feeling for the thought. *Ceci n'est pas une pipe* it reads under his painting of a pipe. 'The valise,' it says, under a church. 'The horse,' under a clock. *The Palace of Curtains* is the title of a painting which doesn't show any curtains, but has the word 'sky' painted on it instead.

Magritte made a lot of little films with his friends in the late 1950s and early 60s which are kept in an archive in Brussels. They record nothing but whimsical nonsense – middle-aged people in mid-century bourgeois sitting rooms pulling faces, dressing up, doing miming acts. Then here and there, something flashes – memories of Surrealism. A couple with sheets over their heads, or Magritte walking down the road in his Gilbert and George outfit – putting on his bowler hat, taking it off again, smiling, frowning. He looks like he's miming the meanings of his famous paintings, paintings that turned meaning upside down.

Like an old Kingsley Amis he appears, with his pals in the Belgium suburb where they all lived. The film running fast. His wife eating a suggestive Freudian banana like there was no tomorrow. And like there was no reason, because the film is running backwards too. The old devils.

Magritte is popular because his jokes don't stay up an ivory tower. But also because everyone knows his painting style is old style and he seems like a real artist. Although actually nothing like it exists in traditional art. It is a sign style, flat like posters or ads – ads in the 1930s. The point of it is to make a point, not to draw attention to itself as a style. But it is beautiful in a way. The economy of the style makes you stare – the ingenious picking out of outlines, making silhouettes expressive.

For example, the multitudinous silhouettes of the famous raining bourgeois men in *Golconda*, from 1953 – a time when Abstract Expressionism, not Surrealism, was the reigning international painting style. These strange little iconic uptight business guys that no one under thirty has ever seen in real life, only in Magritte – are they raining down or levitating up?

René Magritte
b Lessines (Belgium), 1898;
d Brussels (Belgium), 1967
Magritte's characteristic deadpan style may reflect his roots as a commercial artist, but it is also the perfect vehicle for his games with visual truth and illusion. The matter-of-fact look of his works gives them a documentary authority that makes the Surreal subject matter all the more disorientating, and emphasizes the ambiguity of visual truth. The series *Ceci n'est pas une Pipe*, for example, informs us that the pipe in the painting is not one, a reference to the difference between reality and representation. This is constantly blurred in works such as *The Human Condition* (1933), a painted view of a painting of the painted view outside the window. Magritte experimented early in his career with Futurism, Cubism and automatism. It was after seeing a Giorgio de Chirico painting that he adopted the dream-like imagery of Surrealism, becoming a leading member of the movement and only occasionally diverging from this style – most notably in the cartoon-like *vache* works of the late 1940s.

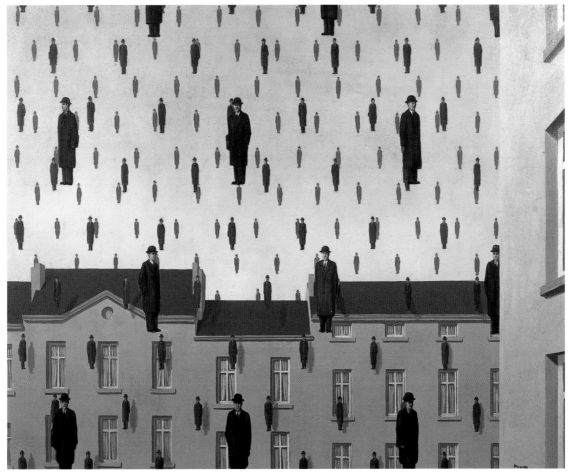

René Magritte
Golconda 1953

Nightmare

Magritte's style is like the illustrations in Ladybird books. The Ladybird book of phenomenology perhaps. What would it say? We have pictures in our heads for everything we see, conceptual signs that guide us round the visual world. But what happens when you paint only the signs and not the things they refer to? And make the signs tell lies? Ugh! That would be horrible!

Magritte tried mixing the deadpan style with a sunny Impressionist style briefly during the War. The results look quite gruesome and they seem to prove that the Magritte delivery must only ever be dead straight for it to work – everything must be absolutely straight in a world of logical wonkiness.

But then later he tried an Expressionist style, even more briefly, in fact only for one exhibition, for which he dashed off all the paintings quickly. And these all look

René Magritte in his studio 1950s

Piero Manzoni
b Soncino (Italy), 1933;
d Milan (Italy), 1963
Manzoni first exhibited his
'Achromes' in 1957. Showing
the influence of Fontana, these
were white paintings made from
folded or stitched canvases,
dipped in kaolin and often
covered in white objects such
as eggshells or polystyrene balls.
Neither paintings nor sculptures,
these reductive works were
characteristic of an artist who
constantly sought out new
artistic definitions. He was
particularly interested in testing
the boundaries between aesthetics
and life. In one work, for
example, he signed the bodies
of naked women, designating
them works of art. Many of
his sculptures, including *Artist's
Shit* (1961), in which he canned
his own faeces, attacked the pre-
tensions of the art world as well
as the wider bourgeois sensibili-
ty. In similar works, he signed
balloons of his breath and blood
as if they were religious relics. In
1959 Manzoni became a founder
member of Galerie Azimuth
in Milan, a showcase for the
growing anti-conventionalist
tendency in Italy. He died
of cirrhosis at the age of 30.

quite funny. One is called *Famine* and it shows heads eating each other. Throughout these paintings, the contours are all unsteady and the colour is all ghastly – tasteless tartans and lurid stripes instead of Magritte's characteristic tasteful greys and browns and infinite nuances of dingy flesh colour. Another one shows a nutty man with too many noses and too many arms, smoking too many pipes, like a nightmare of Modern art.

Cans of shit in the 90s
Piero Manzoni was an Italian artist who died at the age of 29 in 1963. But before he went he got some excrement – his own – and put it in a tin can. 'Excellent!' he said, in Italian, 'I think I'll call it *Merda d'artista!*'

Manzoni's canned shit is well known now, or the idea of it is. It's an idea as powerful in the popular imagination as the idea of blank canvases. In fact the actual cans are not all that well known. There are many of them. Each one contains an amount of the artist's own shit. On the label it says 30 grams but of course no one can really tell. The labels are quite detailed and well designed, with the name of the work in three languages, plus the date, the artist's signature and the name of the collector who owns the individual can – all this is part of the look. PIERO MANZONI is printed on the label in light grey letters on a grey ground, with the name repeating, so it makes a mantra of the artist's name, as well as a grey and yellow pattern.

When they were first sold they cost their weight in gold. Now they're worth much more. If one came on the market today it would cost about £30,000. So when a pile of them was shown in a vitrine in London's Serpentine gallery recently, it was a pile of shit but it was nearly a million pounds' worth.

Holy shit

Money, shit, art: the holy trinity. Manzoni took jokes to a higher plane than Duchamp, in that he elevated them to the spiritual plane which was somewhere Duchamp never wanted to go. Manzoni transubstantiated the things of the earth into mystery things. His signature was his magic medium. With it he could turn balloons filled with his breath into saintly relics or make women into art works. He signed them and issued them with a certificate so they knew what class of living art work they were – temporary, permanent, intermittent and so on. Each state was symbolized by a stamp of a different colour on the certificate – for example, a state of permanent art was symbolized by a red stamp. The women had no special duties as works of art but they did become prisoners of Manzoni, prisoners of his idea.

He wanted to make the whole world into a prisoner too, with a metal cube inscribed with the words 'Base of the world', which he exhibited upside down on the floor, making the earth into a sculpture, one that floated in infinite space.

The cult of the signature

The young British artist, Gavin Turk, has copied Manzoni's signature a few times, not to forge Manzonis, and perhaps make Manzoni his prisoner, but just to see what would happen if he wrote the word on a piece of paper – would it be art? What kind of art? What if he tried writing his own name – 'Gavin Turk?' Or 'Gav'? He did all these things and it was art, because of the cult of the signature, which

Gavin Turk
b Surrey (England), 1967
Turk's works circulate around the theme of the cult of the artist. His piece for his MA degree show at the Royal College of Art – a blue plaque reading 'Borough of Kensington / Gavin Turk Sculptor / Worked here 1989–1991' (*Relic*, 1991–3) placed in an empty gallery – was failed by examiners, but this has not prevented him from joining the group of successful YBAs who emerged at that time. In subsequent pieces he has elevated masticated lumps of his chewing gum to museum status by displaying them under glass (*Floater*, 1993), or presented his signature as the work. By ironically setting up a self-aggrandising connection between his own work and that of famous historical artists, he examines ideas of authenticity and celebrity. He has made self portraits in the guise of David's dead Marat (*The Death of Marat*, 1989), as Sid Vicious in the pose of Andy Warhol's *Elvis* (*Pop*, 1993), or based on Warhol's paintings of himself (*A Man Like Kurtz*, 1994). In 1996, he placed a gleaming black industrial skip (*Pimp*) in the gallery à la Duchamp's readymades.

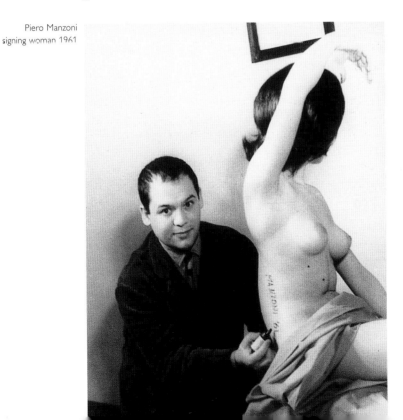

Piero Manzoni
signing woman 1961

Manzoni was already commenting on in the early 60s, like Duchamp in the early teens. But he didn't write on any women because today we draw the line at that kind of thing.

Old boot in the 80s

The year: 1987. The place: Germany. The mood: defiant. The place a bit more specific than Germany: a gallery. Inside: an object on a plinth. The object is a zip-up wedge-heeled square-toed 1970s Glam Rock boot. The item is solid and real and was obviously actually worn by someone and now is genuinely worn out. It is black with a gold pattern. Perhaps because it is black it is not even 70s but early 80s. Which would be even more absurd. Maybe it was worn by Lemmy from Motorhead. The plinth is a cube made of machine-cut thick sections of yellow foam rubber separated by thin sections of chipboard, also neatly cut. On top is a Turkish carpet. Between the carpet and the foam is a metal plate. The old boot stands solidly upon the carpet.

Bergwerk II is the title, which means something like '*Coalmine II or Mine II.*' Because it is the 80s we know plinths are never just plinths. They are loaded with all sorts of meanings. Meaning runs through them like strata. Or emanates off them like ectoplasm or radio waves. This one actually is stratified, so we don't even have to be clever to get it.

But what is it excavating or mining, this sculpture or anti-sculpture? And what was excavated before, in *Mine I*? Was there a *I*? Is mining or excavating really the theme? Is it people's minds that are being mined — the confusions and wrong thoughts in there? Is it everyone's minds or just its creator's, Martin Kippenberger?

Martin Kippenberger
Coalmine II 1987

How long can we keep this up?

8 pictures to see how long we can keep this up is the title of a group of paintings by Kippenberger, from 1983. Kippenberger was a very successful artist of the 80s who became even more successful in the 90s. By the time he died in 1997 from liver failure brought on by alcoholism, he had produced an enormous volume of work, in a lot of different styles and media. His most usual painting style, though, was a fast, light, robust, cartoony, mock-Neo-Expressionist style.

The joke of the title might be against Kippenberger himself and his circle of friends at this time – writers, artists, dealers – who were often criticized for being only a gang of opportunists. Or it might be against other Neo-Expressionists who took the Neo-Expressionist style too seriously, or who believed in it as a style, when it could easily be thought to be only an anachronism.

In any case, a jokey approach to all styles was characteristic of Kippenberger's use of them. *Bergwerk II* was in a Neo-Duchampian style and it was made at a time when the trend for Neo-Expressionism in Germany had died away and been replaced by a trend for a kind of designer-object style with clever Conceptual art ideas attached.

Jokes aren't the whole thing, though, with Kippenberger – it's not just joking for the sake of joking. But probably by now we have got this point about all jokes in Modern art.

Kippenberger churned out many paintings. They were abstract and figurative and they had all sorts of different types of space scrambled up together. They had titles like *Five little Italians made of chewing gum* or *War bad*. One of these was a little green monochrome, the other was a painting of a little Father Christmas making a 'halt' gesture to an army tank. Both paintings have the same scruffy but sensitive painterly aesthetic. You could believe Kippenberger really could paint but also that for him really being able to paint wasn't the main point. What was the main point? It was to be ironic and jokey and creative and individual.

Correct

Was it correct to be an individual? Was it individual to be correct? An untitled painting by Kippenberger has the not-quite-right words *Political corect* painted in red in the middle of a white space. Because the rest of the painting around the white is mostly green and grey, the red and white look good. Under the red letters are some smaller black ones. They spell out *bistro & pub*. The jazzy green and white patterning is actually the pattern on a schematically rendered jazzy shirt. The rest of the painting is wood-grain pattern, like wood-grain wallpaper.

This painting from 1994 is typical of Kippenberger's output as a whole, whatever the medium, in that there seems to be some kind of comment about the modern world. The modern world is definitely there in all his art – the look of it, its surfaces, the feel of it, what people think, changing liberal values, changing lumpen values,

Martin Kippenberger
b Dortmund (Germany) 1953; d Vienna (Austria), 1997 Kippenberger seems to have spent his career rebelling against his strict evangelical upbringing in the Black Forest. Amongst other unconventional acts, he bought a gas station in Brazil as a joke and founded a punk band. His playful work embraces drawing, painting, sculpture, installation, artist's books, graphics and performance. In the mid-1970s he opened a space in Berlin showing work by his collaborators Georg Herold, Albert Oehlen and Werner Büttner. He initially became known as a painter, influenced by Polke, his outrageous imagery taken from cartoons, German tradition, and the conventions of Modernism. Deliberately offensive, he followed an elaborate aesthetic of bad taste and deliberate obfuscation of meaning. In 1987, he incorporated a painting by Gerhard Richter into a banal coffee table, a sardonic gesture that commented on art in the service of bourgeois ornament. The same sense of bitter pain can be seen in his 1985 series of self portraits depicting his deteriorating body. However, he claimed he wanted to disseminate a 'good mood'. This ambition was wittily achieved in his last major project *Metro-Net. Subway Around the World* (1993–97), for which he installed entrances, emitting convincing sound effects, to an imaginary global underground railway in various sites throughout the world.

Martin Kippenberger
Untitled (Political corect) 1994

newspapers, the transport system, racism, sexism, museums, Neo-Nazism, cartoons.

When you try to be clear what the comment is, though, the mind starts sliding. The comment doesn't work in paraphrase. Is the painting a paraphrase of a comment? But paintings have their own autonomy. At least they do if you are an aesthete. Is aesthetics important? Obviously being politically correct is important. But is it important to spell it right? If you are German will you be forgiven if it's wrong? Could painting ever be correct? Is it wrong to be decorative? Should we read lots of books by Wittgenstein?

Wittgenstein

Wittgenstein is the title of a sculpture by Kippenberger, made at the same time as *Bergwerk II*. It is a plain shelving unit probably bought from Ikea. The only work he did on it was to paint it grey, not even with much finesse. So it's a Readymade made into a sculpture by an act of painting rather than naming; although naming is a factor because Wittgenstein was a favourite author among Minimal and Conceptual artists of the 1960s. That's quite a superficial way of referring to the important influence of Wittgenstein on those movements. But it seems appropriate because grey was the favourite colour of both those movements and that's quite a superficial thing to say too.

If the grey was put on more smoothly the whole mood might be different. So lack of finesse is wrong – absolutely the right amount of finesse was used because otherwise this work would have a completely different aesthetic. The distinctive aesthetic draws you in, as does the jokiness. They draw you in up to a point but once you're there you could feel you're not quite sure where you are. Which was the feeling we were beginning to have about *Coalmine II*.

Martin Kippenberger
Wittgenstein 1987

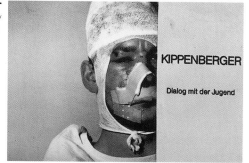

Heil Hitler you fetishists!

The wrongly spelled but politically correct bistro pub – it goes with Kippenberger's exhibition called 'The No Problems Disco' and his endless stream of slogans and jokes and baby-talk and alarming acronyms on scruffy abstractions. (For example, the letters *H.H.I.F* all on top of each other down the right-hand edge of a painting from 1984 of what might be an abstracted German letter-box – *Heil Hitler Ihr Fetischisten!*) If we were at the bistro now, we might be hearing one of his records with lyrics that just go 'ja ja ja' or 'yuppi do' in a mournful idiotic Bavarian beer-hall drone, with an Easy Listening keyboards backing track.

We might be flicking through *No Problem*, his book of thoughts, including his thoughts on identity crisis, alcoholism and chocolate mousse. 'We don't have problems with the Rolling Stones,' one of the thoughts goes, 'because we buy their guitars.'

'We don't have problems with people who look just like us because they feel our pain. We don't have problems with the Guggenheim because we can't say no if we're not invited. We don't have problems with disco door waiters because if they don't let us in we don't let them out. We don't have any problems with women because they know why. We don't have problems with tomato and mozzarella salad because we pay back with *mousse au chocolat*! We drink, we fall down, no problem.'

Maybe he'd be sitting there talking to us, in a non-stop wisecracking way, which could be quite intimidating, or so I thought when I used to have to sit through it sometimes, in Cologne, in the Chelsea Hotel. He owned a part share in the hotel and it was his idea to name it after the one in New York, as a kind of Appropriation art gesture. All of the rooms had art works in them by him or by his friends. He'd be in the restaurant firing off wisecracks. 'Every artist is a human being!' he'd exclaim.

He had a scarred nose, the single legacy of a savage attack by a group of Punk girls outside a bar in Berlin one night, in 1981. 'Dialogue with youth' was the announcement on the invitation card for his exhibition in Stuttgart shortly afterwards, next to a photo of his heavily bandaged and wired-up face in hospital.

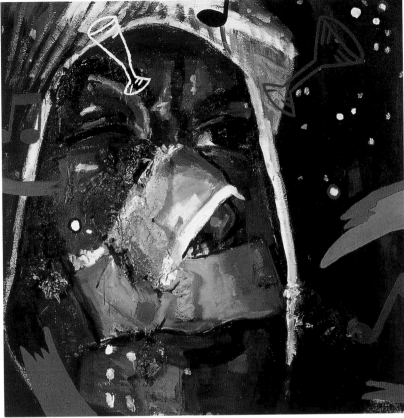

Martin Kippenberger
Self portrait 1982

Kippenberger and Joseph Beuys

When Kippenberger said every artist is a human being it was a twist on Joseph Beuys's famous quote that 'Everybody is an artist.' Beuys – who died in 1987, a year after Warhol and ten years before Kippenberger – was a messianic hero of art who wanted to change the world and make it better. Art should not be an exclusive, hermetic system of inward-looking ideas, he thought, but it should be an integration of all systems of understanding or processing or expressing the world. Whether it was Jung or Zen, or green politics or Marxism, or even a bit of capitalism, or the Maharishi or Duchamp or Andy Warhol, or drawing.

Kippenberger said the Beuys approach was successful when Beuys stated that from an aesthetic point of view the Berlin Wall was bad because it was 8cm too low. But when Beuys attempted to create the impression that the natural end of the Beuys system was for Beuys to take his place in the German parliament – with his famous felt hat and his shamanism – this was the failed side of the approach.

Dictates from above

Meine Fusse von unten gegen das Diktat von oben means 'My feet from below against dictates from above.' It might be a well-known German saying. Maybe children at *kindergarten* learn it and it helps them be more organized. In fact it is the title of another Kippenberger painting from the 80s, showing an abstract shape made of glowing red and blue paint, throbbing in the centre of some gestural squiggles.

To be trapped in contradictions is a well-known idea about modern life. And well-known ideas were Kippenberger's forte. It was odd to make them into art because they already seemed to work OK as ideas. They were banal. They were beneath art. But then once they were made into art they seemed odd as ideas and a bit more up to the level of art.

The images and jokes flow by. A ghastly cartoon kitsch porn prostitute staring aghast at a giant rippling drooping penis of Amazonian Anaconda dimensions. A painting of a naked beauty queen with a face full of goofy, pained disappointment and hands full of shopping, called *Self-inflicted justice by bad shopping*. A painting of Lemmy from Motorhead called *Motorhead II (Lemmy)*. Henry Moore sculptures with holes in the middle, called *Family Hunger* — a photograph on the invitation card shows a woman breast-feeding one of the smaller ones. And hundreds of drawings on hotel stationery from around the world — multi-style but with a lot of recurring jarring, unaesthetic, Woolworths style, or the romantic girly style of *Petticoat* or *Jackie*. A real lamppost from Venice, but adapted for drunks, with the post bent into a graceful S curve. And a wall-size photo of a gas station in Brazil, which Kippenberger owned. He bought it on a trip there once, just to have the answering machine message announce: 'Hello, Martin Bormann gas station here!'

Ugly lumpy

Eggs and egg symbols keep coming up in Kippenberger's art. An egg as big as a head made of plaster with a zip running up the side stands on a plinth. A fried egg table was another sculpture, along with a chair upholstered with fabric bearing a fried egg pattern. A Humpty Dumpty man in a Bavarian hat and *lederhosen* looks angry in an ugly lumpy blue painting called *German Egg Banger*. A painting from 1991 shows Jesus on the cross being menaced by a fried egg. Another one from the same year shows a semi-naked Kippenberger rendered in a queasy ugly-realism style, posing absurdly, like a Renaissance sculpture, with a Van Gogh-style beard and cropped hair, sharing a layered Post-Modern space with multi-style symbols of a hangman's noose, a rubber life belt and a hatching egg.

Traditionally eggs symbolize birth and rebirth and new beginnings. And jokes, because jokes are hatched. Or if you're German they sound like yolks. Which rhymes with folks. And Kippenberger was an artist of the German *volk*. 'One of you, among you, with you,' he announced on a poster from 1979.

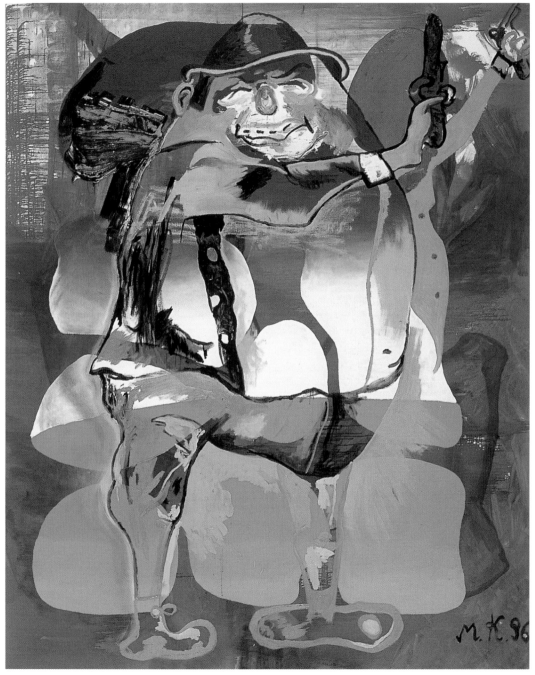

Martin Kippenberger *German Egg-banger* 1996

At the Chelsea Hotel he was often to be found in the restaurant, drinking if it was the evening, or recovering if it was the morning. The artist of the perpetual hangover, staring at his breakfast and making up new egg symbols out of his head.

What would they be hatching? New Kippenbergers, hundreds of them, rolling through his art in oil-paintings, drawings and photos. Each one more ravaged and sagging than the last, as alcohol took its toll. In an art calender called *Elite 88*, he made himself into the pin-up for every month. On the July page, he poses nobly before a mirror in nothing but underpants pulled up over a big belly, Picasso-style – but looking a lot less healthy at 35 than Picasso did at seventy.

Noodles yummy

Eggs for breakfast, noodles for dinner. Pasta and noodles make up another Kippenberger *leitmotif*. They are the stuff of life, of course, but also the stuff of nonsense. In *Daddy do love Mummy, noodles all find yummy* – a woozy, smeary abstract-figurative painting from 1982 – noodles, baby-gurgling and a silhouette boy penetrating a silhouette girl from behind all somehow equate.

Spaghetti and the Pentagon intermingle in another image, this time a photo on a poster, from 1985, showing the artist in sunglasses forking a trail of the stuff up to his mouth – 'Selling America and Buying El Salvador: Problem – No Problem' is the announcement.

A sculpture from 1991 is a life-size golden gondola hanging on chains in an empty space, with two packing crates stacked where the passengers should be. One has the word *Social* printed on the side. The other says *Pasta*. Social pasta – is it that we can't feed the world but we can come up with tomato and mozzarella salad and anachronistic theme park tourist spots? And Venice is the city of art and art is an anachronistic theme park?

The Society of Spaghetti

If only Guy Debord would excommunicate Kippenberger and put us all out of our misery, we are probably thinking by now. The association is right because Kippenberger is a bit Situationist, but it's Situationism adapted to be more modern and alive, less ossified and rigid.

That's enough jokes

Challenge all bourgeois assumptions – this is what art must do. But don't challenge too much because then you lose touch with reality. Reality basically is quite bourgeois. We can't escape it. We are it. We certainly go to all the same restaurants they go to and eat the same noodles. What else? Art must be stylish and good. So it's just as well Kippenberger had a sympathetic aesthetic running through his multi-aesthetic. His painterly style is sympathetic and his jokes draw you in too. You look again at what had seemed gruesome and see that it could be beautiful after all.

A man comes home and finds his best friend in bed with his wife. The man throws up his hands in disbelief and says, "Hey Rick, I have to, but you too?"

Richard Prince *Untitled* 1994

Somebody else's act

When Richard Prince first copied out his psychiatrist's joke in 1986, he was known as one of the main originators in New York of Appropriation. Appropriation artists of the late 70s and early 80s borrowed pre-existing imagery and gave the imagery a new twist. Often, the imagery was from the mass media. And often it was part of the shock of the art that the artist didn't seem to have done any work. For example, Prince rephotographed ads from magazines, framed them and sold them as his own art. So, in this climate, an appropriated joke about somebody's act being appropriated by somebody else and used by them, would have been funny.

Suburbia

Prince is in his studio, now, silk-screening some jokes onto white T-shirts. One reads: *I went down to Miami, they told me I'd get a lovely room for seven dollars a week. The room was in Savannah Georgia.* The studio is a new, purpose-built building next to his house, which is just outside Albany, a pretty, leafy, peaceful small town, four hours' drive from Manhattan. Prince prints the writing – which is his own hand-writing, photographically processed onto a silkscreen – and then paints it out and prints it again further down, with the joke now emerging from a washy atmospheric smear.

Other paintings of jokes from the 80s until now lean against the walls. The more recent ones are bigger. The style is loose and improvised. Some of them look like lyrical 1950s abstracts, with free swirls of thick paint over most of the surface and

Richard Prince
b Panama City, FL (USA), 1949
Prince became an art star in the 1980s with his 'Jokes' – monochromatic canvases presenting visual and verbal gags, sometimes corny, sometimes enigmatic. These gently mock the intellectually rigorous works of Minimalism and Conceptualism, which made use of the monochrome and the text. Appropriating material from popular culture, they also provide a critique of authorship and artistic value. Often taking psychiatry, race and sex as subject matter, they retain the anxious undertow of the original joke. Prince began as a figure painter, but by the mid-1970s was creating collages of photo and text. In 1977 he became the first artist to re-photograph magazine advertisements. These images of luxury items, and later, male and female models, exposed the mechanisms of seduction and alienation. Manipulated travel and leisure ads followed, casting doubt on the authority of the photographic image. Themes of identity and gender recur in his 1984 group 'Cowboys', taken from Marlboro ads, and in 'Girlfriends', appropriated from biker magazines. In 1987, Prince began a series of repainted car-hoods, and by the 1990s, he had conflated these with the jokes in what he calls his 'White Paintings'.

Richard Prince
The Literate Rack 1994

Man walking out of a house of questionable repute, muttered to himself, "Man, that's what I call a business...you got it, you sell it, and you still got it."

the jokes scrawled across the bottom edges. The ones from the late 80s are more minimal: flat bright monochromes with jokes silk-screened across them in type-written lines, the type set in a uniform Helvetica bold.

The type on a red monochrome reads: *Two psychiatrists, one says to the other I was having lunch with my mother the other day and I made a Freudian slip. I meant to say pass the butter and it came out you fuckin bitch you ruined my life.*

Prince is now in his mid-40s. He has been painting jokes since his 30s. They are not particularly loaded for him now. He thinks of the jokes as subject matter and he thinks of his paintings as quite straightforward. Not Conceptual art gags but paintings. It is quite easy to think of them as scenes from suburbia. The subjects are almost always petty cruelty of some kind. If you took almost any of them literally they would be quite painful. You wouldn't want it to happen to you. But because they're just common jokes, they're the kind of thing that happens to everybody.

Once a painting is finished it seems 'extremely abstract' to him and he forgets about the subject matter. He just thinks about the construction and the form, like normal painters. In fact when he started painting jokes it was because he wanted to be normal. He was fed up being thought of as conceptual.

It was New Year's Eve, and the house was brightly decorated with springs of holly and mistletoe. Only the clicking of Grandma's knitting needles broke the silence. The children, Polly, eight, and Janice, six, were seated before the roaring fireplace leafing through a picture book. Then they rose and went over to Grandma's rocker. Polly climbed up on the arm of the chair, and Janice snuggled into Grandma's warm lap.

"Tell us a story, Grandma," Janice pleaded.

"Oh," said the old lady putting aside her knitting and wrapping her arms about the children, "what should I tell you?"

Little Polly's voice came gently, "Tell us about the time you were a whore in Chicago."

Richard Prince
Untitled 1994

I ask him if he always thought of himself as funny.

'No. I never thought I had a sense of humour. I'm very bad at telling jokes. And I've only made one joke up in my entire life – Why did the Nazi cross the road?'

'That's the joke?'

'Yeah.'

Maybe it's a joke on jokes.

Coming second

Prince's painted jokes have different punctuation styles, ranging from no punctuation at all to standard punctuation, depending on the house-style of the source joke book or magazine. But the differences are immediately noticeable and are part of a range of differences that now animate Prince's joke world, making it seem very complicated and baroque and dramatic compared to its original simple beginnings in biro on A4 paper.

Another painting leaning on the wall is a big black and white one with a silk-screened cartoon image of a stock desert island situation. A sexy blonde and a marooned man, a palm tree, the endless sea. The caption for this one is completely dislocated from the joke, which has the effect of emphasizing an ideal joke world – a world of stock situations, which might not be all that ideal in fact because of the pain never stopping.

A wife tells her husband he's the world's biggest schmuck. 'In fact,' she says, 'if they had a contest for schmucks, you'd come in second.' 'Why second?' he asks. Says the wife, 'Because you're a schmuck!'

Tragic joke

Prince says when he likes some of the famous jokers of American pop culture it's because of their seriousness. He likes Mohammed Ali's quick-fire limericks and his self image as a politician and not just a boxer. He likes the fact that Lenny Bruce never thought of himself as a comedian. He likes Charlie Chaplin and Rodney Dangerfield always making themselves the subject of ridicule. He used to work in a night club and he saw first-hand that the cliché of stand-ups being quite depressed was quite true. He likes some of Woody Allen's early comedy routines and he quotes a line from a Woody Allen cassette:

I married my first wife on Long Island and we got married by a rabbi, a very reformed rabbi, a Nazi.

Fearing there might be a misunderstanding about repetition, or Nazi obsession, he says it's the idea of jokes as a survival mechanism that makes him remember this one.

For some reason, he has his first psychiatrist joke in the studio. He pulls it out of a drawer. 'It looks pretty beat. It doesn't really look like art right now. And I suppose that would have been more interesting at the time. But right now I just want to make something that looks like art.'

CHAPTER SIX

THE SHOCK OF THE NOW

Gillian Wearing
Dancing in Peckham, 1994

Tick tock

Hi! You're here. And it's now. And soon it will be the end. Let's sort out all the anxieties of now in ten thousand words. That's already 25. Twenty-eight now. Phew, it's hard to conceptualize time! Why do we have to conceptualize anything, is one of the main anxieties that society has about the art of now. Within art there are many anxieties too because art expresses the anxieties of the society among other things. But it rarely expresses the main one directly, the anxiety that art is vacuous now.

This anxiety exists just as strongly nowadays as the impression that art has suddenly become incredibly popular and full of significance and meanings, whereas before it was unpopular and only had introverted meanings. One is superimposed over another, an anxiety over an impression. Or there is a sequential relationship: the more popular art gets the more vacuous it is. Or one is inside the other.

Jack in the box

Art now has meanings by the bucketful and anyone can get them, at least after an initial puzzlement, because meanings that can't be got straight away have been banished by artists. And the adventure now is for artists ceaselessly to seek out any obvious or inane meanings that might have been overlooked since obviousness became the new thing, whenever it was, the 80s maybe.

Before, in the golden age, with Chagall or Matisse, say, it was quite a leap to accept a musical kind of meaning that art might now have instead of a literary type of meaning. But then with Conceptual art or Minimalism, the meanings were all obscure or too dry or studious and it wasn't worth the effort of leaping at all. And now – the third phase – there is a jack-in-the-box effect, where the lid of meaning is in the closed position but you know when it opens, which it always will do now – on well-oiled hinges because of art's new popularity – something stupid will be popping out and whistling.

Hell

Relatively recently the assumption was that there was no point in thinking about contemporary art because it didn't mean anything to anyone except artists and you could easily live your life without it. Now there is a growing anxiety that there might not be any point to it because its meanings are too available and also too available elsewhere, in ads, rock videos, crappy moronic blockbuster films, on the Internet and so forth. As art draws ever closer to maximum immediate impact it becomes less valued. Films and ads are better because at least you know where you are with them. In hell, probably, or in a Salvador Dalí painting.

Think about it art

When art is about ideas and not about aesthetics or loveliness or inner spiritual depths – well, OK, when it's about ideas, let's keep it simple – how do you tell a

Gillian Wearing
b Birmingham (England), 1963
Wearing's photographs and videos play with the limitations and possibilities of documentary truth. *Sixty Minute Silence* (1996), for example, seems at first to be a still photograph of a group of police officers, but after a few seconds, their twitching and shuffling reveals the work to be an unedited video in which they pose for the duration of an hour. Similarly, while the experience of *10-16* (1997), in which the voices of children emanate from the mouths of lip-synching adults, is bizarrely 'unreal', an interpretation of their words emerges that is not so much false, as insightful. Wearing's enquiry walks the tightrope between perceptive observation and painful voyeurism. For *Confess all on video…* (1994), she persuaded a group of complete strangers wearing masks to divulge their innermost secrets. And in the series of photographs *Signs that say what you want them to say not signs that say what someone else wants you to say* (1992–3) she invited her subjects to write personal messages on cards. In these and other works, she presents a touching, if disturbing, form of portraiture in which the subject is given a voice.

Cornelia Parker
Exhaled Cocaine 1996

good idea from a bad one? The audience for art now feels suspicious because it suspects there isn't a hierarchy – it's just an anything goes ethos, and that makes the audience feel it is being fooled. It isn't necessarily furious about being fooled. It just takes it for granted that fooling is occurring. Therefore the Turner Prize, for example, is an amusing talking-point, a laugh on the cultural calendar, but not an outrage. It is important because culture is part of amusement and part of what makes dinner parties tick. But also not important because it is felt that the art is unimportant.

Anxieties of now

The main anxiety of now is that art is vacuous. Consequently there is an exaggerated and perhaps unrealistic respect for old Modern artists like Chagall, where you can judge for yourself if it's good. Today art is popular and there are lots of new Modern art museums opening up all the time. But the audience feels they could easily think up a lot of this stuff themselves and it would fit the bill providing it was empty, shocking, sexual and a bit pretentious. And that makes them despise it even if they enjoy it as a kind of circus.

Three samples of audience ambiguity

When art is a little pile of burned cocaine by Cornelia Parker, you can't tell if it is successful or not. You want to be able to say you've praised something that seems to be fairly rich. And when something seems vacuous you want to dislike it on the grounds of it being vacuous. But the system won't allow this.

Chris Ofili might well be doing something profound. He's putting the hours in and you can tell he means it. It's art with a lot of ideas but a lot else as well and you can judge when one painting is more successful than another. But you might not care to hear that he is introducing humour into the context of art or into the context of political correctness, because you ought to be allowed to be the judge of that yourself. Yes, he is funny, you think. So what? So are you. On the other hand, there is a discursive aspect to this art and it's quite acceptable therefore to think about the forms being under pressure from some interesting idea or other from outside painting, or to think about the way references and samplings might be operating.

Gillian Wearing's film *Dancing in Peckham* seems interesting straight away so some information about her thoughts might be welcomed. Or it could be a history of the rise of video art since 1967. But, unlike with Ofili's paintings and their multiple layerings, whatever the information was it wouldn't make the film any better.

What made it good in the first place was the silence, the passers-by not looking, the slightly autistic nature of the dancing, the locked-off camera, the fascination of wondering if anything really was going to happen next, the artist's confidence, the feeling it was a brave thing to do, the whole idea, even if it was only an idea about making slightness work.

So there's already a lot going on here just with these examples and it's beginning to be clear that the language and look of art now is important. And it's not all the same, it's not all just trying to get attention in a shallow way.

Anxieties expressed by contemporary art

These are easily listed. Repetition, the media, illness, mutation, the body, surveillance and fragmentation. Repetition is part of art but since the 80s it has become speeded up. Styles are now repeated immediately and not decades after they first appeared, because style itself doesn't mean anything and it is untied from its moorings. In fact style is not style but a new thing you can hop on or off, like hip-hop. The media is bad. Death is important. Illness is AIDS. Mutation is genetic engineering. The body is frightening because it's always changing, there is a mind-body split, and super-models are eerie. Surveillance is automatic video cameras in car parks and banks never closing down. It is an all-seeing eye a bit like Big Brother but not telling you to do anything because power is invisible. Fragmentation is the self fragmented and without a centre, not like *The Second Coming* which is the centre being a good thing that cannot hold any more, but like paranoia, where you don't know who you are because an outside force is controlling your mind and telling you what your values are. Sub-issues of fragmentation are race and gender which both connect to identity. Identity is good but we don't have a single sense of it. We have a multiple sense of it. Art that doesn't acknowledge this is bad.

Cornelia Parker
b Cheshire (England), 1956
Parker tests the physical and spiritual properties of objects by crushing, suspending, exploding, juxtaposing. For *Thirty Pieces of Silver* (1988–9), she subjected the eponymous objects to 'cartoon death' by squashing them with a steam-roller, suspending their mangled, one-dimensional remains in the gallery. *Cold Dark Matter: An Exploded View* (1991), a dramatically lit, sculptural reconstruction of the moment when she exploded a garden shed and its contents, achieved a similar effect – the shards frozen in time like a frame from a comic book. In her collaboration with actress Tilda Swinton, *The Maybe* (1995), she juxtaposed poignant historical objects such as Queen Victoria's stocking or Churchill's cigar with the living form of Swinton, sleeping in a vitrine. This enquiry into the resonance that ordinary things can acquire through association was, paradoxically, further intensified in *Avoided Object* when she displayed what was not present in familiar objects, such as the swarf from the grooves made in a master record, or 'the negative of words' – the crumbs of silver left over after engraving silver.

Mannerisms of anxiety

The 'body' rose in the late 80s starting in New York and soon spread everywhere. Now it has the same buzz about it as acrylics had in the 60s. That is, everyone previously excited by it now probably feels slightly jaded about it.

Perhaps its rise in the first place was due to the obsession in the early 80s with the idea that nothing was real and everything was an illusion. Then at the end of the decade there was a sudden combination of really bad realities that shook artists up – AIDS still going on, the Gulf War arriving and the art market collapsing and all the money going down.

And so then it was the return of reality and nothing could be more real than the body because it's the opposite to the mind. But because unreality was still a strong part of the contemporary mood, the absolutely dominating type of returned body in art was the realistic but clearly totally unfeeling and dead mannequin.

At first mannequins in art in the early 90s were a sign of importance – the body is important because it's alien even when it's your own because its got all its somatic drives driving you nuts.

Then because mannequins became so ubiquitous they became a sign of dreariness unless you could think of something really outrageously unreal to do with them. Have seven life-size replicas of your own body in an art gallery having an orgy, for example, as Charles Ray did with his sculpture *Oh Charley! Charley! Charley!*

But on the whole the mannequins are slipping back in their boxes now and joining other former signs of importance in art, like the colour grey in the 70s, or silk-screened photos and stripes in the 60s, or drips in the 50s.

Importance itself

Today art can be a green pea in the middle of a gallery but somehow some artists still think it should be something like the highest mountain, the widest ocean, the biggest sky. For example, Bill Viola and Anselm Kiefer. These artists stand for dignity. They give their respective forms – video and painting – a good name as far as museums are concerned. But they are both windy and there is a preposterous side to their art that can obscure what is genuinely to be congratulated.

What makes Kiefer seem important is that he has a grand, romantic view of history and art, and he wrenches pre-Modern art meanings out of Modern art paint surfaces. So he is good for an audience which has been starved of schmaltz. He simulates Old Master effects and his works are full of German history and wrought surfaces and visual dynamism. He paints old faces of Goethe and Heidegger or old German heroes who fought the Romans and he constructs vast, wide, perspectival, illusionistic painterly vistas of important architectural structures, like Ziggurats from ancient civilizations, or Valhalla, or monuments to dead soldiers that were designed by Hitler's architect, Albert Speer, but never built. And he is witty and makes artists' palettes with wings made out of lead and sticks them on his paintings.

Anselm Kiefer
b Donaueschingen (Germany), 1945
German History and myth are the central themes in Kiefer's work – which has not always made him popular in his own country. In 1969, striving to come to terms with Germany's recent past, he embarked on a journey through Europe to make the photographic series 'Occupations' in which he depicted himself giving the Nazi salute. Also in that year, he assembled lead books on steel library shelves, symbols of the heavy burden of historical knowledge. However, it was for his densely worked Expressionistic paintings, sometimes incorporating straw, blood, sand and sewn material, that he became known. Kiefer made the first of these large-scale paintings, *Heath of Brandenburg March*, in 1971, going on to explore the Niebelung legends and their adoption by Hitler for nationalistic purposes, subsequently broadening his subject matter to the Old Testament and Alexander the Great. He also made three-dimensional works, beginning his series of monumental painted wooden interiors in 1973 with *Parsifal III*, and later making aircraft sculptures. The theme of flying recurs in his work, particularly the flying palette, symbolizing the transcendence of art.

Chris Ofili *Through the Grapevine* 1998

Anselm Kiefer *Bilderstreit* 1995

Bill Viola

b New York, NY (USA), 1951
Viola is a pioneering video artist,
recognizing its potential as a
student in the early 1970s and
fulfilling it in highly imaginative
ways. In the mid-1970s he
worked for video studios,
gaining access to state-of-the-
art equipment and travelling
extensively to document non-
western cultures. This experience
contributed to the deep seam
of spirituality in his work, which
finds poetic intimations of the
sublime in everyday life, taking
birth, life, death as its central
themes. The works are presented
in increasingly sophisticated
ways: with altered-aspect ratios
or in triptych form (*City of Man*,
1989), twenty-four-hour window
projection (*To Pray Without Ceasing*,
for the seventeenth-century
chapel in Nantes); projected
as ghostly figures onto a veil
(*The Veiling*, 1995); or offering
up the viewer's image in a
teardrop (*He Weeps for you*).
Perhaps his most dramatic work
was *The Sleep of Reason* (1988)
in which a slumbering man
was shown on a monitor in
a sparsely furnished room, which
suddenly became pitch black
while the walls were bombarded
with images of burning buildings,
attacking dogs, a swooping owl.

For years Kiefer's work was shown endlessly in museums and galleries all over the world, to the extent that it became annoying and oppressive and you just wanted to forget about it. Then gradually it wasn't seen so much. And nowadays you can come across one of his paintings in a museum somewhere, having not been oppressed by one for a while, and it will look surprisingly good.

All his works have the same initial impression of a broad, expansive, impacted, seductive powerful surface, very painterly and vigorous, but also like some vast, windy-looking backdrop or piece of scenery for a new staging of a Wagner opera.

And this blowy aspect is what allows a small section of the hyper-informed art audience to find Kiefer pretentious. He is but that doesn't mean he isn't also quite good on an aesthetic level. Maybe there is something a bit tedious about the writing on his paintings but the dynamism of the marks generally is good.

With Bill Viola the pretentious grasping after importance can be really powerfully off-putting and the turgid, bad, unobservant, terrible writing about this artist which is always appearing everywhere can be quite amazing, like an inadvertent parody of art culture. There it will be in the *New York Review of Books*, say, in an article about why Modern art museums are like places of religious contemplation, and how Bill Viola is like St Thomas Aquinas, right next to articles by intelligent writers about interesting subjects.

But behind the grandiosity of Viola's enormous, straining video installations there is something there, some trick he does with the after-image or a dramatization of absences — making absences dramatic in a context of important subjects like death, life, birth, God, what death means, what a numinous experience might be, what a spiritual awakening might be, what art is.

What is it that makes some people contemptuous of Viola? Typically, his video installations show disjointed scenes of significant things: someone giving birth, someone dying, some flames, some water, some darkness, some people disappearing and seeming to be ghosts, some other people meeting each other and looking a bit like they're in a Renaissance painting. Obviousness, banality, sentimentalism — these are all negative absolutes, they can't be turned around. Much art since Warhol has all three but in a mix of other elements so the overall effect isn't these things. There is an element of the pared-down with Viola but it clashes with the element of the overdone.

It's complicated to be irreverent about this kind of thing because anyone should be moved by the idea of someone recording their own wife's labour or their own mother's actual moment of death. But there is a problem when it seems to be all wrapped up in a neat or crass metaphor for the cyclic nature of existence. And astoundingly the bait is taken by museums and the work is sanctified and it becomes a video version of Giotto and a new standard that all contemporary art must now look up to.

So both Viola and Kiefer are contemporary romantic artists who capitalize on

Bruce Nauman
Clown Torture 1987

the general public's too-easy belief in certain signs of greatness or significance. If an artist is romantic and sentimental and works on a vast scale, then they will be considered to be important and profound. Caspar David Friedrich invented a certain cliché of vastnesses equalling the spiritual and these artists keep it going in spades. Friedrich has the benefit of the doubt because he was there first but the others can't complain if there is a bit of resistance to their hocus pocus.

Stripped-down clown

Can sentimentalism ever be good? No, it's a pejorative and it can never be turned round. It is always ill-making and clowns in art are always bad. Except when it's a Bruce Nauman video clown crying 'NO!' at the Hayward Gallery. But his is a stripped-down video clown because Nauman is a Post-Minimalist and he strips things down and looks for the most pared-down form to express the important subjects in life. Clown-ness is only one element of this particular work though, going with video itself as an element and the script as another element, and the throwing around of his body the clown has to do while acting the script. So it's a pretty interesting twist on the unacceptability of clowns.

Are artists clever?

Artists frequently turn out to be alienated from intellectual culture. They take what they need from it but only that. So a significant proportion of the audience for art finds itself asking for an expression of themselves from a section of society which

Gillian Wearing
Sixty Minute Silence 1996

is quite different to them and which doesn't feel comfortable with the same things as them and hasn't had the same experiences. Ideas in art are not like ideas in Nabokov.

The ideas in Gillian Wearing's film about the police, for example, might be said to be about repression, restraint, a sudden relief from restraint. It's a good idea that the police should be restrained and then suddenly released. And that it should all happen in real time and on a human scale, with the police filmed life-size. Because there's so many of them it becomes a monumental scale. And that connects to order and rigidity too. In fact the only bad idea about the film is that it isn't really the police, it turns out, but only actors. This is a disappointment that slightly spoils the idea. But in any case there's virtually nothing here that even begins to parallel literary ideas.

Intellectual culture and mysticism

Anxiety about cleverness connects to anxiety about the spiritual. Today the spiritual often equates with mysticism. Popular culture loves mysticism but it is intellectually

despised. Aliens, psychic readings, Celtic tattoos, stone circles, the tarot, cults, pop medievalism are all part of the mysticism of today. But art isn't.

When intellectuals are not mistaking artists for intellectuals they sometimes mistake them for pop mystic cultists. But this isn't right either. There is a difference of tone, the tone of art culture is less predictable. You can't predict exactly what will happen in an art context as surely as you can in a pop mystical one.

For example, when a discussion starts up about the Macchu Picchu remains in Peru and Tutankhamen and the god Seth and total eclipses of the sun, you know with a heart-sinking certainty they will all turn out to be connected by a very long number. This is an order of things, or a world view, that must never change or be challenged, and people who talk like this get pleasure from the fact that it really does never change. A razor blade will always be sharpened if it's put under a certain type of pyramid and spacemen really did invent runes. But it's wrong to think art is like that. Art changes all the time and it is fundamental to its nature for it to do that.

Cocaine

So this cocaine then, charred and grey and in a little group of crumbs in a vitrine in the Tate Gallery, having initially been confiscated and burned by Customs officers – is it any good? A bit thin maybe. Grey crumbs in a glass case, off-centered, not that interesting to the eye. And the fluff from Freud's couch, also by Cornelia Parker? The same, thinner maybe, because Freud's couch and fluff and Modern art as a set is a cosier notion or joke than burned cocaine and Customs officers and vitrines and museums. But still there's not a lot happening with either of them. Or with both there are too many possibilities or lines of thought that are possible.

For example, with one work Freud might be part of what's happening. And the history of psychoanalysis and the whole of the twentieth century. And imagining the whole process of how she got the cocaine might be a line of thought with the other work. And also wondering who was arrested for it and then wondering about the history of cocaine. And then you'd have to consider Freud being addicted briefly to cocaine because that would be part of the story of Freud and the story of cocaine. So almost any point of departure seems like banality and it seems an effort even to begin to follow any of it up.

But effort is part of art. What did that fluff look like? Like a shadowy feathery form, white on black, very simple as a drawing, delicate, nice; although in fact it was a photo rather than a drawing and and not fluff but some feathers from the stuffing of the couch that were carefully swept up and bagged by the artist and then photographed. So yes it was quite good, very contained and clear.

Sacred cows, publicity, hype

Damien Hirst is not a sacred cow of contemporary art like Viola or Kiefer because he is constantly attacked for crassness and they never are. He is a sacred cow of

Julian Schnabel
b New York, NY (USA), 1951
The huge prices commanded by this hero of the New York art scene led the media to treat him more like a pop star than an artist and by the time he was thirty-one he had already received a retrospective at the Stedelijk Museum in Amsterdam. With the dominance of other art forms in the 1980s, Schnabel brought about a resurgence in painting. Early works were abstract, but by the late 70s, figuration had crept in and Schnabel was presenting a Post-Modernist image of a fragmented world through collage, pastiche, the collision of high and low cultures, and by attaching shards of broken crockery to the surface of his works. Along with recurrent imagery of crumbling classical statues and columns, these introduce an archaeological theme reinforced by the layering of references to history, psychology, literature, art, cinema and the mass media. Perhaps informed by his Eastern European roots and a childhood spent in Brooklyn, Texas and Mexico, a blend of Pagan, Jewish and Catholic imagery creates a kaleidoscopic view of humanity. In 1985, Schnabel began an extensive series of paintings on tarpaulins, Japanese cloths and Spanish linen, and in 1996 he directed the film *Basquiat*.

Julian Schnabel
Prehistory: Glory, Honor, Privilege and Poverty 1981

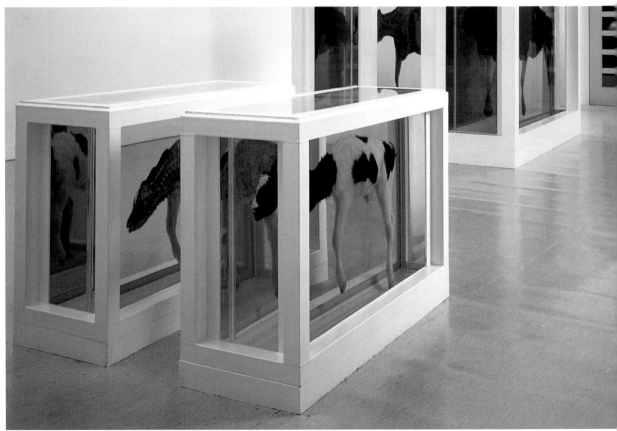

Damien Hirst *Mother and Child Divided* 1993

Andy Warhol
Cow Wallpaper 1966

cow art following Julian Schnabel's antlers on paintings and paintings on pony hide done in the early 80s and Andy Warhol's *Cow Wallpaper* done in the mid-60s.

Death is his subject but it is not expressed in a profound way but in a designer way because his death objects are supreme designer objects. But they really are good as designer objects and that's where the good idea lies. It's a good idea to make something look good if it's art. You don't have to but it's good if you do.

To say 'designer object' is to say that the aesthetic is a designer one. 'Designer' means nothing deep or profound is to be expected and all there is is that which can be grasped straight away. The appearance, the image, the atmosphere of the image, the visual intelligence.

Also, it's a good idea to bring medicine and art together. He makes packets of drugs on shelves look good.

All hype about Damien Hirst on a deep level is to be ignored but there isn't all that much anyway or what there is is not all that oppressive because the constant

Damien Hirst
Carbon Monoxide 1996

attacks on him and the values he stands for, by all sections of the art audience, balance it out.

Utter hype and contemporary art's utter connectedness to it is just a fact of life but it's still obvious when it is hype and it doesn't become the Bible or Nietzsche or Shakespeare or Iris Murdoch just because it's in an art context.

Interestingly, the second and fourth figures on this list, which frankly is an arbitrary one, both wrote about art and both died after losing their minds.

Arbitrariness

Arbitrariness is the bad or unsuccessful idea with Hirst's spin paintings. The colours, shapes and textures are arbitrary and hideous. But with his dot paintings a different kind of arbitrariness must be operating because these paintings look good. The spin paintings make any exhibition they're included in look like a carnival and a bad mess but the dot paintings make a sophisticated decorative statement and they dignify their surroundings.

They were painted with the aid of assistants, or entirely by assistants in many cases, apparently. Maybe they're all done by assistants now. But the assistants must have really entered into the original sensibility because the colours are always interesting and surprising.

Because of John Cage and chance and Jackson Pollock and drips, we have learned to value the arbitrary but we still care how things look because we don't want to be going round all the time being in pain.

Polke and Picasso

We must always be judging. It's part of looking. So Picasso is better than Polke. Really? Well OK, I don't know. It's hard to tell what's better or worse about the art of your own age compared to the art of a previous one.

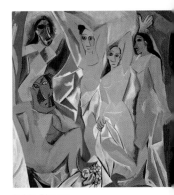

Pablo Picasso
Les Demoiselles d'Avignon 1907

Les Demoiselles d'Avignon is iconic. When you see it, it's got a lot of overlaid drawing that looks profoundly modern and the pleasure in the colour of the painting is always a surprise too. There are many different types of grey and a strong dark green, as well as the main pink, brown, earthy colours and mid-blue and white that are usually associated with the painting.

And there is relatively little black compared to Picasso generally. The outlines are mainly red, blue or white rather than black and the overall effect is very light and fresh. Some of the faces have a lovely sweetness and that's something else you forget about it.

But it's full of reminders of other stages of Picasso – the massive legs, the black, witty lines where there is black, the arbitrary distorted faces, the bodily forms made out of flared shapes and triangles, the many different ways of making space: the odd twists and warps and perceptual strangenesses in all parts of the painting

Sigmar Polke *Nicolo Paganini* 1982

and the resulting impression of an overall magnificent painterly intensity.

That's a catalogue of everything Picasso did throughout the century and all the Modern art that everyone else did in that broad vein up to whenever it was they stopped. So you can't say, 'Compare this historical icon with something in your own period', because an icon is always layered with everything you know about it and you can't go up to a Polke you've never seen before with that level of pre-knowledge.

However, Polke, a German artist born in the 40s who has recently become a sacred cow of American museum culture but who has enjoyed cult celebrity for a much longer period, will probably never quite, if at all, really describe us, because basically the world of representations or sign systems that he references is too thin for that. Even though, of course, he's giddyingly brilliant and a spaced-out pixie former commune-dwelling, top German acid tripper who deserves at least 51.5 per cent of his present worldwide reputation.

Higher beings

A Polke painting from the 60s with nothing in it except a black triangle has some writing in the bottom section of the canvas – painted in by a professional sign-writer – which reads: *Higher beings command – paint the upper right hand corner black!* This is a good joke on materialism and Post-War Germany and the idealism of abstract art, from Malevich's ideal of Suprematism as an art of pure feeling onwards, and the spiritual vacuum of commercial art. But it is not exactly an intense type of human content. It is human but not all that intense.

Moderne Kunst

Sigmar Polke *Modern Art* 1968

Sigmar Polke
b Oels, Lower Silesia (Germany), 1941

Throughout his career, Polke has positioned his innovative work as a humorous parody of the conventions of Modern art. In 1963, he launched what he called Capitalist Realism, a reaction to (and German form of) Pop art, making works such as *Biscuits* (1964), which elevated foodstuffs to the status of aesthetic signs in an exaggeration of Pop's concerns. *Higher Beings Command: Paint the Top Right Corner Black* (1969) attacked conventional ideas about innate creativity. In works such as *Crowd*, 1969, he introduced the pattern of 'Polke' dots, almost obscuring the image, that became his signature. Polke was one of the first artists to present incongruous subject matter, superimposing images, creating witty juxtapositions of high and low culture, appropriated imagery and found materials. *Dürer Hare* of 1968, for example, features a hare drawn in the manner of Albrecht Dürer nestling in a gaudy fabric. These works address questions of reproduction and authorship. In the 1980s he concentrated on process, making a series of large, gestural paintings that mixed traditional materials with dangerous toxins, which continued to react after the painting was 'finished'.

Salvador Dalí
Metamorphosis of Narcissus 1937

Hell coming up

Art is getting more and more relaxed into everything else because everything else is changing and there is no centre of certainty or centre of official ideas that everyone must obey. New ideas are everyone's domain now, not just art's. We go around with a troubled look though because hell is near.

Low Dung

Salvador Dalí is the lowest of the low, just dung that Chris Ofili should fix to a painting with resin. That's the basic idea of Dalí's status within Modern art. Teenagers and the uneducated revere him because of his sensationalism and love of detail. But he was a fake genius and only tried to get money. All the money in the world flowed to him. His burning giraffes with grasshopper legs and his hands with ants coming out the palms were only fake Modern and fake Freudianism.

'How do you like my new paranoic-critical method?' he said to Freud when he met him, showing him his painting *Metamorphosis of Narcissus* which he'd brought with him to Freud's house. 'Get outta here!' Freud is reputed to have said. Or something more Freudian but along those lines.

Dalí was fascinated by ocular trickery. He loved gadgets. He said, 'Painting will be

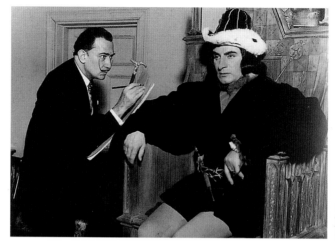

Dalí painting Laurence
Olivier during the
filming of *Richard III*
1955

Salvador Dalí
b Figueras (Spain) 1904;
d Figueras (Spain), 1989
Dalí is one of the best-known
twentieth-century painters,
partly due to his talent for
self-advertisement, partly because
of his bizarre vision. His work
has encompassed most of the key
styles of the century, including
Impressionism and Cubism, but
his admiration for nineteenth-
century realism, combined with
the influence of Giorgio de
Chirico (whom he met at the
Academy of Fine Arts in Madrid
before being expelled for
indiscipline), and later of Miró,
in Paris, led to his famous
dreamlike, hyper-realist paintings.
Developing a method that he
called 'paranoic critical' and
making paintings based on
Freud's theories, he was soon
embraced by the Surrealists, but
was eventually dispelled over his
support for Franco. Dalí was
obsessed with what was forbidden
by conventional society. His
grotesque paintings of chimeric
monsters, burning giraffes and
melting watches – often set
within a dusty Spanish landscape
– eccentric sculptures and
outrageous performances,
and his collaborations with the
filmmaker Luis Buñuel, throb
with references to sex, death,
defecation, and cannibalistic
violence.

stereoscopic or it will not be at all.' André Breton called him Elvira Dollars and expelled him from the Surrealist movement for becoming a fake Surrealist who only exploited the irrational for money. He went to America and was welcomed with open arms and given a lot of Hollywood backdrops to design.

He grew old and his wife Gala grew old too. How weird they both went in their old age! They got the hippies and playboys and playgirls all rounded up off the beaches at Cadaqués and round to Dalí's house to pose. Dalí masturbated over them, especially if they were transsexuals, his favourite, and Gala took the cleanest, pertest, most 70s daytime TV soap opera-looking young men as toyboy lovers.

Dementia set in. They were both as mad and frazzled and decadent as each other.

Gala, a former raging beauty, lover of poets, had her own castle. Dalí could only come round if he wrote first requesting an audience. 'Bring money for toyboys,' she would reply.

He couldn't stay away from the cameras, doing his mad act, appearing in ads for chocolate. 'Salvador Dalí,' he would say. 'Myself,' he would go on, 'is very rich!' The reporters and cameras would all gather round. 'And I love tremendously money and gold!'

He tells the camera in one film from the 70s that he's about to paint a butterfly. Or 'butterflyeeeee' as he suddenly screams, genius-style. He looks down from a wooden scaffolding leading up to a mural on the ceiling, showing his own giant self towering upwards, soaring toward a Renaissance vanishing point, the soles of his bare feet enormous in their foreshortening, his moustache far away, near Heaven, and he announces: 'Dalí sleep best after one day of work receive one tremendous quantity of cheques!'

Now it's another film. Moustaches whirring, genius eyes rolling, mouth open wide, chocolate going in, outrageously amplified masticating sounds crashing forth, and suddenly Dalí's voice-over in French as broken as his English: 'Je suis FOU le chocolat LANVIN!' And then in another film he's fighting giant white sperm bubbles with a walking stick. Unless it's an ad for milk.

He appears like a burning genius in all his publicity appearances except possibly the last few, and particularly the very last one where he's practically dead, with tubes hanging out of his nose, and sight-seers and tourists and reporters are gawping at him, and the Christian concept of Hell now suddenly seems very real. But still he weakly gasps out cheers for Spain, Catalonia, the King and himself before being whisked away on a tube-strewn hospital trolley by sinister minders.

Before this point he got more and more mad and ill and Gala had him on a steady diet of pills. Tranquillisers to shut him up and stimulants to give him the energy to sign blank sheets of paper for fake Dalí's to be printed on, for more money to be made, to line the pockets of who knows who.

Then Gala died and Dalí went down to the fiery pit next, in 1987, after first catching his leg on fire by accident one night in his lonely bedroom. And now he lies in his tomb under the floor at the Dalí museum in Figueras, tourists walking on top of him, not even knowing he's down there. They look out to the courtyard where dozens of tall mock Neo-Classical sculptures are set within the high walls, each one an identical waving Hollywood Oscar.

Dalí posing in front of a photograph of José Antonio Primo de Rivera, founder of the Spanish Fascist Party 1974

I'd like to say a few words

'I'd like to thank my dentist,' Damien Hirst is saying on TV in a close-up shot, live from the Tate Gallery on the Turner Prize platform. 'The winner is' – 'Joan Bakewell starts her announcement, and then so does Agnès B and then Brian Eno – 'Rachel Whiteread!' 'Douglas Gordon!' 'Gillian Wearing!' They all come up and get their cheques and say a few words. 'Such is the culture we live in,' Rachel Whiteread is saying. 'Thank God!' says Chris Ofili. 'Where's that cheque?' he laughs. 'Yes! Yes! Yes!' cries Dalí standing in the French windows in his little house in Spain, his mad act of then joining in with ours of now.

Laurence Olivier

The fishing boats lie on the beach at the little town of Cadaqués in Spain where Dalí lived. The waves lap on the beach. The house is white. The town is full of hippies and tourists. In Gala's former dressing-room the white walls are lined with pictures. Not Dalí's Surrealist ones but framed black and white 10 x 8 photos, the pictures that express Dalí's cult of celebrity – showing scenes of Dalí with Picasso and Jacqueline, Dalí with Laurence Olivier, Dalí with Gregory Peck, Dalí with Ingrid Bergman, Dalí with the Mayor of Figueras, Dalí with General Franco, and Dalí with someone who appears, unbelievably, to be Gandhi.

Dalí standing next to *Soft Self portrait*
c. 1940

Peter Davies and the horrible sight

In a spiritual mood, it would be horrible to see Peter Davies' *The Hip One Hundred*, a very wide painting at the Saatchi Gallery showing nothing but a list of artists' names with numbers beside them and a one-liner description of what the artists do.

For example, 'Bruce Nauman' at Number 9 and the description 'double no.' And at Number 8, 'John Currin – big tits and beardy blokes.' At Number 56, 'Jeff Koons – giant flower power puppy.' Rodchenko is above Warhol and Beuys, Bridget Riley is after Gary Hume, Michael Craig Martin is after Bridget Riley.

What kind of order is this? Who are half these artists anyway? Where are Georges de la Tour and Tiepelo and Chardin? Help, it's contemporaneity! The raw now. Not even a deconstruction of now or a post-structuralist now. At least you wouldn't be able to understand that and you could be angry with it and want to hit it. But this is all too understandable. The gossip of insiders made into art. In fact, not made into art because gossip can't be art. It's short-circuited as art. It doesn't make it as art. It falls short. It doesn't even aim in the first place. It's aimless. It's the hip one hundred but it could be any one hundred because the hip is always changing. That's why the hip is shallow and low. In fact before this painting was finished it had already changed. It was only a fleeting impression of the hip, not a Neo-Classical monumentalizing of the hip, the hip fixed for all eternity, or the hip

THE HOT ONE HUNDRED

#	Artist	Description	#	Artist	Description
1	BRUCE NAUMAN	ALMOST all of it (90-95%)	51	TITIAN	Any featuring monsters/dragons
2	SIGMAR POLKE	Paganini	52	JEAN DUBUFFET	Grungier ones
3	MIKE KELLEY	More love hours than can ever...	53	DAVID SALLE	Porno ones
4	RICHARD PRINCE	Biker Girls/Jokes/Hoods	54	FIONA RAE	Whatever she's just done
5	ANDY WARHOL	Brillo boxes - Jackie O	55	KAREN KILIMNICK	TV Film Bad portraits
6	DONALD JUDD	Perspex + Metal Wall Pieces	56	RICHARD ARTSCHWAGGER	Formica Furniture
7	J.M.W. TURNER	Little boat in storm at sea	57	JEFF KOONS	V. Big Sculpture, New paintings
8	BRIDGET RILEY	B+w op art lines	58	ANDREAS GURSKY	MONTPARNASSE
9	KASIMIR MALEVICH	Monochromes	59	LARRY CLARK	Tulsa
10	MARCEL DUCHAMP	Fountain	60	ROSS BLECKNER	concentric circle white dots on black
11	JOSEPH ALBERS	Homage to square - colours	61	MICHAEL CRAIG-MARTIN	Biggest, brightest wall draw...
12	AGNES MARTIN	Small rectangles - subtle colours	62	DANIEL BUREN	stripe constructions
13	PIET MONDRIAN	severest Hardedge stuff	63	RACHEL WHITEREAD	House
14	JASPER JOHNS	Flags + Alphabets	64	B+H BECHER	Water Towers
15	SOL LE WITT	Wall drawings	65	LAWRENCE WEINER	Letters carved into wall
16	ELLSWORTH KELLY	V. big squares of colour together	66	GARY HUME	Both Figurative + Doors
17	THOS. GAINSBOROUGH	Bad early Portraits	67	ROBERT SMITHSON	Hotel Tape/slide
18	MARK ROTHKO	Seagram Murals	68	NAN GOLDIN	Transvestite photos
19	ROBERT RYMAN	white on white !!	69	DUANE HANSON	Jogger + townsp...
20	FRANK STELLA	Grey line paintings	70	CINDY SHERMAN	Pigs snout
21	GILBERT+GEORGE	As themselves - shitt cunt	71	FELIX GONZALEZ-TORRES	Dancing queen + light bulbs
22	SEAN LANDERS	Text	72	ED RUSCHA	Funky wood paintings
23	WILLIAM HOGARTH	Paintings not etchings	73	FISCHLI + WEISS	Carved studio junk
24	JACKSON POLLOCK	Long brown 'stiful' ones	74	ANDRES SERRANO	Ku Klux Klan Pics
25	BARNETT NEWMAN	V. Big e.g. Voice of Fire	75	DAN FLAVIN	Circular Striplight arrangement
26	GERHARD RICHTER	Baader Meinhof	76	CHARLES RAY	Mannequins + Firetruck
27	JEAN MICHEL BASQUIAT	Miles Davis Play List	77	RICHARD DEACON	Varnished cardboard with triangle
28	DAMIEN HIRST	shark + Dots	78	KIKI SMITH	Wax one from 'Somewhat Mad...'
29	EL GRECO	Light on Face of Monkey	79	JOHN CHAMBERLAIN	Car Crash Sculptures
30	JULIAN SCHNABEL	Plates + Sail cloths	80	THOMAS RUFF	Single Portraits Head + shoulders
31	HOWARD HODGKIN	Frames	81	ANISH KAPOOR	Shiny Metal + Disney Mountains
32	NIELE TORONI	Dabs on wall installations	82	RICHARD SERRA	heavy Metal
33	CY TWOMBLY	scribbles (Lot of it the same)	83	VICTOR VASARELY	Circle + Square coloured OP
34	WILLEM DE KOONING	More abstracted less figurative stuff	84	LOUISE BOURGEOIS	Shiny bronze phallic stuff
35	JONATHAN LASKER	When doodle's big on plain backgrd	85	ED KEINHOLZ	That bar you could walk into
36	LEON KOSSOFF	Swimming Pools	86	RENE MAGRITTE	Not his Pipe
37	CHRISTOPHER WOOL	Text with swearing - single words	87	RICHARD PATTERSON	Thomson skagging + Moto crosser...
38	JOHN BALDESSARI	Hand Pointing + Instructions	88	NAM JUN PAIK	T.V. Pyramid with J. Beuys
39	GEORG BASELITZ	Upside down - white + yellow cheeks	89	ALLAN McCOLLUM	Plaster Surrogates
40	PHILIP TAAFFE	More B+w/B+ colours op Art ones	90	ALEX KATZ	V. big womens heads
41	JOSEPH BEUYS	Talking to Hare/Rabbit?	91	PAUL McCARTHY	Bossie Burger
42	BRICE MARDEN	Earlier Hard Edge strips of colour	92	MARTIN KIPPENBERGER	As a whole
43	PETER HALLEY	More the conduits than cells	93	EVA HESSE	Translucent Wall hang/lean th...
44	CLAES OLDENBURG	Soft Sculpture + bedroom	94	FRANCIS PICABIA	Realist nude women
45	JEFF WALL	Steves Farm + Nosebleed	95	STEFAN BALKENHOL	Tall Figures with carved plin...
46	ROY LICHTENSTEIN	Brush strokes	96	JESSICA STOCKHOLDER	When Wall is ripped out
47	MORRIS LOUIS	Corner Drips	97	MILTON AVERY	Coastal scenes
48	JULIAN OPIE	sculpture + wall drawing together	98	SARAH LUCAS	Sod You Cits, eggs, kebabs etc
49	JOHN McCRACKEN	Planks	99	IAN DAVENPORT	Fine Line bright colour ones
50	CHUCK CLOSE	Recent Big portraits (Not realist)	100	IVAN HITCHENS	bolder brush marks (touching...)

Peter Davies *The Hot One Hundred* 1997

after Poussin. And it was only the hip for one person anyway. It was a subjective view of the hip. Of hipness. And he hardly believed it anyway. Or only believed it for ten minutes. Not even fifteen minutes. The legal time limit on fame. It followed another painting like it called *The Hot One Hundred*, where Bruce Nauman was Number One instead of Number 9.

'I thought he was a really influential artist,' 27-year-old ex-Goldsmiths student Davies says, up in his studio, surrounded by new half-finished paintings of imitated colour abstractions, vaguely Frank Stella/Bridget Riley/Ken Noland, from a vague past world when colour abstractions had a different meaning.

On a desk a postcard advertising a Davies show in a gallery in a pub in Bethnal Green shows a lot of coloured shapes that look like they've been drawn on a canvas with a felt pen and then filled in, which they were. Above it, on the wall, another postcard shows a work by the New York painter Christopher Wool — stark capital black letters arranged on a vertical white ground: IF YOU CAN'T TAKE A JOKE GET THE FUCK OUT OF MY HOUSE.

'In terms of the last ten years and this current generation of British artists that was well known at the time I made *The Hot One Hundred* — in 1997 — I thought Nauman was the most important artist. But also, I wanted the feeling of saying: This is the most important artist in the world. Period. So that's like now and forever. But by the next week I might have been thinking: Well, no actually. Maybe he's not. And by the time I'd finished the painting a month after I started it, I was already thinking: Well, this person should be higher, this one should be lower — I can't believe that one's in there at all!'

This is an anxiety about what the now really is, or where it really is, its precise point before it slips away. It would be frightening if it wasn't funny. The blue sky and infinity, life and death, Zen calm, Goethe and Heidegger — these are all important, but not celebrity and hype and the artistic pecking order.

In fact on a list of a hundred important things about existence, celebrity and hype would be where Piero Manzoni is on Davies' *The Hip One Hundred*. That is, about half way through, somewhere under Gillian Wearing. But nowhere near as high as even Number 9, Bruce Nauman, because as issues they are not burning enough as far as existence is concerned, although, on the whole, they are probably more burning than we might care to admit. And actually any bit of urgency will do probably when it comes to looking for inspiration. Even the urgency of Sean Landers' paintings of words and his videos of chimps painting. When Davies first emerged he seemed to be celebrating Sean Landers or copying him. Then suddenly in Lot 61, the new media hang-out in New York, there was a huge new Sean Landers on the wall with a tiny patch of characteristically mis-spelled text in the middle somewhere, reading: 'Hey English guy whose copying my work and nameing me as the greatest artist. Thanks and youre right but youre eating into my profits.'

Peter Davies
b Edinburgh (Scotland), 1970
Davies became known for his trainspotter-like, large-format paintings, which present hierarchical lists of artists' names. *Text-Painting*, 1996, is a horizontal league-table of his favourite artists, and why he likes them, executed in childlike, multi-coloured letters. Tellingly, it begins with Sean Landers, his nerdy American hero. *The Hot One Hundred* (1997) and *The Hip One Hundred* (1998) continued this theme by cataloguing his all-time greats and living heroes respectively, this time presented in the form of charts. These works comment on the human desire for 'genius', and the urge to catalogue and analyse. They also address the fickle nature of celebrity — even Davies may have changed his mind about the relative importance of his mentors by the time he has finished the work — and play with the formal qualities of colour. Both of these concerns are pursued in more recent works, which revisit Bridget Riley's Op art of the 1970s or the works of Frank Stella, in the form of bright, geometric, optically disorienting mosaics of colour.

Sean Landers
Singerie: Le Peintre 1995

'You could ask who's the most important artist of the twentieth century, Picasso or Duchamp?' Davies is musing now. 'And no historian or academic or anyone will ever agree on who it is. And yet there's a sense in a kind of faddy way that there really is an artist of now. You might get an artist who emerges really quickly like Sean Landers, say, a fantastic artist who makes all kinds of different work that really sums up the world now. But you know these artists come and go. So in a way there might have been a point when Sean Landers really was the most important artist in the world. But when was that point exactly?'

Profits, hype, competitiveness, noticeability – it's a long way from Iris Murdoch.

The Iris within

What did she want anyway? She wanted art to be pictures of who we are, mirrors of our being, like the European art in the museums, a chronicle of ourselves – 'We too are like that.' But instead it was all just 'Minimalism, happenings, abstract paintings, designs designed to invite completion by provoked clients, natural objects or artifacts offered as works of art, ambiguous entities posing the question: "Is this art?"'

Art was based on language now, Iris Murdoch thought, and the meanings within language. And it was all scepticism. It was sceptical of the past and anything that could be intuited as transcendent and anything that might exist separately in its own right outside of language. It was just expressions of the ephemeral or of the deliberately incomplete. And it was all a loss like the loss of grammar and good prose.

Jeff Koons
b York, PA (USA) 1955
Before becoming a
super-successful Neo Geo
artist in the 1980s, Koons was
a super-successful stockbroker
who used his earnings to
produce his first works: a series
of pristine vacuum-cleaners,
each encapsulated in a clinical,
neon-lit vitrine (*The New*, 1980).
The Equilibrium Tanks, basketballs
suspended in water, followed in
1985. Koons went on to produce
kitsch, large-format sculptures
that were exact, scaled-up
replicas of trashy ornaments,
made in wood or porcelain by
craftsmen. In the gallery context,
they represent an elevation of
the everyday object to the status
of icon. This recognizes the
dominance of consumer culture
in the twentieth century, and
raises questions about the value,
authorship and originality of the
artwork. Koons continued this
blurring of art and life, high and
low, by recording his union with
the Italian porn-star La Cicciolina
in a group of massive, explicit
photographs and glass sculptures,
prettified by butterflies and
flowers. He is now working
on *Celebration*, a large-scale,
multi-media project for New
York's Guggenheim Museum.

When did the now start?

In the 80s it started to become quite widely accepted that everybody expected to live an ideology-free lifestyle. And artists did too. And coinciding with this general mood was the rise of a new official super-preciousness that the leaders of the international art world had as their way of thinking and talking and being. Perhaps in the past the leaders were fanatically politically ideological or fanatically aesthetic, for example, depending on the era. But now they were fanatically delicate and that was the new ideology. Also the 80s saw the rise of corporatism, and preciousness seemed to fit with this.

So nowadays Modern art museum curators who rose in the 80s write the catalogue introductions to their corporate display exhibitions in a super-precious way. How moved they were by some drips they hadn't noticed before in a Jackson Pollock and how moved they were by a blurry scene in a video and how it reminded them of something else blurry they saw once in *Hiroshima Mon Amour*, or maybe they read about it in a novel by Alain Robbe-Grillet.

Smile

Jeff Koons is a well-known artist of the 80s who is often condemned for being a symbol of everything bad about that time – its artificiality, commercialism, corporatism, shallowness. And from this perspective there's not much that could be said to save him from the guillotine. I personally feel he is good though. His style of talking has a gliding feel about it, with a lot of inaccuracy in the use of prepositions, and the meanings and references and concepts just come up however they like and that's refreshing.

The bourgeoisie, the aristocratic, the objective realm, banality, sexuality, advertising, the media, God, love, society, a position of weakness, a position of strength, right now, puppy, embrace, humiliate – these are his often-used words and phrases. He only picks the ones that already have a good feel about them.

In the 80s he saw banality everywhere and he thought it should be embraced like a cuddly kitten. He saw art as equilibrium, as everything levelled. It was something people should love like they loved anything – like babies and sunshine and smiling. And it turned out to be quite a strange and unpredictable idea, after all, to think about what people actually want and then try to give it to them. Not from a Hollywood position but from a position of extreme avant gardism. So when they get it they're horrified.

Our dreams

Koons has not been talked about much for a few years but now he's back. He's been given the job of being our society's Michelangelo – given millions of dollars by a consortium of dealers in Germany, America and London to take years to produce the paintings and sculptures that will make up his *Celebration* exhibition, as yet still to be completed.

Jeff Koons *Amore* 1988

It will be art that expresses society or expresses the collective unconscious, our dreams, even if we don't know we're dreaming them and in fact never dreamed of dreaming anything like this. Normally we dream about buried bodies that someone's going to be finding soon – if only we'd buried them better! Or teeth falling out, or the roof leaking, or not being able to pay the therapist.

Not so much giant mild kittens and flower puppies, cakes and flowers, bows tied in heart shapes, brightly coloured Play-Doh, children's games of tying the tail on the donkey. Or colossal, sexy, metal balloon dogs.

Good dog

Whatever Koons' *Balloon Dog* allegorizes or dreamily expresses I don't mind because it's a good dog, very big, the size of a room, an impressive monumental sculptural arrangement of big, nice, steel, shiny bulbous tubes. Cast in an edition of three, there is one standing in a room now, in a collector's private gallery space in LA. It has a pert shiny tail at one end and at the other the beautiful – it now appears – complicated roseate thingummy that happens when you tie up a balloon. All the surfaces are mirror-reflective, showing not so much society's unconscious as lots of distorted reflections of some of Koons' new wall-size Neo-Pop paintings of cakes and ribbons and stuff, hanging in the same room.

His new paintings are his Sistine Chapel ceiling. They appear slowly from year to year in bits, a painting here, another there, one or two seen in a magazine maybe, but the promised show of all of them all together keeps having its deadline extended because they can never be quite perfect enough.

It's like *The Agony and the Ecstasy*, with the Pope played by Rex Harrison always calling up to Michelangelo, 'When will it be ready? When will it be ready?' And Michelangelo, played by Charlton Heston, calling down 'Soon! Soon!'

Flower power puppy

Another Koons doggy can be seen in Spain at the new Guggenheim Museum in Bilbao, a puppy made of flowers, standing taller than a five-storey house.

'*Puppy* has 60,000 live growing flowers,' he says. 'And it has a hundred and fourteen separate irrigation and fertilization systems. So the technology of it is very sophisticated. But with this work I wanted to make a piece that people could really just feel a sense of warmth which has to do with the relationship with God. One of the important parts about *Puppy* is the sense of exercizing one's control where one can: choosing the heights of the plants and the richness. But after that, it's out of everyone's hands. It's in the hands of Nature then. Some plants are going to shoot off this way, others are going to start to dominate and so on. And the public has really taken the piece to heart. I'm told by many people it's like their Statue of Liberty.'

Bruce Nauman
One Hundred Live and Die 1994

LIVE AND DIE	LIVE AND LIVE	SING AND DIE	SING AND LIVE
DIE AND DIE	DIE AND LIVE	SCREAM AND DIE	SCREAM AND LIVE
SHIT AND DIE	SHIT AND LIVE	YOUNG AND DIE	YOUNG AND LIVE
PISS AND DIE	PISS AND LIVE	OLD AND DIE	OLD AND LIVE
EAT AND DIE	EAT AND LIVE	CUT AND DIE	CUT AND LIVE
SLEEP AND DIE	SLEEP AND LIVE	RUN AND DIE	RUN AND LIVE
LOVE AND DIE	LOVE AND LIVE	STAY AND DIE	STAY AND LIVE
HATE AND DIE	HATE AND LIVE	PLAY AND DIE	PLAY AND LIVE
FUCK AND DIE	FUCK AND LIVE	KILL AND DIE	KILL AND LIVE
SPEAK AND DIE	SPEAK AND LIVE	SUCK AND DIE	SUCK AND LIVE
LIE AND DIE	LIE AND LIVE	COME AND DIE	COME AND LIVE
HEAR AND DIE	HEAR AND LIVE	GO AND DIE	GO AND LIVE
CRY AND DIE	CRY AND LIVE	KNOW AND DIE	KNOW AND LIVE
KISS AND DIE	KISS AND LIVE	TELL AND DIE	TELL AND LIVE
RAGE AND DIE	RAGE AND LIVE	SMELL AND DIE	SMELL AND LIVE
LAUGH AND DIE	LAUGH AND LIVE	FALL AND DIE	FALL AND LIVE
TOUCH AND DIE	TOUCH AND LIVE	RISE AND DIE	RISE AND LIVE
FEEL AND DIE	FEEL AND LIVE	STAND AND DIE	STAND AND LIVE
FEAR AND DIE	FEAR AND LIVE	SIT AND DIE	SIT AND LIVE
SICK AND DIE	SICK AND LIVE	SPIT AND DIE	SPIT AND LIVE
WELL AND DIE	WELL AND LIVE	TRY AND DIE	TRY AND LIVE
BLACK AND DIE	BLACK AND LIVE	FAIL AND DIE	FAIL AND LIVE
WHITE AND DIE	WHITE AND LIVE	SMILE AND DIE	SMILE AND LIVE
RED AND DIE	RED AND LIVE	THINK AND DIE	THINK AND LIVE
YELLOW AND DIE	YELLOW AND LIVE	PAY AND DIE	PAY AND LIVE

The nice, the mild, the monumental

What Koons' art says is: 'Here's the ephemeral, the temporal, the fragile, the kitsch – and here it is carved in stone.' And in fact it's a surprise to see it like that. It's not the colours and surfaces, nice as they are, but the scale which is the striking thing about his art – the monumentalizing of the utterly inconsequential.

Come in Number 9

Bruce Nauman. What an excellent surname for this chapter. Words sentient with loaded meaning are his medium. His art is aphoristic and striking and funny and he uses blunt, everyday, American-type short-hand language as if it were Latin phrases in important literature. It's an art connected to some kind of idea about the human condition. But what is the idea? Perhaps that the human condition is very dark.

In fact, it never seems all that convincing as an idea and there is something else about his genuinely striking art that makes it striking, some distance he puts between himself and the idea of what it is to be human and have feelings. He comes up with words and phrases that seem to describe life or existence. Then he sometimes puts them in lists, so it's like the human condition spelled out as a list.

Bruce Nauman
b Fort Wayne, IN (USA), 1941
Without the example of Bruce Nauman, it is difficult to imagine the current landscape of contemporary art, especially in the areas of Body art, video and performance. As a student of painting in California (1964–6), Nauman was impressed by Man Ray's focus on ideas, not media, which now characterizes his own, wide-ranging work. He became a prominent member of the West Coast art movement, passing through a brief phase of subversive Funk art before embarking on his Conceptual sculptures, wax body casts and holographic self portraits. His Beckettian films recorded repetitive performances in which he stamped in the studio or played one note on the violin. During the 1980s he produced a number of animal sculptures and a long series of puns, linguistic experiments and neon text works inspired by Wittgenstein. Amongst his most powerful films are the 'Clown' videos, in which he performs ritualistic, repetitive actions and emotions, exploiting the ability of the clown to be simultaneously funny and discomfiting. These are often included in Nauman's ambitious installations, which corral all the elements of his work – spoken and written language, film, video, and performance – into a hard-hitting, superbly choreographed experience.

But there are lots of other forms as well that he uses. Words are spoken or droned or shouted across a gallery or whispered in a room or set in neon, or printed in ink or drawn in charcoal. Or simple images are dramatically animated – TV monitors on the floor with some cages and lights show real rats in a cage. Other TV sets in stacks or hanging in the air or standing singularly on plinths show people fighting or falling over or spinning and groaning or calling out stark propositions about sucking and dying. Psychological traps or loops or hells are shown on little monitors or giant screens or combinations of both.

Whatever the point is it isn't the ineffable, the deep, the inexpressible, but the sayable and the believable. And matching them up in a dramatic but minimalistically pared down way that leaves them still a bit disconnected.

Sucking and dying

In Nauman's film installation *Anthro/Socio (Rinde facing camera)*, 1991, shown in 1998 at London's Hayward Gallery as part of a retrospective of his work, a giant bald-headed face, twenty-feet high maybe, repeated on different screens, calls out phrases in an operatic drone. The drones are overlaid so the phrases can only be made out in bits and it is only after the viewer has been standing around for a while within this installation that the whole set of words that makes up the repeated phrases can really be heard.

The same droning head on different screens seems to flicker into action because the film is edited in jump-cuts. One of the heads is upside down, another one isn't, then they're both the right way up. Close to, the head is all multi-coloured dots on a film screen, quite nice in themselves.

The mouth opens, four-feet wide, out comes the drone but from a speaker somewhere else. 'Feed Me,' another head drones, 'Feed me.' The same head upside down drones 'Feed me.' And on small TV monitors it's droning 'Feed me' too. But by now you can hear 'Eat me' in there as well. It's a big droning Modern art opera, seductive, beautiful, the apotheosis of video art and definitely giving video art a good name and a bit of museum dignity. 'Feed me Eat me Anthropology, Help me Hurt me Sociology.'

This droner is an opera singer, the 'Rinde' of the title. The clown in *Clown Torture*, 1987, another video, is an actor. 'Oh!' he says in a dismayed childish way, as if something didn't add up. Then he tries out a little saying: 'Pete and Repeat were sitting on a fence, Pete fell off, who was left?' 'Oh!' Then he tries saying it quicker in case the answer might come out differently and then it goes on and on, the repeats and the groans of despair. And you can hear the cries of 'NO NO' all through the rest of the gallery, merging with all the other groanings and shoutings.

SUCK AND DIE, STAND AND DIE, KILL AND DIE, COME AND DIE. There is a wall of many variations on these three-word sentences set in coloured neon lights in four vertical rows near the entrance to the exhibition – variations on two verbs

and an AND. When he was young he played guitar in a jazz band and studied engineering and he was impressed by the notion of the elegant solution in mathematics. And his art works always have a rough and ready look but a wittily tailored look too. And they have a coded look and they look as if they might be solving some kind of problem. With this one, one sentence flickers on in white, then another one in blue, then more in other colours, then they're all on, blazing away, with the sound of the wires buzzing and hissing. Leaving art school, he paced about his studio in Pasadena, not knowing what to do next to make art, seeing the messes on the floor, watching the neon beer sign across the road flickering on and off.

'This must be life then,' he probably thought. 'Make art from it!'

Corny heads in void

Nauman certainly can be quite corny with his waxy heads all spinning in a void and stuck upside down on each other, like it's an Existential hell. But like Samuel Beckett, he is dryly humorous. Only not all that like him because he is not loquacious and slippery and poetic as well as dryly humorous. He repeats and repeats and makes meanings go blank and then animates the emptiness in a witty way. And he uses colour in a witty way too, so it seems like colour-coding rather than colourism, although of course you never know what the code is or if it's really a code.

All over the world his works fill out celebrated private collections. In the basement at the Eli Broad Foundation in LA, one of his circles of wax heads hangs in

Bruce Nauman
Ten Heads Circle/Up and Down
1990

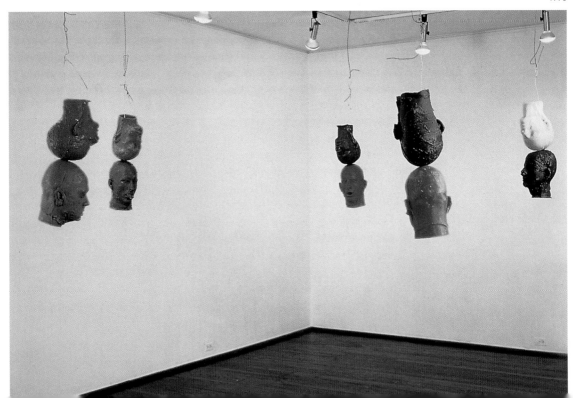

space at this moment, surrounded by large-scale colour photos by Cindy Sherman. Staged Shermans surrounding spinning Naumans. The heads are in sets of twos, one upside down, one the right way up, the two skulls meeting. Each one is a waxy, transparent 'off' colour. A waxy, ivory-yellow bald head on a liverish-grey one. Orange on brown. Pink on pink. Grey on pink. Pink on pink-orange or flesh.

The eyes are closed, there is still stuff up the nose and in the mouths and ears to keep the plaster out during casting, the finish is rough. The pulled-down expressions are like the expression on William Blake's death mask, all doomy. Frozen, waxy, lollipop Existentialism, creepy and camp, a bit voodoo and silly. The Cindy Shermans surrounding them show dirt-covered, waxy dead faces with wispy, peroxide wig hair, or fragments of plastic bodies in science fiction goo, and the contents of horror film prop baskets.

More time

Time. There's nothing we can do about it. There's no use complaining. A film screen as big as a room shows an image of the actual room that it's as big as – a real prison cell, filmed in real time for ninety minutes. A bunk, two beds, chairs on the beds. A locker. Some heating pipes. A barred window. And a timecode on the screen. It ticks off the seconds, with the fractions of the seconds whirring by very fast.

The film is a live feed running into an art gallery. The sounds heard are doors opening and closing and many overlapping echoing voices, not violent particularly but keeping up a continuous medium-level racket. The time runs out when the cell is needed for a new prisoner. It's some art by Darren Almond, an artist in his late twenties. He makes live relays of situations. Empty rooms with the clock ticking. You can't get any more now than that.

So it's not a modern version of Van Gogh's prisoners going round a courtyard then?

'No,' he says. 'It's very specific. I wanted the cell to be empty in a working prison. I didn't necessarily want to focus on somebody's personal tragedy.'

Another film shows the artist's studio – a drawing table, an electric fan unplugged, a swivel chair, a radiator, and a clock.

'It was set up by the BBC from my studio. And it was broadcast via a very complicated set of satellite dishes all around London to a disused shop in Exmouth Market in the East Side of London to my studio in the West. It was a still shot of my studio. In the middle of the frame, on the back wall, was an industrial flip clock. The microphone was inside the flip clock. So every minute, you saw this life-sized image of my studio and then crash! – over came the time! You'd wait and wait and wait and then smash!'

So it's all pretty interesting. He says he could do it anywhere, in an operating theatre, for example, 'where you could watch someone die!' Crikey! Or on the moon.

'The next satelite link is going to be the moon. It's probably going to be in California but the moon will be the clock, because time begins with the moon.'

Darren Almond
b Wigan (England), 1971
The relationship between space and time is central to Almond's work, often represented through trains and clocks, the machines that attempt to negotiate these concepts. In *Schwebebahn*, 1995, Almond filmed Wuppertal's 20-km, inverted monorail. By slowing down and reversing the footage so that the train appears the right way up but everything else is upside down, he created an eerie distortion of temporal and spatial perception. *A Real Time Piece*, a live, 24-hour video relay of film of Almond's studio, led to *Tuesday (1440 minutes) (with clock)* (1996). For this work he took a photograph every time the clock in his studio flipped over to the next minute, laying out the 1,440 images representing a whole day in a sequential grid. In *HMP Pentonville* (1997), time and space converged again in footage of a claustrophobic, alarmingly noisy cell, satellite-beamed from Pentonville Prison to the ICA, giving an immediate, disturbing taste of the experience of 'doing time'.

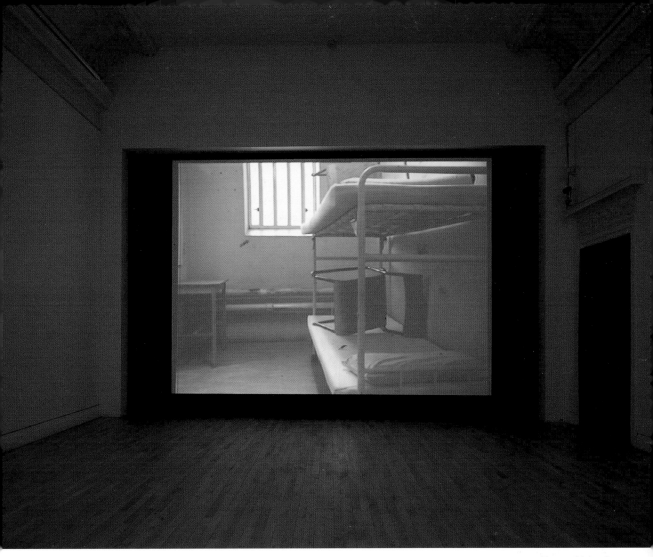

Darren Almond
H.M.P Pentonville 1997

Real reality

Real-time art about doing time, until reality sets in and a new prisoner arrives or the patient dies and the art has to stop. Reality is what new art has to adjust to. It's adjusting all the time. It's working overtime to keep up.

Jaunty and Maine and Courbet

One thing that still exists, though, is painting. Thank goodness! Painting with palette knives and brushes and linseed oil and turpentine. John Currin is a good example of painting never dying. Or a devil sent to torment the *Moral Maze* panelists on Radio Four. He paints like Courbet but in a way that seems 100 per cent kitsch. But being unreal, the paintings are quite funny about what society often seems to want from

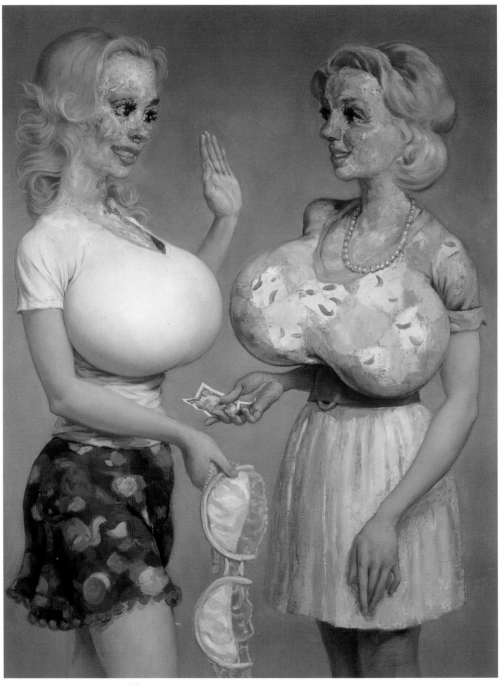

John Currin *Jaunty and Maine* 1997

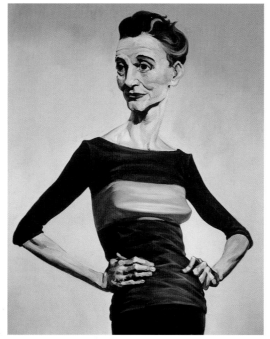

John Currin *Ms Omni* 1993

the art of museums, even though society might not admit that something so low as big breasts might be so high on the agenda.

Jaunty and Maine, 1997, features a spectacular meeting of busts. The heads of the two figures are vigorously modelled with a lot of skilful palette knifing, like the modelling of rocks in a Courbet landscape only not grey and green but livid flesh-coloured, while the flat, red background is post-60s American abstract style. The bottoms are as exaggeratedly rounded and solid as the busts. And there are even some symbolic gestures for the imagined art lover not to bother interpreting: Jaunty or Maine holds out a dangling bra to Maine or Jaunty, while Maine or Jaunty holds out a fluttering dollar bill to Jaunty or Maine.

Other paintings show a recurring male figure that looks like a jazzy swinger or an intellectual arty type. *Entertaining Mr Acker Bilk* is the title of one of these weirdy beardies. Sometimes the figure is accompanied by blondes who stand for art or loveliness or sensuality or Nature or who are just painterly, cartoon, kitschy bunnies.

The paintings are like amplified caricatures or cartoons of stereotyped experience. You don't have to do any work when looking at them. It's quite unusual to have that in a contemporary art context. Usually you have to do a lot of work yourself because that's the contract between the art work and the viewer. Here it's all done for you and you can relax with a cigar.

John Currin
b Remscheidt (Germany), 1965
The early paintings of New York-based John Currin include a series of portraits of teenage girls based on photos taken from a high-school yearbook, reduced to a set of uniform, characterless images with empty, black eyes. He has continued to investigate stereotypical representations of different social groups in subsequent series, including a group of paintings of older women, caught between icy glamour and touching vulnerability. His more recent works feature bearded, middle-aged men, sportily dressed in country casuals, the implausible idols of wide-eyed, busty young blondes. Initially, these conjure a male fantasy of compliant, pneumatic femininity, but Currin is taking an ironic look at the relationship between the sexes, and the clichés of gender. This irony is underlined by the way in which he caricatures his subjects, rendering their skin-tones in heightened colours that would be at home in a Rococo painting but are quaintly anachronistic in a work of contemporary art.

'Yes,' says Currin. 'It's like having narrative in the movies – instead of making a Godard movie, making a Hollywood movie. It's going to appeal to more people. And therefore it's going to be considered low brow and obvious, not as smart, more right wing – it's going to have all those kind of associations.'

What are the associations of *Ms Omni,* painted in 1993?

'A menopausal kind of woman, cultivated, a member of an elite. In other words, the kind of person that would look down on my work at the time I was making it.'

What kind of painting would he say the more recent *Jaunty and Maine* was?

'Partly, this painting was meant to be less subtle, obviously, than my other work. In a way to kind of ruin the premise – to consciously start out with a failed irony, or to take the stance of a failed bad boy. It would be so much of a lame joke. You tell the big joke, nobody laughs and there's this awful silence for the rest of the painting.'

Another painting shows a bra dangling from a screen and a doctor with a stethoscope leaning into the space behind the screen. The screen takes up the centre of the picture – the brush work is sensitive, or parody-sensitive, abstract, flat, self-conscious, with an unmistakable suggestion, for anyone who's been to art school or read any recent art books, of a parody art history lecture, a lecture on painterly Modernism from Manet to Brice Marden.

Well, that's enough kitsch, however nuanced or quirky or studied or enjoyable, we might be thinking, except Courbet is very kitsch too – for example, his paintings of naked women in forest glades which are weekend crowd-pleasers in the nineteenth-century wing of the Metropolitan Museum in New York.

'It's never been my intention to be ironically low brow,' Currin says.

'In thirty or forty years it'll look pretty clearly like something from the decade in which it was made,' he says about *Jaunty and Maine.* 'And that's either a good or bad thing but you certainly can't escape that. No matter what. No matter how consciously you try to expand out of your own time I think you're always pretty dated. And great art is dated as much as terrible art.'

New Modern art museums

New museums of Modern art are opening all the time. Léger-like scenes of heroic construction workers operating cranes swinging horizontal girder shapes across complicated, interesting, angular abstract structures, are a familiar sight throughout the art capitals of the world, as the new museums spring up. Once finished, everything that is glossy and current will shine inside them and vast crowds will stream through them, like Nuremberg rallies of the now, saluting the new.

Museums are important because they go beyond society's preoccupation with material things. Just as the art of Europe from the last several centuries collected in the old museums offers transcendent meanings and a chronicle of ourselves and our history, so new Modern art museums are places of higher values, dedicated

Jeff Koons' *Puppy* in front of Guggenheim Museum, Bilbao 1998

not only to collecting and preserving but also, like the old museums, to searching – searching for meaning. They stand for civilization's highest achievements.

And of course new Modern art museums are works of architectural genius in their own right, as well as centres of high artistic excellence. For example, Frank Gehry's new Guggenheim spin-off in Bilbao. This strange, funny, shiny building with its strikingly non-Western curvilinear shapes, like a flowing silver outfit on a fashion model, looks like a quintessential work of Post-Modern architecture. Playful, enjoyable, silver and curvy, it houses a big display of the achievements of Post-War American art.

These include a circular labyrinth by Robert Morris, rectangular Minimal sculptures by Morris and Judd, big curved paintings by Frank Stella, a big black one by Warhol, and an endless, architectural, curve-echoing, high-walled, rippling abstract sculpture by Richard Serra that you can walk through, like you can walk through the labyrinth. Throughout, there is an unmistakable curatorial theme, a theme of curves.

Was that a joke by Lawrence Weiner, the 60s Conceptual artist? His one work here is a single word on the gallery wall, the word REDUCED in silver letters twenty-feet high. It certainly looks good and expansive from an aerial position, looking down from one of the curved white balconies, across Morris's circular labyrinth. Close to, you stand with your head near the top of the curve at the bottom of the U. From both positions it looks good and means little or nothing or just something ironic, an ironic flourish on the end of a blandness, the blandness being the whole, bland, idiotic, curatorial mindlessness of the rest of the exhibition.

But this is the most popular spot in the city, always crowded, so a big corporate global display not meaning anything is obviously the right idea for a museum now. Outside, near the main road, with the cars going by and the people passing, *Puppy*, inhabiting its own space, having its own charm, gets a loving pruning every week from skilled gardeners up a yellow crane.

Get in your own head

So if there's no meanings at all going on in the new museums we'll have to stay up here in our own chaotic heads for this last lap, the final stage of our enquiry into now. Dalí, our leader, will be watching over us, with his love of the past, and his love of money, and his virile moustaches and familiar burning eyes. And with Time now devouring the last minutes, and the industrial flip clocks booming, I look down and see the word-count on my laptop Toshiba mounting reassuringly.

'Will this do?' the twentieth century asks, all its great achievements in the arts laid out, waiting for rosettes from posterity. 'Well, that's something you'll never know,' the future replies. So 'will it last?' is not a question worth asking even now when frankly we're letting anything pass and anything goes.

Richard Serra
Snake 1997

Bruce Nauman
Self portrait as a fountain
1966

Mae West

Oh look, Dalí lying in state, but at the same time not dead yet, because time is going backwards and space is folded like the space in Cubism, and oracular truths about the power of genius issue from the lips of his pink Mae West sofa in his front garden at Cadaqués. Not the original sofa, I noticed when I was out there earlier this year, but a simulacrum for tourists, as enjoyably tacky as the rest of the chintz in his garden, including the spurting fountains there that go on and off like thoughts surging.

In the pellucid blue of his garden rock pool, with the fountains spraying, reflections reflect reflections, like the meanings in reviews of Conceptual art exhibitions. And I think I see Bruce Nauman's youthful photo of himself as a fountain, blowing a stream of water from his lips, called *Fountain*, after Marcel Duchamp's *Fountain*, which Nauman saw as a student in Duchamp's first museum retrospective held in Pasadena, a suburb of LA, in 1963.

And from the rock formations around Cadaqués a paranoic-critical vision of the great, wide field of Modern art arises, looking for all the world like a composition with boiled beans and burning giraffes one minute, and then with a subtle shift of stereoscopic vision, turning into all the new sons and dead dads of art, from Picasso to now, portrayed with a tiny sable brush. Not that it's all men of course.

Photo realism

And now it's Ron Mueck's *Dead Dad* dead once again in 'Sensation' as this exhibition goes on repeating forever on its world tour, restaged from city to city, exactly mirrored but looking slightly worse at each stop because that must be how they like it in the museums in Berlin and Brooklyn and elsewhere.

Mueck's popular sculptural photo-realism is a marvel to see. Or at any rate a kind of freakish thing, not quite art. A movement from the 60s repeated in the 90s to the same kind of applause. Kind of dying out quite quickly after the initial rise, because as a movement it hasn't changed all that much from how it was then – possessing a high degree of stare-ability, maybe seeming much better than art in a way, but not particularly having anywhere to go after the shock of the incredibly realistic nose hair, or the realistic frown, or in this case, realistic death at three-quarter scale.

Le deluge

Someone's own real dad, dead. Death, the big meaning of art now. However much Saatchi buys our stuff we will die. And then there will be nothing. *Après le deluge* the *Dead Dad* gets it plus all the other art. Well that's a bit depressing. But no! Here's an angel called *Angel*, also by Ron Meuck, in the same eternal 'Sensation' show, with realistic white wings like the wings of the Albatross.

Neo ego

Excitement still swelling after the music's faded – fibreglass *Angel* frowns on its wooden stool, regarding the landscape of art back to Picasso. And his copies of Poussin. *Et in Arcadia ego* – 'Even in paradise I am.' That was Death in seventeenth-century paintings of paradise. But now it's all inverted. However suspicious and blank and empty and ironic and repetitious contemporary art might be, hope is always here. Or some nice greys or something. Hope, marvels, beauty, a route to transcendent meanings, a few laughs.

First show of American art at
Guggenheim Museum, Bilbao 1998

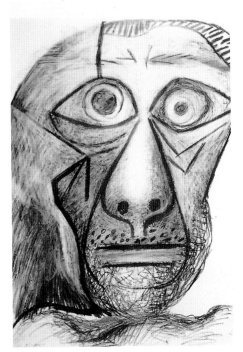

Pablo Picasso *Self portrait facing death* 1972

PICTURE CREDITS

Pictures on pages 2, 7, 21, 32, 63, 92, 95, 101, 130, 141, 178, 183, 204, 223, 262 are taken from *This is Modern Art*, an Oxford Television Company Production for Channel Four.

Introduction

Gary Hume in his studio, 1999
© Jill Furmanovsky

Gary Hume, *Messiah*, 1998
Courtesy Gary Hume Studio
© Jill Furmanovsky

Monet Exhibition at the Royal Academy, 1998
Photo courtesy PA NewsCentre, London
© Fiona Hanson

Tracey Emin, Blue Sapphire Gin advertisement, 1998
Courtesy Banks, Hoggins, O'Shea, FCB

Damien Hirst, *Away from the Flock*, 1994
Courtesy Jay Joplin, London

Jake and Dinos Chapman in their studio, 1999
Photo © Antonio Olmos

Pablo Picasso, Self portrait taken in Picasso's studio
© Succession Picasso/DACS 1999
© Photo RMN – B. Hatala
Musée Picasso, Paris

Duane Hanson, *Tourists II*, 1998
Courtesy Saatchi Gallery, London
© Jochen Littkemann, Berlin

Simon Patterson, *The Great Bear*, 1992
Courtesy Lisson Gallery, London
Photo © John Riddy, London

Chapter One

Gilbert and George, *The Singing Sculpture*, 1970
Courtesy Anthony d'Offay Gallery, London

Joseph Beuys, *Explaining Paintings to a Dead Hare*, 1965
© DACS 1999

Joseph Beuys, *Vitrine for: Two Fräuleins with Shining Bread*, 1963–82
Courtesy Anthony d'Offay Gallery, London
© DACS 1999

Cindy Sherman, *Untitled No 70 (Girl at Bar)*, 1980
Courtesy Saatchi Gallery, London/Cindy Sherman and Metro Pictures

Sophie Calle, *Days under The Sun B, C & W* (detail), 1998
© Violette Editions

Picasso at Villa la Californie, Cannes, 1960
© David Douglas Duncan

Billy Name, Andy Warhol in the Factory, New York, 1960
© Bruce Coleman, New York

Jackson Pollock on Model A Ford, 1948
Courtesy Peter Namuth
© Hans Namuth, 1990

Damien Hirst and Maia Norman at the Turner Prize, 1995
Courtesy Rex Features, London
Photo © Richard Young

Bank, *Press Releases*, 1999
Courtesy Bank Collective, London

Jake and Dinos Chapman, *Disasters of War*, 1999
Courtesy Victoria Miro Gallery
Photo © Stephen White

Marcel Duchamp, 1963
Photo © Julian Wasser

Rachel Whiteread, *Untitled (Book Corridors)*, 1998
Courtesy Anthony d'Offay Gallery, London

Jeff Koons, *Signature Plate (Parkett Edition)*, 1989
Portfolio Edition of 50, artist's proof

Pablo Picasso, *The Head of a Bull*, 1943
© Succession Picasso/DACS 1999
© Photo RMN – B. Hatala
Musée Picasso, Paris

Sarah Lucas, *Au Naturel*, 1994
Courtesy Sadie Coles HQ, London

Sarah Lucas, *Two Fried Eggs and a Kebab*, 1992
Courtesy Sadie Coles HQ, London

Sarah Lucas, *Sod You Gits!*, 1990
Courtesy Sadie Coles HQ, London

Pablo Picasso, *Les Demoiselles d'Avignon*, 1907
© Succession Picasso/DACS 1999
The Museum of Modern Art, New York. Acquired through the Lillie P. Bliss Bequest.
Photo © 1999 The Museum of Modern Art, New York.

Pablo Picasso, *Self Portrait*, 1903
© Succession Picasso/DACS 1999
© Photo RMN – B. Hatala
Musée Picasso, Paris

Hans Namuth, *Pollock painting*, 1950
Courtesy Peter Namuth
© Hans Namuth, 1991

Jackson Pollock, *One* (Number 31), 1950
© ARS, New York and DACS 1999
The Museum of Modern Art, New York. Sidney and Harriet Janis Collection Fund (by exchange).
Photo © 1999 The Museum of Modern Art, New York

Cecil Beaton, *Autumn Rhythm* for *Vogue*, 1951
Courtesy Sotheby's, London

Willem de Kooning, *Merritt Parkway*, 1959
© Willem de Kooning, ARS, NY and DACS, London 1999
The Detroit Institute of Arts, USA.
Courtesy Bridgeman Art Library, London

Andy Warhol, *Ambulance Disaster*, 1963
© ARS, NY and DACS, London 1999
© The Andy Warhol Foundation for the Visual Arts, Inc.

Andy Warhol, *Marilyn Diptych*, 1962
© The Andy Warhol Foundation for the Visual Arts, Inc/ARS,
 New York and DACS, London 1999
Photo © Tate Gallery, London 1998

Andy Warhol, *Blow Job*, 1964
© 1990 The Andy Warhol Museum, Pittsburgh, PA,
 a museum of Carnegie Institute
Film still courtesy the Andy Warhol Museum

Andy Warhol, *The Chelsea Girls*, 1966
© 1994 The Andy Warhol Museum, Pittsburgh, PA,
 a museum of Carnegie Institute
Film still courtesy the Andy Warhol Museum

Jane and Louise Wilson, *Gamma (Silo)*, 1999
Courtesy Lisson Gallery, London

Jane and Louise Wilson, *Gamma (detail)*, 1999
Courtesy Lisson Gallery, London

Chapter Two

Damien Hirst, *Some Comfort Gained from the Acceptance of the Inherent Lies in Everything*, 1996
Courtesy Jay Jopling, London

Francisco Goya, *Saturn Devouring One of His Sons*, c. 1820
© Museo del Prado, Madrid

Francis Bacon, *Seated Figure*, 1961
© Estate of Francis Bacon/ARS, NY and DACS, London, 1999
Photo © Tate Gallery, London

Francisco Goya, *Cannibals Contemplating Human Remains*, c. 1804
Musée de Beaux-Arts et d'Archéologie/Cliché Charles Choffet, Besançon, France

Francisco Goya, *Great Deeds! Against the Dead!*, c. 1810 (etching from *Disasters of War*)
© British Museum

Jake and Dinos Chapman, *Great Deeds against the Dead*, 1994
Courtesy Victoria Miro Gallery

Pablo Picasso, *Guernica*, 1937
© Succession Picasso/DACS 1999
Museo Naçional Centro de Arte Reino Sofia, Madrid
Courtesy Bridgeman Art Library, London/New York

Jake and Dinos Chapman, *The Un-Namable*, 1997
Courtesy Jake and Dinos Chapman

Gilbert and George (stills with tongues)
from *The World of Gilbert and George*, 1981
Courtesy Gilbert and George

Gilbert and George, *Underneath the Arches*, 1971
from *The World of Gilbert and George*, 1981
Courtesy Gilbert and George

Gilbert and George, *Human Shits*, 1994
Courtesy Prudence Cuming Associates Ltd, London

Francisco Goya, *The Sleep of Reason Produces Monsters*,
 plate 43 of 'Los Caprichos', 1799
Private Collection/Index/Bridgeman Art Library, London/New York

Edvard Munch, *The Scream*, 1893
© Munch Museum/Munch-Ellingsen Group/DACS, London 1999
Photo J Lathion, © Nasjonalgalleriet, Oslo

Tracey Emin on Channel Four, 1997
Courtesy Illuminations, London

Tracey Emin, *Monument Valley (Grand Scale)*, 1995
Courtesy Jay Joplin, London

Edvard Munch, *Painting on the Beach in Warnemünde*, 1907
© Munch Museum/Munch-Ellingsen Group/DACS, London 1999
Courtesy Munch-museet, Oslo

Vivienne Westwood, Gay Cowboys T-shirt, c. 1975
Courtesy *Mojo* magazine

Jake and Dinos Chapman, *Hell*, 1999
Courtesy Jake and Dinos Chapman

Paul McCarthy, *Santa Chocolate Shop*, 1997
 (videotape, mixed media, still from performance)
Courtesy Luhring Augustine Gallery, New York

Vito Acconci, *Trappings*, 1971
Courtesy Barbara Gladstone Gallery, New York

Edvard Munch, *The Dance of Life*, 1899–90
Nasjonalgalleriet, Oslo/DACS, London 1999
Photo J. Lathion © Nasjonalgalleriet, 1997

Francisco Goya, *What Next?*, plate 69 of 'Los Caprichos', 1799
© British Museum

Francisco Goya, *Dog Drowning in Quicksand*, 1820
© Museo del Prado, Madrid

Chapter Three

Henri Matisse, *Capucines à la Danse II*, 1912
© Succession H. Matisse/DACS 1999
Sammlung S.I. Schtschukin, Moscow, Pushkin Museum
Courtesy AKG Photo

Henri Matisse, *Luxe, Calme et Volupté*, 1904
© Succession H. Matisse/DACS 1999
Musée d'Orsay, Paris
Courtesy AKG/Erich Lessing

I lenri Matisse, *Large Red Interior*, 1948
© Succession H. Matisse/DACS 1999
Musée National d'Art Moderne, Paris/Peter Willi/Bridgeman Art Library, London/New York

Pablo Picasso, *Nude in Red Armchair*, 1929
© Succession Picasso/DACS 1999
Musée Picasso, Paris
Photo RMN – J.G. Berizzi

Henri Matisse, *Odalisque with Tambourine*, 1926
© Succession Matisse/DACS 1999
The Museum of Modern Art, New York. The William S Paley Collection.
Photo © 1999 Museum of Modern Art, New York

Piet Mondrian, *Composition with Large Blue Plane*, 1921
© Mondrian/Holtzman Trust, c/o Beeldrecht, Amsterdam, Holland/DACS 1999
Museum of Art, Dallas, Texas
Courtesy AKG, London

Henri Matisse, *Blue Nude 1*, 1952
© Succession H. Matisse/DACS 1999
Fondation Beyeler, Riehen/Basel

Morris Louis, *Aleph Series I, DU#262*, 1960
© 1960 Morris Louis
Courtesy Bridgeman Art Library, London

Jules Olitski, *High A Yellow*, 1967
Courtesy Lauren Olitski Poster
© DACS, London/VAGA, New York 1999

Jules Olitski, *Envisioned Sail*, 1998
Courtesy Lauren Olitski Poster
© DACS, London/VAGA, New York 1999

Alex Katz, *Lawn Party*, 1965
Courtesy Marlborough Gallery, New York

Elizabeth Peyton, *Jarvis at Press Conference*, 1996
Courtesy Gavin Brown's Enterprise, New York

Jean-Michel Basquiat, *Untitled (Yellow Tar and Feather)*, 1982
© ADAGP, Paris and DACS, London 1999
Courtesy Gerard Basquiat

Jasper Johns, *Flag on Orange Field*, 1957
© Jasper Johns/VAGA, New York/DACS, London 1999
Lüdwig Musuem, Cologne
Courtesy AKG, London

Jean-Michel Basquiat, *New Nile*, 1985
© ADAGP, Paris and DACS, London 1999
Courtesy Gerard Basquiat

Jean-Michel Basquiat in his studio in New York, 1985
© ADAGP, Paris and DACS, London 1999
Courtesy Gerard Basquiat

Tony Shafrazi/Bruno Bischfberger present Warhol and Basquiat, joint show, 1985
© Michael Halsband 1999, New York

Jean-Michel Basquiat, *Untitled*, 1984
© ADAGP, Paris and DACS, London 1999
Courtesy Gerard Basquiat

Chris Ofili, *Afrodizzia (2nd version)*, 1996
Courtesy Victoria Miro Gallery, London

Hélène Adant, *Henri Matisse at work on the Chapel at Vence*, 1949–50
Succession Matisse/DACS, 1999
Musée National d'art Moderne, Centre Georges Pompidou

Henri Matisse, *The Rosary Chapel at Vence: l'Autel*, 1949–50
Succession Matisse/DACS, 1999
© Photo RMN – H del Olmo

Patrick Heron in his studio, 1997
© Susanna Heron

Patrick Heron, *Red Garden Painting: June 3-June 5*, 1985
© Patrick Heron. 1999 All Rights Reserved, DACS

Chapter Four

Martin Creed, *Work Number 200, Half the Air in a Given Space*, 1998
Installation at Analix Gallery, Geneva
Courtesy Cabinet Gallery, London

Martin Creed, *Work no 88, A sheet of A4 paper crumpled up into a ball*, 1994
Courtesy Cabinet Gallery, London

Martin Creed, *Work no 127, The lights going on and off*, 1995
Courtesy Cabinet Gallery, London

Carl Andre, *Equivalent VIII*, 1966
© Carl Andre/VAGA, New York/DACS, London 1999
Installation at Tibor de Nagy Gallery, New York
Photo © Tate Gallery

Dan Flavin, *The Diagonal of May 25, 1963 (to Constantin Brancusi)*, 1963
© ARS, NY and DACS, London 1999
Photo: Cathy Carver, Courtesy Dia Center for the Arts, New York

Donald Judd, *Untitled*, 1972
© Estate of Donald Judd/VAGA, New York/DACS, London 1999
Photo © Tate Gallery, London

Giovanni Lorenzo Bernini, *The Abduction of Proserpina*, 1622
Rome, Galleria Borghese
Courtesy AKG, London

Stool in form of a kneeling woman, 19th century
British Museum, London
Courtesy AKG, London

Robert Morris, *Two Columns*, 1961
© ARS, NY and DACS, London 1999
Courtesy Solomon R. Guggenheim Museum, New York

Carl Andre, *Equivalent I-VIII*, 1966
© Carl Andre/VAGA, New York/DACS, London 1999
Installation at Tibor de Nagy Gallery, New York
Courtesy Paula Cooper Gallery, New York

Ad Reinhardt, *Abstract Painting*, 1960
© DACS 1999
Courtesy Solomon R. Guggenheim Museum, New York
Photo by David Heald © the Solomon R. Guggenheim Museum, New York

The Black Square Room, Ad Reinhard Exhibition, Jewish Museum, New York, 1966–7
© The Jewish Musum, New York, Visual Resources Archive
ARS, New York and DACS, London

Robert Ryman, *Term 2*, 1996
Courtesy Pace Wildenstein
Photo © Ellen Page Wilson

Kasimir Malevich, *Black Suprematist Square*, 1914–15
Tretiakov Gallery, Moscow

Kasimir Malevich, *Suprematism (with eight red rectangles)*, 1915
State Russian Museum, St Petersburg

Last Futurist Exhibition 0, 10, 1915
Stedelijk Museum, Amsterdam

Kasimir Malevich, *Red Square: Painterly Realism of a Peasant in Two Dimensions*, 1917
State Russian Museum, St Petersburg

Mark Rothko in his studio, 1964
© Hans Namuth Estate, Collection Centre of Creative Photography,
University of Arizona

Mark Rothko, *Number 22*, 1949
© Kate Rothko Prizel and Christopher Rothko/DACS 1999
The Museum of Modern Art, New York. Gift of the artist.
© 1999 The Museum of Modern Art, New York/Kate Rotch

Interior, Rothko Chapel, Houston, TX, USA
© Kate Rothko Prizel and Christopher Rothko/DACS 1999
Nicolas Sapieha/Art Resource, NY

Yves Klein, *Leap into the Void*, 1960
© Yves Klein ADAGP, Paris/Harry Skunk, DACS, London 1999
Photo © Shunk-Kender

Yves Klein, *IKB 79*, 1960
© ADAGP, Paris and DACS, London 1999
Photo © Tate Gallery, London 1998

Yves Klein, *Ant 63 Anthropometry*, 1961
© ADAGP, Paris and DACS, London 1999
Private Collection/Bridgeman Art Library, London/New York

Yves Klein, Anthropometry performance in Paris, 1960
© ADAGP, Paris and DACS, London 1999
Galerie internationale d'art contemporain, Paris

Peter Halley, *Glowing and Burnt-Out Cells with Conduit*, 1982
Courtesy Peter Halley

Glenn Brown, *Searched Hard for You and Your Special Ways*, 1995
Collection Byron Meyer, San Francisco, CA
© Glenn Brown

Jason Martin, *Untitled (jet loop paint #6)*, 1997
Courtesy Lisson Gallery, London

James Turrell, *Meeting*, 1996
Courtesy PS1 Gallery, New York
Photo © Michael Moran

Chapter Five

Piero Manzoni, *Artist's shit No 068*, 1961
© DACS, 1999
Archivio Opera Piero Manzoni, Milan

Yoko Ono, *Film No.4 (Fluxfilm ≠ 16)*, 1966
© Yoko Ono

Richard Prince, *Untitled*, 1985
Courtesy Barbara Gladstone Gallery, New York

Sarah Lucas, *Receptacle of Lurid Things*, 1991
Courtesy Sadie Coles HQ, London

George Maciunas, Dick Higgins, Wolf Vostell, Benjamin Patterson, Emmett Williams
performing Philip Corner's Piano Activities, 1962
Photo © Harmut Rekord

May Ray, *Marcel Duchamp as Rrose Sélavy*, 1921
Philadelphia Museum of Art

Marcel Duchamp, 1965
© Ugo Mulas

Marcel Duchamp, *Large Glass or Bride Stripped Bare by Her Bachelors, Even*, 1915–23
© Succession Marcel Duchamp, DACS 1999
Courtesy Philadelphia Museum of Art: Bequest of Katherine S. Dreier

Marcel Duchamp, *Étant Donné*, 1946–66
© Succession Marcel Duchamp/DACS 1999
Philadelphia Museum of Art: gift of the Cassandra Foundation

Sean Landers, *Bubble Boy*, 1998
Courtesy Andrea Rosen Gallery, New York
Orcutt & Van Der Putten

Sean Landers, *Self-Something*, 1994
Courtesy Andrea Rosen Gallery, New York
Photo © Peter Muscato

René Magritte, *Golconda*, 1953
© ADAGP, Paris and DACS, London 1999
Private Collection/Lauros-Giraudon/Bridgeman Art Library, London/New York

René Magritte at work, 1963
Photo © Skunk Kender, Paris

Piero Manzoni, *Living Sculpture*, 1961
Archivio Opera Piero Manzoni, Milan

Martin Kippenberger, *Coalmine II*, 1987
Courtesy Galerie Gisela Capitain, Cologne

Martin Kippenberger, *Untitled (Political corect)*, 1994
Courtesy Galerie Gisela Capitain, Cologne

Martin Kippenberger, *Wittgenstein*, 1987
Courtesy Galerie Gisela Capitain, Cologne

Invitation to the show *Dialogue with Youth*, Achim Kubinski Gallery, Stuttgart, 1981

Martin Kippenberger, *Self portrait*, 1982
Courtesy Galerie Gisela Capitain, Cologne

Martin Kippenberger, *German Egg-Banger*, 1966
Courtesy Galerie Gisela Capitain, Cologne

Richard Prince, *Untitled*, 1994
Courtesy Barbara Gladstone Gallery, New York

Richard Prince, *The Literate Rack*, 1994
Courtesy Barbara Gladstone Gallery, New York

Richard Prince, *Untitled*, 1994
Photo © Ian Macmillan

Chapter Six

Gillian Wearing, *Dancing in Peckham*, 1994
Courtesy Maureen Paley/Interim Art

Cornelia Parker, *Exhaled Cocaine*, 1996
Courtesy Frith Street Gallery, London

Chris Ofili, *Through the Grapevine*, 1998
Courtesy Victoria Miro Gallery, London

Anselm Kiefer, *Bilderstreit*, 1995
Courtesy Anthony d'Offay Gallery, London

Bruce Nauman, *Clown Torture*, 1987
© ARS, NY and DACS, London 1999

Gillian Wearing, *Sixty Minute Silence*, 1996
Courtesy Maureen Paley/Interim Art

Julian Schnabel, *Prehistory: Glory, Honor, Privilege and Poverty*, 1981
Courtesy Julian Schnabel Studio, New York

Damien Hirst, *Mother and Child Divided*, 1993
Courtesy Jay Joplin, London

Andy Warhol, *Cow Wallpaper*, 1966
© ARS, NY and DACS, London 1999
© The Andy Warhol Foundation for the Visual Arts, Inc.
Photo © Richard Stoner

Damien Hirst, *Carbon Monoxide*, 1996
Courtesy Jay Joplin, London

Sigmar Polke, *Nicolo Paganini*, 1982
Courtesy Saatchi Gallery, London
Courtesy Bridgeman Art Library, London

Sigmar Polke, *Modern Art*, 1968
Courtesy Rene Block, Berlin

Salvador Dali, *Metamorphosis of Narcissus*, 1937
© Salvador Dali – Foundation Gala – Salvador Dali/DACS 1999
Photo © Tate Gallery, London 1998

Dalí standing next to *Soft Self portrait*, c. 1940
Courtesy Tate Gallery, London

Peter Davies, *The Hot One Hundred*, 1997
Courtesy Saatchi Gallery, London
Photo © Stephen White

Sean Landers, *Singerie: Le Peintre*, 1995
Courtesy Andrea Rosen Gallery, New York

Jeff Koons, *Amore*, 1988
Courtesy Sonnabend Gallery, New York

Bruce Nauman, *One Hundred Live and Die*, 1994
© ARS, NY and DACS, London 1999
Collection Fukutake Publishing Co. Ltd
Naoshima Contemporary Art Museum, Kagawa
Courtesy Sperone Westwater, New York

Bruce Nauman, *Ten Heads Circle/Up and Down*, 1990
© ARS, NY and DACS, London 1999

Darren Almond, *H.M.P Pentonville*, 1997
Courtesy Jay Joplin, London

John Currin, *Jaunty and Maine*, 1997
Courtesy Saatchi Gallery, London
© Andrea Rosen Gallery, New York

John Currin, *Ms Omni*, 1993
Courtesy Saatchi Gallery, London
© Andrea Rosen Gallery, New York

Jeff Koons' *Puppy* in front of Guggenheim Museum, Bilbao, 1998
Photo Erika Barahona Ede
© FMGB Guggenheim, Bilbao

Richard Serra, *Snake*, 1997
© FMGB Guggenheim, Bilbao. Photo: David Heald
© ARS, NY and DACS, London 1999

Bruce Nauman, *Self portrait as a fountain*, 1966
© ARS, NY and DACS, London 1999
Part of Eleven Color Photographs, 1966–7/70
Courtesy Sperone Westwater, New York

First show of American art at Guggenheim Museum, Bilbao, 1998
Photo Erika Barahona Ede
© FMGB Guggenheim, Bilbao

Picasso, *Self portrait facing death*, 1972
© Succession Picasso/DACS 1999
Courtesy Galerie Louise Leiris, Paris

ACKNOWLEDGEMENTS

I had a lot of help with this book from Emma Biggs, so thanks a lot Emma. Also thanks to Rebecca Wilson at Weidenfeld for being so kind as to commission this and then edit it very patiently, and laugh at one or two of the jokes. Plus thank you Catherine Hill, also at Weidenfeld. Thanks to Ian Macmillan, Chris Rodley and Phil Smith for many good ideas. Thanks to Melissa Larner for the very well-written artists' biographies. Thanks finally to Herman Lelie and Stefania Bonelli for their patience and their design and type-setting.

INDEX

Page numbers in *italic type* refer to picture shown in the book.

A

Abstract Expressionism 27, 44–50, 82, 119, 122, 148–9, 155, 160–1, 166
 Greenberg and Rosenberg 48–50
 mythology 48
 pessimism 166
abstraction 161, 240
 and beauty 108, 110
 Non-Objectivity 159–66, 176
 Post-Painterly Abstraction 115–17
Acconci, Vito 90, 92–3, *92*
 biography 93
 Manipulations 93
 Seedbed 90
 Theme Song 93
 Trappings 90
 Two Takes 93
Action Painting 50, 175
advertising 12–13, 35, 225, 242
aesthetic 103–39, 248
 anti-aesthetic 44, 104, 108–10, 133, 153
 Greenberg and Rosenberg 48–50
 horror vacui 144
African art 44, 129, 132, *151*
Allen, Woody 222
Almond, Darren 254–5
 biography 254
 H.M.P. Pentonville 255
Alogism 163
Andre, Carl 144, 145–6, 154, 157
 biography 145
 Equivalent I–VII 154
 Equivalent VIII 146, 148
Antonioni, Michelangelo, *Blow-Up* 13
Apollonian and Dionysian, concept of 115
Appropriation art 185, 219–20
arbitrariness 238–9
Auerbach, Frank 178
avant gardism 108
 and beauty 109

B

Bacon, Francis 67, 76
 biography 69
 Seated Figure 68
Bakewell, Joan 198
banality 232, 248
Bank artists' collective 33–4, *33*
Basquiat, Jean-Michel 121–9, *127*, 128
 biography 126
 graffiti art 126
 Gray 126
 mythology 121
 New Nile 125
 Untitled (1984) *129*
 Untitled (Yellow Tar and Feather) 123
Beardsley, Aubrey 132
Beatles
 album covers 13
 Revolution Number Nine 185
Beaton, Cecil 48, *49*
beauty 19, 103–39
 and abstraction 108, 110
 and avant gardism 109
 see also aesthetic

Beckett, Samuel 76, 253
Belmondo, Jean-Paul 173
Bernini, Giovanni Lorenzo 151
 The Abduction of Proserpina 151
Beuys, Joseph 215, 244
 biography 23
 Explaining Paintings to a Dead Hare 23
 Fluxus 192
 mythology 22, 23–4
 Vitrine for: 'two Fräuleins with shining bread 24
Blake, Peter, *Sergeant Pepper* album cover 13
body art 14, 229
Boecklin, Arnold, *Island of the Dead* 177–8
Bourgeois, Louise 31
bourgeois consciousness 186, 188, 218
Brancusi, Constantin 149
Brando, Marlon 69
Breton, André 132, 192, *193*, 196–7, 232
 biography 197
 manifesto of Surrealism 196
 Nadja 196
Brown, Glenn 177–9, *178*
 biography 179
 The Living Dead 178
 Searched Hard For You And Your Special Ways 177, 178

C

Cage, John 239
Calle, Sophie 24
 Days under The Sun B, C & W (detail) 25
Caulfield, Patrick 10
Chagall, Marc 165, 225, 226
Chapman, Jake and Dinos 14, 15–16, 35, 67, 82–3, 86, 87, 96
 biography 73
 Disasters of War 73
 Great Deeds Against the Dead 70, *71*, 72
 Hell 87–9, *88*
 Little Death Machine 89
 The Un-Namable 74, *74*, 76
colour 112
 Post-Painterly Abstraction 112, 115–17
comic strips, Situationist 190, *190*
Conceptual art 14, 35, 83, 85, 123, 203, 211, 213, 225
Constructivism 161, 166
Cornell, Joseph 36
Courbet, Gustave 258
Creed, Martin 142–3, 145
 biography 143
 Half the Air in a Given Space 142
 The lights turning on and off 143, 144
 A Sheet of A4 paper crumpled into a ball 142–3, 143
Cubism 16–18, 40, 44, 163
Cubo-Futurism 163, 165
Cubo-Primitivism 163
Currin, John 244, 255–8
 biography 257
 Entertaining Mr Acker Bilk 257
 Jaunty and Maine 256, 257, 258
 Ms Omni 257, 258

D

Dalí, Salvador 178, 206, 241–4, *242*, *243*, 244, 260–1
 biography 242
 Metamorphosis of Narcissus 241, *241*
 Soft Self portrait 244

Davies, Peter 244–7
 biography 246
 The Hip One Hundred 244, *245*, 246
 The Hot One Hundred 246
de Kooning, Willem 50, 178
 biography 50
 Merritt Parkway 50
Debord, Guy 192, 196, 218
 biography 196
 The Society of the Spectacle 196
designer objects 237
Duchamp, Marcel 8, 35–7, *36*, 109, 149, 151, 153, 196–203, *199*, 247
 biography 198
 Etant Donné 35–6, 201, *202*, 203
 Fountain 151, 185, 197–8, 200, 261
 Large Glass or *The Bride Stripped Bare By Her Bachelors, Even* 200–1, *201*
 Readymades 36–7, 151, 185, 197–8, 200, 203

E

Emin, Tracey 12, 12, 83–5, *83*, 96
 biography 12
 Exploration of the Soul 83
 Monument Valley (Grand Scale) 84
Existentialism 48, 50, 76
expression 112, 161
 and colour 112, 115
Expressionism 82, 84–5
American Abstract see Abstract Expressionism
 German 82

F

fashion
 artists as models 12
 Westwood 86–7, *87*
Fauvism 103
Feminism 59, 69
figurative art 118
film 13, 31, 69, 156
 Fluxus 192
 Magritte 206
 Mondo Kane 173–4, *174*
 Situationist 190
 Warhol 53–4, 55
 Wilson twins 59
Flavin, Dan 144, 148–9, 151, 157, 160
 biography 148
 The Diagonal of 25, 1963 (to Constantin Brancusi) 148, *148*
Fluxus 185, 192–6, *193*, *194*, *195*, 197
found objects, use of *39*, 40–1, *40*, *41*, 43
fragmentation 227
 fragmented and dismembered bodies 69
 in Modern art 31, 137
Fragonard, Jean-Honoré 178
Frankenthaler, Helen 115
Freud, Sigmund 19, 27, 196, 198, 235, 241
Friedrich, Caspar David 233
Futurism 160, 161

G

genius, notion of 19, 22–62
 myths, importance in Modern art 22–31
 Picasso 26, 35, 38
 Pollock 26
Géricault, Théodore 69
Gilbert and George 22–4, 76–80, 170

biographies 22
Human Shits 79
The Singing Sculpture 22
Underneath the Arches 78
The World of Gilbert and George 76, 77
Godard, Jean-Luc 173
Goya, Francisco 35, 65, 67, 96–100
biography 67
Cannibals Contemplating Human Remains 69–70, 70
Caprices 80, 96–9, 97
Disasters of War 70–3, 71, 96, 100
Dog Drowning in Quicksand 99, 100
Great Deeds! Against the Dead! 70–3, 71
Pintura Negra 66, 99–100, 99
portraits 80, 96
Proverbs 96
Saturn Devouring one of his Sons 66, 100
The Sleep of Reason Produces Monsters 80, 98
What Next? 97, 98
graffiti
Basquiat 126
Situationist 189, *191*
Greenberg, Clement 47, 48–50, 112, 115, 117

H
Halley, Peter 176
biography 177
Glowing and Burnt-Out Cells with Conduit 176
Hamilton, Richard, *The Beatles* album cover 13
Hanson, Duane, *Tourists II* 16
Heron, Patrick *136*, 137–9, *137*
aesthetic 134, 137
biography 134
Red Garden Painting: June 3–June 5 138
Hirst, Damien *30*, 39, 69, 235, 237–8, 244
Away from the Flock 13
biography 31
Carbon Monoxide 238
Minimalism 67
Mother and Child Divided 64, 236
mythology 30–1
The Physical Impossibility of Death in the Mind of Someone Living 64
Some Comfort Gained from the Acceptance of the Inherent Lies in Everything 39, 64
spin paintings 238
spot paintings 12, *30*, 238–9, *238*
horror vacui 144
Hume, Gary 8–13, *8*, 244
biography 9
hospital doors series 8–9
King Cnut 9
Messiah 10, *11*
portrait of Kate Moss 12–13
hype and contemporary art 237–8

I
immateriality 170, 172
Ingres, Jean-Auguste-Dominique, *Turkish Bath* 175
installation art 31, 59

J
Johns, Jasper 36, 122–3, 128
biography 124
Flag on Orange Field 124
jokes in Modern art 19, 184–245
Jonathan Richman and the Modern Lovers 175
Judd, Donald 144, 146, 148, 149–54, 157, 160, 175, 260
biography 149
Untitled (1972) *150*, *151*

K
Kandinsky, Wassily 165
Kapoor, Anish 188
Katz, Alex 117–19, 139
biography 118
Lawn Party 119
Kiefer, Anselm 229–33
Bilderstreit 230
biography 229
Kippenberger, Martin 210–18, *214*
8 pictures to see how long we can keep this up 211
Coalmine 210, *210*, 211, *212*, 213
biography 211
Daddy do love Mummy, noodles all find yummy 218
Elite 88 218
Family Hunger 216
Five little Italians made of chewing gum 211
German Egg-Banger 216, *217*
Jackie 216
Meine Fusse von unten gegen das Diktat von oben 216
Motorhead II (Lemmy) 216
No Problem 214
Petticoat 216
Self-inflicted justice by bad shopping 216
Self portrait 215
Untitled (Political correct) 211–12, *212*, 214
War bad 211
Wittgenstein 213, *213*
kitsch 251, 258
Klein, Ralph 47, 48
Klein, Yves 170–5
Anthropometries 172–4, *173*, *174*
biography 172
IKB (International Klein Blue) 170, *171*, 172, 174
Leap into the Void 170, 172
Monotone - Silence - Symphony 172
Untitled Anthropometry 173
Kline, Franz 122
Kokoschka, Oskar, *Murder Hope of Women* 132
Koons, Jeff *38*, 38, 39, 244, 248–51
Amore 249
Balloon Dog 250
biography 248
'Celebration' 248
Puppy 250, *258*, 260
Krasner, Lee 47

L
land art 14
Landers, Sean 203–6, *204*, 246–7
biography 203
Bubble Boy 205
Italian High Renaissance and Baroque Sculptures 203–4
Self-Something 205
Singerie: Le Peintre 246, *247*
'Last Futurist Exhibition' 162–3
Lissitzky, El 166
Louis, Morris 115
Aleph 114
Lucas, Sarah 32, 39–40, 43
Au naturel 39
biography 41
Bitch 39, 40
Receptacle of Lurid Things 186, *186*, 188, 197
Sod You Gits! 40, *41*
Sunday Sport blow-ups 40, *41*, 43
Two Fried Eggs and a Kebab 39, 40

M
McCarthy, Paul 95
biography 89
Santa Chocolate Shop 89, 90, 92, 94–5

Maciunas, George 192–6, *193*
biography 192
works by *194*, 195
Magritte, René 16–17, 206–8, *208*
biography 206
Ceci n'est pas une pipe 206
Famine 208
Golconda 206, *207*
The Palace of Curtains 206
Malevich, Kasimir 144, 159–66, *165*, 240
biography 160
Black Square 159–60, *159*, 162–3, 165
Cubo-Futurist works 163, 165
manifesto of Suprematism 163
Red Square: Painterly Realism of a Peasant in Two Dimensions 164, *164*
Suprematism (with eight red rectangles) 161
Victory Over The Sun 163
Manzoni, Piero 208–10, *209*, 246
Artist's shit No 068 184
biography 208
Merda d'artista 208–9
Martin, Jason 179–80
Untitled (aeolam #8) 182
Untitled (jet loop paint #6) 180
Marxism 189
Matisse, Henri 16–17, 103–12, 115, 118, 128, 129, 139, 225
aesthetic 103–4, 108–12, 134
biography 103
Blue Nude I 113
Capucines à la Danse II 102
Chapel of the Rosary, Vence 134, *135*
colour 112, 115
cut-outs 134
expression 112, 115
Fauvism 103
Large Red Interior 105
Luxe, Calme et Volupté 103, *104*
Modernism 122–5
Odalisque with Tambourine 107, 108–9
Red Studio 167
meaning in art 35, 225, 226
Abstract Expressionism 49–50
Michelangelo Buonarroti 151
Minimalism 9, 12, 14, 16, 37, 123, 144–58, 203, 213, 225
popular culture, absorption into 12–18, 145
Modernism 123
Modigliani, Amedeo 173
Mondrian, Piet 110–11
biography 110
Composition with Large Blue Plane 110
Monet, Claude 10–11, *11*, 19, 65
Charing Cross Bridge, overcast weather 19
Morris, Robert 148, 153–4, 157, 260
biography 153
Two Columns 153
Mueck, Ron
Angel 262
Dead Dad 261–2
Munch, Edvard *85*, 91
biography 82
The Dance of Life 91, *91*
The Scream 76, 80, *81*, 82, 84–5
museums of Modern art 248, *258*, 258, 260, 262
music
album covers 13
art bands 32–3, 126
Kippenberger 214
Klein 172
Post-Modernism 175
mysticism 158, 234–5
mythology 22–62, 121

N
Namuth, Hans, Pollock painting *45*
Nauman, Bruce 244, 246, 251–4
 Anthro/Socio (Rinde facing camera) 252
 biography 251
 Clown Torture 233, *233*, 252
 One Hundred Live and Die 251
 Self portrait as a fountain 261, 261
 Ten Heads Circle/Up and Down 253
Neo-Expressionism 211
Neo Geo 197
Neo-Plastic art 161
Neo-Pop 250
Noland, Kenneth 115
Non-Objectivity 159–66, 176

O
Ofili, Chris 111–12, 130–3, *130*, 176, 227, 241, 244
 The Adoration of Captain Shit and the Legend of the
 Black Stars 132, 133
 aesthetic 133, 137
 Afrodizzia (2nd version) 131
 Through the Grapevine 228
 biography 132
 Captain Shit 133
 The Chosen One 133
 Foxy Roxy 132
 The Holy Virgin Mary 133
Olitski, Jules 115, 116–17
 biography 117
 Envisioned Sail 117
 High A Yellow 116
Ono, Yoko 185, 192, 194
 Fluxfilm ≠ 16 185
 Painting to hammer a nail 192
Op art 13, 130, 176

P
painting 255, 257–8
Parker, Cornelia 226, 235
 biography 227
 Exhaled Cocaine 226, *226*, 235
Patterson, Simon, *The Great Bear 18*
performance art 14, 90, 92–3, 156
Peyton, Elizabeth 120–1
 biography 121
 Jarvis at Press Conference 120
photo realism 261–2
Picasso, Pablo 10–11, 15–16, *15*, *28*, 35, *37*, 38, 96,
 109, 128, 129, 134, 175, 176, 239–40, 247, 262
 aesthetic and anti-aesthetic 103, 108–11, 144
 archaism 26, 39, 124
 biography 43
 blue and rose periods 43
 The Charnel House 69, 73–4
 Les Demoiselles d'Avignon 11, 40, *42*, 43, 44, 103,
 196, 239
 Guernica 69, 73–4, *74*
 Head of a Bull 39, 40, 43
 Modernism 122–5
 mythology 22, 26, 27, 30, 35
 Nude in a Red Armchair 106, 108–9
 Self portrait 43
 Self portrait facing death 263
 Woman Dressing Her Hair 109
Polke, Sigmar 239–40
 biography 240
 Higher beings command - paint the upper right hand
 corner black! 240
 Modern Art 240
 Nicolo Paganini 239

Pollock, Jackson 29, 44–8, *45*, 51, 112, 115, 122–3, 160,
 161
 Autumn Rhythm 46, *49*
 biography 47
 drip paintings 45–7, *45*, 239
 mythology 22, 24, 26, 27, 30, 45–8
 One (Number 31) 46, *46*
Pop art 13, 14, 115, 123
popular culture
 absorption of art into 12–18, 34, 86–7, 145, 225–6
 Basquiat 122
 Malevich 164
 stars and stardom 120–1
Post-Minimalism 156, 158, 233
Post-Modernism 122–9, 175–7
Post-Painterly Abstraction 115–17
Poussin, Nicolas, *Et in Arcadia ego* 262
primitivism 44, 48, 129
Prince, Richard 219–22
 biography 219
 The Literate Rock 220
 Untitled (1994) 221
 Untitled (1985) 185, 186, 219
 Untitled (1994) 219, *219*
Psycho-geography *189*, 190
publicity 31–4, 242–4
 mythologizing 22–31
 television 31
Punk 190

R
Rauschenberg, Robert 36, 122
Ray, Charles, *Oh Charley! Charley! Charley!* 229
Ray, Man 197
reductionism 142–82
 immateriality 170, 172
 Minimalism see Minimalism
 Non-Objectivity 159–66, 176
 Post-Minimalism 156, 158, 233
 reaction against 156
 Suprematism 159–65
Reinhardt, Ad 155, *156*, 158
 Abstract Painting 155
 biography 156
Riley, Bridget 176, 244
Rodchenko, Aleksandr 166, 244
Romanticism 188, 232–3
Rosenberg, Harold 48–50
 'The American Action Painters' 50
Rothko, Mark 166–9, 170
 biography 166
 Black on Maroon 167
 Rothko Chapel, Houston 168–9, *169*
Ryman, Robert 144, 157, 179
 biography 157
 Term 2 158

S
Schnabel, Julian 237
 biography 235
 Prehistory: Glory, Honor, Privilege and Poverty 236
'Sensation' exhibition 64, 86, 261
Serra, Richard, *Snake* 260, *260*
Sherman, Cindy 254
 mythology 24
 Untitled No 70 (Girl at Bar) 25
Situationism 188–97, 218
Socialist Realism 164
Society of the Spectacle 189–90, 196

space
 Minimalism 154
 negative 151
spiritual in art 134, 137, 166–7, 234–5
Stella, Frank 260
Suprematism 159–65, 240
 manifesto 163
Surrealism 67, 104, 161, 188, 189, 192, 196–7, 206–8,
 242
 manifesto 196

T
Taaffe, Philip 176
Tatlin, Vladimir 160
Turk, Gavin 209–10
 biography 209
Turner Prize 34, 104, 226, 244
Turrell, James 180, 182
 biography 180
 Meeting 180, *180*, 182
Twombly, Cy 122

U
Unitary Urbanism 190

V
Van Gogh, Vincent 82
Velvet Underground 13
Venice Biennale 11
video art 14, 31, 156
 Landers 203–4
 Nauman 233, 251–4
 Viola 229, 232–3
 Wearing 227
Viola, Bill 229, 232–3
 biography 232

W
Warhol, Andy *28*, 51–7, 76, 122, *128*, 167–8, 170,
 198, 232, 244, 260
 album covers 13
 Ambulance Disaster 52
 Beauty No.2 54
 biography 53
 Blow Job 53, 55
 Chelsea Girls 54, 56
 Cow Wallpaper 237, *237*
 disaster diptych 167
 Empire 53
 films 53–4, 55
 Haircut 53
 Marilyn Diptych 54
 My hustler 54
 mythology 22–3, 26, 27, 30
 Sleep 53
Wearing, Gillian
 biography 225, 246
 Dancing in Peckham 227
 Sixty Minute Silence 234, *234*
Weiner, Lawrence 260
Westwood, Vivienne 86–7, *87*
Whiteread, Rachel 37, 244
 biography 36
 Untitled (Book Corridors) 37
Wilson, Jane and Louise 58–9
 biography 57
 Gamma 58, *58*, *60*
Wittgenstein, Ludwig 213
Wool, Christopher 246

Y
Young British Art 197